SHAW
and
RELIGION

The Annual of Bernard Shaw Studies
Volume One

continuing

The Shaw Review

Stanley Weintraub, *General Editor*

SHAW
and
RELIGION

Edited by

Charles A. Berst

The Pennsylvania State University Press
University Park and London

Quotations from published Bernard Shaw writings are utilized in this volume with the permission of the Estate of Bernard Shaw. The previously unpublished parody of the Lord's Prayer is Copyright © 1981 The Trustees of the British Museum, The Governors and Guardians of the National Gallery of Ireland, and Royal Academy of Dramatic Art.

Library of Congress Cataloging in Publication Data

Main entry under title:

Shaw and religion.

(SHAW; v. 1)
Includes bibliography
 Contents: Shaydullah see Shaw / R.F. Bosworth
—In the beginning: the poetic genesis of Shaw's
God / Charles A. Berst—Shaw and Ra: religion
and some historic plays / J.L. Wisenthal—[etc.]
 1. Shaw, Bernard, 1856–1950—Religion and ethics
—Addresses, essays, lectures. 2. Religion in
literature—Addresses, essays, lectures. I. Berst,
Charles A. II. Series
PR5369,R4S5 822'.912 81-956
ISBN 0-271-00280-8 AACR2

Note to contributors and subscribers. SHAW's perspective is Bernard Shaw and his milieu—its personalities, works, relevance to his age and ours. As "his life, work, and friends"—the subtitle to a biography of G.B.S.—indicates, it is impossible to study the life, thought and work of a major literary figure in a vacuum. Issues and men, economics, politics, religion, theatre and literature and journalism—the entirety of the two half-centuries the life of G.B.S. spanned—was his assumed province. SHAW, published annually, welcomes articles that either explicitly or implicitly add to or alter our understanding of Shaw and his milieu. Address all communications concerning manuscript contributions (in 2 copies) to S234 Burrowes Building South, University Park, Pa. Unsolicited manuscripts are welcomed but will be returned only if return postage is provided. In matters of style SHAW recommends the MLA Style Sheet.

We note with regret the death of Arthur H. Nethercot, who had served on the editorial board of The Shaw Review / SHAW since 1959.

The Editors

CONTENTS

BIBLIOGRAPHY

REVIEWS AND CHECKLIST

INTRODUCTION

R. F. Bosworth[1]

SHAYDULLAH SEES SHAW

Back in 1931 Boris Artzybasheff (whose wry pictorial comments and humanoid machines are now so familiar to readers of *Time* and *Fortune*) wrote and illustrated a children's book entitled *Poor Shaydullah*. Shaydullah is a beggar of Marrakech in the days of the Sultan, Yakoubel-Mansour. As he watches the rich merchants drive by, he is consoled by the thought that because he is a good man Allah will someday reward him. But finally he becomes impatient for his reward, so he sets off in search of Allah. In the Great Desert he is beset by monsters and demons, and in his fear he cries out for Allah. Allah appears to him in the midst of a whirling ball of fire.

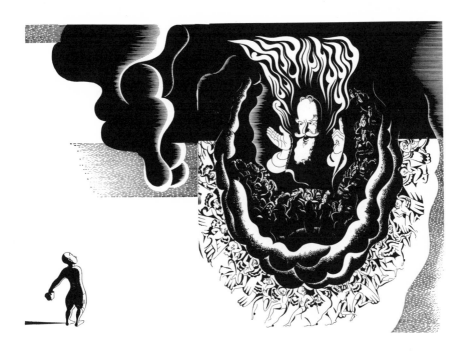

And who is Allah? None other than G.B.S., surrounded by houris and Moslem angels! And in his speech to Shaydullah there appears the very Shavian line, "There is to say Be, and It Is."

We asked Mr. Artzybasheff how he happened to see Allah as Shaw.

He replied: "I read the Koran shortly before writing the fable and was much impressed by Allah's self-esteem. Somehow he reminded me of Shaw's rather condescending manner, with which he scatters pearls of wisdom. And the Shavian beard was very fine too . . .

"By coincidence my story was published a few months before Shaw's *The Adventures of the Black Girl in Her Search for God* came out. The editor-in-chief of Macmillan mailed Shaw a copy of opus just for fun, but, as I remember, the old man misunderstood the gesture, or so I was told. The editor is now dead, so I cannot ask him for details."

Poor Shaydullah is now out of print, and so with the late Mr. Artzybasheff's permission, we reprint its image of Allah so that other Shavians may see G.B.S. in a, slightly, new role.

Note

1. A former member of *The Shaw Review* Editorial Board, Mr. Bosworth is Professor Emeritus at Simmons College and retired director of its School of Publication.

Charles A. Berst[1]

IN THE BEGINNING: THE POETIC GENESIS OF SHAW'S GOD

An interesting aspect of the essays to follow is that they start with Shaw at age forty-two, and, apart from Shaw's contributions and a biographical episode of his later years, they focus on his plays. Yet in proposing this volume no guidelines other than "Shaw and Religion" were set: no topics were assigned, no specific papers solicited. Therefore while the emphasis of these essays on the later G.B.S. may be mere chance, possibly they reflect a certain frame of mind among Shavian scholars. This could consist of several factors. First, Shaw emerged most signally as a religious dramatist with *Man and Superman* in 1903, and the plays which follow and immediately precede this event seem most pertinent to his mature views. Second, the taste of literary scholars runs more to drama than philosophy or theology. And third, there is perhaps some consensus that the development of Shaw's philosophical thought has been well covered in recent fine studies of the subject by Alfred Turco, Jr., and Robert F. Whitman.[2]

To introduce this volume, however, I believe that a stage should be set, or at least a backdrop provided, for Shaw the religious playwright. In attempting this I wish to point up an ingredient in his philosophical background which has heretofore been underplayed or overlooked: my assertion is that Shaw derived his religious views less from formal philosophical thought than from art. His religious beginnings took very little shape outside the realm of art. While he was indebted to numerous philosophers, he *experienced* religion largely in poetic terms. And for Shaw experience was the grindstone of thought. His religious views first formed in an aesthetic response to life; later he gave personal life to abstract ideas by finding them in the art of others; and finally he explored and realized his ideas in his own art. Thus in the whole process from conception to germination to expression, aesthetics played a more strategic role than philosophy. Furthermore, central to his religious de-

velopment was his perception of himself in relation to God. On these grounds this essay serves as a springboard for the rest of the volume: it starts in the beginning, traces Shaw's engagements with divinity, and, finally, having probed the aesthetics as well as the theology of these engagements, ends with an open door to the plays.

Shaw forthrightly acknowledged many sources of his thought. Perhaps his most famous listing is an oft-cited one in the Epistle Dedicatory to *Man and Superman*: "Bunyan, Blake, Hogarth, and Turner (these four apart and above all the English classics), Goethe, Shelley, Schopenhauer, Wagner, Ibsen, Morris, Tolstoy, and Nietzsche are among the writers whose peculiar sense of the world I recognize as more or less akin to my own. Mark the word peculiar. I read Dickens and Shakespear without shame or stint; but their pregnant observations and demonstrations of life are not coordinated into any philosophy or religion."[3]

Here is fertile territory indeed; perhaps almost too fertile. In sorting through this richness, most scholars who deal with Shaw's thought have emphasized his indebtedness to the philosophical and social ideas of Ibsen, Wagner, and Schopenhauer, to whom, among others, they have added Hegel, Mill, and Butler. But with the exception of one critic who focuses briefly on Blake,[4] there is a striking imbalance in their selection. Doubling over to allow for double talents in a few cases, observe the primary areas of genius of the figures Shaw cites: one is an allegorist, one a caricaturist, one a painter, one an artist-socialist, one a novelist, one a musician, two are playwrights, two are philosophers, and *six* are poets. In toto, aesthetics apply primarily to ten, philosophy to only two. Considering this, is it balanced to assume that philosophy is foremost in Shaw's "peculiar sense of the world"? Clearly philosophy is important, as Shaw's comments on Dickens' and Shakespeare's lack of it reveal, but he appears to respond to it most closely when it is an ingredient of art.

Perhaps some of the tendency to focus on Shaw's religion more in terms of philosophic prose than poetry or mysticism results from the less rational, more elusive nature of the latter. The ghosts of Cesare Lombroso, who linked genius with madness, and Max Nordau, who linked artistic genius with decadence, linger on. And, for the orthodox, to link religion primarily to poetry smacks of irreverent sophistry. At any rate, the subject is difficult to handle. But one must face up to the fact that Shaw proclaimed, "I am, and always have been, a mystic."[5] And if there is a philosopher to whom he is even closer than Schopenhauer or Hegel it is Bergson, the philosopher of intuition, whose *élan vital* he frequently equated to the Life Force, and whom he called "the established philosopher of my sect."[6] Strangely enough, a book on Shaw and Bergson is yet to be written.

More interesting than Shaw's indebtedness to a multitude of sources, however, are the ways in which he incorporated their ideas into a personal metaphysics, orchestrating their various themes to his particular overture. When he engages the genius of others he commonly pushes beyond mere rationalism. His focus is on the unconventional, the imaginative, the inspired. In earthly terms he grasps the social and socialistic insights of his sources, but, except for a few years in his young manhood, he even deals with such matters in terms of a spiritual thrust which is permeated with a poetic sensibility. Habitually his eye moves beyond the social to the spiritual, and at this point he finds that spirit, mind, and aesthetics go together. In his preface to *Androcles and the Lion* he observes that "Belief is literally a matter of taste." The idea is simple but penetrating. He follows this with an even more telling comment: "The thing [a man] believes may be true, but that is not why he believes it; he believes it because in some mysterious way it appeals to his imagination" (*Plays*, IV, 510, 511). Those with profound imaginations, such as the great poets, have profound beliefs. On the other hand, "The mass of mankind must have something to worship that the senses can apprehend." Finally, "no two men can have exactly the same faith unless they have exactly the same mental capacity."[7]

A passage in Shaw's preface to *Plays Pleasant* is not untypical of his linking of genius, art, and spiritual insight. Introducing *Candida*, he contrasts "the higher but vaguer and timider vision" of Marchbanks with "the clear, bold, sure, sensible, benevolent, salutarily shortsighted Christian Socialist idealism" of Morell. In embracing socialism and religion the parson combines qualities Shaw admires; but the poet in Marchbanks probes toward a higher spirit. Shaw likens Marchbanks' poetic struggle to that of the religious art of the Middle Ages:

> To distil the quintessential drama from pre-Raphaelitism, medieval or modern, it must be shewn at its best in conflict with the first broken, nervous, stumbling attempts to formulate its own revolt against itself as it develops into something higher. A coherent explanation of any such revolt, addressed intelligibly and prosaically to the intellect, can only come when the work is done, and indeed *done with*: that is to say, when the development, accomplished, admitted, and assimilated, is a story of yesterday. Long before any such understanding can be reached, the eyes of men begin to turn towards the distant light of the new age. Discernible at first only by the eyes of the man of genius, it must be focussed by him on the speculum of a work of art, and flashed back from that into the eyes of the common man. Nay, the artist himself has no other way of making himself conscious of the ray: it is by a blind instinct that he keeps on building up his masterpieces until their pinnacles catch the glint of the unrisen sun. [*Plays*, I, 373–74]

Here a striving artistic consciousness is the primary Life Force vehicle: prose and intellect follow its revelation. As examples Shaw cites Wagner, Blake, Shelley, and Ibsen, in company with Tintoretto and Rembrandt, Mozart and Beethoven. Most importantly, he is not talking about the social writings of these four poets; rather, he exalts them as artists. Lighting the way for their revolutionary social views is the genius of their creative talents. The instinctive artist provides a vision for the ascent of man.

To fully appreciate this vision in Shaw one must go to his beginnings, and, with wry aptness, a key to his beginning is in Saint John's poetic account of Genesis. John's gospel was Shaw's favorite, and in later years he frequently cited its first chapter, verses one and fourteen: "In the beginning was the Word, and the Word was with God, and the Word was God. . . . And the Word was made flesh, and dwelt among us . . . full of grace and truth." In the dialogue between Jesus and Pilate which prefaces *On the Rocks* Shaw has Jesus paraphrase this, and in his postscript to *Back to Methuselah* (1944) he explicates it in Shavian terms: "the Creative Evolutionist believes firmly in Providence and in what used to be called the will of God. . . . Instead of dwelling morbidly on the quite unedifying and not too interesting inference that in the beginning the earth was a wisp of blazing gas torn off from the sun, the votary of Creative Evolution goes back to the old and very pregnant lesson that in the beginning was the Thought; and the Thought was with God; and the Thought *was* God, the Thought being what the Greeks meant by 'the Word'. He believes in the thought made flesh as the first step in the main process of Creative Evolution. He believes in a new Jerusalem, and resolves, like Blake, that he will not cease from mental fight nor shall his sword sleep in his hand till he has built that paradise in England's green and pleasant land" (*Plays*, V, 698).

For Shaw, thought was a necessary first principle in the universe. But his concluding metaphor from Blake suggests that while thought is the first step in Creative Evolution, when it comes to man it translates into inspired metaphor. Considering his own life, Shaw time and again gives credit to instinct and inspiration before thought. For example: "I am not governed by principles; I am inspired, how or why I cannot explain"; and later: "When I am writing a play I never invent a plot: I let the play write itself and shape itself, which it always does even when up to the last moment I do not foresee the way out. Sometimes I do not see what the play was driving at until quite a long time after I have finished it; and even then I may be wrong about it just as any critical third party may."[8] Shaw's Earth Mother, Lilith, while aiming at pure intelligence, starts as "a whirlpool in pure force" (*Plays*, V, 630), and so, seemingly, did Shaw. Typically he wrote his plays first, his prefaces afterward.

Actually the Biblical key is more instructive than Shaw makes it. He takes the Greek original of John's "Word," which is "Logos"—reason, in its aspect as the controlling principle of the universe. But he fails to complete its meaning: it is not only a controlling principle, it is manifested by speech. Hence the Christian "Word," or Jesus, the second person in the Trinity—being the Word made flesh, Jesus is the entity who articulates God. Such articulation goes beyond speech: exegetes have pointed out that it is also God in action, creating (Gen. 1.3; Ps. 33.6), revealing (Amos 3.7–8), and redeeming (Ps. 107.19–20).[9] Taken altogether, the Word made flesh and manifest as articulation, creation, revelation, and redemption is nothing less than an ultimate metaphor; and, curiously enough, all of these qualities apply to Shaw's aesthetic and spiritual impulses and to his Life Force in action. In sum, in the beginning was the Metaphor—and so, in most strategic spiritual ways, it was with Shaw.

The genesis of Shaw's Word may be found not in any philosopher but in elements of his boyhood which he conceived metaphorically and which in fact formed metaphoric patterns that remained with him all his life. When he reminisces about his family's shabby gentility, its snobbery, the humiliating alcoholism of his father, and his loveless mother, he most commonly images his youthful environment as a hell from which he sought refuge in reading, music, and his imagination. In *Sixteen Self Sketches* he inhabits this hell with "three fathers"—his ineffectual natural one, his blasphemous Rabelaisian uncle, Walter Gurly, and his mother's dynamic voice teacher, Vandeleur Lee (p. 14). For a seemingly drab childhood this was a remarkably evocative Trinity. Consider Shaw's response upon discovering that his father was habitually drunk: "It is a rhetorical exaggeration to say that I have never since believed in anything or anybody; but the wrench from my childish faith in my father as perfect and omniscient to the discovery that he was a hypocrite and a dipsomaniac was so sudden and violent that it must have left its mark on me." In contrast was Uncle Walter: "He was always in high spirits, and full of a humor that, though barbarous in its blasphemous indecency, was Scriptural and Shakespearean in the elaboration and fantasy of its literary expression." And, finally, there was Lee's virtually spiritual influence: "My mother's salvation came through music" (pp. 12–15). In short, as Shaw looked back on his childhood he perceived a metaphor whose pattern and values were to be permanently fixed in his imagination: set in the hell of a world of social hypocrisy was a defunct God, a high-spirited literary devil, and salvation in music. For a sensitive, imaginative soul the pattern had enduring psychological, aesthetic, and spiritual strength. It gives extra point to such future Shavian utterances as his

comment to Tolstoy in 1910: "we none of us want to be like our fathers, the intention of the universe being that we shall be like God."[10]

Although a prime element of Shaw's gospel is that one must learn to engage reality vigorously, he admitted even at the end of his life that imaginative constructs were more real to him than life itself. He speaks of once having taken a word-association test: "When this Freudian technique was tried on me it failed because the words suggested always something fictitious. . . . I was living in an imaginary world. Deeply as I was interested in politics, Hamlet and Falstaff were more alive to me than any living politician or even any relative. . . . All I can plead is that as events as they actually occur mean no more than a passing crowd to a policeman on point duty, they must be arranged in some comprehensible order as stories" (*Plays*, VII, 384–85).

As Shaw recalls his youth, this arranging process first took place almost musically in his nightly devotions: "In my childhood I exercised my literary genius by composing my own prayers. I cannot recall the words of the final form I adopted; but I remember that it was in three movements, like a sonata, and in the best Church of Ireland style. It ended with the Lord's Prayer; and I repeated it every night in bed. . . . I did not care whether my prayers were answered or not: they were a literary performance for the entertainment and propitiation of the Almighty."[11]

Thus Shaw's first substantial response to deity was an imaginative one, combining propitiation with instincts for literature, music, and entertainment. When he was almost ten his irreligious parents at last gave up the middle-class pretense of sending him to church (he hated church) and the prayers were abandoned, but not the imagination which had made entertainments of them. At about the same time Vandeleur Lee moved into the household, eclipsing Shaw's father, and Uncle Walter's blasphemy took ever greater hold. The aesthetic and religious effects of these events on Shaw were no doubt greater than his relief at leaving church and prayers behind. The debunked Father figure was overthrown, an energetic savior was providing Shaw with a gospel of music, and an attractive devil was playing in syncopation with his soul. His life, seemingly so drab, was charged with this microcosmic metaphor of macrocosmic archetypes—a metaphor which apparently stimulated his imagination, however half-consciously, because he responded to it compulsively and in kind. Biographers have referred to the following passage as a curious, somewhat humorous fact. They have failed to engage its far more revealing nature as a strategic point at which metaphor became a way of life for Shaw:

Even when I was a good boy I was so only theatrically, because, as actors say, I saw myself in the character; and this occurred very seldom, my taste running so strongly on stage villains and stage demons (I painted the whitewashed wall in my bedroom in Dalkey with watercolor frescoes of Mephistopheles) that I must have actually bewitched myself; for, when Nature completed my countenance in 1880 or thereabouts (I had only the tenderest sprouting of hair on my face until I was 24), I found myself equipped with the upgrowing moustaches and eyebrows, and the sarcastic nostrils of the operatic fiend whose airs (by Gounod) I had sung as a child, and whose attitudes I had affected in my boyhood. Later on, as the generations moved past me, I saw the fantasies of actors and painters come to life as living men and women, and began to perceive that imaginative fiction is to life what the sketch is to the picture or the conception to the statue. [*Works*, I, xxii–xxiii]

This moves a significant step beyond Shaw's creative prayers. They had included religion, literary composition, musical form, and performance, ending with the Lord's Prayer as a ceremonial coda, all aimed at the propitiation of the Almighty. Their childish spirit welled forth from an ambiguous impulse half way between assertive aesthetics and a cringe. Now with church out of the way, a hypocritical father-figure exposed and dethroned, a prevailing gospel of music in the house, and Uncle Walter's appealing blasphemy setting an example, Shaw's spirit had more exciting stimulants. The result, captured in the quotation above, was a composite of actor, playwright, painter, musician, and arch rebel—all seeds for the later G.B.S. Shaw remarks that at the age of twelve "I was a Boy Atheist, and proud of it" (*Self Sketches*, pp. 23–24). But even more important than the fact of his atheism was its aesthetic and psychological nature. While the boy prided himself on his rationalism, all signs are that he was propelled into his future course more by imaginative impulses and psychological need.

Shaw's stultifying boyhood, from which he escaped only in reading, music, and his imagination, was capped by his four dreary years as a clerk in a Dublin estate agent's office. But once again external dullness was offset by a crescendo of internal poetry. As a boy he had absorbed the romantic glamor of Byron; however "when I was nearing twenty, Shelley got me; and I went into him head over heels and read every word he published. That was a sort of literary falling in love: Shelley's kingdom was not of this world for me."[12] The last sentence is especially telling. So much has been written about Shaw's debt to Shelley's radical social views that his strong aesthetic and spiritual involvement with the poet has generally been overlooked. While he had little taste for Shelley's romanticizing about love, especially in *Epipsychidion*, Shaw's

total absorption of Shelley in his late teens was one in which his personal attitudes and social consciousness soared with Shelley's total sense of aesthetics, and this composite stayed with him. Near the end of his life he remarked: "It was Shelley who converted me to vegetarianism. I must have been the only man who took his poetry seriously, because it was mainly women who attended the Shelley Society. You see, vegetarianism to Shelley, like marriage and atheism, was a form of poetry. I am always asked how it is that my opinions have changed so little since my youth. It is because I got to them by poetry. As I always say, the aesthetic is the most convincing and permanent. Shelley made his ideas sing; I made them dance."[13]

Via Shelley, Shaw perceived that an enlightened consciousness can be spiritual in atheistic terms. Referring to Thomas Paine, Voltaire, and Rousseau, he comments: "It was then part of the education of a gentleman to convince him that the three most religious men in Europe had been impious villains, and were roasting in blazing brimstone to all eternity. Shelley cured me of all that" (*Self Sketches*, p. 108). Most likely the greater the flexibility, capaciousness, and poetry of consciousness, the greater its essential spirituality, and Shaw's view in 1894 was that "In this century the world has produced two men—Shelley and Wagner—in whom intense poetic feeling was the permanent state of their consciousness."[14] In such a light Shaw felt a special kinship to both: "I am a poet, essentially a poet. I lived in a time when poetry meant something to people. In my penurious days I carried a Shelley in my pocket and thought myself the wealthiest person in the world. That book was my talisman."[15] Both early and late in Shaw's life this poetry was holy. In 1944 he wrote to Sister Laurentia McLachlan: "The saint who called me to the religious life when I was eighteen was Shelley."[16]

The religious impact of Shelley's spirit on Shaw clarified and broadened his rebellious impulses. From his instinctive Mephistopheleanism he moved toward the culture hero of *Prometheus Unbound:* Shelley had colorfully identified the orthodox, repressive Jehovah as the Almighty Fiend, and then gone on to promote humanism on a personal and social level. It was in this newly found culture-hero vein that Shaw first broke into print in 1875, late in his eighteenth year, with a letter to the editor of *Public Opinion.* Writing about the Dublin meetings of the American revivalists Moody and Sankey, Shaw spends less space on the preachers than on their little true spiritual effect on the audience. Here the young Promethean appears patiently and subversively, trying to civilize the uncivilized.[17]

Obviously significant in a life so fraught with religious ideas as Shaw's was is the fact that his first major literary effort was a "Passion Play."

Although it is a somewhat crude piece of work, the play is arresting since it not only presents Shaw's early attitudes towards Christianity, but also reflects his biography, ethics, and sense of poetry. Yet most biographers and critics have passed it by. First published in a limited edition of 350 in 1971, it was not generally available until it appeared in Volume VII of the Bodley Head edition of the plays in 1974.[18]

Shaw's manuscript is entitled "The Household of Joseph," but the editions have called it, simply, *Passion Play*. Written in 1878, when Shaw was twenty-one and barely two years in London, the play is in blank verse and unfinished. The manuscript in the British Library reveals that Shaw worked it over carefully before abandoning it in the middle of the second act. Act I is set in Nazareth. Scene I sketches Mary as a shrew, Joseph as drunken and brutal, Jesus's brother John as scholarly, prim, and pious, and Jesus (a bastard) as an honest, poetically disposed idealist with fervent spiritual impulses. Jesus is scorned by Mary as a good-for-nothing vagrant, disparaged by John for his bohemianism and unorthodox views, and defended by Joseph. A wealthy traveller, Judas Iscariot, drops by the family's carpenter shop to have a valuable cabinet repaired. Jesus, much to Mary's disgust, says that he and his family are too unskilled and would botch the job. Scene II takes place in a field that night. Judas comes across Jesus's girlfriend Rahab and briefly flirts with her. When Jesus enters and Judas suggests that the three of them go together Rahab huffs off, whereupon the two men converse. Their dialogue is the crux of the incomplete play: Judas, a rationalist and atheist, confronts the poetic man of faith.

There are several remarkable aspects to this dialogue. Not only does it reveal a great deal about Shaw's spirit at the age of twenty-one, it also throws a strong light on the germination of so much of the G.B.S. of later years. And while the rationalistic Judas is the author's primary mouthpiece, both he and his author are impressed by Jesus's poetic spirituality.

The conversation starts with Judas responding to Jesus's infatuation with Rahab. He disparages romantic notions about women and then moves into his realist's view of man and the universe. Surprisingly, this sequence bears a great similarity to patterns of argument in the later Shaw. Some thirteen years afterwards, *The Quintessence of Ibsenism* moves from disparagement of the Victorian idealization of women into an explanation of the realist's view of existence. Similarly Shaw's preface to *Three Plays for Puritans* (1900) evolves from disparagement of romantic stage conventions about women and love to his view of the diabolonian, Caesarean, and Promethean realist; and the hell scene of *Man and Superman* switches midway from talk of women and marriage

to the realistic matters of man's deadly instincts versus the evolution of his mind. In all cases, from the *Passion Play* to *Man and Superman*, romantic illusion is contrasted with rigorous yet aspiring realism. The fact that Shaw's arguments repeatedly and over such a span of time follow this development from flesh and illusion to matters of reality and spirit points as clearly as anything else to a prevailing religious impetus throughout his life, an impetus starting as far back as his "atheistic" twenty-first year.

As might be expected, Judas's criticism of romantic ideas about women and God is less discriminating than similar passages in Shaw's later writings: he attacks women and God themselves almost as much as the romance about them. Also foreshadowing but more strident than the later Shaw is his atheism:

> Think for thyself, and it must come to this:
> That the great God will seem a silly idol;
> The prophets, raving and hysteric madmen,
> Poets driven wild by their corrupt surroundings;
> Creation will retire behind a veil,
> Riddle inexplicable!
>
> [*Plays*, VII, 504]

So much for the old tribal idol Jehovah, a bogey Shaw was to denigrate time and again and to dissect most pointedly in his *Black Girl in Her Search for God*. And regarding Creation this is a precursor of Shaw's exclamation in 1901: "Enough. You expect me to prate about the Absolute, about Reality, about The First Cause, and to answer the universal Why. When I see these words in print the book goes into the basket. Good morning" (*Self Sketches*, p. 55). Judas continues:

> Then must thou
> Learn to stand absolutely by thyself,
> Leaning on nothing, satisfied that thou
> Can'st nothing know, responsible to nothing,
> Fearing no power and being within thyself
> A little independent universe.
>
> [p. 504]

Such is almost the nature of Shaw's superman, the hero he was later to prefigure when he analyzed Wagner's Siegfried in 1898. Rather like Judas, Siegfried stands against the god Wotan as "a type of the healthy man raised to perfect confidence in his own impulses by an intense and joyous vitality which is above fear, sickliness of conscience, malice, and the makeshifts and moral crutches of law and order which accompany them" (*Works*, XIX, 225). Jesus responds:

But this is atheism.
JUDAS. 'Tis so. What then?
JESUS. Behold the world. Somebody must have made it.
JUDAS. Somebody must have made this somebody.
JESUS. Some cause must have existed from all time.
JUDAS. I may as easily say the world has too.

[pp. 504–5]

Here is an existentialist taproot, existence preceding essence. In the nature of existence, however, Judas observes life's growth principle which Shaw was later to propose as essence in his Life Force philosophy:

But friend, thou reasonest like a carpenter.
Thou makest coffers; ergo, all visible coffers
Must have been made by hands intelligent
As thine are. But behold yon sheaves of wheat.
They were not planed nor sawn; from a small grain
They grew, containing in themselves the principle
That thou would'st force on an eternal craftsman.

[p. 505]

Continuing to shoot out roots for the later G.B.S., Judas states proudly that he does not need paradise—he is "the only man who dares to die"; in the manner of the mature Shaw he thanks nature for his unruly mind wherewith he may know others according to himself and himself according to others, and with which he can envision the evolution of men in humanistic terms.

With all of this proto-Shavian assertion it would seem that Judas is his author's champion. But there is another side to the matter. In this dialogue—before its author had read either Hegel or Marx—is a lively dialectic, a poetically charged ambiguity. Similar to so many dialectics in Shaw's later dramas, both sides in the contest are represented by virtuous, well-intentioned beings who have valid points to make. As Judas is assertively independent and unconventional so is Jesus. The one reaches beyond the norm with tough-minded atheism, the other transcends the norm with poetically inspired faith.

Since Judas's speeches in Scene II are mostly far longer than those of Jesus he appears to carry the argument, yet the scene tends to build Jesus's special role, a role first glimpsed amidst the family farce of Scene I. There Jesus is the instinctive poet: "I think on Rahab and my mocking spirit/Flies fiercely up, and 'mid the singing stars/Ecstatically dances." But although he desires to be "a son of fire and air" Jesus laments that he is just "the base issue/Of a poor workman's shrew," and he upbraids his mother for driving "All noble aspirations from my

head/And poetry from my heart"(pp. 493, 497). After this the rational-
istic Judas comes as a second challenge to Jesus's poetic spirit. But now
there is an important difference: while Mary scorns her son's nature,
Judas acknowledges its special qualities as opposed to his own:

> I'll not debate with thee, for I perceive
> Thou art a poet, and hast made a refuge
> In rosy bowers of imagination
> Where thy o'erburdened, questioning soul may rest.
> Yet would I not exchange the mail of proof,
> Hard though it be, in which I combat destiny
> For the soft woven but delusive robe
> In which thou dost so meekly wrap thyself.
>
> [p. 506]

Judas's combined sympathy and skepticism here gain extra point in
light of a soliloquy he delivers early in the scene. Thinking he is alone
in the night, he makes a personal confession:

> Once—in my youth—
> I hoped to be a poet, ere my pride
> In reason's empire made me a philosopher;
> And still the perfume of my early dreams
> Smacks in my brain, responsive to the call
> Of this enchanting scene. Judas! I love thee.
> Thou art a rare fellow—now in Pilate's hall
> An earthy libertine, and anon in Nazareth
> Ethereal and sublime, a wanderer 'midst
> The radiant stars. And yet a sorry creature
> Without a crumb of knowledge to replace
> The anchor, Faith, which thou hast cast away.
>
> [p. 499]

The philosopher has buried the poet, but not the poet's sensibilities. He
is a rare fellow, both an earthy libertine and poet-wanderer amongst
the stars. Tugged at by both reason and poetry, he realizes how little
knowledge his reason has, and laments that without knowledge, poetry,
or Faith he is an anchorless, sorry creature. He immediately seeks to
regain his cynical composure: "Pah!—A beastly world!—better believe
in nothing/Than old wives' tales and murder-stained Jehovahs." But
obviously he is discomposed. He even rejects logic in favor of the vital-
ity of his own youth: "Avaunt, ye trains of logic. Up, Iscariot!/Be irre-
sponsible, sublime, and young." What he has actually done is to substi-
tute one poetry for another: the poetry of Being for the poetry of
Faith. So it was, one can guess, with the young Shaw, the striking thing
being that apparently he knew it.

In perceiving himself as a sorry creature without Faith Judas reveals a private Jesus-like sensitivity. His skepticism and sense of loss foreshadow Jesus's later response to his cynicism about a First Cause. Jesus replies to his atheism:

> For, till this day, I never met a man
> Who believed less than I. I do confess
> The God of Scripture is a gloomy tyrant
> On whom I cannot bring myself to look.
> But, were I to believe no God at all
> I would, despairing, die; I could not face
> A stony blank of vegetable life
> Preying upon itself.
>
> [p. 506]

This exchange between atheist and believer undoubtedly derives from an incident Shaw recalls in his preface to *Back to Methuselah*. Not long before writing his *Passion Play* he had an argument with a priest, Father Addis, in the Brompton Oratory. To Father Addis's commitment to God as a First Cause, Shaw responded, "By your leave . . . it is as easy for me to believe that the universe made itself as that a maker of the universe made himself: in fact much easier; for the universe visibly exists and makes itself as it goes along, whereas a maker for it is a hypothesis." Father Addis's concluding reflection was "that he should go mad if he lost his belief." Shaw, on the other hand, "glorying in the robust callousness of youth and the comedic spirit, felt quite comfortable and said so; though I was touched, too, by his evident sincerity" (*Plays*, V, 287).

In reporting his youthful callousness, Shaw then goes on to undercut it. He comments on the argument as an example of a historical and spiritual problem: society had divided itself between belief in a Jehovah-bogey on the one hand and atheistic scorn on the other, with true spiritual awareness dropping through the gap: "One hardly knows which is the more appalling: the abjectness of the credulity or the flippancy of the scepticism. The result was inevitable. All who were strongminded enough not to be terrified by the bogey were left stranded in empty contemptuous negation . . . It was easy to throw the bogey into the dustbin; but none the less the world, our corner of the universe, did not look like a pure accident: it presented evidences of design in every direction. There was mind and purpose behind it" (pp. 287–88).

Brought together, these strains from the Shaw of 1878 and 1921 reveal striking parallels. Although he was callous, the young man who argued with Father Addis was "touched" by the priest's evident sincerity. By the time he wrote the play this emotion came forth more

strongly in his Judas who appreciates the poetry and imagination of the believer. Further, not only has Judas himself once hoped to be a poet, but he exemplifies an argument of the mature Shaw when he privately admits that without Faith he is anchorless. Jesus reflects Shaw in his limited belief and his recognition that "The God of Scripture is a gloomy tyrant." Finally, in his very need to believe, Jesus anticipates the older Shaw; like Shaw, he is repulsed by the mindlessness of such ideas as natural selection: "I could not face/A stony blank of vegetable life/ Preying upon itself." To outface this stony blank Shaw was to hypothesize a Life Force much as his Jesus hypothesizes "A grand, ineffable, benevolent Power" (p. 506).

At the conclusion of the Judas-Jesus dialogue the rational and poetic views literally come together when Judas says,

> Thus I to reason trust, and thou to dreams.
> But, save that I ask no part for myself
> Except the foretaste which my mind supplies
> We look to the same end. Then let's take hands.

With the joining of hands Shaw effects a Hegelian synthesis long before he had read Hegel:

> Henceforth, thy gentle faith
> Shall travel hand in hand with hard negation,
> Tempering its unsympathetic edge
> And learning somewhat from its breadth of vision.
> Trust me not, though, too quickly. Man is fickle,
> And all that I have said under these stars
> Tomorrow I may laugh at. But fear nothing:
> I will not laugh at thee.
>
> [pp. 508–9]

The question may be, who will learn the most from whom? Shaw's fragment left him far short of a rendering of Judas's betrayal of Jesus, although he hints at it in the "Trust me not." Significantly, Judas's words suggest that *reason* is untrustworthy: tomorrow's laughter at to-day's ideas may chastize and purify them, but "reason" may be laugh-able and subject to the fickleness of man—perhaps, then, not reason-able at all, quite possibly a secondary faculty, not a prime mover. If this be the case, how is reason to be relied upon? It would seem that Shaw is edging instinctively towards Schopenhauer's concept of will over rea-son; more immediately this statement is juxtaposed with the poetry of Jesus which, although it may have much to learn, is *not* fickle. Of the two men, even in this version of the story, the poetry and faith of Jesus, not the rationalism and skepticism of Judas, seem more likely to change the world.

Critics have been quick to observe the autobiographical analogy in the play's story line—a romantic young man (illegitimate?) discontent with provincialism, unhappy with the shabbiness and conventional hypocrisies of his family, a potential prophet unhonored in his own home and country, leaves behind a drunken father to pursue his destiny in a big city where he can "begin to live and work." However subconscious the analogy may be, its audacity is obvious: it aligns Shaw more with Jesus than with Judas.

Actually Shaw is both outside and inside Jesus. In giving Judas the longer speeches and more lively character, the young atheist is projecting the Mephistophelean role of his childhood into his first sustained work of art: Judas is the flexing of his iconoclastic spirit. But at the same time Jesus is obviously an intriguing figure to him: while the young diabolonian playwright ruthlessly brings the Messiah to earth by making him a bastard and Mary a shrew, and by drawing him as simple and romantic, yet even the diabolonian finds that Jesus embodies an attractive genius and poetry. Also there was the appealing pattern of Jesus's rise from frustration and obscurity to fulfilment and fame, a pattern no doubt striking sympathetic chords in the young playwright's spirit. Consequently his Jesus embodies his own aspiring spirit, his own poetic romanticism, while his Judas is Shaw the incipient critic, appreciating his own poetic impulses yet chastizing their romance.

Thus Shaw's internal spiritual condition found expression in an external drama—the one serving as a metaphor for the other. And this was to be a large component of his creative writing throughout his life. Finally, by partaking of a personal spiritual metaphor the play's driving force is a spiritual quest of its author as well as of its characters, and its autobiographical analogy forwards its author in the most ambitious archetypal terms. Privately and instinctively as well as artistically and rationally Shaw was testing the sandals of a superman.

One might suppose that Shaw's immersion in Shelley at the end of his teens predisposed him to the atheistic attitude of Judas, but probably the reverse was true. The atheism of Shelley's "Essay on Christianity" is in fact sensitively spiritual. He writes: "The universal Being can only be described or defined by negatives which deny his subjection to the laws of all inferior existences. Where indefiniteness ends idolatry and anthropomorphism begins."[19] Such a view, in itself, is atheism only to men of cramped imagination. In fact it is akin to the view commonly held by the greatest Christian mystics, who sometimes tried to express their experiences of divinity as light or fire, but often found language inadequate, and consequently would describe divinity in terms of what it was *not*.[20]

Yet like the later Shaw, Shelley does try to attribute a quality to God's

indefiniteness. His motive is much the same as Shaw's: the mind aspires to conception, no matter how limited man's capacities are. Beset by such a drive, Shelley offers a precursor to Shaw's Life Force: "There is a Power by which we are surrounded, like the atmosphere in which some motionless lyre is suspended, which visits with its breath our silent chords at will. . . . This Power is God; and those who have seen God have, in the period of their purer and more perfect nature, been harmonized by their own will to so exquisite [a] consentaneity of power as to give forth divinest melody, when the breath of universal being sweeps over their frame."[21] When Shaw's Jesus speaks of "A grand, ineffable, benevolent Power" he is close to this, but then he slips into anthropomorphism by imagining the Power "throned in the clouds" (p. 506).

More directly relevant to Shaw's *Passion Play*, Shelley identifies Jesus as a poet and at the same time gives poetry the highest spiritual status. He calls Jesus an "extraordinary genius," a "wonderful man," a "sublimest and most holy poet" who possessed a "daring mind": "such an expression as he has used was prompted by the energy of genius, and was the overflowing enthusiasm of a poet."[22] And in Shelley's lexicon "Poetry is indeed something divine. It is at once the centre and circumference of knowledge." By contrast, "Reason is to imagination as the instrument to the agent, as the body to the spirit, as the shadow to the substance."[23] Shelley incorporates this aesthetic-spiritual vision in his *Prometheus Unbound,* in which the major themes of forgiveness and selfless love dramatize the ethics of the Sermon on the Mount. The play draws numerous analogies between the sufferings of Prometheus and the Passion of Christ. Prometheus is freed not by Hercules but by his ceasing to hate and starting to pity Jupiter. "God" is never explained in the play: he is not Jupiter; his force is a vague power of necessity and process called Demogorgon; man must redeem himself through aspiration and love.

It was in these spiritual terms, terms related to socialistic thought and vegetarianism, that Shaw experienced Shelley as "a religious force" (*Plays,* II, 499), one which no doubt influenced the writing of his *Passion Play*. And complementing these terms were others from his youth. In his late eighties he remarked, "That I can write as I do without having to think about my style is due to my having been as a child steeped in the Bible, the Pilgrim's Progress, and Cassell's Illustrated Shakespear."[24] The subject matter and idiom were in his consciousness. They came together in a private expression (obviously unpublishable and too sacrilegious for the Victorian stage) which suited his private needs. The fitful flames of his youthful diabolism were joining with a Promethean fire which involved as much spirit as revolt.

Shaw may have abandoned his manuscript for any number of rea-

sons. Most suggestive is his inscription "Vile Stuff" across one deleted passage. But how "vile stuff"? Possibly because the blank verse is frequently stilted, the poetic diction and images often forced, the characterizations more lively than deep. By comparison with Shakespeare his efforts were bumbling. For that matter, perhaps the idiom of Shakespeare was not worth emulating. He commented later: "Elizabethan Renascence fustian is no more bearable after medieval poesy than Scribe after Ibsen" (*Plays*, II, 519). In his play there is certain poesy in the like of the medieval mystery plays which combine farce with Biblical subject matter. A subtler form of this serio-comic idiom was later to become his hallmark. But here he had committed himself to blank verse and the shackles of a Biblical tradition which ran counter to his creative and spiritual energies. As he recognized later in writing his Jesus-Pilate dialogue for his preface to *On the Rocks*, his version had to fly free of its source. After having written the Jesus-Judas dialogue, his big stone had been thrown: beyond this his imagination could only play an irreverent hopscotch with numerous Biblical details, and finally it was up against a far greater poetry—that of the Christ legend itself.

For whatever reason, this particular effort was dropped. But for all its brevity and imperfections it does reveal Shaw thrusting himself forth at the very start of his creative career in a way which, for all its skepticism, is assertively spiritual. In his ambiguous struggle with these materials he was an example of his own words: "The truth is that dramatic invention is the first effort of man to become intellectually conscious" (*Plays*, I, 378).

Shaw's five novels, ground forth methodically at the rate of one a year between 1879 and 1883, were his first major attempt to move from the private world of his imagination into the public arena. Their motive, method, and limited artistic and commercial success have resulted in their being largely passed over by critics and biographers.[25] Although they display glimmerings of talent, they are pedestrian in comparison with the outpourings of Shaw's later genius. But overarching their mundanity is their importance as a factor in his spiritual growth. In toto they comprise an aesthetics of being, a type of personal poetry. Shaw expresses it simply: "to preserve myself from the dry rot of idleness [I] attempted to realize myself in works of Art."[26] But most ambitiously he links this self-realization with divinity: "How much should a competent novelist know? Well, everything. . . . This, however, requires the novelist to be God Omniscient, if not God Almighty. It is a counsel of perfection; but it is not therefore useless. A counsel of perfection is the great desideratum in all branches of conduct—to be striven towards if never attained. The novelist must do his best."[27]

Although the subject matter of the novels is mostly far from reli-

gious, they do give evidence, in a seminal way, of a spiritual quest. Having viewed the poetry of one superman in his *Passion Play,* Shaw gives vent to others in his fiction. Metaphorically, four of the five novels stretch human limits. While their protagonists are of this world they are also heroic in very special ways, and, as each is quite different, they reveal their author exploring various godlike possibilities of man.

Shaw started on a personally frank ground floor. He comments that his first novel, "was called, with mercilous fitness, Immaturity" (*Works,* IV, xi). Robert Smith, the hero of *Immaturity,* is at the same time the most autobiographical and the least admirable of all the heroes. Retiring, lonely, introverted, and ineffectual, yet sententious and snobbish, one of his few redeeming characteristics is that he, like Shaw, has thrown over Byron for Shelley. And one of the few redeeming qualities of the novel is that the author can mock his own fictional alter ego. This was not a bad starting point. At least it was close to home, and self-criticism must be active at the start of spiritual growth. Beyond Smith and even beyond himself Shaw reached for more impressive alternatives. Instinctively, almost poetically, he was striving to fulfill his conviction that "The business of a novelist is largely to provide working models of improved types of humanity."[28]

The first of these improved types was a nineteenth-century extension of his Judas: Edward Conolly of *The Irrational Knot.* In Conolly, an extraordinarily rational and practical electrical engineer, Shaw pushed his own rationalism to the limit. Being both a dedicated scientist and an accomplished musician, Conolly embodies materialistic mind, inventiveness, commercial usefulness, social grace, and cultural savoir-faire: he is, in short, a specifically modern god. Being almost too much so, he was a purge for his author. In 1892 Shaw remarked: "I hardly know anybody who has got through 'The Irrational Knot.' . . . I suspect that the model Conolly was as incompatible with the public as with his wife. Long before I got to the writing of the last chapter I could hardly stand him myself."[29] Later he wrote to Sister Laurentia McLachlan: "I exhausted rationalism when I got to the end of my second novel at the age of twenty-four, and should have come to a dead stop if I had not proceeded to purely mystical assumptions."[30] So much for Conolly and the strictly rational side of Judas.

Nowhere in Shaw's life is a spiritual shift clearer than in the three years from 1881 to 1883. Shaw himself pinpoints September 5, 1882, when his eyes were opened to socialism by a lecture of Henry George, author of *Progress and Poverty.* As a result he delved into Marx's *Capital,* remarking afterwards, "I was a coward until Marx made a Communist of me and gave me a faith" (*Self Sketches,* p. 109). However this faith had a groundwork. Not only had Shelley moved his spirit, but through his

third and fourth novels his imagination had broken free of rationalism into an expanding celebration of that which was instinctively heroic. The protagonists of his three novels during this period are Blakean and Promethean. They assert the virtue of the diabolical or pagan culture hero. And each is identified as a type of god.

Shaw's comments on the hero of his third novel, the composer Owen Jack in *Love Among the Artists,* indicate this expansive change in his aesthetic and spiritual values: "Jack is just the opposite of Conolly: the man of genius as opposed to the rational man. The novel marks a *volte face* on my part. I had before kept within intellectual bounds: here I let myself go and guessed my way by instinct"; and, later, he describes Jack as "a British Beethoven, utterly unreasonable and unaccountable, and even outrageous, but a vital genius, powerful in an art that is beyond logic and even beyond words."[31] Jack is ugly, pock-marked, and demonic, but at the same time his spirit is an aspiring one, almost other-worldly. At one climactic point he rejects money and marriage, exclaiming, "Back to thy holy garret, oh my soul!" (*Works,* III, 213). Edward Conolly, reappearing from the preceding novel, observes: "He would make an excellent God, but a most unpleasant man, and an unbearable husband" (p. 246). With the performance of Jack's magnum opus, *Prometheus Unbound,* Shaw coalesces Beethoven, Shelley, a devil-god, and Prometheus all in a model of aesthetic and spiritual energy.

The hero of Shaw's fourth novel, *Cashel Byron's Profession,* is a sharp contrast to Jack in appearance and talent, but as a champion prize-fighter he is fully as instinctive and also much like a god: this time a Greek one, a statement of pagan divinity in flesh, an Apollo. When the novel's heroine first encounters him exercising in a forest opening she is dazzled—he is like a beautiful statue: "His broad pectoral muscles, in their white covering, were like slabs of marble. Even his hair, short, crisp, and curly, seemed like burnished bronze in the evening light. It came into Lydia's mind that she had disturbed an antique god in his sylvan haunt" (*Works,* IV, 37). The gospel of this god is "executive power" and, reflecting Shaw's pugilistic spirit and current interest in boxing, he looks upon life as a fight in which one must have courage, sharp instincts, training, and knowledge. In contrast, Lydia is a reincarnation of the Shavian rationalist, and in comparison with Byron she is a fragile creation: delicate, high-strung, artificial; finally, according to Shaw, she is "machine-made . . . full of wheels and springs."[32] In Lydia pure rationalism appears slightly pathetic, a bit absurd: she decides to marry this sylvan god on eugenic principles, but the principles go awry when their girls take after Byron and their boys after her.

The ebullience of Shaw's fifth hero, Sidney Trefusis of *An Unsocial Socialist,* reflects that of his author, in whom Marx had just excited a

religious response. ("From that hour I was a speaker with a gospel" [*Self Sketches,* p. 58]). Trefusis is loquacious, egocentric, outrageous— and intent on converting the world to his socialist cause. In him Shaw's spiritual impulses burst through a social spout. This hero is a bizarre, would-be Messiah: "With my egotism, my charlatanry, my tongue, and my habit of having my own way, I am fit for no calling but that of saviour of mankind—just of the sort they like" (*Works,* V, 110). Thus in his last novel Shaw ironically contemporizes the poetry of Jesus.

Shaw said that he intended *An Unsocial Socialist* to be "a gigantic grapple with the whole social problem," but that he left it incomplete because "I broke down in sheer ignorance and incapacity."[33] There was another obvious reason: since his novels were all rejected by publishers, he must have felt compelled, as a type of Trefusis, to move from unsuccessful fiction to the realities of social activism. But while he had embraced an inspiring gospel through Marx, in retrospect it seems probable that the confident extrovert of the late 1880s was first born in a more poetic element. At least in part he had grown in perception through fictional alter egos, metaphoric extensions of his own im- pulses—heroic embodiments of rationalism, art, pugilism, and social- ism. And insofar as he conceived of these as godlike he was building in himself, via art, a sense of immanent divinity. This highly personal sense, generated so imaginatively here and over such a period of time, was to well forth in his later Life Force convictions. Take, for example, an argument he launches against Darwinism and materialism in 1919: "Such a thing cannot last; it is too entirely against all our poetic in- stincts. . . . We know there is intention and purpose in the universe, because there is intention and purpose in us. People have said, 'Where is this purpose, this intention?' I say, 'It is here; it is in me; I feel it. I directly experience it, and so do you, and you need not try and look as if you didn't' " (*Religious Speeches,* p. 76).

In 1889 Shaw called his novels "bad sermons, which failed because I, thanks to skulking in picture galleries, was a nonentity; and the realiza- tion of a nonentity in a novel is not interesting."[34] But the linking of sermons, self-realization, and alter egos with godlike attributes suggests strongly that here was a major origin of the later voice which stated, "I strive to surpass myself and produce Superman."[35]

The years of Shaw's socialist activity following his conversion by Marx have been viewed by biographers as largely secular, yet in fact they were filled with artfulness (if not art) and a religious quality. Often quoted is the statement with which he shocked members of the Shelley Society in January 1887: "Like Shelley, I am a Socialist, an Atheist, and a Vegetarian." And almost equally telling is his response to a paper on "Saul" at a Browning Society meeting the next May. The Society's min-

utes report: "Although not a Christian, [Shaw said] he would like to say a word or two on Christ from a purely secular point of view. In regard to the statement that Christ is always with us, he thought that if Christ were to come on earth and see what was taking place, he would be very greatly hurt to be told that it was the influence of his spirit, for [Shaw] thought this was the most desperately mean, sordid, selfish, rascally, dastardly century that any one could wish to live in."[36]

What can so easily be missed about such statements is their religious nature and their literary setting. At this time Shaw was a faithful member of the Shakespeare, Shelley, and Browning Societies. Like the most diligent of preachers he lectured on his socialist gospel virtually every Sunday, and sometimes two or three times a Sunday, from 1883 to 1895. In 1889 he admitted to the Church and Stage Guild: "I have an incorrigible propensity for preaching."[37] On the one hand his statement to the Browning Society is rhetorically Trefusis-like, on the other hand it identifies with Christ and anticipates Shaw's "Preface on the Prospects of Christianity," which outweighs *Androcles and the Lion*. No one seems to have noticed that by the end of the 1880s he was identifying ever more with Christ—tentatively, rhetorically, playfully, but not insignificantly for a man to whom every jest was an earnest in the womb of time.

During the 1880s Shaw sprouted with pseudonyms in his essays and letters to the press (possibly these were an ancillary means for him to move art into life) and one of his most audacious in 1888 was "J. C.," on the subject, "Is Christianity a Failure?": "As to the eighteen centuries of what you call Christianity, I have nothing to do with it. It was invented by an aristocrat of the Roman set [St. Paul], a university man whose epistles are the silliest middle class stuff on record. When I see my name mixed up with it in your excellent paper, I feel as if nails were going into me—and I know what that sensation is like better than you do"(*Letters*, I, 197). This is even closer to the *Androcles* preface than his comment to the Browning Society. And the public jest seems to have become a private earnest in his personal correspondence: "My only boast is that in these days when it is so easy & cheap to be a Christ, I have ventured to follow the poor, despised, but always right Devil" (26 September 1890); "What can I say except Saul, Saul, why persecutest thou me?" (12 December 1890); "I have also protested against the practice of making saints of people who, like myself, abstain from the ordinary pleasures of society because they have no taste for them. Formerly it may have been difficult to live in a modernized Jesus Christ style; but now it is easy, convenient and cheap; and if a man makes a merit of it he is pretty sure to be a humbug" (18 December 1890; *Letters*, I, 266, 274, 280).

In all of these cases Shaw is toying with a kinship, sizing it up, testing it, manipulating the analogy dramatically or rhetorically. On April 26, 1891, he had occasion to surprise the National Secular Society which was considering him for its presidency. He felt that there was as high a percentage of fundamentalists among the Secularists as in the Salvation Army, and these he jolted: "My demonstration that the Trinity is not an arithmetical impossibility, but the commonplace union of father, son, and spirit in one person; that the doctrine of the Immaculate Conception is an instalment of the sacred truth that all conceptions are immaculate; that the Roman Catholic worship of the Madonna is in effect a needed addition of The Mother to The Father in The Godhead; and that any clever Jesuit could convert an average Secularist to Roman Catholicism, froze the marrow in their bones" (*Self Sketches*, p. 74).

Shaw's recognition at this point of the need for the addition of the Mother to the Father in the Godhead is even more notable than his perception of the Trinity. This is a step toward Lilith and the Life Force, one apparently suggested to him by a poet who shared his "peculiar sense of the world." Much later he recalled that "Goethe rescued us from [the horror of atheistic despair] with his 'Eternal Feminine that draws us forward and upward' which was the first modern manifesto of the mysterious force in creative evolution. That is what made Faust a world classic" (*Plays*, V, 703).

In toto the set of assertions with which Shaw shocked the Secularists is striking for its imaginative engagement of religious metaphors and its deft linking of metaphor to life. Its religious sense is informed with an artist's perception, a perception supporting Shaw's view that superior spiritual conviction is largely a matter of superior mind and aesthetics. In such a light, almost exactly at this time, he viewed his role as a music critic: "I should be a very poor critic indeed if I did not take my function to be as religious a one as man can discharge, and one which, if it is not fit to be exercised in a church, is not fit to be exercised anywhere" (*Works*, XXVI, 137).

Perhaps during these months Shaw was especially sensitive to religious metaphors and his religious function as a critic because he was writing *The Quintessence of Ibsenism*. Recent scholars have subjected the social and philosophical aspects of the *Quintessence* to much fine analysis. The philosophical influence of Schopenhauer, Hegel, and Butler has been examined closely, as have Shaw's particular social values.[38] But these critical views, valuable as they are, should probably be enlarged to include Shaw's sensitivity to Ibsen's poetic qualities, particularly since a common complaint of early critics was that Shaw neglected Ibsen the poet for Ibsen the social pioneer. Although he was well aware of Ibsen

from the mid 1880s, Shaw admits that when he played the part of Krogstad in a private reading of *A Doll's House*, he was not strongly impressed by Ibsen or the play: "its novelty as a morally original study of marriage did not stagger me as it staggered Europe." What, then, stimulated his interest? He explains succinctly: "Indeed I concerned myself very little about Ibsen until, later on, William Archer translated Peer Gynt to me *viva voce*, when the magic of the great poet opened my eyes in a flash to the importance of the social philosopher" (*Works*, II, xxi–xxii).

"The magic of the great poet opened my eyes in a flash"—in psychological studies of the creative process an equivalent of this type of sudden awareness has been called the "eureka phenomenon"; in studies of mysticism it is called "illumination": both involve a flash of insight occurring often in an off moment to one who has long aspired toward a high goal. Whatever the process, Shaw's comment is striking: Ibsen the poet led him to Ibsen the social philosopher. Elsewhere he says that *attention* is the key factor in learning anything: the Norwegian first captured his attention via poetry.

Under these circumstances it seems by no means incidental that Shelley is the first person mentioned in the *Quintessence* and that he is a major point of reference in the early part of the essay. Shaw introduces him as a rare example of those who are pioneers in the march to the plains of heaven—a two-sided hero, hated like the devil for exposing mankind's hidden evils, adored like a savior for rejecting tyrannous traditions.

The purpose of his essay, says Shaw, "is to distil the quintessence of Ibsen's message to his age" (*Works*, XIX, 46), and in order to convey this quintessence Shaw sets forth his famous metaphor of society: imagining a community of a thousand persons, he proposes that 700 will be thoughtless, sheeplike Philistines; 299 will be self-ashamed, institution-exalting idealists; and only one will be a self-respecting, truth-facing realist. The idealists are the particular bane of society since they promote its social illusions; the very rare quality of realists is that they strip away the illusions. Among these latter few apostles of truth Shaw emphasizes two: "you and I, reader, will be at cross purposes at every sentence unless you allow me to distinguish pioneers like Shelley and Ibsen as realists from the idealists of my imaginary community of one thousand" (p. 32).

Shaw's application of this social metaphor to Ibsen's plays raises a basic issue: Is he imposing his own metaphor on Ibsen, or is he deriving it? Shaw claimed that he was deriving it—that he was conceptualizing what Ibsen presents instinctively and dramatically. In a letter dated 16 December 1890 he observes:

> Now what Ibsen had done is to call attention to the fact that the
> moment we begin to worship [the ten] commandments and [social]
> ideals for their own sakes, we actually place them in opposition to the
> very purpose they were instituted to serve, i.e. human happiness. His
> plays are simply dramatic illustrations of the terrible mischief and mis-
> ery made every day, not by scoundrels, but by moral people and ideal-
> ists in their inexorable devotion to what they call their 'duty.' The merit
> of my Ibsen paper lies in its discovery of this clue to Ibsen's meaning.
> [*Letters*, I, 277–78]

In short, by dramatic illustrations Ibsen has called *attention* to religious
and social realities. In a kindred manner as critic, Shaw creates his
metaphor of a society of one thousand in order to direct attention to
what he perceives as Ibsen's meaning: he uses a type of analytical
poetry to highlight and build upon the dramatic poetry of his subject.

The foregoing helps provide a groundwork for Shaw's more adven-
turesome leap into Ibsen's metaphysics. Second only to the social meta-
phor in the *Quintessence* is a spiritual one, and through this Shaw seems
to have clarified his spiritual thought. He starts his analysis of the plays
with Ibsen's poetic dramas, *Brand* and *Peer Gynt*. He appreciates
Brand's concept of a young God, having himself followed Goethe's lead
in proposing the feminine in the godhead: conventional, sentimental
images of the divine must be shattered. But Brand sacrifices himself
and others to his saintly idealism. Peer Gynt, in contrast, is a selfish
rascal but equally idealistic: with indomitable will he seeks to be Em-
peror of Himself, a hopeless illusion, "for the world-will is outside Peer
Gynt as well as inside him" (p. 49).

From the willful poetry of *Brand* and *Peer Gynt*, Shaw moves to *Em-
peror and Galilean*. Like Shaw's *Back to Methuselah*, *Emperor and Galilean* is
a philosophical and religious monster which its author appraised more
highly than anyone else; and, as though anticipating such a parallel,
Shaw comes spiritually closest to Ibsen at this point. He comments that
here, as in Wagner's case, "we find Ibsen, after composing his two great
dramatic poems, entering on a struggle to become intellectually con-
scious of what he had done" (p. 54). This nearly expresses Shaw's case
as well: Archer's reading aloud of *Peer Gynt* had opened his eyes, and in
this chapter he, too, strives to become intellectually conscious of what
has been done. Apparently for both men inspired art provided the
brightest flame for the analytical consciousness which came afterwards.

Near the start of the chapter on *Emperor and Galilean*, Shaw spends
several pages on Samuel Butler, Darwin, and evolution, emphasizing
Butler's discovery that Darwin's theory of natural selection had ban-
ished mind from the universe; thus while Darwin's theory freed man
from the tyranny of the old Biblical God, it also plunged him into the

despair of materialism. But Shaw subordinates this important observation (one he had already anticipated in his *Passion Play*) to a form of spiritual answer in *Emperor and Galilean*. He comments that "[Ibsen's] prophetic belief in the spontaneous growth of the will made him a meliorist without reference to the operation of Natural Selection" (p. 57). Beyond this Shaw's primary interest lies in the central metaphor of Ibsen's play wherein Maximus the Mystic attempts to show the Emperor Julian the ultimate nature of spirit. In Shaw's words: "He who can see that not on Olympus, not nailed to the cross, but in himself is God: he is the man to build Brand's bridge between the flesh and the spirit . . . Maximus's idea is a synthesis of relations in which not only is Christ God in exactly the same sense as that in which Julian is God, but Julian is Christ as well." In the end Julian fails because "He had felt the godhead in himself, but not in others. Being only able to say, with half conviction, 'The kingdom of heaven is within ME,' he had been utterly vanquished by the Galilean who had been able to say, 'The kingdom of heaven is within YOU.' But he was on the way to that full truth. A man cannot believe in others until he believes in himself; for his conviction of the equal worth of his fellows must be filled by the overflow of his conviction of his own worth" (pp. 59–63).

These passages represent a marked advance in Shaw's articulation of his perceptions about man's relation to spirit and divinity: what formerly was largely instinctive or abstract is now conceptualized. One can trace strains of Shaw's indebtedness—as he does—to Samuel Butler's evolutionary theories, Schopenhauer's concept of will as a greater power than reason, and Hegel's thesis/antithesis/synthesis. Shaw read them all in 1887, and all apply here in varying degrees. But not until 1890 did he bring his ideas into a concentrated focus and statement, and apparently it took Ibsen's dramatic poetry to bring this about. On July 18, 1890, he delivered a paper on Ibsen, which he expanded and published as the *Quintessence* in October 1891. In this period of time it would seem that Ibsen's art not only coalesced his views but gave personal continuity and energy to his metaphysics. Maximus's insight as interpreted by Shaw is essentially Shelleyan and Promethean. It is foreshadowed in Judas and Jesus joining hands in the *Passion Play*. Its assertion of the godlike man is anticipated in varying ways in Shaw's last three novels. In its acknowledgement of divinity in all men it had been the spiritual premise of Shaw the socialist-preacher for many years. But all of these strands—artistic, philosophical, and social—had not come together until Ibsen the poet opened his eyes. Via Ibsen, the Christ figure whom he had viewed ambiguously in the *Passion Play* and mimicked in *An Unsocial Socialist* suddenly became a spiritual counterpart. His view of the implicit metaphor in Christ, of the Word made

flesh, both deepened and broadened. Hence, perhaps, the flurry of
Christ references in his letters at the time, and his increasing tendency,
as the years went on, to draw a personal comparison. His summary
perception of the spiritual powers in Ibsen's art is best stated in his
preface to the 1913 edition of the *Quintessence:* "It is not too much to
say that the works of Ibsen furnish one of the best modern keys to the
prophecies of Scripture" (*Works,* XIX, 6–7). This, at least, had been
true for Shaw.

In his essays, letters, and plays over the next seven years Shaw re-
peatedly linked poets and art with spirit. From the public platform and
in print he espoused Shelley the "sinner," remarking that "I had noth-
ing to do but give a faithful account of Shelley's real opinions, with
every one of which I unreservedly agree" (*Works,* XXIX, 257). Like a
priest he urged Janet Achurch to give up drugs and alcohol by turning
to the art of religion and the religion of art: "You then get two sorts of
people: irreligious people, whom no amount of culture can make
otherwise than worthless, and artists, who find in their art an irresist-
ible motive. . . . there is always religion if you can reach it—the religion
of Beethoven's ninth symphony, the religion which rediscovers God in
man and the Virgin Mother in every carpenter's wife" (*Letters,* I, 504–
5). In this vein it is the Shelley-like Marchbanks in *Candida* who sees the
Virgin in a parson's wife and who, in a clear reference to Ibsen's recent
play, has the potential of "a master builder." And the possibility that an
apparent devil (like Shelley or Shaw?) may be deeply religious is a
poetically inspired paradox of *The Devil's Disciple:* "A century ago Wil-
liam Blake was, like Dick Dudgeon, an avowed Diabolonian: he called
his angels devils and his devils angels. His devil is a Redeemer. Let
those who have praised my originality in conceiving Dick Dudgeon's
strange religion read Blake's Marriage of Heaven and Hell, and I shall
be fortunate if they do not rail at me for a plagiarist" (*Plays,* II, 34).
Perhaps more than anyone else, poets with such visions were driving
towards Life Force ends.

Shaw's longest and most important essay in the mid–1890s is "A
Degenerate's View of Nordau," which he revised for booklet publica-
tion in 1908 as *The Sanity of Art.* The essay is a response to Max Nor-
dau's huge tome *Degeneration,* whose English translation in 1895 had
caused a considerable stir. Here Shaw specifically takes up the banner
of the spiritual powers of art. Against Nordau's claim that modern art
and artists are decadent, he asserts the exact opposite: by defying and
breaking up old forms and by asserting new energies and a new sense
of realities, art advances civilization. It is through art that philosophy is
rendered accessible: "[Schopenhauer's] turn for popularity did not
come until after Darwin's, and then mostly through the influence of

two great artists, Richard Wagner and Ibsen." Most importantly, great art is essentially, deeply spiritual: "The great artist is he who goes a step beyond the demand, and, by supplying works of a higher beauty and a higher interest than have yet been perceived, succeeds, after a brief struggle with its strangeness, in adding this fresh extension of sense to the heritage of the race. This is why we value art; this is why we feel that the iconoclast and the Puritan are attacking something made holier, by solid usefulness, than their own theories of purity; this is why art has won the privileges of religion."[39]

In his essay "On Going to Church" (1896) Shaw gives one of the purest of spiritual rationales for the building of great cathedrals. As opposed to the more vulgar assumption that cathedrals are tributes to the grandeur of God and should awe one accordingly, his approach is highly private and Protestant as well as aesthetic and spiritual. Through architecture he seeks to bring out the transcendent spirit from within himself: "In my consciousness there is a market, a garden, a dwelling, a workshop, a lover's walk—above all, a cathedral. My appeal to the master-builder is: Mirror this cathedral for me in living stone; make it with hands; let it direct its sure and clear appeal to my senses, so that when my spirit is vaguely groping after an elusive mood my eye shall be caught by the skyward tower, showing me where, within the cathedral, I may find my way to the cathedral within me."[40]

Inspired by the cathedral within himself, Shaw wrote in August 1895: "I want to write a big book of devotion for modern people, bringing all the truths latent in the old religious dogmas into contact with real life—a gospel of Shawianity, in fact" (*Letters*, I, 551). Very possibly this desire bore fruit in 1898 when he completed *The Perfect Wagnerite*, where once again his religious and social ideas take shape in a response to art. At any rate in preparing for the essay's publication he advised his publisher that "it should be got up as a book of devotion for pocket use" (*Letters*, II, 58).

Although the *Wagnerite* (especially for pocket use) is hardly a big book, it did, in effect, cap a trilogy which approximates Shaw's ambition. When the *Quintessence*, *The Sanity of Art*, and the *Wagnerite* were gathered into one volume of his *Works* in 1930 no one seemed to notice the coherence of the combination. The volume's prosaic title, *Major Critical Essays*, gives little indication that all three essays are strongly related. But in many ways these may be seen as Shaw's big book of devotion, his gospel—or at least proto-gospel insofar as the essays were a spiritual loam for his religious plays, lectures, and essays of the next fifty years. An overview of the three reveals their common denominator: all three are greatly concerned with matters of society and spirit, and all three spring primarily from a base of art. Further, from a

gospel viewpoint, there is an apposite, complementary shift of focus from one to the other: the religious highlight in the first deals with the Galilean, the Son; the emphasis in the second is on the spiritual function of art, art as Holy Spirit; and the figure of greatest concern and interest in the last is Wotan, the god. In sum, the *Essays* comprise a Shavian type of Trinitarian gospel, a gospel alive with sermons, spiritual metaphors, and dramatic parables, all aimed at edifying—if not converting—mankind socially and spiritually.

Until recently critics have objected, much as they did to the *Quintessence,* that Shaw's allegorical interpretation of Wagner's *Ring* cycle in *The Perfect Wagnerite* violates the original with his socialistic views. These critics are at least half wrong on each of two counts: first, both Ibsen and Wagner had strong social views not far from Shaw's (the critics have not done their homework); second, Shaw's interpretations, especially in the *Wagnerite,* are nearly as metaphysical as they are social, and his metaphysics work closely with premises in his sources. More recent critics have seen in the *Wagnerite* a development of Shaw's earlier distinction between Philistines, idealists, and realists: he characterizes Wagner's dwarfs and giants as Philistines, the god Wotan as an idealist, the hero Siegfried as a realist. Evolution demands that the idealist god be overthrown by the realist hero. But at this point there is a new wrinkle: like Wagner, Shaw is relatively sympathetic to Wotan: he perceives that Wotan must in all responsibility uphold laws because laws give necessary order to existence; yet at the same time laws commonly exist beyond their useful function—they become ossified, sacrosanct impediments to the evolutionary flow of life. Wotan is additionally sympathetic because he also perceives the problem, and consequently, for the sake of the evolutionary process, he half wills his own overthrow by Siegfried. His idealism is not just illusory and inhibiting—it has an enlightened view of evolutionary necessities.[41]

What makes the *Wagnerite* especially interesting regarding the genesis of Shaw's God is that in and around this allegory Shaw engages not one or two but *four* manifestations of the godly, and in these four his sympathies combine with his conceptions to forge his mature perception.

The primary god of the *Wagnerite* is the Life Force, not yet so named, but clearly defined in the first chapter:

> Such a force there is, however; and it is called Godhead. The mysterious thing we call life organizes itself into all living shapes, bird, beast, beatle and fish, rising to the human marvel in cunning dwarfs and in laborious muscular giants, capable, these last, of enduring toil, willing to buy love and life, not with suicidal curses and renunciations, but with patient manual drudgery in the service of higher powers. And these higher powers are called into existence by the same self-organization of life still

more wonderfully into rare persons who may by comparison be called gods, creatures capable of thought, whose aims extend far beyond the satisfaction of their bodily appetites and personal affections, since they perceive that it is only by the establishment of a social order founded on common bonds of moral faith that the world can rise from mere savagery. [*Works*, XIX, 186]

As though to emphasize this memorable point in his own mind as well as in the reader's, Shaw repeats it at the end of the chapter. This repetition is worth observing closely for its more precise foreshadowing of the terms he was to use later in reference to the Life Force: "After all, a god is a pitiful thing. But the fertility of the First Mother is not yet exhausted. The life that came from her has ever climbed up to a higher and higher organization. From toad and serpent to dwarf, from bear and elephant to giant, from dwarf and giant to a god with thoughts, with comprehensions of the world, with ideals. Why should it stop there? Why should it not rise from the god to the Hero? to the creature in whom the god's unavailing thought shall have become effective will and life, who shall make his way straight to truth and reality . . . ?" (pp. 196–97).

Both passages have rudimentary origins in Judas's perception of life's principle in the growth of wheat, and in "the world-will which is outside Peer Gynt as well as inside him." A more immediate precursor appears in a letter of January 1897: "And never stagnate. Life is a constant becoming: all stages lead to the beginning of others" (*Letters*, I, 722). The second passage reflects Shaw's deep feminist strain: he goes back atavistically to the ancient sense of an Earth Mother, much as he did when in 1891 he suggested, probably echoing Goethe, that it was important to add the feminine to the Godhead. In the *Ring* he sees Brynhild embodying this primal spirit: "Brynhild is the inner thought and will of Godhead, the aspiration from the high life to the higher that is its divine element" (p. 208). Reflecting the instinctive aspects of the serpent, bear, and elephant in the above definition, Ann Whitefield of *Man and Superman* is described by her reluctant lover as a boa constrictor, a grizzly bear, an elephant. And perhaps most telling of all, the speech of Lilith, the First Mother who ends *Back to Methuselah*, quite clearly has its origin in this conception. She too is an evolutionary force moving upward from instinct to thought which is tied to matter, and at last to godly thought which expresses will and life, truth and reality (cf. *Plays*, V, 629–31).

The second godly type in the *Wagnerite* derives from the above, being an ultimate evolutionary fruit of the First Mother: this is the Hero, personified by Siegfried. Shaw calls Siegfried a New Protestant. In a passage we have observed previously in reference to Judas, he is

defined as "a type of the healthy man raised to perfect confidence in his own impulses by an intense and joyous vitality which is above fear, sickliness of conscience, malice, and the makeshifts and moral crutches of law and order which accompany them" (p. 225). Here, obviously, is the embodiment of a superman, one who elicits Shaw's eugenic conviction soon to be expanded in *Man and Superman,* that "it is necessary to breed a race of men in whom the life-giving impulses predominate" (p. 227).

According to Shaw's allegory and his professed convictions, Siegfried as the Hero, an ultimate fruit of the First Mother, ought to be the highlight of his discussion. But not at all. For all his health, instinct, and joy—or perhaps because of them—Siegfried is not very interesting. No sooner has Shaw exalted the Hero than he takes a look at him in terms of a third godly type, Wotan. The god, realizing the limitations of law and order and secretly desiring his own supersession, is a more intriguing, more dramatic figure. Dare one say a maturer figure? Shaw almost does: he compares Shelley's youthful conception of Jupiter as a melodramatic demon with Wagner's middle-aged understanding of Wotan's ambiguity. He then disparages the panacea of love which both Shelley and Wagner offer as a cure for the world's ills. According to Shaw the evolution of life, not love, must be life's goal. Presumably the spirit of Siegfried, expressing its selfhood freely and throwing over old institutions, represents this evolution. But does it? Socially Siegfried's free spirit threatens anarchy. At this point Shaw balks and reveals his ingrained Fabianism by adding anarchism to love as a false panacea: he believes that man's general welfare must rise from some social constraints: "I must refer disciples of Siegfried to a tract from my hand published by the Fabian Society and entitled The Impossibilities of Anarchism" (p. 235). Are these the words of a disciple of Siegfried or of a prudent father figure; are they nearer to the spirit of Siegfried or Wotan? Despite his impulse to cheer the instinctive Hero, Shaw finds himself, almost before he knows it, defending an outpost of the god.

Here Shaw appears to be tangled: his instincts urge him one way, his reason another. But there is a fourth godlike type involved in his analysis which is central and in large part resolves the problem. It is easy to miss, however, because it requires a broad focus, while details of the story's allegory tend to capture the reader's attention. This godlike type is the poet—the poetic sensibility in general and Wagner in particular.

In analyzing *The Rhine Gold* at the start of his essay, Shaw stresses the modern relevance of Wagner's allegory and the importance of a poet's vision regarding the social realities it portrays. *The Rhine Gold* presents the dwarf Alberic exploiting hordes of fellow-creatures, laying up gold at the expense of their slavery and health. To Shaw this is

no mere legend but an allegory of immense contemporary value: it dramatizes the frightful reality of modern commercial life. And all too few persons perceive the ghastly social effects of such a state of affairs: "It is only the poet, with his vision of what life might be, to whom these things are unendurable. If we were a race of poets we would make an end of them before the end of this miserable century. Being a race of moral dwarfs instead, we think them highly respectable, comfortable and proper, and allow them to breed and multiply their evil in all directions" (p. 185).

Hence the poet is a unique seer who in accurately perceiving the present provides the motive for a better future. He is a godlike type apart from the others in the allegory of the *Ring* because his view is more penetrating and all-encompassing than theirs. Siegfried answers to the role of the Hero in his perfect self-confidence, but he lacks breadth of vision, and one side of his instinctive freedom is potential anarchy. Wotan controls anarchy and has some breadth of vision, but at the loss of instinctive freedom. The poet, on the other hand, combines both Siegfried's free-flowing instincts and Wotan's awareness of a social context; he embodies the two aspects of life which spring from the First Mother: life's growth and its organization.

Shaw emphasizes Wagner's overarching poet's role by devoting his second chapter to "Wagner as Revolutionist." It might seem that Wagner, finally, is more in Wotan's camp, but this is only a partial view: the very tug of instinct and intellect in him is revolutionary. While his intellect may be engaged by Wotan, his instincts go out to Siegfried, and his instincts came first. In this respect, as we have briefly noted in looking at the *Quintessence*, Shaw likens him to Ibsen: "Richard Wagner, one of the greatest poets of our own day, has left us as many volumes of criticism of art and life as he has left musical scores; and he has expressly described how the keen intellectual activity he brought to the analysis of his music dramas was in abeyance during their creation" (p. 54).

In their discussions of the *Wagnerite*, critics have missed a most remarkable example of its concern about godhead and the hero, an example which also applies directly to the relationship of art and thought in Shaw. Clearly Shaw's analysis of Wagner's *Ring* furthered his conceptions about godhead, the superman, and the Life Force; but almost as pertinent to his essay is the fact that at exactly the same time he was writing it he was also working on *Caesar and Cleopatra*. Shaw started both works in April, 1898. On May 3 he wrote Richard Mansfield: " 'C & C' is the first & only adequate dramatization of the greatest man that ever lived. I want to revive . . . the projection on the stage of the hero in the big sense of the word" (*Letters*, II, 90). One needs little ingenuity

to see how closely "the hero in the big sense of the word" relates to the *Wagnerite,* and also that Shaw's desire to dramatize "the greatest man that ever lived" was very possibly an ambition to give flesh to the *Wagnerite*'s mythical ethos. Quite likely he alludes to his ambition in his preface to *Plays Pleasant*—also, notably, written in 1898: "Now I am no believer in the worth of any mere taste for art that cannot produce what it professes to appreciate" (*Plays,* I, 372).

The close relationship between the essay and the play gains further evidence in a reference to Caesar in the *Wagnerite.* At the end of the second chapter Shaw outlines the three orders of humans allegorized in the *Ring:* those people, respectively, who are equivalent to the greedy dwarfs, the stupid giants, and the talented gods. Beyond these, Shaw says, "History shews us only one order higher than the highest of these: namely, the order of Heroes." At this point Caesar is his one example: "Now it is quite clear—though you have perhaps never thought of it—that if the next generation of Englishmen consisted wholly of Julius Caesars, all our political, ecclesiastical, and moral institutions would vanish . . . Julius Caesars would no more trouble themselves about such contrivances as our codes and churches than a Fellow of the Royal Society will touch his hat to the squire and listen to the village curate's sermons." Shaw goes on to make the Caesarean type a signal example of Creative Evolution: "This is precisely what must happen some day if life continues thrusting towards higher and higher organization as it has hitherto done" (pp. 201–2).

Thus in the character of Caesar we have Shaw's Word made flesh, his prime human example of the Hero. And highly intriguing is the fact that Caesar resembles Wotan more than he does Siegfried, even though his spirit incorporates them both. Shaw gives a poetic clue to this spirit in Caesar's apostrophe to the Sphinx at the start of Act I. This, though it is one of the play's most memorable and often-cited speeches, has been only vaguely appreciated. Especially paradoxical and puzzling is its conclusion: "I am he of whose genius you are the symbol: part brute, part woman, and part god—nothing of man in me at all. Have I read your riddle, Sphinx?" (*Plays,* II, 182).

The riddle has remained; at least no critics have read it clearly. Yet this speech gains poetic clarity and special force when it is understood in terms of Shaw's definitions in the *Wagnerite:* First, Caesar is part brute because far beyond the base brutality of the *Ring*'s dwarfs and giants he possesses the instinctive nature of a Siegfried, being a man perfectly confident of his own impulses, above fear, malice, and the moral crutches of law and order. Despite his age, when action calls him at the ends of Acts II, III, and IV, Caesar leaps to its demands with all the instinctive vigor of a young hero. In Act II he bluntly ignores the

religion of the theocratic Egyptians by sitting on a sacred tripod. In Act V he pardons Rufio's killing of Ftatateeta because it was not a judicial murder, but a "natural slaying."

Second, Caesar is part woman because he embodies the life-oriented, evolutionary spirit of the First Mother. He savors life even in moments of peril and instinctively avoids killing except in the pressing demands of battle. Thus he plays with the kitten queen throughout the play, even when he is in extreme danger. In Act II he frees the Egyptian court when it is at his mercy; in Act III he refuses even to determine the identity of traitors from their captured correspondence; in Act IV he puzzles everyone by allowing the treacherous Pothinus to live as his guest. And, upon Pothinus' murder, his famous speech against vengeance is a plea for the principle of life and evolution against mankind's dog-eat-dog instincts for death and destruction.

Third, Caesar is part god because he is Emperor, and, like Wotan, he must uphold law and order. In Act I he rapidly puts Ftatateeta in her place, advises Cleopatra about the role of queenship, and is hailed by his legions. In Act II he confidently manipulates the Egyptian court and shocks it by his straightforward demand for money, taxes being the mundane foundation for a government of law and order. At the start of Act III the obedience of the centurion and the sentinel to Caesar's commands attest to his natural role as absolute authority. In Act IV all look to Caesar as an almighty father figure, their ethic of vengeance having turned back upon them in earnest. And in Act V all, even the Egyptian gods, are in obeissance to his supreme power. Yet for all his transcendence, power, and authority, Caesar, like Wotan, realizes that he is old and fit for the knife. To maintain his imperial rule he must rely on the likes of the treacherous Lucius Septimius, the doglike Rufio, and a stern law and order which makes the murder of Vercingetorix, along with the severing of the right hands of the Gauls, prudent necessities. There is a rottenness and hypocrisy in laws and government which appall Caesar's Siegfried-like instincts and life-oriented, First-Mother goals. Despite his triumphs he is, at the end, a bit world-weary; and as Wotan secretly desires his own supersession by the virile Siegfried, Caesar willingly proposes to send Antony to Cleopatra.

Thus Caesar is part brute, part woman, and part god. There is nothing of man in him because there is nothing in him of the *Ring*'s greedy dwarfs and stupid giants—nothing of man's gross Philistinism. In seeing in the Sphinx a spiritual counterpart and symbol of himself, he has read its riddle; and so, like Oedipus, has Shaw.

But also, as in the *Wagnerite*, there is a fourth godlike type in *Caesar and Cleopatra*, one which overarches and synthesizes the rest: Caesar the

poet. Just as Shaw presents the poet at the beginning of the *Wagnerite*, he reveals him in Caesar's opening speech. The man who perceives and embodies the Sphinx in such ambiguous, metaphorical, rhetorical terms is, most fundamentally, a poet. Caesar's exchanges with Cleopatra in Acts I and III are those of a poet playing and striving to open up the consciousness of youth. With the romance of a "poet-artist" he invokes the Nile god in Act IV. His perceptions of reality throughout the play are those of a poet cutting through life's many illusions. In Act IV he admires the poetry of Apollodorus and disparages the prosaic Romans as doers and drudgers; yet always for Caesar as for Shaw (and for the poets Shaw admires most) art must engage life and give it meaning. Thus in Act V when Apollodorus disparages Rome's ability to produce art, Caesar responds, "What! Rome produce no art! Is peace not an art? is war not an art? is civilization not an art? All these we give you in exchange for a few ornaments" (p. 288).

It is in the light of this poet's vision, including his ambiguous essence as brute, woman, and god, that Caesar intuitively likens himself to Christ. Deploring the ethic of vengeance which the others have voiced in support of the killing of Pothinus, Caesar states, "If one man in all the world can be found, now or forever, to k n o w that you did wrong, that man will have either to conquer the world as I have, or be crucified by it" (p. 277). Such knowledge is that of a poet, a prophet, a superman. Not only does it transcend that of Philistine dwarfs and giants, it is more self-conscious and wordly-wise than a Siegfried and spiritually deeper than a Wotan. Like Christ, Caesar knows that the way of true life is charity, but in a world of wolves the man of charity must either rule or be torn apart. In choosing charity he realizes that he walks a fine line between supernal life and ignominious death; but the glory of the life is worth the shadow of the death. In this manner Caesar moves with the pulse of the Life Force.[42]

Thus at the end of the 1890s Shaw completed his Trinitarian gospel, his big book of devotion which prepared the way for his forthcoming espousal of Creative Evolution, the Life Force, and the superman. Primarily through dramatic poetry he had conceived a sophisticated sense of godhead. Through engaging Ibsen's Galilean he saw the Son more clearly. In defending art against Nordau he explored art as Holy Spirit. In conceptualizing the allegory of Wagner's *Ring* he grasped the implications of the Father in a new metaphoric, metaphysical, Life Force context. And, as though to provide a dramatic parable for his new gospel, he created the character of Caesar. As a prototype of the superman Caesar embodies not only Wagner's allegory, he is also the Word made flesh: in toto he is a spiritual Father, an instinctive Son, and, as a manifestation of spiritual consciousness in action, the Holy Spirit.

In Shavio-theological terms the Trinity which emerges from Shaw's gospel as of 1898 thus has a Father (or, more precisely, a Mother) which may be described most nearly as Life and which contains within it an organizing principle. The Son is the Hero who instinctively gives expression to this Life and its organizing principle. The Holy Spirit is Life in its evolutionary action, an action represented by the Hero. Most completely, philosophical poets are Heroes because through their art they perceive and articulate the Holy Spirit: insofar as they accordingly create, reveal, and redeem they are God in action, the Word made flesh. Hence, no doubt, the designation *artist*-philosopher in *Man and Superman.*

Personally informed and inspired by this gospel, Shaw found himself ever closer to the poetic Jesus that he had glimpsed in his *Passion Play.* His terms and images were different from those of Jesus because they were aimed at the modern world, but they came from a kindred spirit: "we were both led to become preachers of the same doctrine in spite of different circumstances and by independent ways . . . whether Jesus be placed in a sub-species or in a super-species, it is a species to which I apparently belong philosophically."[43]

Notes

1. Charles A. Berst is Associate Professor of English at the University of California, Los Angeles, and author of *Bernard Shaw and the Art of Drama.*

2. Alfred Turco, Jr., *Shaw's Moral Vision: The Self and Salvation* (Ithaca: Cornell Univ. Press, 1976); Robert F. Whitman, *Shaw and the Play of Ideas* (Ithaca: Cornell Univ. Press, 1977). See also, Julian B. Kaye, *Bernard Shaw and the Nineteenth-Century Tradition* (Norman: Univ. of Oklahoma Press, 1958); J. Percy Smith, *The Unrepentant Pilgrim: A Study of the Development of Bernard Shaw* (Boston: Houghton, 1965); Anthony S. Abbott, *Shaw and Christianity* (New York: Seabury, 1965); Alan P. Barr, *Victorian Stage Pulpiteer: Bernard Shaw's Crusade* (Athens: Univ. of Georgia Press, 1973).

3. *The Bodley Head Bernard Shaw: Collected Plays with Their Prefaces,* ed. Dan H. Laurence (London: Max Reinhardt, 1970–74), II, 519–20. Subsequent citations from this edition will appear in the text.

4. J. L. Wisenthal uses Blake as a touchstone in his *The Marriage of Contraries: Bernard Shaw's Middle Plays* (Cambridge: Harvard Univ. Press, 1974). See also the articles by Valli Rao and Daniel Leary in this volume.

5. *The Religious Speeches of Bernard Shaw,* ed. Warren S. Smith (University Park: Pennsylvania State Univ. Press, 1963), p. 33. Subsequent citations from this volume will appear in the text.

6. *Sixteen Self Sketches* (London: Constable, 1949), p. 77. Subsequent citations from this volume will appear in the text.

7. *Shaw on Religion,* ed. Warren S. Smith (New York: Dodd, 1967), pp. 154, 160.

8. *Shaw on Theatre,* ed. E. J. West (New York: Hill, 1959), p. 116; *Plays,* V, 685.

9. *The New Oxford Annotated Bible,* eds. Herbert G. May and Bruce M. Metzger (New York: Oxford Univ. Press, 1962), p. 1286.

10. *Bernard Shaw: Collected Letters 1898–1910,* ed. Dan H. Laurence (New York: Dodd, 1972), p. 901. Subsequent citations from this volume will appear in the text as *Letters,* II. Citations from *Collected Letters 1874–1897,* ed. Laurence (New York: Dodd, 1965), will appear in the text as *Letters,* I.

11. *The Works of Bernard Shaw* (London: Constable, 1930–38), I, xxi. Subsequent citations from this edition will appear in the text.

12. *To a Young Actress: The Letters of Bernard Shaw to Molly Tompkins,* ed. Peter Tompkins (New York: Potter, 1960), p. 72. The best treatment of Shaw's indebtedness to Shelley is Roland A. Duerksen's "Shelley and Shaw," *PMLA,* 78 (1963), 114–27.

13. Quoted in Stephen S. Winsten, *Days with Bernard Shaw* (New York: Vanguard, 1949), p. 195.

14. "The Religion of the Pianoforte," *Fortnightly Review,* 55, n.s. (1 Feb. 1894), 264.

15. Quoted in Stephen S. Winsten, *Shaw's Corner* (London: Hutchinson, 1952), p. 14.

16. Quoted in *In a Great Tradition: Tribute to Dame Laurentia McLachlan, Abbess of Stanbrook,* by the Benedictines of Stanbrook (London: Murray, 1956), p. 273.

17. For the text of this letter see Archibald Henderson, *George Bernard Shaw: Man of the Century* (New York: Appleton, 1956), pp. 47–48.

18. Bernard Shaw, *Passion Play: A Dramatic Fragment 1878,* ed. Jerald E. Bringle (Iowa: Windhover, 1971); *Plays,* VII, 487–527. It was first mentioned, in passing, by Hesketh Pearson in *G.B.S.: A Full Length Portrait* (New York: Harper, 1942), p. 38. J. Percy Smith discusses it briefly in *The Unrepentant Pilgrim,* pp. 131–34. Critical commentaries of recent value are Bringle's Introduction; Rodelle Weintraub, "Shaw's Jesus and Judas," *ShawR,* 15 (1972), 81–83; and especially Ishrat Lindblad, " 'Household of Joseph': An Early Perspective on Shaw's Dramaturgy," *ShawR,* 17 (1974), 124–38. My argument intersects and takes off from several points of the last four.

19. *Essays and Letters by Percy Bysshe Shelley,* ed. Ernest Rhys (London: Walter Scott, 1905), p. 88.

20. See Evelyn Underhill, *Mysticism* (London: Methuen, 1912).

21. *Essays and Letters,* p. 87.

22. Ibid., pp. 83, 93, 86.

23. "A Defence of Poetry," ibid., pp. 33, 1–2.

24. *Everybody's Political What's What?* (London: Constable, 1944), p. 181.

25. A notable exception is R. F. Dietrich's *Portrait of the Artist As a Young Superman: A Study of Shaw's Novels* (Gainesville: Univ. of Florida Press, 1969). See also E. Nageswara Rao, *Shaw the Novelist: A Critical Study of Shaw's Narrative Fiction* (Masulpitam: Trivini, 1959); and Stanley Weintraub, "The Embryo Playwright in Bernard Shaw's Early Novels," *TSLL,* 1 (1959), 327–55. My argument adds a metaphysical stress to Dietrich's biographical view.

26. "Acting, by One Who Does Not Believe in It" (1889), in *Platform and Pulpit,* ed. Dan H. Laurence (New York: Hill, 1961), p. 20.

27. "Fiction and Truth" (1887), in *Bernard Shaw's Nondramatic Literary Criticism,* ed. Stanley Weintraub (Lincoln: Univ. of Nebraska Press, 1972), pp. 16–17.

28. "Mr. Bernard Shaw's Works of Fiction: Reviewed by Himself" (1892), in *Selected Non-Dramatic Writings of Bernard Shaw,* ed. Dan H. Laurence (Boston: Houghton, 1965), p. 311.

29. Ibid., p. 312.

30. *In a Great Tradition,* p. 241.

31. Quoted in R. F. Rattray, *Bernard Shaw: A Chronicle* (Luton, England: Leagrave, 1952), p. 39; *Letters*, I, 48.

32. "Shaw's Works of Fiction," *Selected Writings*, p. 311.

33. Ibid., p. 313.

34. "Acting," *Platform and Pulpit*, p. 20.

35. *Shaw on Religion*, p. 134.

36. Quoted in Henderson, pp. 151, 144.

37. *Shaw on Religion*, p. 34.

38. See especially Whitman and Turco, to whom I am indebted at a number of points in this discussion.

39. *Selected Writings*, pp. 359, 363–64.

40. Ibid., p. 381.

41. For a full development of the allegory along these lines, see Turco, esp. pp. 111–18, and Whitman, pp. 124–28.

42. This point crosses swords with J. L. Wisenthal's argument in the next article.

43. *Shaw on Religion*, p. 81.

TOWARD RELIGION IN THE PLAYS

J. L. Wisenthal[1]

SHAW AND RA: RELIGION AND SOME HISTORY PLAYS

Caesar and Cleopatra, in its original 1898 version, begins with a religious oath. "By Apis," exclaims Belzanor, the captain of the Egyptian queen's guard, after losing a throw of the dice—"By Apis, Persian, thy gods are good to thee."[2] Throughout the play there are many religious oaths and other references to the gods of Egypt, Rome, Persia, and Britain; E. Dean Bevan's *Concordance to the Plays and Prefaces of Bernard Shaw* lists 81 occurrences of the word "gods" (in the final text of the play). "As the gods will," is Achillas' conventional response to Caesar's friendly greeting in Act II (II, 199), and in the next act one of the porters gratefully calls Apollodorus "O favored of the gods" (II, 237), while Ftatateeta in the same scene asks the gods to speed Apollodorus on his mission to the lighthouse and to protect her nursling Cleopatra: she refers in three speeches to "the gods," "gods of the seas," and to "gods of Egypt and of Vengeance" (II, 237–38), and she falls on her knees in her prayer that Cleopatra be borne safely to her destination. In Act IV Cleopatra comments on Ftatateeta's oath "by my father's gods" (II, 254). Caesar's first response to Cleopatra in Act I is his startled oath— "Immortal gods!"—and elsewhere he invokes Jupiter (II, 182, 248, 261).

In addition to all the oaths (of which I have given only a few examples), there is much talk about characters' divine descent or godlike qualities. In the "Alternative to the Prologue" Bel Affris, a guard in the temple of Ra in Memphis, announces himself as "descended from the gods" (II, 171), and the phrase is bandied about a good deal in this opening scene. Cleopatra in the banquet scene in Act IV (in which the set includes a life-size image of Ra) reminds Caesar that "the Nile is my ancestor; and he is a god." She then arranges the religious ceremony with the miniature sphinx, which makes Caesar and his companions feel curious in spite of their determination not to be impressed (II,

271). Whereas Cleopatra claims descent from a god, Caesar in his address to the Sphinx in Act I goes further and describes himself as "part god" (II, 182); and Cleopatra later in the play says of Caesar, "Can one love a god?" (II, 257). She states here that she loves another Roman who is man rather than god, but earlier in the play when she is asking Caesar about Mark Antony she protests, "Oh, you must not say common, earthly things about him; for I love him. He is a god" (II, 214).

The gods are also present in the language of *Caesar and Cleopatra* as the controlling power in human affairs and the destiny of nations. Ftatateeta suggests that the gods have taken Cleopatra "out of our hands" to protect her from the invading Romans, but Bel Affris, threatening to kill the nurse, taunts her by saying "your gods are asleep or away hunting," and Ftatateeta accepts that "the high gods" have put the sword into Bel Affris' hand (II, 178–79).

The strength of Caesar and his army is expressed in terms of the strength of the Roman gods as opposed to the Egyptian. Caesar tells Cleopatra in Act I that "your gods are afraid of the Romans" (II, 187); and in Act IV when Pothinus begins a speech with the oath "Now by the gods" Ftatateeta cuts in: "Enough of your gods! Caesar's gods are all powerful here" (II, 259). Pothinus admits as much to Caesar and Rufio a few minutes later.

> POTHINUS. I will deal plainly. I know not by what strange gods you have been enabled to defend a palace and a few yards of beach against a city and an army. Since we cut you off from Lake Mareotis, and you dug wells in the salt sea sand and brought up buckets of fresh water from them, we have known that your gods are irresistible, and that you are a worker of miracles. I no longer threaten you—
> RUFIO [*sarcastically*] Very handsome of you, indeed.
> POTHINUS. So be it: you are the master. Our gods sent the north west winds to keep you in our hands; but you have been too strong for them.
> [II, 263–64]

On the face of it, then, the play is suffused with religion, but the suggestion here of *Saint Joan*—in particular the Loire scene with the change in wind and the relief of the besieged Orleans—raises questions about how we are to take the gods in *Caesar and Cleopatra*. In *Saint Joan* the shift in the direction of the wind is not literally a miracle, but the religious atmosphere of the play causes it to function dramatically as if it were miraculous; the ending of Scene III is a moment of high excitement not only for Joan, Dunois, and the Page, but also for the audience.

> DUNOIS [*looking at the pennon*] The wind has changed. [*He crosses himself*] God has spoken. [*Kneeling and handing his baton to Joan*] You command the king's army. I am your soldier. [VI, 122–23]

The audience feels here that in some sense God *has* spoken; the language may be ultimately metaphorical, but the metaphor is vital and powerful. Furthermore, religious oaths are a serious matter in *Saint Joan.* Joan treats Robert de Baudricourt's conventional "Well, I *am* damned" in Scene I as a meaningful utterance (VI, 87), and the death of Foul Mouthed Frank in Scene II is supposed to proceed from his swearing. When Joan tells Charles at the end of Scene II, "I shall dare, dare, and dare again, in God's name" (VI, 115) the invocation of the divine has considerable emotional resonance.

In *Caesar and Cleopatra,* on the other hand, what is the dramatic effect of all the references to the gods? Pothinus' suggestion that the gods are responsible for the Romans' success simply marks him as credulous; the audience knows that Caesar's resourcefulness is what counts. And the oaths in *Caesar and Cleopatra* do not create or draw on a religious atmosphere; they are just a matter of local color, part of the necessary background in a play about Egyptians and Romans in 48–47 B. C. All of the religions of the play—Egyptian, Roman, Persian, and British— are, from the audience's point of view, superstitions. Apis, the Egyptian god whose name begins the first act of the 1898 play, suffers at the beginning of the final act the indignity of having had his image offered for sale to Caesar by the Egyptian priests for five talents; and the Persian soldier comments scornfully on the god's impotence (II, 285). The mighty Ra is also slighted at the hands of the Romans. Rufio sits on his stone altar in Act IV (II, 274), and when there is no chair for Caesar in the council chamber in Act II, Rufio takes the bronze tripod from before the image of Ra, "*shakes off the incense; blows away the ash; and dumps it down behind Caesar*"; and Caesar completes the sacrilege by sitting down on the proffered seat (II, 199). The stage direction mentions Rufio's "*indifference to foreign superstitions,*" and this phrase would also describe the attitude of the audience and the tone of the play itself.

The play's superstitions have an unpleasant, barbaric side to them. The religions of Egypt, Persia, and Britain are each associated with human sacrifices. In Act IV Cleopatra threatens Ftatateeta, "Must I sacrifice you to your father's gods to teach you that *I* am Queen of Egypt, and not you?" (II, 255). Then later in this act she tells Caesar as her miniature sphinx is brought in that "to do it properly, we should kill something to please him" (II, 271), and the culmination of this particular religious ceremony turns out to be the death cry of Pothinus. The altar of Ra is also linked with the murder of Pothinus. When Ftatateeta returns after killing him she "*drags herself sleepily to the altar; kneels before Ra; and remains there in prayer*" (II, 273). At the end of the act it is on this same altar that Cleopatra discovers the slain Ftatateeta's corpse. Throughout the play the Egyptian religion is associated with the murderousness of

Ftatateeta and the vengeful cruelty of Cleopatra. The Persian religion seems similar to the Egyptian in this respect in that the Persian soldier, threatening Ftatateeta with his knife in the "Alternative to the Prologue," says that "Persia has but one god; yet he loves the blood of old women" (II, 178). The British religion is also devoted to human sacrifice: Caesar's retort to Britannus in Act III is "I do not make human sacrifices to my honor, as your Druids do" (II, 241).

If there is any true religion (in Shaw's sense of the word) in the play it must lie with Caesar, and clearly Caesar's humane, enlightened view of the world is set off by contrast with the primitive, dark superstitions and cruelties of the people around him—for example Cleopatra's cat worship and table rapping, and her pronounced taste for flogging and decapitation. Caesar's "gods" are in opposition to the Egyptian gods of vengeance and human sacrifice in Act IV. After Pothinus' murder, Caesar concludes his celebrated denunciation of vengeance by proclaiming, "And so, to the end of history, murder shall breed murder, always in the name of right and honor and peace, until the gods are tired of blood and create a race that can understand" (II, 278). This is the closest the play comes to the religious language of *Saint Joan*, and there is an earlier pronouncement of Caesar's that anticipates subsequent Shaw plays; he says to Rufio in Act II, "Might not the gods destroy the world if their only thought were to be at peace next year?" (II, 221).

In spite of these verbal flourishes, I do not think the 1898 *Caesar and Cleopatra* is a religious play or that Caesar is a religious figure. A good way of examining this question is to turn to the section of the revised text that I have so far deliberately omitted from my discussion.

In Act IV Ra may be associated with sacrifice and murder, and in Acts II and V the god may be violated by the Romans, but in the Prologue he speaks with authority and without interruption. And some of what he says would seem to contradict my dismissal of the religious language of *Caesar and Cleopatra* as lacking dramatic force or conviction for the audience.

> The way of the soldier is the way of death; but the way of the gods is the way of life; and so it comes that a god at the end of his way is wise and a soldier at the end of his way is a fool. . . . And Pompey's friend Julius Caesar was on the side of the gods. . . . And the gods smiled on Caesar; for he lived the life they had given him boldly. . . . [At Caesar's victory over Pompey at Pharsalia] the blood and iron ye pin your faith on fell before the spirit of man; for the spirit of man is the will of the gods. . . . I had not spoken so much but that it is in the nature of a god to struggle for ever with the dust and the darkness, and to drag from them, by the force of his longing for the divine, more life and more light. [II, 162–67]

These excerpts have the ring of the authentic Shavian religion, and the point I want to make here is that there is a clear discrepancy between the Prologue and the original play. The Prologue was written in 1912, and sounds like the post *Man and Superman,* post *Major Barbara* Shaw. The play itself was written 14 years earlier in 1898, and it sounds more like the Shaw of the 1890s, in whose plays the religious impulse is much less evident.[3]

In the same year that Shaw wrote Ra's Prologue, he gave a speech on "Modern Religion" to the New Reform Club in London. He told his audience of society's desperate need for religious people, and then indicated his sense of the word "religious."

> What I mean by a religious person is one who conceives himself or herself to be the instrument of some purpose in the universe which is a high purpose, and is the native power of evolution—that is, of a continual ascent in organization and power and life, and extension of life. Any person who realizes that there is such a power, and that his business and joy in life is to do its work, and his pride and point of honor to identify himself with it, is religious. . . . Any man of honor is a religious man. He holds there are certain things he must not do and certain things he must do, quite irrespective of the effect upon his personal fortunes.[4]

There are many similar utterances in Shaw's plays and other writings, and we can fairly take this excerpt to represent his mature religious position. It certainly represents the spirit of the 1912 Prologue to *Caesar and Cleopatra.* It also represents the spirit of another work that Shaw wrote in this same year: *Androcles and the Lion,* in which Lavinia is ready to die "for something greater than dreams or stories. . . . If it were for anything small enough to know, it would be too small to die for. I think I'm going to die for God. Nothing else is real enough to die for" (IV, 625). At the end of the play, after the Emperor's change of heart, when there is no longer the need to die for this power, Lavinia chooses to live for it and to do its work. She rejects the Emperor's counsel of prudence and the handsome Roman captain's offer of love, choosing to "strive for the coming of the God who is not yet" (IV, 634).

If the passages from the 1912 speech on "Modern Religion" represent Lavinia in *Androcles and the Lion* and the Caesar of the 1912 Prologue to *Caesar and Cleopatra,* to what extent do they represent the Caesar of the actual 1898 play? Ra's Prologue asserts that Caesar is "on the side of the gods," and conveys the impression that we are to witness the actions of a religious man whose will is part of the universal will, and who works to fulfil a transcendental, universal purpose. In the 1898 play, however, Caesar is adroit rather than inspired. It is true that he is much greater than those around him; that he has a higher morality; that he is liberated from shams and superstitions; and that he

follows his own will. But he does not identify his will with any power outside of himself, and the play (apart from the Prologue) does not convey a sense of the world-purpose of which Caesar is a part and beside which his personal fortunes are insignificant. Caesar is not aware of an evolutionary power that pushes towards an extension of life, a world-will that both embraces and transcends his own. It is not Caesar's business and joy in life to do the work of this power, to help life in its upward struggle. In spite of his remark about building the future on the ruins of the past (II, 219), his business in the play is rather to hold out in Alexandria until reinforcements arrive, behaving with prudence and common sense and making the best of his situation.

In Ra's Prologue Caesar's victory over Pompey is presented as part of a world-historic moment: the victory of the new Rome over the old Rome; and Caesar's defiance of the law of the old Rome is his participation in the historical evolution of his time. Caesar is said to be on the side of the gods in that he is helping to bring a new era into being. All of this is impressively stated in the 1912 Prologue, but is it applicable to the 1898 play? Margery M. Morgan argues that Caesar anticipates Christ, and she points to his repudiation of the murder of Pothinus in Act IV: "If one man in all the world can be found, now or forever, to *k n o w* that you did wrong, that man will have either to conquer the world as I have, or be crucified by it" (II, 277).[5] But while Caesar's moral values are higher than those of the others in the play, these values are not dramatized as part of an historical process. Morgan suggests a parallel between Caesar and Joan as messiah figures, but the contrast between *Caesar and Cleopatra* and *Saint Joan* in this respect is revealing.[6] Joan is impelled by a sense of divine mission to expel the English from France; her religious impulse leads her to identify herself with the historical forces of the emerging era of nationalism in Europe. Like Lavinia, she strives for the coming of the God who is not yet. Caesar, on the other hand, is a master strategist who in the 1898 play is working to preserve the military power of Rome. Whereas Joan defies the established (and imperialist) powers of the day, Caesar embodies and upholds them. Unlike the youthful Joan, who is passionately committed to a mission, the middle-aged Caesar conveys a hint of fin-de-siècle world-weariness: "Oh, this military life! This tedious, brutal life of action! That is the worst of us Romans: we are mere doers and drudgers: a swarm of bees turned into men" (II, 261). Caesar may have private aspirations towards a different life from the one he is leading, but his historical role in the play does not make him an agent—conscious or unconscious—of evolutionary forces. *Caesar and Cleopatra* is not particularly concerned with such forces; unlike *Saint Joan* it exhibits a single great person in isolation from the patterns of history. (Note

that the cry of Ptolemy's courtiers in Act II, "Egypt for the Egyptians" [II, 205], is an anachronistic joke which makes the point that nothing really changes in history; contrast this with the expressions of nationalism in *Saint Joan*.)

Caesar and Joan are both military leaders who succeed against great odds. But their respective attitudes towards military matters are quite different.

> CAESAR [*to Achillas*] So you can make war on the Egyptians in the name of Rome, and on the Romans—on *me*, if necessary—in the name of Egypt?
> ACHILLAS. That is so, Caesar.
> CAESAR. And which side are you on at present, if I may presume to ask, general?
> ACHILLAS. On the side of the right and of the gods.
> CAESAR. Hm! How many men have you? [II, 204][7]

Contrast this with Joan's spirit when her side, like Caesar's, is at an apparent disadvantage:

> ROBERT. . . . That is why the goddams will take Orleans. And you cannot stop them, nor ten thousand like you.
> JOAN. *One* thousand like me can stop them. *Ten* like me can stop them with God on our side. [VI, 94–95]

In the *Caesar and Cleopatra* scene it is the inferior Rufio who truculently challenges Achillas, "Are your men Romans? If not, it matters not how many there are, provided you are no stronger than 500 to ten." In *Caesar and Cleopatra* this attitude is just a foolish boast, to set beside Caesar's realistic common sense. In *Saint Joan* it is an expression of the religious person's knowledge that "the spirit of man is the will of the gods" (in the words of Ra's Prologue). Joan knows what the post *Man and Superman* Shaw knew: that men and women can be inspired, that they are capable of transcending their ordinary selves. She tells Robert de Baudricourt:

> Our soldiers are always beaten because they are fighting only to save their skins; and the shortest way to save your skin is to run away. Our knights are thinking only of the money they will make in ransoms: it is not kill or be killed with them, but pay or be paid. But I will teach them all to fight that the will of God may be done in France; and then they will drive the poor goddams before them like sheep. [VI, 95]

Caesar, whose business in Act II of *Caesar and Cleopatra* is the collection of 1600 talents from Pothinus and who blandly asserts that "taxes are the chief business of a conqueror of the world" (II, 200), does not transform the people around him by imbuing them with a sense of

religious purpose. In the "Alternative to the Prologue" Bel Affris describes the military methods of Caesar's invading army: "He throws a legion at you where you are weakest as he throws a stone from a catapult; and that legion is as a man with one head, a thousand arms, and no religion" (II, 172). In *Saint Joan*, by contrast, Joan's enemy Cauchon says that her victories prove "that the courage of faith, even though it be a false faith, will always outstay the courage of wrath" (VI, 131). It is an interesting and revealing point that in his 1901 Notes to *Caesar and Cleopatra* Shaw uses Joan as an example of the half-witted genius who enjoys "the worship accorded by all races to certain forms of insanity" (II, 302).

Joan's promise that she will *teach* the soldiers to fight that the will of God may be done in France indicates a main theme of both *Caesar and Cleopatra* and *Saint Joan* (and other Shaw plays as well).[8] Caesar and Joan are both teachers, but again—as in their roles as military commanders—their methods are notably divergent. Joan's most conspicuous pupil is the Dauphin, and in her appeal to him we see the way in which she inspires others to do the will of God by presenting herself as the messenger of a higher power that must use both her and her listeners for its own universal ends: "I tell thee it is God's business we are here to do: not our own. I have a message to thee from God; and thou must listen to it, though thy heart break with the terror of it" (VI, 114). Although he is 26, Charles is still in most respects a child, and Joan's mission is to turn the boy-Dauphin into a man and a king. In the Epilogue, which alters our perspective on the six chronicle scenes, the 51-year-old Charles tells Joan of his successes since her death:

> CHARLES. . . . Do you know, I actually lead my army out and win battles? Down into the moat up to my waist in mud and blood. Up the ladders with the stones and hot pitch raining down. Like you.
> JOAN. No! Did I make a man of thee after all, Charlie?
> CHARLES. I am Charles the Victorious now. I had to be brave because you were. [VI, 194–95]

That is the main function of the teacher in Shaw's plays: to transform a child into a man or woman. In *Major Barbara* another prophetess-figure tries to help the bully Bill Walker grow up.

> BARBARA [*softly: wooing his soul*] It's not me thats getting at you, Bill.
> BILL. Oo else is it?
> BARBARA. Somebody that doesnt intend you to smash women's faces, I suppose. Somebody or something that wants to make a man of you. [III, 112]

In *Caesar and Cleopatra*, Caesar attempts to turn the girl-cat into a woman and a queen.

CAESAR. . . . Now you are a silly little girl; and you are descended from the black kitten. You are both a girl and a cat.
CLEOPATRA [*trembling*] And will he [Caesar] eat *me*?
CAESAR. Yes; unless you make him believe that you are a woman.
CLEOPATRA. Oh, you must get a sorcerer to make a woman of me. [II, 187]

Caesar tells her that she must confront the dreaded Roman leader "as a brave woman and a great queen." But he does not appeal to any suprapersonal power beyond them both; he threatens her and offers her the reward of becoming the real ruler of Egypt. Cleopatra says to him in Act I, "I always want to be let do as I like, no matter whether it is the will of the gods or not" (II, 184). In *Saint Joan* Joan persuades Charles that he cannot always do as he likes, but that he must carry out the will of God. In *Caesar and Cleopatra,* Caesar, who invokes only his own authority rather than that of the gods' will, is a secular rather than a religious teacher. And he is a teacher who, unlike Barbara or Joan (or Henry Higgins in *Pygmalion*) has little faith in the capacity of others to learn or to change. Like the early Shaw of the 1890s, he seems to accept human nature as unalterable. In Act I the scene in which Caesar tells Cleopatra she must become a woman ends with his response to her superstitious obsession with the sacred white cat: "Incorrigible, oh, incorrigible! Away!" (II, 188). When in Act IV Pothinus reveals to him Cleopatra's desire for his departure, he calmly replies, "Well, my friend; and is not this very natural?" (II, 266). He is not disappointed in Cleopatra because he has no expectations in the first place.

Although Cleopatra tells Pothinus early in Act IV that she has learned from Caesar to do what must be done instead of what she likes (II, 256), it is apparent that she is only offering a mechanical imitation of Caesar's wisdom here, for later in the same act she orders the murder of Pothinus. The limits of Caesar's success are evident in his exclamation to her near the end of the play: "What! As much a child as ever, Cleopatra! Have I not made a woman of you after all?" (II, 291). We have seen that the Epilogue to *Saint Joan* indicates Joan's achievement in making a man of Charles. But if *Caesar and Cleopatra* has an epilogue it is Shakespeare's *Antony and Cleopatra,* and the audience knows at the end of Shaw's play that Caesar's teaching has failed in that his pupil is fit only for the strong round arms of Shakespeare's Antony.

What then of Caesar's address to the Sphinx in Act I? Here surely he sounds more religious than secular. He speaks of his isolation from ordinary mankind: "Sphinx, you and I, strangers to the race of men, are no strangers to one another. . . . Rome is a madman's dream: this is my Reality." He refers to the Sphinx as "an image of the constant and immortal part of my life," and he explains: "I am he of whose

genius you are the symbol: part brute, part woman, and part god—
nothing of man in me at all" (II, 182). It might be claimed that the
Sphinx is the equivalent of Joan's voices, and that here we have the
religious side of Caesar. Caesar is more otherworldly here than else-
where in the 1898 play, but we must remember that Shaw's own use
of the word religion includes the idea of dynamic purpose, and the
static, immobile Sphinx does not represent purpose in this speech or
elsewhere in the play. And the religious person "conceives himself or
herself to be the instrument of some purpose in the universe which is
a high purpose"; the purpose must be both within and outside one-
self. Caesar cannot conceive of himself as an instrument, for he sees
himself as the divinity. In his opening speech he is essentially bringing
fraternal greetings to the Sphinx—as opposed to Joan, who recognizes
a power greater than herself in which she participates. Furthermore
one must not dissociate the address to the Sphinx from what follows
in the play. What follows immediately is the anticlimactic reply not
from the Sphinx but from Cleopatra, and her revelation that Caesar
has not been addressing *the* Sphinx at all but "only a dear little kitten
of a Sphinx" (II, 185). And the rest of the play, as we have seen,
concentrates not on "the constant and immortal part" of Caesar's life
but on his work as a practical and resourceful military leader in the
service of Roman imperialism.

I do not wish to suggest, however, that *Caesar and Cleopatra* shares
nothing with Shaw's later history plays. This play, like *Androcles and the
Lion, Saint Joan,* and *"In Good King Charles's Golden Days,"* is concerned
with the conflict between a more and a less enlightened view of life. In
Caesar and Cleopatra this takes the form of a conflict between Caesar's
secular humanism and the primitive superstition of the Egyptian reli-
gion with its worship of Ra and the rest of the Pantheon. *Androcles and
the Lion* brings us forward 200 years or so into a world in which the
conflict is between the official irreligious Roman religion (Caesar's
nominal religion in *Caesar and Cleopatra*) and emergent Christianity.
Then in *Saint Joan* we move forward another 1200 years to find that
Lavinia's Christianity has hardened into the mediaeval Roman Catholic
Church, which behaves rather in the way the enemies of Christianity
did in *Androcles and the Lion,* and persecutes Joan as a Protestant. And
then in *"In Good King Charles's Golden Days"* one of the violent persecu-
tors is a development of Protestantism, which has hardened into (the
offstage) Titus Oates and his No Popery mob. The true Protestant
spirit now expresses itself in George Fox, the founder of the Quakers,
who denounces all Churches, Protestant and Catholic alike, as "snares
of the devil" (VII, 233). As in *Androcles and the Lion* and *Saint Joan* the

most authentic religion is the newest; the genuine religious movement is in rebellion against established, outworn, lifeless mechanisms.

It is not accidental that the three twentieth-century history plays have obviously religious major characters, while *Caesar and Cleopatra* does not. Shaw chose religious subjects for *Androcles and the Lion, Saint Joan,* and (to a lesser extent) *"In Good King Charles's Golden Days,"* because of his growing interest in—and respect for—religion, after the turn of the century. In the plays of the 1890s we do have Marchbanks in *Candida* and Dick Dudgeon in *The Devil's Disciple,* who exemplify certain aspects of Shavian religion, and then there is the guide to Wagner's *Ring* cycle, *The Perfect Wagnerite,* which Shaw wrote at the same time he was writing *Caesar and Cleopatra.* Parts of *The Perfect Wagnerite,* like Caesar's speech on vengeance, anticipate Shaw's mature religious position, but it is only in and after *Man and Superman* (1901–2) that we find powerful, energetic religious figures who are religious in Shaw's sense. It is in accord with Shaw's general development that in his 1898 history play he treated Caesar's conflict with the Egyptians in the mainly non-religious way I have been discussing. If the play is produced with the 1912 Prologue, then the audience is offered a misleading introduction to the play—an indication of how Shaw might have approached Caesar's Egyptian campaign had he written the play a few years later than he did. It is best if the play is staged in its original, internally consistent 1898 form, and if the 1912 Prologue is reprinted in texts of the play as an indication of Shaw's religious development as a dramatist. For Ra's Prologue nicely underlines some of the distinctions between the 1898 *Caesar and Cleopatra* and the later history plays that are truly religious, *Androcles and the Lion* and *Saint Joan.*

Notes

1. J. L. Wisenthal, of the English Department at the University of British Columbia, is author of a study of Shaw's "middle plays," *The Marriage of Contraries,* and of *Shaw and Ibsen.* He has recently edited *The Man of Destiny* and *Caesar and Cleopatra* for the Garland edition of early Shaw play texts.

2. *The Bodley Head Bernard Shaw,* ed. Dan H. Laurence, 7 vols. (London: Max Reinhardt, The Bodley Head, 1970–74) II, 169. All subsequent references to Shaw's plays will be to this edition, with volume and page numbers indicated parenthetically in the text. In the first edition of *Caesar and Cleopatra* (in *Three Plays for Puritans,* 1901) the line quoted is the beginning of Act I. When Shaw later provided a Prologue to the play, this palace

scene became "An Alternative to the Prologue." I shall refer to "the 1898 *Caesar and Cleopatra*" to indicate the play as published in 1901, without the Prologue. The changes from the 1898 manuscript to the printed text in the first edition do not affect my argument; nor (apart from the Prologue) do the changes made by the time of the revised text of 1930, which is used in the Bodley Head edition.

3. For an excellent account of Shaw's development from a pragmatic to a more spiritual position see Alfred Turco, Jr., *Shaw's Moral Vision: The Self and Salvation* (Ithaca, N.Y.: Cornell Univ. Press, 1976). Turco discusses *Caesar and Cleopatra* on pp. 100–6.

4. *The Religious Speeches of Bernard Shaw*, ed. Warren Sylvester Smith (University Park: The Pennsylvania State Univ. Press, 1963), pp. 38–39. It seems to me of some significance that Smith's selection of religious speeches begins in 1906; not that there is no religion in the works of the earlier Shaw, but the Shavian religion takes shape around the beginning of the new century. See Smith's introduction to the volume, pp. xiii–xxiii.

5. Margery M. Morgan, *The Shavian Playground* (London: Methuen, 1972), pp. 243–44. See also Timothy G. Vesonder, "Shaw's Caesar and the Mythic Hero," *Shaw Review*, 21 (1978), 72–79.

6. Relationships between Caesar and Joan are also examined in Charles A. Berst, *Bernard Shaw and the Art of Drama* (Urbana: Univ. of Illinois Press, 1973), p. 265.

7. The MS of *Caesar and Cleopatra* has a passage that provides an expanded view of this practical side of Caesar. In Act III, in a scene that was dropped by the time the play was published in 1901, Caesar interviews messengers about military relief that he can expect, and his concern is consistently with the numbers of men and galleys available. For example:

> SYRIAN. I am sent to say that a host comes from Syria, and that since the gods are on its side, it cannot but prevail over the Egyptians.
> BRITT [Britannus]. Good. That is well said.
> CAESAR. How many men are there?

There are parallel exchanges between Caesar and two other emissaries, who assure him that "the gods are on the side of the right" and that the augurs and oracles have spoken "and declare that the gods are propitious to Caesar." (British Library Add. MS. 50609C, fols. 25–30. For the MS of *Caesar and Cleopatra* see Bernard Shaw, *Early Texts: Play Manuscripts in Facsimile* [New York: Garland, 1981].)

8. Peter Ure, "Master and Pupil in Bernard Shaw," *Essays in Criticism*, 19 (1969), 118–39, discusses *Caesar and Cleopatra*, *Major Barbara*, *Pygmalion*, and *Heartbreak House*.

Ina Rae Hark[1]

LADY CICELY, I PRESUME: CONVERTING THE HEATHEN, SHAVIAN STYLE

When Bernard Shaw chose the title *Three Plays for Puritans* for his volume that contains *The Devil's Disciple, Caesar and Cleopatra,* and *Captain Brassbound's Conversion,* he did not do so because of any theological content in the plays. As he explains in the first section of his preface, "Why for Puritans?" Shaw meant to identify himself with the seventeenth-century Puritans as a man who found the plays presented in British theatre immoral. He disapproved of the contemporary stage in England because of its distorted portrayals of human motivations and values, a distortion that he believed had the power to convince its audiences to emulate the false reality in their own lives.

The religious concerns that a reference to Puritans suggests are nevertheless hardly absent from the three plays, and Shaw himself uses puritanism in its most common sense when he discusses Dick Dudgeon as a "Puritan of the Puritans" who becomes "like all genuinely religious men, a reprobate and a scoundrel." Turning to that play and its companions one finds that religious metaphors particularly suit Shaw's purposes, a fact that would be apparent even without the pointers provided by the collective title and preface.

The precise reason for Shaw's use of a religious model becomes clearer when one considers the parallel ways that model figures in all three plays. Each takes place in the homeland of a culture whose native religion strongly influences daily conduct. That influence is, according to Shaw's standards, detrimental to the fullest moral development of its believers. Thus, the superstitions of the Egyptian religion fill Cleopatra with irrational fears but also sanction the cruelties perpetrated by the rulers whom it equates with the gods. Dick Dudgeon's fanatical mother has used her religion, as Shaw notes in the preface, to excuse her "indomitable selffulness [*sic*]" and its "master passion of hatred in all its phases of cruelty and envy." The Moroccan Moslems in *Captain Brass-*

bound hate the European Christians so virulently that they kill or enslave any who fall into their hands unless the colonial military forces are nearby to protect the Europeans.

Each of the cultures portrayed is in the process of being or has been affected by occupiers of another culture and another creed. (The British and Americans in *Devil's Disciple* are, of course, all Christians; but Puritan dissent is quite another thing fron conventional Anglican observance.) One person from each occupying group—General Burgoyne,[2] Caesar, Lady Cicely—is not bound by the fallacies of either creed and serves to educate both sides away from perverted moral ideals by presenting a Shavian view of genuine religion. Like so many of Shaw's dramas, all three plays are in effect about Shavian conversion; the framework of religious discussion underlines how similar in process, if antithetical in philosophy, the enlightenment of Shavian idealists by Shavian realists is to the work of the successful proselytizing missionary.

Shaw's disapproval of organized religion throughout his career did not arise because he had an anti-religious temperament but because the churches, as he perceived them, had anti-religious temperaments. He would open the preface to *Androcles and the Lion* with the question, "Why not give Christianity a trial?" and would insist that all the churches, empires, moralities, and political constitutions for two thousand years had ignored Christ's message and adhered strictly to "the old cry of 'Not this man, but Barabbas.' " If religion means codified dogma, prescribed rules for conduct, and acceptance of an elaborate institutional hierarchy and system of ritual, then Shaw opposed religion. If religion exists to foster the development of ethical and spiritual wholeness in the individual, to let him see clearly the purpose of life on earth, and to ensure that his desires tend toward the moral well-being of mankind, then Shaw is deeply concerned with promoting religion. His Life Force works inside the individual and is no external deity demanding worship, yet it serves much the same role in Shaw's world view as that which conventional religions assign to God. Most of the assumptions Shaw challenged touch on those problems in human experience that religion should ameliorate but that the churches had in fact exacerbated. In proposing to set right the failures of organized religion, Shaw frequently invoked the metaphor of the theatre as a church and himself as preacher and prophet. Accordingly, the transformations many of his protagonists undergo when their ideals are destroyed are analogous to religious conversion.

The title of the last play in the *Puritans* volume, *Captain Brassbound's Conversion*, announces the analogy outright, and the first character discovered on stage is an actual missionary. Shaw's use of the word "con-

version," of missionaries, and of repeated allusions to conventional religion has two purposes. The first is to establish the familiar Shavian paradox. He includes traditionally religious characters to underscore the moral bankruptcy of traditional religion. Captain Brassbound's "conversion" is notable because it occurs completely outside the context of petty parochialisms that pass for faith among the other characters. At the same time Brassbound does, in Shavian terms, progress from spiritual blindness to spiritual awareness and thus experiences a conversion of sorts. This comes about only because Lady Cicely exposes the falsity and viciousness of his existing values; in that respect she performs the function of a secular missionary. Shaw wishes to stress that the improvements people erroneously assign to religious conversions may in fact be gained from Shavian-style conversions.

Because the apparent central theme of the play concerns Shaw's evaluation of societal "justice" as organized vengeance, the emphasis on true and false spiritual transformations, illustrated through the missionary paradigm, is generally subordinated to the justice theme in critical discussions of the play.[3] In fact events, characterizations, and allusions make conversion a theme of equal importance, as a wider consideration of Shaw's work might lead us to expect. As GBS perceived them, the faults of "Crosstianity," with its carrot-and-stick road to salvation, paralleled the rewards and punishments of the criminal court system, and he frequently combines criticisms of law and religion in his plays. (The crucial event in his one work about a bona fide saint, Joan, is a trial.) The two other works in *Three Plays for Puritans* also contain this linkage. Dick Dudgeon almost becomes a martyr to the law of the occupying British before he is saved to assume his rightful role as minister. Finding no one to support his contention that Cleopatra's judicial murder of Pothinus is morally wrong, Caesar prefigures Christ by saying, "If one man in all the world can be found, now or forever, to know that you did wrong, that man will have either to conquer the world as I have, or be crucified by it." Justice merely seems a more burning issue than religion in *Captain Brassbound* because so much more explicit discussion of justice as a concept occurs here than in other plays. But if we look carefully, we find a good deal of explicit discussion of conversion as a concept. *Captain Brassbound* is a play in which ideas that Shaw often treats implicitly and by historical analogy elsewhere, as he does in the other Puritan plays, are dealt with openly, albeit still within a melodramatic plot structure.

In one sense this approach renders the play a cruder and less-accomplished piece of dramatic philosophy, although as pure comedic entertainment it has been sadly underrated and under-performed. The lack of subtlety makes it especially fruitful for observing Shaw's ideas on conversion, properly used, as a way of changing individuals

and, through them, society. Moreover, certain inconsistencies in *Captain Brassbound* point up weaknesses in the efficacy of this Shavian method. These weaknesses are present, though less noticeable, in earlier works as well, but they are more glaringly obvious here, partially because Shaw is hard at work to camouflage them. Given the play's position in his canon, coming directly before *Man and Superman*, whose *Revolutionist's Handbook* declares "Man will return to his idols and his cupidities, in spite of all 'movements' and all revolutions, until his nature is changed," it may well represent a failure to salvage conversion, alone, as a means for world reform. And Shaw may have been well aware of this failure even as he crafted a play in which the Shavian missionary, Lady Cicely Waynflete, seems to achieve her goals with especially complete and effortless success.

To obtain a setting where it would be possible for him to contrast actual, ill-directed missionary efforts with a superior Shavian kind, the playwright chose colonial Africa of his own day. As I have noted, the other two plays in the volume also concern colonialism of some sort and can easily be seen to comment on the strengths and foibles of British imperialistic enterprises in the latter part of the nineteenth century. (Shaw is very careful to provide Caesar with a British valet.) *Captain Brassbound*, however, does not work by analogy; it directly concerns European and American activities in Africa and focuses particularly on the religious impulse so influential in the British efforts to explore and colonize the continent. Through a wide-ranging series of references, Shaw evokes as many facets of that endeavor as he can.

The action of the play is confined to Morocco (as described by Cunninghame Graham) and the natives are Moslem Arabs rather than primitive black tribesmen. These latter inhabitants of west and central Africa receive frequent mention, for Lady Cicely has just returned from traveling through their lands. As Drinkwater reports, she has "walked acrost Harfricar with nathink but a little dawg, and wrowt abaht it in the Dily Mile."[4] The juxtaposition of Arab North Africa and black Central Africa brings to mind the African slave trade whose destruction Livingstone and other prominent missionaries made a primary target of their exertions. The trade functioned largely through the sale of blacks by other blacks to Moorish slavers. It figures prominently in Captain Brassbound's activities in Africa. While he informs Lady Cicely that his uncle "will be pretty fortunate if he is allowed to live out his life as a slave with a set of chains on him" (p. 645), his truce with the slave-trading Arabs is ironic: he had first come to Africa under the command of the Christian soldier, General Gordon, who trained him in smashing up the slave raiders. When he speaks of the general's death at Khartoum, he acknowledges the religious fervor on the other

side of that siege as well: "[Sidi] knows that the Mahdi killed my master Gordon, and that the Mahdi died in his bed and went to paradise" (p. 642). Brassbound thus expresses a willingness to respect the actions of all fanatics who, however dubiously, claim a divine injunction for their vengeance. Acting out his role of avenger in a "holy" cause, the Captain no doubt identifies with the Mahdi and can therefore excuse even the murder of his much-revered "master." Gordon's influence remains only strong enough to keep Brassbound from ever personally dealing in slaves (or gin).

Gordon was a political as well as a religious figure, and in an important letter to Ellen Terry, for whom Shaw had created the role of Lady Cicely, only to have her dislike the character, Shaw seems to stress *Captain Brassbound* as a commentary on the political, militaristic excesses of imperialism. He denounces Bismarck and Kitchener and informs Miss Terry:

> I accordingly give you a play in which you stand in the very place where Imperialism is most believed to be necessary, on the border line where the European meets the fanatical African, with judge on the one hand, and indomitable adventurer-filibuster on the other. . . . [5]

And yet he opens his letter with the reproach: "Listen to me, woman with no religion." This use of the term "religion" indicates, I believe, that to someone with moral and spiritual clear-sightedness, Lady Cicely's superiority over the ordinary imperialistic exploiters should be obvious. When he tells Miss Terry to compare the travel accounts of Mary Kingsley and H. M. Stanley and so contrast "the brave woman, with her commonsense and good will, with the wild-beast man, with his elephant rifle, and his atmosphere of dread and murder, breaking his way by mad selfish assassination out of the difficulties created by his own cowardice," it also becomes clear that the many strong personalities Africa had attracted appealed to him. He would focus in the play on the real power of such forceful individuals to change people and events.

In the terms of the letter to Ellen Terry, Judge Hallam, backed by "England's vengeance" and American gunboats, represents the Bismarcks and Kitcheners; Brassbound, as filibuster, stands for Stanley; and Lady Cicely is based on Mary Kingsley.[6] Perhaps the most famous figure in the British exploration of Africa, Dr. David Livingstone, remains unmentioned in either the letter or the play, but details in the characterization of Leslie Rankin, the declared and failed Christian converter of the heathen, and Lady Cicely, the undeclared but successful Shavian proselytizer, suggest him. Like Livingstone, Rankin acts as a medical missionary and is an "elderly Scotchman"[7] and a Presbyte-

rian. These superficial similarities invite a Livingstone/Rankin comparison, but that comparison in turn points up how far short Rankin falls of embodying those qualities that made Livingstone great. Lady Cicely bears no external resemblance to Livingstone, but Shaw endows her with many of the personal traits that made the doctor unique among African missionaries.

Owen Chadwick relates that "Though [Livingstone] remained a missionary, he was an unusual missionary. He had no interest himself in building up strong congregations, in gathering a nucleus of faithful men, in creating the first beginnings of a church. He believed in the diffused influence of a white and Christian civilization as the christianizing force in Africa; and he conceived his own travels as the opening gates for the spread of that influence."[8] Although Mary Kingsley's travels are the direct source for Lady Cicely's lone journeys, such solitary explorations characterized Livingstone's African endeavors as well. Cicely has no desire to use the force of her character to "christianize" anyone, but she reflects Livingstone's ability to sway men to his beliefs primarily through "unity of style and personality"; she also shares his opinion of the Africans as "peoples of humour and friendliness, of faith and loyalty, needing only to be treated like human beings to respond as human beings."[9] She observes, "Why do people get killed by savages? Because instead of being polite to them, and saying Howdyedo? like me, people aim pistols at them. I've been among savages—cannibals and all sorts. Everybody said theyd kill me. But when I met them, I said Howdyedo? and they were quite nice" (p. 617).

The one time Shaw does mention Livingstone by name in his dramatic works, in the preface to *The Simpleton of the Unexpected Isles*, he refers to him with approval and makes Livingstone's missionary pursuits an analogue to his own efforts to educate the British public:

> Livingstone did not say to the sun-colored tribesman "There is between me and thee a gulf that nothing can fill": he proposed to fill it by instructing the tribesman on the assumption that the tribesman was as capable mentally as himself, but ignorant. That is my attitude when I write prefaces.[10]

Shaw therefore defines conversion as the liberation of man's intellectual—and by implication moral and spiritual—faculties from ignorance, and he acknowledges that conversion, so defined, is one of his principal aims as a writer. By comparing Livingstone to himself, he also suggests that though Shavian realists are rarely advocates of organized Christianity, conventional church affiliation does not *de facto* rule out the possession of the realist's vision by exceptional individuals.

Lady Cicely herself claims some sketchily defined affiliation with or-

ganized religion via the Waynflete Sunday School, although she prob-
ably keeps up the connection because of its appropriateness to her
carefully cultivated image as Victorian lady and doer of good works.
She certainly has come to Africa only to follow her own inclinations,
not as the representative of any official religious denomination. She
would no doubt agree with Miss Kingsley that "the effects of missionary
teachings were simply to destroy the indigenous and wholesome system
of morality based on the traditional system of religion, and replace it by
nothing substantial."[11] At the same time, Lady Cicely never displays the
contempt that Miss Kingsley had for most missionaries.[12] Although
Cicely scorns both "Crosstian" injunctions to do one's duty and ortho-
dox methods of proselytizing, perhaps she recognizes her kinship, in a
Shavianly altered way, to the missionary vocation of a man like Rankin.
He is limited by the conventional religiosity that Livingstone also
shared with the mass of Crosstians. Cicely is fettered by none of this,
but she does possess the empathy and humaneness that made both
Livingstone and Mary Kingsley positive moral forces amidst the pre-
dominantly immoral European meddling in Africa.

As far as his function in the plot of *Captain Brassbound* goes, Rankin
could just as easily be the British consul or a colonial landowner. Shaw
makes him a missionary for thematic purposes and then dwells on his
extended failure to convert the natives to Christianity or even improve
their dubious ethical standards. Shaw does so in order to provide a
marked contrast to Lady Cicely's rapid success in getting Europeans
and Africans alike to behave in ways satisfactory to her moral sense.
Why does Rankin fail where she succeeds? First it should be made clear
that he never departs from being a decent, if none too intellectually
acute, human being. GBS, as usual, does not condemn faulty ideals by
making their possessor into a villain. Rankin has gained the respect of
the Moslems to the extent that they call him "the Christian who is not a
thief." Shaw introduces him "following the precept of Voltaire by culti-
vating his garden," a practice he would recommend as the best form of
worship to his black girl in search of God in another religious parable
set in Africa. But in his twenty-five years in Morocco, Rankin has never
made one convert except Felix Drinkwater, the Cockney pirate who
mouths pious sentiments and will convert to any creed that promises to
advance his self-interest. (Subsequently, while a prisoner of the U.S.
gunboat crew, he expresses to the American chaplain an interest in
converting to Episcopalianism.) When Shaw initially describes Drink-
water as "a man who is clearly no barbarian, being in fact a less agree-
able product peculiar to modern commercial civilization," a reader
might suspect that Shaw's particular criticism of African missionary
activity is that so much work remains to be done closer to home in

England; this is the point Dickens makes through Mrs. Jellyby in *Bleak House*, whose Man from Shropshire GBS refers to in his note to *Captain Brassbound*. But Drinkwater is a direct ancestor of Snobby Price in *Major Barbara*, and there Shaw demonstrates that the "bribe of bread" will engender insincere conversions no matter where it is offered. Moreover, *Captain Brassbound* focuses primarily on the prototypical Bill Walkers, the aggressive Arabs and "filibuster" who defy conversion arrogantly when confronted by would-be proselytizers. The reason these non-hypocrites resist even so well-intentioned a man as Rankin derives from a flaw in the very conception of conversion as held by established religions.

Most churches feel that they must convert people in order to save them. They equate adherence to a false religious doctrine with being in a state of sin. And they frequently blur in their minds the distinction of which has given rise to the other, i.e., whether inferior moral natures give rise to heathen theology or whether believing false dogma leads to moral turpitude. Try as he may, the proselytizer inevitably betrays the suspicion that the unbeliever is evil in some way and needs to be re-formed, not just informed. Shaw illustrates the dubious validity of such a state of mind by paralleling the derogatory opinions of Christians about Moslems with those of Moslems about Christians in order to stress the basic identity in the behavior of each toward unbelievers.

The Arabs call Rankin the Christian who is not a thief because they assume that most Christians will be thieves. Sir Howard calls Hassan and the two Krooboys an "entirely villainous trio," and Drinkwater marvels that any men claiming to be Christians could sell weapons to "eathen bleck niggers." To Hassan, in turn, Sir Howard and Lady Cicely are "a Christian dog and his woman." Osman thanks Brassbound for tipping him a dollar by promising that "Allah will make hell easy for the friend of Sidi el Assif and his servant." The Arabs allow Brass-bound to escort "true believers" through their territory. Captain Kearney refers to such clients as "heathens." Even Rankin names them "poor benighted creatures." Brassbound thinks to scare off the tourists with tales of the fanaticism of the Arabs; Lady Cicely easily convinces the Cadi to head back to the hills with tales of the fanatical Christianity of the Americans. Rankin also warns Lady Cicely of the Moslems that "every man of them believes he will go to Heaven if he kills an unbe-liever," to which she knowingly replies: "Bless you, dear Mr. Rankin, the people in England believe that they will go to heaven if they give all their property to the poor. But they dont do it. I'm not a bit afraid of that" (p. 616).

While both sides have some reason to distrust the other, that reason derives from their shared failings as human beings, not from the

creeds that divide them. The two Arab functionaries, Hassan and Os-
man, in their maneuverings to get the most for their services, work in
precisely the same way as the conniving Drinkwater, a fact he ac-
knowledges when he momentarily drops his mask of Uriah Heepish
servility: "Jist thort eed trah it orn, e did. Hooman nitre is the sime
everywheres. Them eathens is jast lawk you an' me, gavner" (p. 609).
Except for Lady Cicely, all the characters in the play resort to religion
primarily to justify selfish acts of self-aggrandizement or hostility.

Neither Moslems nor Christians, therefore, know what to make of
"the shameless one" for whom "theology" is "common sense," who
"talks nonsense on purpose"; for Lady Cicely happily accepts all men as
equals and intimates regardless of color, creed, class, or larcenous incli-
nations, declaring that they have "nice faces" and need not change in
any way. By approaching people in this manner, she effectively defuses
any hostile or dishonest impulses that might lie behind the faces and so
reduces all the dangerous cannibal chiefs, Moorish sheikhs, and brig-
ands she meets to "children in the nursery" to whom she is a sympa-
thetic but firm mother. (At the trial, her account of the skirmish is
couched in simple, primer-like phrases that equate the conflict to a
squabble between two groups of naughty school boys.) While she pre-
tends not to wish to change or convert anyone, she could have quite
easily marched the Arabs that Rankin has vainly tried to bring to Chris-
tianity for twenty-five years "to church next Sunder lawk a bloomin lot
of cherrity kids," as Drinkwater shrewdly observes.

Lady Cicely's methods, based on a set of different assumptions about
human nature, define the difference between Shaw's idea of what con-
version should entail and the idea held by established religion. Shaw
believes that men do evil with the best intentions, in the name of duty,
social responsibility, and other abstract ideals. And like Shaw, Lady
Cicely discounts the inherent wickedness of most men: "Men are always
thinking that they are going to do something grandly wicked to their
enemies; but when it comes to the point, really bad men are just as rare
as really good ones" (pp. 645–46). Thus she can defend Sir Howard's
apparently villainous behavior on the bench as the actions of an inof-
fensive man lavishly rewarded and encouraged by society to do its dirty
work. Most religious men assume that prospective converts to their
faith need to be changed, to be redeemed from a deeply ingrained evil.
Shaw believes that men must cast off false ideals in order to realize
their true, and therefore good, selves. The distinction between the two
kinds of conversion is pinpointed by an exchange between Brassbound
and Lady Cicely. As she tries to point out the absurdity of his doing his
"duty as a son" by exacting vengeance upon his uncle, the Captain
declares: "You twist my words very cleverly. But no man or woman has

ever changed me." Cicely responds in her usual disingenuous but per-
ceptive manner: "Dear me! That must be very nice for the people you
deal with, because they can always depend on you; but isn't it rather
inconvenient for yourself when you change your mind?" (p. 647).
Shaw's missionaries do not want to convert people *to* any specific creed,
but they do want to convert them *away* from all the ideals that hinder
the flexibility and unhampered growth of what Arnold would have
called their "best selves."

No matter what one may think theologically of Shaw's conception of
sin, one must admit its practicality in application. Approaching a man
with the attitude that he is in error and must change his ways to save
his soul is quite likely to arouse his hostility and make him doubly
defensive as to the virtue of his position. On the other hand, as Lady
Cicely demonstrates with devastating success, it is difficult for any but a
thoroughly evil man to defend himself against having his actions and
intentions judged better than they are.[13] Cicely knows very well that all
those "nice faces" do not belong to men with pure hearts and noble
aims, but by telling such men that she knows they are "Nature's
gentlemen"[14] she forces them to behave as Nature's gentlemen. Her
methods also illustrate the Shavian belief that people tend to act the
way others expect them to act, a belief most succinctly stated by Eliza
Doolittle when she declares that the difference between a lady and a
flower girl is not in the way she behaves but in the way she is treated.

Nevertheless, most of the changes Lady Cicely accomplishes through
assuming the best of everyone she meets do not qualify as deep, inter-
nal conversions. She merely manipulates their actions, engaging in
what modern-day psychologists would call behavior modification. Al-
though she makes Sir Howard her accomplice in defeating justice, he
does not share her gladness that "it's been defeated for once"; he exits
the play "gloomily," giving no sign that he intends to resign his judge-
ship or change his standards of judging. Captain Kearney's admonition
to Brassbound not to escort any more Christian parties through the
remoter Moslem strongholds indicates that the Arabs will not perma-
nently be seized with feelings of brotherly love for men of all faiths.
Drinkwater's one moment of sincerity comes when Kearney threatens
to burn his "lawbrary" of penny dreadfuls. He begs Cicely to save the
books, and she restores to him the false illusions that "took me aht of
the sawdid reeyellities of the Worterleoo Rowd" (p. 676).

Lady Cicely only effects one genuine internal conversion, the one
described in the play's title. It has nothing to do with the various com-
peting creeds whose catch phrases fill the dialogue, nor with any system-
atic theology at all. Captain Brassbound's conversion follows a classic
Shavian pattern. He begins as a man firmly committed to carrying out

a wrongly conceived belief that he substitutes for a true religion. He uses religious allusions throughout in describing his mission. The newspaper clippings concerning Sir Howard's public honors "were more weighty, more momentous, better revelations of the wickedness of law and respectability than the book of the prophet Amos" (p. 682). His schooner is named the *Thanksgiving*. He pursued his vengeance steadfastly because "Whatever I may be, I am none of your fairweather sailors thatll do nothing for their creed but go to Heaven for it. I was ready to go to hell for mine" (p. 681).

Once again Shaw demonstrates how conventional conceptions of religion do not lead to spiritual purity but merely provide justification for vindictive, destructive behavior. The irony of Brassbound's claiming continued devotion to Gordon's memory while dealing with slave traders shows that Gordon's kind of religion produces only skin-deep moral commitment; Brassbound's invocation of the prophet Amos to sanction his own vengeance reiterates the point. Brassbound is disillusioned when Lady Cicely points out the melodramatic absurdity of this purportedly noble quest for vengeance, and he realizes that he took his uncle for "a villain out of a storybook" of the type Drinkwater treasures. He goes through a period of "drifting" and lack of purpose ("You have taken the old meaning out of my life; but you have put no new meaning into it") before he discovers for himself "the secret of command" and "a man's power and purpose restored and righted" (pp. 683, 687).

In essence Brassbound has become himself, when before he could only subordinate his will to that of admired commanders like Gordon or to rigid purposes like his crusade to avenge his mother's wrongs. (Shaw emphasizes his lack of any true sense of self by having him known only through aliases like Black Paquito or Captain Brassbound—or Captain Paquito, as Cicely purposely jumbles the two. His actual surname is, of course, Hallam, but she stops herself the one time she begins to address him as Mister Hallam. Shaw never provides his real first name.)[15] This process, not dissimilar to Carlyle's sequence of Everlasting No, Centre of Indifference, and Everlasting Yea, occurs in precisely the same manner to Vivie Warren, to Eugene Marchbanks, to Barbara Undershaft, to Eliza Doolittle, to Ellie Dunn, just to name the more notable of many convertees in Shaw's works. Unlike Carlyle's paradigm, however, Shaw's conversions do not come solely through the individual's experience and self-discovery but are instigated by another figure, who, like Lady Cicely, can be classified as a Shavian missionary.

As a single means for producing the kind of men who would create the kind of world Shaw desires, the missionary method is not without problems. First one has to trust that people will abandon their false

conceptions of duty and honor once the deficiencies of these concep-
tions have been pointed out. As I have noted above, only the Captain
does this. Alfred Turco further observes about Shaw's interpretation of
self and salvation in general: "While this premise allows ignorance (in
all its manifestations and disguises) to supplant sin as a master principle
to explain the state of the world, the belief that man is ignorant pro-
vides legitimate grounds for hope only if one believes that man is
educable as well. Since it is at exactly this point that Shaw's faith tended
to break down, his determination to view human nature as basically
well-meaning makes his perception of human misdeeds all the more
poignant."[16]

But even if a character does relinquish his ideals, he has only taken
the first step. Because Shaw's characters are converted away from false
beliefs and because adopting any new set of abstract principles would
negate Shaw's purpose, his characters must replace external dictates
with internal commitment to positive action. Brassbound receives no
new creed from Lady Cicely, only an injunction to "do whatever you
like. Thats what I always do." In fact, such an injunction is advisable
only if the disillusioned person has the basic desire to do productive,
altruistic deeds once he is freed from the entanglements of his ideals.
At the end of the play we see that Brassbound does have this capacity.
But when Marzo proclaims himself as converted from "dam pirate"
and "dam rascal" by Lady Cicely's kindly ministrations and confidently
asserts "She saint. She get me to heaven—get us all to heaven. We do
what we like now," she must quickly reprimand him: "Indeed you will
do nothing of the sort, Marzo, unless you like to behave yourself very
nicely indeed." In short, Shavian conversion is only totally effective if
men are all potential Supermen,[17] and the majority of men in this play
clearly are not.

Shaw generally surrounds the role of the proselytizer with considera-
ble ambiguity as well. But Lady Cicely is anomalous among the promi-
nent saints and missionaries of the early and middle plays in escaping
these ambiguities to a great extent. I believe that she represents an
unsuccessful attempt on Shaw's part to convince himself that such mis-
sionaries could have the power to dissipate all the stupidities that make
ordinary social and political life Shaw's version of hell. He therefore
suppresses in her characterization evidence of his doubts about such
figures.

Shaw's missionaries can be divided into two categories. One group
contains characters like Mrs. Warren, General Burgoyne, and Andrew
Undershaft, who are essentially pragmatists. They see life without be-
ing blinded by ideals and so can easily disabuse their idealist protégés.
They may talk like Shavian realists, but they are content to tolerate,

and even profit from, conditions no realist would accept. Often their converts leap-frog over them in perception, so that Vivie ends more enlightened than her mother and Barbara more so than her father. There is frequently a sinister quality about these pragmatic preachers. Burgoyne would hang Dick Dudgeon for the mere sake of political expediency. Mrs. Warren continues to exploit the prostitution business when her own need to escape poverty is past. Undershaft blows men up for a living.

In the second group of missionaries are found born realists like Dick, Bluntschli, and Caesar, who teach people to follow their own desires rather than society's, with generally mixed results. And if the pragmatists are sometimes associated with murder, the realists are often associated with being murdered. Dick almost dies on the gallows, Bluntschli is imperilled by the enemy soldiers, and Caesar, we know, leaves Egypt to confront the assassins' knives in Rome. In later plays Lavinia and her fellow Christians barely escape death in the arena, and Joan is burned at the stake. When the realists do escape, they usually owe their physical salvation to some wielder of pragmatic force like Rufio, Anthony Anderson, or Ferrovius.

When one tries to see where Lady Cicely fits into this pattern, one finds that she fits neither category comfortably. On the one hand, her humane and clear-eyed attitudes about justice and about the causes of man's wickedness make her appear Caesar's equal.[18] She plays good Samaritan to Marzo and "baptizes" Drinkwater by forcing him to bathe, lending symbolic weight to Marzo's claim that she is a saint, as well as a realist. Yet she suffers none of the perils that Shaw's other saints must endure. In fact the playwright goes out of his way to put her in situations that ought to be dangerous—meeting cannibal chiefs, being captured by fanatical Moors[19]—only to demonstrate that she has "some clue to the world that makes all its difficulties easy" (p. 683). So while the presence of the American sailors sends the Cadi to rescue the Hallam party in the nick of time, it is clear that Cicely has already rescued them by agreeing to go off with Sidi, whom she has firmly in control.

On the other hand, some evidence in the play suggests that Cicely is not the thorough-going realist most critics consider her to be. Thus she need not be as vulnerable in the face of force as many Shavian realists are. Although she perceives the idiocy of false idealist views of the world as it is, she seems content with managing that world, unaltered, so long as strife, violence, and other misbehavior by its naughty inhabitants can be controlled. As Margery Morgan notes, she is a reformer, but not a revolutionary.[20] She more than casually resembles pragmatic Shavian women like Candida and Hesione Hushabye (and, dare I say,

Lady Brit) who suffice themselves with setting foolhardy men straight
on the true nature of romance and domestic affairs. She simply trans-
fers the method to world affairs. Her ideas about what Brassbound
should do "to make the most of your opportunities" with his newly
established position in English society sound decidedly Philistine.

Lady Cicely is further anomalous in that she is the only Shavian
missionary of either type who gets her way by pretending to be an
idealist, as she adopts the persona of the wealthy, slightly eccentric
Victorian great lady who goes in for good works while cheerfully—and
charmedly—walking into situations where those angels would never
have dared to tread. Most Shavian missionaries, like GBS himself, say
shocking things but rarely do them; she reverses this pattern. Yet her
unconventional actions do not involve violence or any malice. Even her
shameless manipulations of people tend toward the others' good. Shaw
seems to allow her the advantages of each missionary type while elimi-
nating the complementary disadvantages. Her unusual combination of
invulnerable success and moral purity may have resulted from Shaw's
desire to create the most attractive character possible for the admired
Ellen Terry to play.[21] But other aspects of the play, combined with the
radical changes in Shaw's view of the conversion pattern in his next
drama, *Man and Superman,* reinforce the idea that Lady Cicely is an
attempt by the playwright to gloss over the flaws that his conception of
conversion entailed.

In all three *Plays for Puritans,* Shaw had battled the contemporary
theatrical tradition that maintained that one person could or would
want to influence another of the opposite sex only if love were the sole
motivating factor. He intentionally paired characters like Dick Dud-
geon and Judith Anderson, Caesar and Cleopatra, Lady Cicely and
Captain Brassbound, implied a sexual element in their relationships
through stage conventions, then exploded those conventions and did
not join the characters romantically.[22] The reversal of melodramatic
expectations is meant to show that truly significant and lasting changes
in a person's perception of reality, and the actions that result from that
change, must have a basis in something beyond sexual infatuation.
Sexual attraction may, however, be one component of these significant
relationships. Because Shaw wished to deny that this attraction was the
primary element in determining the behavior of his characters, he
often exaggerated by denying its presence in his plays altogether. In
Captain Brassbound Shaw does admit that Lady Cicely's power to change
people is partially sexual in nature, but he then discounts that fact in an
awkward and not wholly convincing manner.

There is absolutely no doubt that Lady Cicely manages men so well
primarily because of her sexual attractiveness. Sir Howard rightly re-

marks: "In short, we are to have an escort of Hooligans commanded by a filibuster. . . . You will most likely admire all their faces; and I have no doubt at all that they will admire yours" (p. 618). All the cannibal kings wanted to "marry" her. Sheikh Sidi is so infatuated with her (a fact she reports at the trial) that even the Cadi's presence cannot keep him from demanding her as his own; he must be restrained by force when she leaves. And when she responds to Brassbound's proposal with: "Do you know, Captain Paquito, that Ive married no less than seventeen men [*Brassbound stares*] to other women. And they all opened the subject by saying that they would never marry anybody but me" (p. 685), one is tempted to view her less as a saint above the carnal desires of ordinary humans (as Marzo does) than as a high-minded tease.

In the pseudo-seduction scene that follows, Shaw works very hard to get out of this quandary, having Cicely define her avoidance of sexual commitment as the secret of her beneficent powers: "I have never been in love with any real person; and I never shall. How could I manage people if I had that mad little bit of self left in me? Thats my secret" (p. 686). Nevertheless as we see the two drawn ever more intensely to each other, all the while insisting that love has no part in their attraction, the relationship becomes either ludicrous or perverse. And their last minute separation, effected by the firing of the guns—Brassbound's means of sexual sublimation?—is far harder to swallow than Candida's dismissal of Marchbanks following his similar conversion.

Shaw's clumsiness results because, just as he is doubting that conversion can remake all men, much as he would like it to, he is having misgivings that sex can be discounted in even the loftiest human relationships, much as he might like it to be. I would further suggest that, recognizing the effort to salvage those two concepts in this play as a failure, he admitted defeat and began formulating a non-missionary method, taking account of the power of the sexual drive, for redeeming man from his follies. For in his next play, *Man and Superman*, when the Shavian missionary Jack Tanner is held for ransom by brigands,[23] their leader does not convert, but becomes a very persuasive representative of the devil. And the woman of the piece embodies a strong sexual drive (the Shavian Life Force) that knocks all of Tanner's "talking" into a cocked hat and claims him for its own. Furthermore, in his next major conversion play, *Major Barbara*, the converted heroine marries her fellow convert Dolly Cusins rather than going off into the asexual isolation of such earlier new-fledged realists as Vivie Warren, Marchbanks, and Brassbound. The missionary figure, Andrew Undershaft, reflects Shaw's continuing uncertainties about Shavian conversions by ambiguously combining both saint and devil.

Although Shaw at the time of the 1935 *Simpleton* preface could still

view himself as analogous to Livingstone, the success he grants Lady
Cicely in such a role almost forty years earlier nevertheless seems a
desperate compensation for fears he suppressed then but voiced often
in the late plays and prefaces, when they had been confirmed, that as a
missionary GBS himself would make no greater number of genuine
converts to Shavianism than had Leslie Rankin to Christianity.

Notes

1. Ina Rae Hark is Associate Professor of English at the University of South Carolina.
2. I interpret *The Devil's Disciple* as having two destroyers of ideals, the pragmatic
Burgoyne and the realist Dick Dudgeon.
3. See, for example, Raymond Nelson, "The Quest for Justice in *Captain Brassbound's
Conversion*," *Iowa English Bulletin Yearbook*, 21 (Fall 1971), 3–9, and Margery Morgan, *The
Shavian Playground* (London: Methuen, 1972). Both consider the Christian references as
Shaw's indication of a divine mercy that the so-called justice of men opposes. Anthony
Abbott in his *Shaw and Christianity* (New York: Seabury, 1965), fails to consider the play at
all. Martin Meisel anticipates my approach very briefly in *Shaw and the Nineteenth- Century
Theater* (Princeton: Princeton University Press, 1963), p. 214.
4. Bernard Shaw, *Complete Plays with Prefaces* (New York: Dodd, Mead, 1963), I, 603.
All references to *Captain Brassbound* are to this edition and will subsequently be indicated
in the text.
5. *Ellen Terry and Bernard Shaw: A Correspondence*, ed. Christopher St. John (New
York: Putnam's, 1932), p. 248.
6. For a complete examination of Mary Kingsley as a source for Lady Cicely's char-
acter, see Stanley Weintraub, "Shaw's Lady Cicely and Mary Kingsley," in *Fabian Feminist:
Bernard Shaw and Woman*, ed. Rodelle Weintraub (University Park: Pennsylvania State
University Press, 1977), pp. 185–92.
7. Scotsmen in general were very prominent in British missionary work in Africa.
Charles Frederick MacKenzie, an Anglican Scot, was the first Bishop of Central Africa
and, like Livingstone, died while carrying out his mission. Cunninghame Graham was
also Scottish.
8. *MacKenzie's Grave* (London: Hodder and Stoughton, 1959), p. 23.
9. Ibid., p. 14.
10. *Complete Plays*, VI, 526.
11. John E. Flint, "Introduction," in Mary Kingsley, *Travels in West Africa*, 3rd ed.
(London: Frank Cass, 1965), p. xvii.
12. In a typical passage Mary Kingsley remarks: "So to missionary literature I address
myself with great ardour; alas! only to find that these good people wrote their reports
not to tell you how the country they resided in was, but how it was getting on towards
being what it ought to be, and how necessary it was that their readers should subscribe
more freely, and not get any foolishness into their heads about obtaining an inadequate
supply of souls for their money" (ibid., p. 3).
13. Drinkwater's protestation of being wrongfully acquitted by Sir Howard comically

epitomizes this principle; most of Cicely's evaluations of events in the play result in what society would consider wrongful acquittals.

14. The complete exchange goes as follows:

SIR HOWARD. You are mad. Do you suppose this man [Sidi] will treat you as a European gentleman would?

LADY CICELY. No: he'll treat me like one of Nature's gentlemen: look at his perfectly splendid face. [p. 655]

15. Rodelle Weintraub, in her introduction to the manuscript of *Captain Brassbound's Conversion* in that volume of *Bernard Shaw—Early Texts: Play Manuscripts in Facsimile* (New York: Garland, 1981), observes that Shaw intended to identify Brassbound as *Clement Hallam* but scratched the ironic name out.

16. *Shaw's Moral Vision: The Self and Salvation* (Ithaca: Cornell University Press, 1976), p. 283.

17. Shaw defined the Superman in *The Perfect Wagnerite* as "a perfectly naive hero upsetting religion, law and order in all directions, and establishing in their place the unfettered action of Humanity doing exactly what it likes, and producing order instead of confusion thereby because it likes to do what is necessary for the good of the race."

18. See Charles Carpenter, *Bernard Shaw & the Art of Destroying Ideals* (Madison: University of Wisconsin Press, 1969), for an extended comparison of Caesar and Lady Cicely. Stanley Weintraub parallels Cicely's selflessness to that of Caesar and Dick Dudgeon: "Shaw's Lady Cicely and Mary Kingsley," p. 189.

19. J. B. Priestley in *Literature and Western Man* (New York: Harper, 1960), p. 349, points out that "when we see *Captain Brassbound's Conversion* now, and watch a cool and smiling Lady Cicely settling everything in that corner of Morocco, we wonder why it never occurs to her or anybody else there that charming ladies like her in similar places have been raped and then had their throats cut." To be fair to Shaw, Mary Kingsley had duplicated some of Cicely's adventures and come through them unscathed.

20. Morgan, p. 59.

21. Shaw tells Miss Terry in the letter: "I try to shew you fearing nobody and managing them all as Daniel managed the lions, not by cunning—above all, not by even a momentary appeal to Cleopatra's stand-by, their passions—but by simple moral superiority," *Shaw/Terry Correspondence*, p. 248.

22. Bluntschli and Raina in *Arms and the Man* are an exception to this pattern in the early plays. Shaw frequently had difficulty with actors implying romantic relationships through gestures and expressions that ran counter to the lines. The problem was especially acute in *The Devil's Disciple* and later in *Pygmalion*.

23. Morgan notes the similarities of Brassbound's men to Mendoza's brigands: *Shavian Playground*, p. 56.

SHAW AS PROPHET

Charles A. Berst

"SOME NECESSARY REPAIRS TO RELIGION": RESURRECTING AN EARLY SHAVIAN "SERMON"

Introduction

On August 12, 1892 Shaw wrote to Sidney Webb: "I have preached an open air sermon & an indoors one—the former in heavy rain—at the Labor Church, Manchester."[1] This may be the first record of a Shavian "sermon." Its contents vanished in the Midlands deluge, but no doubt it conveyed more socialism than theology, however much Shaw would sometimes mix the two. In the next fourteen years he frequently engaged religion in one form or other in his plays and essays, but not until 1906 did he vigorously espouse spiritual views from the speaker's platform. When he did he created a sensation. On October 20, 1906 he again preached in Manchester, this time to the Ancoats Brotherhood. He repeated that speech the next day to the Birmingham and Midland Institute, and on November 22 delivered it in London at the City Temple. His subject: "The Religion of the British Empire."[2]

Responding to Shaw's presumptuousness, Bishop James E. C. Welldon, Dean of Manchester, fumed, "We don't want men of letters coming down to tell us the Commandments are of no use. (Applause.) . . . Let that man of letters go home and learn the rudiments of morals and religion, and let him never come to Manchester again": Satan, get thee hence! Many laymen were equally incensed. A few months later Shaw wryly poked fun at their ire by citing a speech given by a Member of Parliament from Yorkshire, an unfortunate who had been urged to defend religion against him: "His address . . . was a striking proof of the need for mine. He pleaded, in effect, that we must not hit religion when it is down. The Bible, he said, is venerable because, although

nobody believes it now, it has old associations which no man of taste wishes to disturb. In short, religion is a sore subject; and every man who considers himself a gentleman instinctively avoids it. . . . Although I cannot accept this very parliamentary view as a deeply devout one, I think it does very correctly express the feeling of the irreligious majority today." In light of this, G.B.S. etched his Shavian motives: "I am a Socialist because I have learnt from the history of Manchester & other places that freedom without law is impossible; and I have become a religious agitator because I have observed that men without religion have no courage."[3]

The religious agitator in G.B.S. had flared forth four years before in *Man and Superman*, but few recognized the fact. Shaw had expressly intended the play's third act to be "a revelation of the modern religion of evolution . . . a new Book of Genesis for the Bible of the Evolutionists."[4] However, in surrounding that act with lively comedy, "the effect was so vertiginous, apparently, that nobody noticed the new religion in the centre of the intellectual whirlpool" (*Plays*, V, 338). The religious impulses behind Keegan of *John Bull's Other Island* (1904) and *Major Barbara* (1905) were noticed even less. Newly fired with the conviction that Darwinism, materialism, and cowardice were incapacitating modern man, and that "men never really overcome fear until they imagine they are fighting to further a universal purpose—fighting for an idea, as they call it" (*Plays*, II, 657), Shaw was trying to forward *his* idea of a religion relevant to the twentieth century. To him the implications were portentous: "I knew that civilization needs a religion as a matter of life or death" (*Plays*, V, 337). But his plays were not doing the job. What was he to do? He must perforce be more direct, and as he had so long served socialism from the public platform he now transformed that platform into a pulpit on behalf of his burgeoning spiritual convictions. Hence a new role for the famous iconoclast: G.B.S. the irreverent Reverend.

The most convenient source of Shaw's religious lectures is Warren S. Smith's edition of *The Religious Speeches of Bernard Shaw* (University Park: Pennsylvania State University Press, 1963). This includes eleven lectures dating from 1906 to 1937. An important one available to Smith only in a brief report—"On Christian Economics" (1913)—was later given at length in Allen Chappelow's *Shaw—"The Chucker-Out"* (New York: AMS Press, 1971). The sources of Smith's texts are varied, including pamphlets, recordings, and journal accounts. Chappelow reproduces a full transcription made by a diligent socialist. While Shaw prepared carefully for his lectures, he seldom wrote them down.

Given the scattered locations of the original materials, Shavians are much indebted to Smith and Chappelow. However there is an unfortu-

nate omission from *The Religious Speeches*. On November 29, 1906, Shaw spoke before the Guild of St. Matthew in Essex Hall on the topic "Some Necessary Repairs to Religion." This was Shaw's second religious lecture, and Smith regrets that he cannot print it, since no sufficient text survives. Apparently a major address, it was presented before a well-primed audience: it took place just one week after Shaw's London rendition of "The Religion of the British Empire," on the night following an extensive report of that speech in the *Christian Commonwealth*, and just a month after he had raised orthodox eyebrows in Manchester.

The time was propitious. "Some Necessary Repairs to Religion" promised to be a notable event, and those in attendance were not disappointed. Observing the audience's reaction, R. B. Suthers reported in the *Clarion:* "You can get a tooth drawn for five shillings, with gas, and judging from the torture suffered by a number of people present, I should think they would have preferred to have a tooth drawn, without gas, than to have their cherished religious convictions torn out by the author of *You Never Can Tell.* . . . One man literally squirmed in his seat. His facial muscles were twisted, his teeth ground together, his hands nervously gripped his coat. And yet he seemed to feel that the dentist was quite right. The tooth was a bad one. It must come out. . . . One dear old lady nodded her head in dissent for an hour. An old man sat and glared with an expression of gloom which gradually deepened into despair. A jovial young man tried to assume an air of smiling, good-natured contempt, but the smile went all awry at times. His tooth had begun to ache" (Smith, pp. xix–xx).

St. John Ervine happened to be one of the achers in Essex Hall. He recalls the occasion and the crowd: "I remember vividly the first time I heard him lecture. He had then almost reached the peak of his worldwide renown, and large audiences everywhere thronged to listen to him." Ervine's orthodoxy bristled at Shaw's belief that all conceptions are immaculate: surely this was a distinction accorded only to our Lord and Lady. "Nevertheless," he remarks, "I came out of the Essex Hall with my beliefs in disarray. As I walked along the Thames Embankment, I wondered whether I should ever be able to assemble my faith again. Such was his effect on audiences."[5]

The person who was most reviled for Shaw's speech was not the speaker but the meeting's chairman, the Rev. Stewart D. Headlam. A Christian Socialist clergyman, Fabian, and founder of the Guild of St. Matthew, Headlam was an old-time friend of Shaw's, the two having met at a meeting of the Land Reform Union in 1883. In 1892 Headlam had written the Fabian tract "Christian Socialism," in 1894 he was elected to the London School Board as a Fabian candidate, and he

served on the Fabian Executive Committee for many years. He achieved special notoriety in 1895 when he raised the bail money for Oscar Wilde; and he alone signed Shaw's petition for Wilde's release. In old age Shaw reminisced: "The dramatization of the religious character as such was child's play to me, as I was hand in glove with all the leading Christian Socialist parsons of the day, from Stopford Brooke on the extreme right to Stewart Headlam and Sarson on the left, whereas the fashionable playwrights did not know of the existence of such strange animals, nor would have understood them if they had."[6]

One such animal is the Rev. James Morell in *Candida*. Shaw conceived Morell as "a first-rate clergyman," and claimed that he was closest in character to Stopford Brooke.[7] However Headlam more directly haunts the play when early in Act I "*Morell bursts open the cover of a copy of The Church Reformer, which has come by post, and glances through Mr Stewart Headlam's leader and The Guild of St Matthew News*" (*Plays*, I, 520). The audience can hardly see the allusion, but the detail is a friendly nod and undergirds Morell's character. Late in Act II Morell telegraphs the Guild, canceling a speech he was to have given for them that evening. His curate is dismayed: "Theyve taken the large hall in Mare Street and spent a lot of money on posters." Morell reflects the Shaw of 1894: "These people forget that I am a man: they think I am a talking machine to be turned on for their pleasure every evening of my life" (*Plays*, I, 568). But the harried man changes his mind. Like G.B.S. such talking machines, programmed to Life Force ends, were compulsive. And Headlam and the Guild were worthy Life Force channels. Accordingly, Shaw comments in his preface: "To me the members of the Guild of St Matthew were no more 'High Church clergymen' . . . than I was to them 'an infidel.' There is only one religion, though there are a hundred versions of it. We all had the same thing to say" (*Plays*, I, 372–73).

Given the early date of "Some Necessary Repairs to Religion," the strong public response to it, Shaw's close association with Headlam, and the background light this association throws on one of his major plays, little wonder Warren Smith regrets that he cannot recover its text.

However all is not lost. What follows are two accounts of the speech. The first appeared in the London *Times* the next day. Although this is briefer than the *Christian Commonwealth* rendition of Shaw's first lecture, which Smith provides, the reporter here seems to have a sharper ear and a more precise pen. It is more spontaneous; there is a greater sense of Shavian presence. And although Smith cites *The Times* to the effect that this was "essentially the same" speech as Shaw's preceding one, its content appears to be quite different. Further, it forwards themes and examples Shaw was to expand upon later. Reflecting its newsworthiness, an abridged report immediately followed in *The New*

York Times—by "Special Cablegram" from London—under the title, "Why Not Personify God as a Woman?—Shaw."[8]

The second account is one which Stewart Headlam published as a Guild of St. Matthew pamphlet. Publicly pressed to apologize for chairing the blasphemous occasion, Headlam had defended himself and Shaw at a special Guild meeting in Clifford's Inn Hall. Afterwards he composed this pamphlet for a wider audience. It is important not only as a supplement of *The Times* report, but for its broader focus: it observes the historical and social context of the occasion, provides a sensitive Christian Socialist and Anglo-Catholic gloss on the speech, and quotes a number of responses, revealing the shockwaves Shaw sent among the orthodox. The gloss is particularly telling. Headlam makes an eloquent plea for Shaw's principal aim: the *revitalization* of religion through dropping its obsolete nonsense in favor of enlightened spiritual ends. His stance is a synthesis combining modern thought from a Christian Socialist viewpoint and traditional theology from his position as an Anglo-Catholic. At the same time his demurs reflect the difference between Shaw and the Christian Socialists: Shaw was a socialist with a personal religion; they were churchmen with socialistic sensibilities. But one may also sense that the balance in Shaw was shifting from socialism informed by a personal religion toward a personal religion informed by socialism.

Notable in Headlam's account is his repeated claim that the attacks on this speech were made by people who had not heard it. Those who were there were for the most part not only shaken but moved. A doctor recalled the power of Shaw's lecture "On Christian Economics" seven years later: "I thought it was the best, noblest, and most powerful, yet clearest and simplest, sermon ever given anywhere—with the exception of the one on the Mount" (Chappelow, p. 161). "Some Necessary Repairs to Religion" hardly gives signs of such heights, but G.B.S. as a religious agitator was on his way.

London *Times*, November 30, 1906

In connexion with the Guild of St. Matthew, Mr. G. Bernard Shaw gave a lecture in Essex-hall last night on "Some Necessary Repairs to Religion." The Rev. S. D. Headlam presided.

Mr. Shaw said that we had a great deal of very pressing social problems to solve but lacked religion, which would impel us to tackle them. Socialism as presented by those able middle-class Jews, Marx and Lassalle, was a demonstration that working men were being robbed of 50 per cent. of the proceeds of their labour, but it was found that people would not make a revolution for 50 per cent. Men were always cow-

ards. If they were not afraid they would constantly be getting run
over. The more intelligent and sensitive a man was, the more cowardly
he was. Women, having less experience and reflection, had more cour-
age. A man's wife had a constant tendency to involve him in risky
emergencies. (Laughter.) If the great congregation of cowards called
the human race were to be got to disregard their own safety and inter-
est, they must be made religious. A religious man was not one who
belonged to the Church of England or who did not, and the enthusi-
asm with which men did not belong to that Church seemed much
greater than that of men who did. (Laughter.) Nor was he a man with a
special creed. A religious man was one who had a sure knowledge that
he was here not to fulfil some narrow purpose but as the instrument of
the force which had created the world and probably the universe. Reli-
gion made a man courageous, and, if he was not also intelligent, made
him also extremely dangerous. A curious fact was that, in the absence
of religion, the coarse man had most courage; but, with religion, the
most fragile and sensitive became enormously courageous. Till we
could get rid of the Bible, in the sense in which we had spoken of it for
300 years, religion in this country would be impossible. Another obsta-
cle was Darwin's "Origin of Species," in which evolution, its great reli-
gious and philosophic side being ignored, became a materialistic and
soul destroying conception of the universe. There was no established
religion on the earth to-day in which an intelligent and educated man
could believe. No such man could belong to the Church of England
without very considerable reservations. The great body of legend which
every religion accreted round itself might be true as Hamlet was true,
but to tell children that the stories of Jonah and Noah's Ark were
literally true was a lie; to say they were a religious truth was an abomin-
able lie; and to say their salvation depended on belief in it was a damn-
able lie. Yet in the disputes on the Education Bill all that people ap-
peared to agree on was that children should be taught this particular
lie. It was important, even politically, that all men should believe the
same truth. Till they did we should never be a real empire. Many
people who said they believed in God did so because they thought that
otherwise He would probably strike them dead. That was abominable
idolatry, yet in schools religion was taught very much in this way. Jeho-
vah of the earlier parts of the Bible was an abominable idol who was
pleased to have Jephthah's daughter sacrificed to him, and who sent
bears out of a wood to eat up little children. The result was that the
masses became so irreligious that people did not dare to teach them
genuine religion, for they would not believe it—just as they insisted on
having rooms disinfected with sulphur, though sulphur was not a disin-
fectant. Coming to the New Testament, we found something very new

and startling—a man who spoke of himself as God, and who, when he did, always caused a riot, because the people could not stand such a stupendously religious idea. The end of the Gospel story, the popular and bloody part, spoiled the beginning. If Christ had died in a country house worth five thousand a year, everything He said would be just as true as if He had been crucified. The main truth that required to be taught was the powerlessness of God. If we conceived God as a moral force we must admit that apart from us He was powerless. Millions revolted against religion when confronted with the question, "If God is powerful, why is the world such a horrible place?" It was no use saying that God could not be understood. The man in the dock would not be excused because he said he had some higher purpose that others could not understand. The only way in which God could work was through ourselves. He had no hands or brains but ours. He was nothing but a will. We could not think of God as eternal if in our minds He was an elderly gentleman rather nicely dressed, as painted by Michael Angelo. If we wanted to personify Him, why not personify Him as a woman? The doctrine of the Immaculate Conception should be incorporated in all religions, because it reminded us of woman's place in the Godhead and made us realize that all conception was immaculate and not a sin. The will that drove the universe was driving every man more or less, even the most sordid stockbroker in London, and it was evidently driving at some sort of moral conception. Another thing to remember about God was that He made mistakes. Only after many trials He had produced man, who, though only a makeshift, was at his best a rather wonderful creature. If men realized that what God was driving at finally was perfect comprehension of his own purpose, there would be little difficulty in making them religious, observant, and intelligent. The one thing religion could give us was not comfort but courage and self-respect. No religion promising personal immortality really got over the fear of death. The idea that his [Shaw's] body would persist for ever was unpleasant to him, and what must it be for others? (Laughter.) He wanted the life which he represented to continue on the earth doing what was called the will of God. If he had startled them, he would ask them to believe that, though in many ways he was very unready and stupid, yet he had a faculty of analysis which the ordinary Englishman had not. People lumped in with their religion and philosophy and morals a number of other things which were merely associated ideas and customs. He never talked disrespectfully of religion, but his mission was to tell people of the rubbish that choked religion. Until the rubbish was got rid of there was no chance of getting a world in which anything worth talking about would ever be done. (Loud cheers.)

Replying to questions from Mr. G. K. CHESTERTON, Mr. SHAW said he knew of seven or eight doctrines of original sin and entirely disagreed with most of them. Nor did he believe in the Devil, though there was a great deal to thwart the will of God. Being asked whether Socialism as such was going to do anything, he said that Socialism merely aimed at rearranging society's way of doing its business. When that was done, as it might be in 100 years or so, mankind should go on with its main work, the realization of God. One questioner asked whether the minds that had done most to repair religion in the past had not been chiefly synthetical rather than analytical. Mr. Shaw replied that, if a synthetical man was not also keenly analytical, there was no saying what harm he would do. The main thing that Christ, Mahomet, Luther, and others referred to had done [,] was to reject rubbish and point out that much that had been thought part of religion was not religion at all. As to the Crucifixion, it was a terrible adulteration of religion to make a public execution its central fact; but another horrible thing was that Christ should be represented, as He was in pictures, as the perfect gentleman. To another question Mr. Shaw replied that the idea of the virtue of self-sacrifice was a commonplace of irreligious people. What they called self-sacrifice was really self-construction. He was not an ascetic but a voluptuary. The spectacle of the Cross and Passion appealed to a savage instinct. Asked to explain his views on immortality, he said he believed his life force would not be destroyed, but would be organized in cleverer people after him. (Laughter.) He did not believe in the continuance of individual consciousness. He regarded the Gospel story as largely fiction, but fiction was more valuable than fact, all the essentials of which it collected. The fourth Gospel was a much finer work of art and a more religious Gospel than the others. As to the Resurrection, he did not believe it ever happened.

At the end of a long "heckling" a hearty vote of thanks was accorded to the lecturer.

Occasional Paper of the Guild of St. Matthew
January, 1907

A MUCH ABUSED LECTURE

A STATEMENT BY THE REV. STEWART D. HEADLAM
WITH REFERENCE TO MR. G. BERNARD SHAW'S LECTURE
ON "SOME NECESSARY REPAIRS TO RELIGION"

IT may be well first of all to explain how it was that Mr. Shaw came to lecture for us.

I had the good fortune to preside at a meeting of the Fabian Society in March last, when Mr. Shaw, lecturing on Darwin, made a vigorous attack on neo-Darwinian materialism and incidentally said how much truer the teaching of the "Benedicite" was than the teaching of the materialists. He hinted in this lecture that he was much taken up with the whole question of Religion, as indeed I knew from other sources. I felt at once that it would be a matter of great interest to the Guild if we could get him to come to us and rehearse the Articles of his Belief. He was a Socialist, as we are, and he did not seem to agree with those Socialists who hold that you must destroy Religion in order to accomplish Socialism.

I knew also—and if I had not known this, I should never have asked for the Lecture—but I knew from a twenty-five years' experience that Mr. Shaw was really in dead earnest about life; that notions to the contrary are the result of a foolish public asking its Press to give them perpetually funny, sensational, paradoxical paragraphs—which a certain impishness in Mr. Shaw's nature made it very easy for them to do in his case. Mr. Shaw most kindly consented to lecture for us, and when I heard the title of the lecture "Some necessary repairs to Religion"—I thought of F. D. Maurice's sentence "Religion against God, that is the great heresy of our age," and remembering how we, in our Guild, have for thirty years been engaged in endeavouring to emancipate people from false notions about Religion, I was all the more anxious to hear what Mr. Shaw had to say.

Well, Mr. Shaw gave his Lecture; various questions were replied to by him, and we thanked him for it. The next day several reports of the lecture appeared—the fullest being about three-quarters of a column in the *Times;* an excellent summary, but of course a quite inadequate account.

It is on these reports that a series of most virulent attacks have been made on me, on the Guild, and in a lesser degree on Mr. Shaw; but it is important to note that no such attacks have been made by anyone who heard the lecture itself.

As is usual in these cases, the Bishop of London was inundated with letters of protest—there seems to be a lot of busybodies whose main occupation is to look after other people's morals and religion. The Bishop himself wrote and remonstrated with me. His letter is private but I do not think I wrong him, I do not think I minimise the strength of his remonstrance, when I say that in his first and subsequent letters he has been most kind to me.

The substance of my reply to the Bishop, and to others, was as follows:

WAVERTREE,
ST. MARGARET'S-ON-THAMES.
December 3rd, 1906.

"The Guild of St. Matthew is a Society of *Catholic* Socialists, and, there-fore, it goes without saying that we are opposed to anything which Mr. Shaw said which was contrary to the Catholic Faith.

"But I don't think you quite appreciate the facts of the case:—Here is a man, and a leader of men, who has been an atheist but who has been forced by the facts of life into a profound belief in God, who has broken away from the neo-Darwinian materialism; who has, at any rate, a great reverence for our Lord and His Blessed Mother, and goes so far as to lay emphasis on the importance of our Lord's claim to be God. Here is a man who really is athirst for God—who feels that the Socialism for which he has lived cannot be accomplished without religion; he comes to us to rehearse the articles of his belief—and to say what it is in the popular religion of the time which prevents him going further and becoming a pronounced Churchman. It was essential that he should be free to speak his mind, but, of course, he alone is responsible for what he said: we, in the Guild, had the responsibility of listening; we are interested in the growth of his faith, and we think that our faith is strengthened rather than damaged by hearing what may be said on the other side. It would have been impossible to attempt to deal with the lecture that evening, indeed, the questions were not over till 9:45. But probably the Guild will deal with the whole thing later on. In the mean-while, if you want a formal repudiation by me of anything in Mr. Shaw's lecture which was contrary to the Catholic Faith, I hereby make it.

"But I warn you that a large proportion of the lecture was a repudia-tion by Mr. Shaw of a lot of rubbish—and worse—which has been al-lowed to accumulate round the Catholic Faith, and which is seriously damaging our Holy Religion. Whoever carts away that rubbish is doing good service for the Church. For helping to do this, and for making a most valuable positive profession of faith, Mr. Shaw deserves our thanks, our encouragement, our prayers; on a few matters of tremendous im-portance he is still wrong; but his face is set in the right direction, and we may believe that the kindly Light will lead him on.

"As I am writing, permit me to say that as Warden to the G.S.M. for just on thirty years—especially during the last two years—I have found that men and women in earnest about life have broken away from the Church and the Christian Religion on account of the intolerable teach-ing they have received from the clergy, Sunday school teachers, day school teachers, both in Church schools and Board schools—this teach-ing is making atheists wholesale.

"STEWART D. HEADLAM."

Now I desire to say that, after considering and re-considering the whole matter, as I have indeed been forced to do during the last fort-

night, I make no kind of apology for my action or for the Guild's action: I think we have done just what according to our principles we were bound to do; and I again openly and advisedly thank Mr. Shaw for his Lecture, and I add my belief that the giving of it will result in the more confirmation of the Faith.

I know that the lecture gave pain—I daresay that what I say will give pain—but that can't be helped: you can't destroy the evil of 300 years of Protestant Bible worship without giving pain to the worshippers; when those who live in a Fool's Paradise have their Paradise invaded ruthlessly, as it was that Friday morning when the *Times,* for the first time in its history, let its readers understand just a little of what people are saying about Religion, when those who lead sheltered lives are suddenly forced to realise what thousands of their fellow citizens, whose lives are by no means sheltered, are thinking and saying about Religion, there must be pain caused—it is inevitable, but in the long run salutary.

Let me now deal with the Lecture and see how we stand with regard to it.

I. (1) First of all we note that Mr. Shaw spoke as a Socialist—as one who wants to see a co-operative brotherhood take the place of the present anarchic competition, as one who has the eminently Christian conception of the establishment of the Kingdom of Heaven upon Earth. That instantly makes him a better Christian than those who, however much they may say "Lord, Lord," are not taking pains to get the people properly clothed, fed and housed. It shews that at any rate there is in him the *"anima Naturaliter Christiana"*—the soul that is Christian without knowing it.

(2) In opposition to Karl Marx, who taught that in order to bring about Socialism you must overthrow Religion: and in opposition to those Socialists who say now that they want to have nothing to do with Religion one way or the other, Mr. Shaw maintained that it is only Religion which will supply a sufficient motive power for the accomplishment of Socialism—and incidentally attacked the "Materialistic and soul-destroying conception of the Universe" which has been associated with the name of Darwin.

(3) He made a solemn profession of faith in God—the Will which has created the world—and insisted that it is essential for us to believe that we are here for no narrow purpose but as an instrument of that Divine Will.

(4) He bore witness to the unique and startling character of the Gospel story, to the importance of Christ's teaching, above all, he laid emphasis on the fact that Christ claimed to be God, and that it was that claim which roused the anger of His enemies.

(5) He laid great stress on the importance of reverence for our Lady, shewing how essential it was that She should hold a prominent place in our Religion.

(6) He said that in the Gospels you had collected in an artistic fashion the essential facts about Christ; and that in his opinion the fourth Gospel was a finer work of art and a more intensely religious Gospel than the other three.

(7) But above all he insisted that in carrying out the divine Will which Jesus Christ believed was revealed in Him, we had to be co-operators with God, as St. Paul phrases it; that we have the tremendous responsibility of remembering that it is by means of *our* brains and *our* hands that God works. Teaching at once the well-known doctrines of the divine immanence, and of the self-limitation of God, he held that each of us must realise the fact that God is in him, that God cannot do without him; that He dwells in us and we in Him; and that this great religious belief would alone give us the courage and motive power to tackle the great social problems.

That is a short account of some of the positive teaching of the man whom the religious world and the religious press during the last fortnight has been denouncing as an atheist. Right well do we recall the fact that "atheist" was the name hurled by their enemies at the early followers of our Lord Jesus Christ.

II. But it was not only Mr. Shaw's positive teaching which was so valuable, and was so welcome and so surprising to many who did not know him intimately; he gave us also some negative teaching which was equally important and equally welcome.

(1) The monstrous dogma of Chillingworth that the Bible and the Bible only is the Religion of Protestants has had a terribly blighting influence over English Religion for the last 300 years. Against this notion of the Bible as the infallible word of God, Mr. Shaw made his protest—a strong protest though not of course stronger than what we in the Guild of St. Matthew have made any time for the last thirty years.

I solemnly endorse Mr. Shaw's words so wisely sent by the *Times* into the sheltered homes of the upper and middle class. "The great body of legend which every Religion accreted round itself might be true as "Hamlet" was true, but to tell children that the stories of Jonah and Noah's Ark were literally true was a lie; to say that they were a religious truth was an abominable lie, and to say that the children's salvation depended on believing them was a damnable lie." And I say further that it is my experience as a Guild lecturer which convinces me that such and similar teaching about legends and stories in the Bible is one of the main causes of the revolt against the Church: that this kind of

rubbish must be swept up and carted away before that great return to the Church, for which in our Guild we are longing and working, can be accomplished.

(2) Further, Mr. Shaw made a valuable protest against the assumption that because people in the earlier stages of Jewish religious life attributed to Jehovah all sorts of cruelties and follies—that therefore those cruelties and follies were not to be condemned: quoting the terrible story of Jephthah's daughter and the story of Elisha and the bears. Of course all this is a commonplace to you who are members of our Guild and who know that you must not call the Bible the word of God, but that it is an inspiring literature, shewing how the idea of God was gradually unveiled to men until the perfect Word of God was revealed, full of beauty and full of truth. But there is a danger lest we too in the Guild should be living in a Fool's Paradise, and because we have been delivered from condoning cruelties and follies (which believers in the dictation by God to men of each sentence in the Bible are committed to)—there is a danger lest we should forget how many there are still thus tied and bound. Now it is this Bible worshipping which is the main cause of Atheism; it is a confusing of these things with the Catholic Faith which has caused the revolt from the Church; and negative criticism like that of Mr. Shaw's is needful in order to make it possible for a whole mass of intelligent men and women to be kept from revolting, or, having revolted, to be brought back to the delights of Christian worship and fellowship.

But I can quite understand that to people who have not an intelligent appreciation of that great Library which we call the Bible, to people who believe that every sentence in it is inspired, to people who confuse legends and stories with historical facts, this destructive teaching of Mr. Shaw's must be very painful. One only wonders where they have lived not to have heard it long ago.

So far then we thank Mr. Shaw both for what he has built up and for what he has pulled down.

III. I now come to some statements which, as reported, gave (owing to the way in which they were put) unnecessary pain; this is due largely to the fact that, as reported, they are condensed and given apart from the context, and, what is more important, apart from the lecturer's personality.

Now, though, as you know, I quite admit that we shall have ruthlessly, and regardless of the pain we inflict, to cut down the worthless stuff which hinders the growth of the Catholic Faith, and leave it to be burnt up in unquenchable fire, yet I maintain that just on that account one ought to be careful not to hurt people when there is no need to hurt them; and Mr. Shaw sometimes forgets this. For instance:—It is

quite true that God is love, and that in the face of false religions, Calvinism and others, it is necessary to assert this—but to talk about "our old friend God" gives unnecessary pain to those to whom a mode of expression is more important than the fact expressed. Again, the portraits of God the Father, and of Christ, in the art of Christendom may be ridiculed without the slightest ridicule being cast upon God or on our Lord Himself, and with the view of making the real personality of God as the Eternal Will, and of Christ as the perfect man, more true to us; but I think I could have found ways of putting this better than those which were adopted by our Lecturer. These and a few other sentences which have shocked some people are really very small matters: they are not of course blasphemous at all—but for the sake of the weak people who have to be dealt with very severely on matters which are really important it would have been well if the statements of these truths could have been phrased differently.

But on this question of blasphemy of which Mr. Shaw has been freely accused, and for condoning which I have been freely denounced, I want to say a few serious words.

In the first place I would remind you that the real terrible blasphemer is not the man who speaks against God or Christ—but the man or the woman who says the "Our Father" morning and evening and takes no pains during the day to realise the human brotherhood; or who goes to the Holy Communion week by week or month by month, and in industrial or social life acts as if competition and not fellowship was the human law.

And in the second place I would remind you of the teaching of Christ Himself—who, by the way, was constantly charged with blasphemy. Here is what He said very plainly: "Every sin and blasphemy shall be forgiven unto men but the blasphemy against the Spirit shall not be forgiven. And whosoever shall speak a word against the Son of Man it shall be forgiven him, but whosoever shall speak a word against the Holy Spirit it shall not be forgiven him, neither in this age nor in that which is to come."

I commend these words to the Religious Press of this country, and to those who have written me letters. Even if Mr. Shaw had in my presence said a word against the Son of Man, which I solemnly declare he did not do, his sin would have been as nothing compared with the sin of those who deny that it is the Holy Ghost who has been leading him from materialistic atheism into a belief in God; of those who speak with contempt and contumely and insult of a man who has devoted his life under the guidance of the Holy Ghost to help bring about a Kingdom of Heaven upon earth, and who at last has been led to acknowledge openly that he is conscious that it is God who guides him.

IV. I now come to those statements in Mr. Shaw's lecture which in my judgment are frankly heretical, which are contrary to the Catholic Faith—and which at the Bishop's request, for the sake of those who did not know that I was a Catholic, I have repudiated: as I would willingly, if I had the chance, repudiate much that I have heard in sermons or read in Church papers. When I heartily thanked Mr. Shaw for his lecture I thanked him for making these heretical statements as well as for the others: for nothing can be better than that these things should be stated plainly and frankly by men who are serious and in earnest about life: it does the Church good to know what such men think, especially does it do good to those Churchmen who live sheltered lives in a Fool's Paradise to know what these men think: it cannot in the slightest degree shake their faith if their faith is built on a sure foundation; if it is not the more it makes them seek for that foundation the better.

(1) Let me now give you the statement in which in my opinion Mr. Shaw contradicts the Catholic Faith: he says:—"The end of the Gospel story, the popular and bloody part, spoils the beginning. If Christ had died in a country house worth five thousand a year, everything He had said would have been just as true as if He had been crucified: as to the Crucifixion, it was a terrible adulteration of religion to make a public execution its central fact. The spectacle of the Cross and Passion appealed to a savage instinct."

Now as I am making this the main cause of my contention with Mr. Shaw, let me acknowledge, in the first place, all that is good in these statements. It is certainly the case that the truth of Christ's teaching did not depend on His Crucifixion. His teaching would have been equally true if He had never been crucified. It is also true, and of the utmost importance that it should be understood, that the popular Protestant notion that Christ by means of His blood shed, bribed an angry Father to let off the people who afterwards should believe in Him from the punishment due to their sins—that He died instead of them—is horrible. It is putting the figment of substitution in the place of the Catholic doctrine of atonement: it is also true that some of the figures of the Passion, to be seen in churches, especially in Italy—are repulsive and probably harmful: and that the teaching of some preachers and of some hymn writers who dwell, or used to dwell, on these physical horrors may do more harm than good. I grant all this—but I still say that on this matter Mr. Shaw is distinctly and dangerously wrong. Where Mr. Shaw is wrong, where he is heretical, where he is contrary to the Catholic Faith, is that he does not see that it was by Christ's apparent failure, that it was by His self-sacrifice, that He is enabled to conquer the world. It is quite true that the Crucifixion is not, as Mr.

Shaw supposes, the central fact of our Religion. In our one great unique act of worship, it is not the Crucifixion which is made the most of, it is the Incarnation: the words at which we solemnly kneel are these: "And was conceived by the Holy Ghost of the Virgin Mary, *and was made man,*" the taking of the manhood into God: the divine immanence: the sacredness of humanity—that is the central thing. But the fact of the Crucifixion, the idea of the blood shed, which simply means the life given up, if not central, is at any rate of great importance, it is an essential part of our Belief. Men have revolted against the misrepresentations attached to the Crucifixion which I have suggested to you are dangerous: but I believe that the common human instinct is attracted by the Cross itself. And that is where, in my opinion, Mr. Shaw is wrong: to him self-sacrifice, conquest through suffering, the need to risk apparent failure for the sake of the truth, the immense power of humility,—to him all these things do not seem to appeal: at any rate they are not yet parts of his philosophy, they are not yet parts of his verbal equipment, though probably, if he will look back far enough, they are indeed parts of his life.

I would put it in this way. Supposing that next Spring there was some great attack by the forces of the combined monopolists on Socialism; supposing that Mr. Shaw had to choose between renouncing Socialism and dying a violent death, which would Mr. Shaw choose—the coward's renunciation or the bloody death. I have no doubt that though he is in the heyday of his dramatic popularity, that he would choose the death, and I have no doubt that death under such conditions would enormously increase the influence of his life and work.

Now surely if this be true of one man it must be true of the Son of Man, of the Head and representative of the whole human race. And, therefore, I submit to Mr. Shaw that he is wrong in depreciating Christ's Crucifixion; that the orthodox belief on this matter is more truly human than his little heresy. And I should not wonder that when he comes to reconsider it he will feel that notwithstanding all his verbal denials he really does believe in self-sacrifice, which is none the less self-sacrifice because he calls it self-concentration, because he believes that it will lead to a final triumph: Christ had the conviction that He would win eventually, but none the less it was a real human defeat which he had to undergo: he accepted the defeat and has conquered in consequence. This is the divine paradox which ought to appeal to Mr. Shaw.

Anyhow, as a matter of fact, Christ did not die in a country house but was crucified under Pontius Pilate; that, I think, is history; and Mr. Shaw with all his splendid powers would be the better if he would humble himself to feel that, history or no history, the best men conquer

through suffering, and that there are worse things than physical pain or even the shedding of blood: that, indeed without shedding of blood there is no remission, and that the only way to avoid a blood Revolution for the establishment of Socialism is to recognise that the blood shedding of Christ compels to a common brotherhood. That the Cross is the symbol of the final victory of crushed humanity. However, I think Mr. Shaw has the right to be told that in the one great document on the Catholic Faith there is a good deal about the Incarnation, and nothing by name or detail about the Crucifixion—only the simple statement that Christ "suffered for our salvation"—if he can bring himself simply to believe that, it will be well with him.

(2) Ah! but he says he does not believe the further statement that "Jesus Christ rose again from the dead." He did not say this as part of his lecture, but in reply to a question as whether he "believed in the Resurrection," and he had not the wisdom to ask his questioner what he meant by the Resurrection. In his speech he made it pretty clear that he looked forward to some kind of Resurrection, not indeed to the resuscitation of the skin and bones and gases and so on, which now form his body, but of himself: but on this he was not clear as to details: as indeed which of us can be clear as to details?

There may be great differences of opinion with reference to the details reported about Christ's Resurrection: indeed the reports vary; but to say blankly and baldly I do not believe that the Resurrection happened seems to deny that Christ is the living power in the world now, and is of course heretical. I expect that when we know a little more about the power of Will over Matter, most of the reported details will seem reasonable—but they will only seem reasonable to those who know otherwise and entirely apart from these details what kind of a person Christ was.

But I would venture to say to those who have written to me, and to those who, terrorstruck, have written in the Church newspapers, that these great verities of the Crucifixion and the Resurrection do not depend for their truth upon Mr. Shaw's belief that they happened, and that we of the Christian Church who do believe that they happened, and who long to get the two-thirds of our fellow citizens who have ceased to express publicly their belief that they happened, to come back to us, would do well to remember the lesson from this St. Thomas' Day. This is how it is summed up: "that doubts about Christ's Resurrection are valuable, and that the way to get the full value out of them is to be loyal to Christ Himself." The mere otiose consent to the fact of a miraculous resurrection would be worth nothing—but a living loyalty to Christ Himself would save the world. It is the person rather than the event in whom you believe.

I am therefore especially glad that our Guild has seen fit to re-issue, this very month, the Lecture I gave more than thirty years ago on the Secular Work of Jesus Christ, for whenever Religion begins again from time to time to be made much of, as it is now beginning again to be made much of, there is always a danger of its being side-tracked on to considerations of what is to happen after death to the ignoring of life in this world. I am glad therefore to be again reminding you that our Lord said very little indeed about life after death, but a great deal about the Kingdom of Heaven to be established on Earth; a great deal about the Eternal or Divine life to be lived here.

I have now indicated to you where, in my judgment, Mr. Shaw's lecture was profoundly right both in its confession of faith and in its attack on evils which are choking the faith. I have suggested to you that one or two sentences which when reported gave offence, contained in themselves important truths, though they might have been differently phrased. I have told you where, so far as I understand his words, Mr. Shaw is wrong.

[V.] And now I ask you just to face the language which has been used by writers in the Religious Press, and by others.

The *Church Times* speaks of the lecture as: "A blend of smartness, bad taste and profanity," the whole thing "ought to have filled a Christian audience with absolute loathing," whereas we in the Guild offer a platform to anyone who is smart enough to amuse our members.

A Diocesan Inspector of Schools wrote in the *Guardian:* "Anything more outrageously blasphemous from a Christian point of view I have never seen recorded as a public utterance. I defile my pen by writing words which have roused my indignation to a degree almost beyond expression. But," he adds, "Mr. Shaw does not matter. The Rev. Stewart Headlam holds a license from the Bishop of London. . . . Is that license to be continued or revoked: is our Church to be a cesspool into which may drain any and all false doctrines, heresy and schism, so long as the holder of them is broad-minded and popular, and works for the amelioration of social conditions? It is a matter of vital concern to the Church that she repudiates the act of Mr. Headlam and his friends in passing a vote of thanks without protest: if nothing is done, I shall not be the only one who will seriously consider the possibility of continuing in communion with a body which officially condones such blasphemy."

The *Guardian* says: "Whether Mr. Headlam agrees with Mr. Shaw's opinions about the Christian religion we do not know, and we do not much care; but every Churchman will take it for granted that the clergyman who can sit still while the most sacred truths of religion are ridiculed will be dealt with immediately by the Bishop whose license he holds. It was Mr. Headlam's obvious duty either to vacate the chair or

to refuse to permit Mr. Shaw to continue his odious talk. We would allow atheists complete liberty to make themselves heard at proper times and in proper places, and if they choose, to disgust decent people with their mountebank witticisms. But in this case an audience of members of a Christian sodality was placed in the painful position of hearing the foundation truths of religion derided, while their Chairman, who presided as representing that sodality, raised no effective protest . . . The Guild of St. Matthew will do well in the future to be a good deal less Socialistic and much more aggressively Christian."

A lady writes to me from the office of a well-known Church Society: "The lecture breathes defiance of God and denies the most sacred doctrines of our Religion. You I consider the worst blasphemer of the two. On the private unbeliefs of Mr. Shaw it would be impertinent to comment. But when the 'fool' is not content with saying in his heart there is no God, but comes forward with insults and ribald foulness on that tongue which Evil spirits are controlling, and hurls out malign words to Christians, striving to induce them to forsake their hold on their Heavenly Father, then I say it is time to call on you, the Chairman, either to express your deep contrition, and submit yourself to the Penance your Father in God will doubtless require of you, or to quit that army you have betrayed into the enemies' hands."

All these whirling words and many more to the same effect are from people who did not hear the lecture. I have had no word of protest from anyone who did hear it, but I have a letter, not intended for me, from one whose name I do not know, which I think is worth quoting. "Last night's was one of the most helpful and most ennobling lectures I have ever listened to. The more I hear Shaw the more I admire him, but not as the general public, for his brilliancy and wit, but for the magnificent work he is doing in trying to improve the whole of mankind, and in giving man confidence in his own powers to bring about a better state of things."

[VI.] Now how are we to account for the fact that those who heard the lecture valued it and those who did not hear it denounced it? (1) Well, partly I think by facing the fact seriously that a great deal of what we in the Guild and Mr. Shaw know to be rubbish choking the Catholic Faith is still taught by a good many clergy and probably by the majority of Sunday school teachers; it is not taught by any of the authorized documents of the Church; probably many of the clergy do not themselves believe in it—but as they have not definitely repudiated it—they are always so afraid of alienating a few pious souls that they have managed to alienate two-thirds of the population—the thing has gone on traditionally fostered by Sunday school teachers, Council school teachers, and Church school teachers.

To get rid of all this we must urge the clergy to speak out plainly, and we must try and get a wider circulation for our literature. I say without fear of contradiction that the religious life of thousands depends on this: that thousands are alienated from the Catholic Faith by having things mixed up with it which are no essential part of it—which are choking it.

(2) Then, further, it must be remembered that there are always zealots about who, forgetful of the claims of the divine charity, rejoice in iniquity, and take no pains to find out the truth. When they find a soul—and there are thousands of them—with the sacred fire of our holy Religion smouldering in it—they become full of righteous indignation because it is not already flaring to the full; they do not fan it, encourage it, make the best of it, no, they throw water upon it, trample upon it, and plume themselves that they are thereby striking a mighty stroke for God. These are the people who think that our Guild, after hearing Mr. Shaw's splendid confession of Faith, and valuable denunciation of what hinders Religion, should have risen in indignation against him because he did not in a trice recite the Athanasian Creed and owned up to two heresies.

But I see exactly what has happened. Men of ill-will have taken the reports—the very brief reports—of a long lecture, they have read into them every head-lined paragraph of every joke or paradox which Mr. Shaw has been reported to have made during the last few years, and so they have created for themselves a series of blasphemies and profanities on Mr. Shaw's part, and peals of laughter on our part: and then they have attacked him and us. This is the way in which the *Guardian*, the *Church Times*, the *Layman* laboriously investigated the truth of an accusation before they gave currency to it.

I hope that, notwithstanding all this—on account of all this—we in our Guild shall go on vigorously. I hope we may get a few more Churchmen to have the courage to join us. I hope there will, among others, be an honest study of our books and pamphlets. And I hope, quite apart from any direct influence our little Society can have, that the much-abused Lecture will help to lead many out of the bondage of materialism into a Religion which will give men confidence and courage to work for social welfare.

Mr. Shaw said in his lecture that though he did not believe in the Devil he knew that men could do a great deal to thwart the will of God. As he receives the press cuttings he will know how much people who presume to speak in the Christian name can do towards that thwarting. But I earnestly entreat him and his friends not to be misled by the Religious Press, to judge of the Church of England by it documents, not by its newspapers.

If this new return to Religion does not mean a great return to the Church, the responsibility will not rest with our Guild but with those who have so blindly attacked us.

Notes

1. *Bernard Shaw: Collected Letters 1874–1897*, ed. Dan H. Laurence (New York: Dodd, Mead, 1965), p. 360.

2. *Bernard Shaw: Collected Letters 1898–1910*, ed. Dan H. Laurence (New York: Dodd, Mead, 1972), p. 670.

3. Ibid., pp. 671–72.

4. *The Bodley Head Bernard Shaw: Collected Plays with Their Prefaces* (London: Max Reinhardt, 1970–74), II, 531–32. This edition will hereafter be cited in the introduction as *Plays*.

5. St. John Ervine, *Bernard Shaw: His Life, Work and Friends* (London: Constable, 1956), p. 96.

6. Hesketh Pearson: *George Bernard Shaw: His Life and Personality* (1942; rpt. New York: Atheneum, 1963), p. 190n.

7. *Evening Standard* (London), November 30, 1944. Cited by Louis Crompton, *Shaw the Dramatist* (Lincoln: University of Nebraska Press, 1969), p. 224.

8. Reprinted in *The Independent Shavian*, 10, No. 1 (Fall, 1971).

Israel Cohen

SUPERMAN AND JEW: MR. BERNARD SHAW AND HERR BRAININ—A NOTABLE CONVERSATION

[On 1 February 1909 the *Evening Standard* and *St. James's Gazette,* London, published an extended report of a meeting which had recently occurred between Bernard Shaw and Reuben Ben-Mordecai Brainin (1862–1939), a Hebrew and Yiddish author. Brainin, born in Byelorussia but a resident of Vienna since 1892, was a prolific contributor to every Hebrew periodical of his time and a champion of contemporary young Hebrew writers and poets. Shortly after his visit with Shaw he emigrated to America, where he eventually founded and edited two Hebrew journals and published the first volume of an uncompleted biography of Theodor Herzl. Israel Cohen (1879–1961), who served as interpreter at the meeting and provided the "verbatim" report of the interview, was born in Manchester. One of the pioneer Zionist journalists in Great Britain, he was a prolific author of books, pamphlets, and articles on Jewish affairs, anti-Semitism, and Zionism. He was for many years the English-language secretary of the Zionist Central Office in Cologne, and later, Berlin, and special correspondent for *The Times* and *Manchester Guardian.* His report of the Shaw-Brainin meeting has not previously been published in America.]

It would be hard to conceive of a more interesting meeting between men of letters of contrasted types than that which has taken place between Mr. Bernard Shaw and Herr Reuben Brainin. The one is an Irishman, whose unconventional plays for the English stage first won him fame on the Continent; the other is a Russian Jew, who roams among the Ghettos of Europe and indites his impressions and meditations in the language of the Bible. The one dreams of a new world of

Supermen; the other dreams of a new world in which a rejuvenated Judea will form the pinnacle of civilisation. Mr. Bernard Shaw is a passionate Irishman, whose sense of patriotism has evaporated in the misty visions of a new humanity; Herr Brainin is a passionate Jew, whose sense of patriotism has triumphed over the sufferings of exile and inspired him to advance a Jewish Renaissance and create a modern Hebrew literature. A restless spirit brought the wandering Jew to London, and he wished to meet the brilliant Irishman whose plays he had admired in a Berlin theatre. But he could not write to him in English, and he thought it useless to write in Hebrew. So I acted as intermediary, with immediate and happy results; and one afternoon the two met in Mr. Shaw's silent, lofty retreat in Adelphi-terrace. They greeted each other warmly, but could not understand one another's language. Herr Brainin condescended to speak German, as more nearly related to English than the tongue of Holy Writ; but Mr. Shaw frankly confessed that his command of German was useless, except for the barest needs of the traveller. So mine was the privilege of interpreting the thoughts and sayings of these two intellects to one another as they endeavoured to come into closer communion.

MR. SHAW. Are you a Zionist?

HERR BRAININ. Yes.

MR. SHAW. My friend Zangwill is also a Zionist, and has greatly interested me in the movement.

HERR BRAININ. Zangwill is not a Zionist, but a Territorialist—that is, one who doesn't look upon Palestine as the only possible home for the Jews, but who will be content with any land in any part of the world.

MR. SHAW. I don't know why the Jews should be looking for a land of their own. Their dispersion throughout Europe gives them so much power and influence. They get on wherever they settle, just like Irishmen, who languish in their own country, but flourish in every other.

HERR BRAININ. The movement for getting a land of our own is to enable us to live our own national life. Jews have wasted a great deal of energy in adapting themselves to their environment, and they have thus lost much of their individuality.

MR. SHAW. I haven't noticed any signs of Jews in England adapting themselves to their environment in recent years. When I was younger, this practice of adaptation, such as the changing of names, was very prevalent. But since the days of George Eliot a better attitude has been adopted towards the Jews, and artificial adaptation has ceased. As an Irishman, I find that one gets popular by pluming oneself on one's nationality.

HERR BRAININ. Are you aware of the Jewish Renaissance that is now developing, of the Jewish art and literature that have been created by the spirit of nationalism?

MR. SHAW. No, I cannot say that I am aware of this culture movement. Of course, I know that Jews play a big part in all revolutionary movements, and revolutionaries, as a rule, are fed on the Bible. That suggests something. I wonder whether the Jews have more influence in England than on the Continent owing to the superiority of the English translation of the Bible. The English translation, you know, is a work of art. But the foreign translations are bad, and are hardly read. I frequently use Scriptural expressions and quotations in my plays, and I find that my translators are often puzzled by them. So I refer them to their Bibles, and the puzzle is solved.

HERR BRAININ. The Bible is quite untranslatable. The genius of the Jew has manifested itself not in painting, or sculpture, or architecture, but in the word-painting of the Bible, and nothing of its true grace or poetic atmosphere can be reproduced in another tongue. I am willing to admit that the excellence of the English translation is due to the English love of the Bible. But surely this alone does not account for the position of the Jews in this country. What about historical forces, political conditions, social and psychological circumstances?

MR. SHAW. True, there is a variety of circumstances to be noted. And yet I should expect Jews to be most unpopular in England, not among Irishmen or Scotchmen, but among Englishmen. The reason is because of their intellectual consciousness. The Englishman doesn't like this intellectual consciousness, and is even afraid of it. He prefers not to know what he is doing, otherwise he might fear that he is doing wrong, and so do nothing at all. But he knows that the Jew can see through and beyond what he is doing, and he doesn't like it. The Englishman is content to muddle through. As Cromwell said, "No man goes so far as he who does not know how far he is going." Of course, muddling gets the Englishman into trouble. Antonio, in "The Merchant of Venice," was a typical Englishman in not knowing what the bond contained, and in getting angry when he afterwards found out. So far as business dealings are concerned, I have found Jews most satisfactory, and have never been deceived by them. But I can hardly say the same about Englishmen with whom I have had dealings. From this you can gather what my opinion is of the Jew. I should like to say that I was rather sorry that Dr. Nordau felt offended by my letter that appeared in a German paper last year.[1] I had not the least intention of saying anything offensive, but apparently on the Continent people live in such a sensitive atmosphere that to mention the word Jew is taken to be a slight. And yet I meant it as a compliment.

HERR BRAININ. I read the letter you allude to, and was sorry that my friend Nordau felt offended by it. But I agree with you that it contained nothing to which one could take objection. I should like to turn from these matters of Jewish interest to others of a more general interest. I feel that we are on the eve of great happenings, that we are on the threshold of a great change of ideas and feelings. Can you tell me how this new era pictures itself in your mind, and how dramatists can hasten its approach? What message have you to give at this pregnant moment?

MR. SHAW. I am not aware of any such movement or ferment as you seem to imagine, nor have I any message to give. All my goods are in the shop-window; I have kept nothing behind. I do not notice any new era coming, as I do not see a new race developing. Besides, progress is not made by leaps, but by gradual evolution. But it seems to me that the most urgent question of the hour is the solution of social problems arising from the vast aggregations of mankind in large cities. Modern humanity has neither the strength nor the character to solve these problems. That is why we need a new race, a race of supermen.

HERR BRAININ. By what means do you imagine this new race can be brought into being?

MR. SHAW. That question should be addressed to a god, not to a man. First of all we are not decided what kind of man we want. It is not enough that we should be decided upon not breeding madmen or drunkards. That does not bring us very far. And if you say we want good and virtuous men, I ask, "What is goodness, what is virtue?" Are we yet clear as to the meaning of these moral qualities? There can be no doubt that before new ideas can be possible we must get rid of a good many old ideas. For example, we must sweep away the Darwinian notions of fatalism and determinism which have been reigning for the last fifty years, declaring that everything is pre-ordained and depriving humanity of all will, purpose, and energy.

HERR BRAININ. I am quite agreed about the paralysing effect of those Darwinian doctrines, and as a Jew who is enthusiastic about the revival of his people and their national regeneration, I feel the necessity of destroying those ideas.

MR. SHAW. To help in the advance of the new era we must banish the idea of a terrible Almighty God, for the dissemination of which the Jews are largely responsible.

HERR BRAININ. But in the Old Testament you meet with constant references to a merciful God, and the Church conception of God as our Father was adopted from Judaism.

MR. SHAW. But Judaism does not regard God as weak and helpless: that is the conception which I would proclaim aloud. God is really

impotent, and cannot achieve anything alone. He works through the hands and brains of men, who have to destroy or repair what is evil. In His groping after a perfect world God has created the tiger, and man must kill it. He has created cancer, epilepsy, and typhoid microbes, and man must fight them. Thus it is only through man that the full power of God is brought to light, and only by a tremendous output of human effort can God become really God, when He will become embodied in man perfected.

HERR BRAININ. Is that the idea which you would seek to convey in your works?

MR. SHAW. I may not have given very full and clear expression to it as yet, though that is the idea which dominates the scene in Hell in "Man and Superman." But I am now at work on a play in which I shall give free expression to my religious ideas.[2] It is because of my desire for the coming of a new race that I am an adherent and advocate of Socialism, for the new era can be produced only by the principle of equality in society, and I believe that only Socialism can achieve this equality, this destruction of class distinctions. At present, in his desire to produce a better type, a man who wishes to marry may find his choice limited to four women, and he may hate all four. What I should like to see is complete equality of opportunity so that any man in England might choose any one of the twenty million women.

HERR BRAININ. Your vision of a new race is interesting, but I venture to think that the Jewish people approaches the ideal in your mind. Consider the struggles which it has endured and survived, how its weaklings have been lopped off, and how suffering has steeled it and made it stronger. In any case, it will interest you to know that Jews are among your most ardent admirers on the Continent, and they have done most to disseminate your ideas in Germany, Austria, and Russia. Fifteen years ago I wrote an essay on your dramas in a Hebrew newspaper.[3] When a play of yours is produced in a Berlin theatre, ninety per cent of the audience are Jews, and Maximilian Harden, the editor of "Die Zukunft," who is of Jewish birth, has called you the "second Heine."[4]

MR. SHAW. It is much the same here. Jews are generous supporters of the drama and of art in all its forms. They even determine the success of a woman on the stage. They prefer the Latin to the Teutonic type.

HERR BRAININ. I wonder whether you are acquainted with the view expressed by most German critics, that your plays are the products of pure intellect rather than poetic creations or the revelations of inner experience.

MR. SHAW. I know very well that many people say my plays are all brain without any heart. I cannot say whether it is so or not. But I

should like to ask: How is it possible for any writer of plays who deals with the foibles and emotions of humanity to write simply from his brain without any impulses from the heart? Is it conceivable? The fact is that people ascribe heart only to melodrama, where the passions shown are pretty strong; but as soon as they are made to think about a play they say it is all brain. For them there is only physical passion. They are ignorant of intellectual passion—of moral passion; and yet these are much higher than the other. I, at least, have found it so. As for the origin of my ideas, I feel that whatever I am driven to say is the result of inspiration. Others may comment upon them as they please.

Throughout the conversation, which lasted fully an hour and a half, both men paid diligent attention to my interpretation, and each studied the effect of his remarks upon the demeanour of the other a few minutes after he had completed his utterance. "It has been very interesting," said Mr. Bernard Shaw, in response to Herr Brainin's gratitude for the pleasant and exhilarating afternoon, "Come and see me when you are in London again." And as we made our way into the tumultuous Strand the Hebrew author was eloquent with praise over the amiability of the philosophic playwright.

Notes

1. [Shaw's "Wie Shaw den Nordau demolierte" (a translation of his "A Degenerate's View of Nordau," 1895, revised for London publication in 1908 as *The Sanity of Art*, appeared in *März* in October-November 1907. A letter from Max Nordau on 24 November in the *Frankfurter Zeitung* elicited a reply by Shaw in the same paper on 14 December. The full English text of this letter, as "An Open Reply to Dr. Max Nordau's Open Letter," appeared in the *New Age*, London, on 18 January 1908.]
 2. [*The Shewing-up of Blanco Posnet*, which Shaw began writing on 16 February 1909.]
 3. [This is either an exaggeration by Brainin or an error by Cohen. The essay could not have been written prior to the first publication and performance of Shaw's plays in Siegfried Trebitsch's German translations in 1903.]
 4. [Maximilian Harden (1861–1927), German journalist and polemicist, had edited *Die Zukunft* since its founding in 1892. Born Witkowski in Berlin, he converted to Christianity at 16, but in his later years took a strong interest in Jewish problems.]

PERSPECTIVES ON THE RELIGIOUS PLAYWRIGHT

Sidney P. Albert[1]

THE LORD'S PRAYER AND
MAJOR BARBARA

You pray with sincerity "Our blunderer which art not in heaven, blessed
be thy excellent intentions, hurry up with thy kingdom which is so long
coming, get thy job done on earth which will then be heaven. Give us
this day our daily vitality; and forgive us our trespasses as we forgive
yours, knowing that you mean well. Lead us into all sorts of temptations,
and never say die; for thine is the impulse and the gumption and the
glory, world without end, Amen."[2]

Much of Bernard Shaw's theology is epitomized in this irreverent par-
ody of the Lord's Prayer. Indeed, it is advanced during, and as part of,
an earnest explication of his religious views to his learned friend, Gil-
bert Murray. That Shaw would turn to this prayer as a vehicle for
expounding his own distinctive doctrines is not in the least surprising
in view of his penchant for appropriating to his own uses traditional
religious phraseology, and infusing it with heterodox Shavian meaning.
Besides, this was a prayer that held a lifelong fascination for him.

In the autobiographical Preface to *Immaturity,* Shaw relates that in
childhood he had directed his literary talent to the creation of his own
prayers:

> I cannot recall the words of the final form I adopted; but I remember
> that it was in three movements, like a sonata, and in the best Church of
> Ireland style. It ended with the Lord's Prayer; and I repeated it every
> night in bed.

The prayer, he makes clear, was no petition:

> I had too much sense to risk my faith by begging for things I knew very
> well I should not get; so I did not care whether my prayers were
> answered or not: they were a literary performance for the entertainment
> and propitiation of the Almighty . . .
>
> The Lord's Prayer I used once or twice as a protective spell. Thunder-
> storms are much less common in Ireland than in England; and the first
> two I remember frightened me horribly. During the second I bethought
> me of the Lord's Prayer, and steadied myself by repeating it.[3]

Obviously he bethought himself of this prayer many times in his adult life as well, for it is oft mentioned or alluded to in both his dramatic and nondramatic writings. Though in his days as a dramatic critic he took exception to the assumption "that what makes a play religious is the introduction of the Lord's Prayer,"[4] as a playwright he unhesitatingly availed himself of its language. Especially is this true of its doxology: "For thine is the kingdom, and the power, and the glory, for ever, Amen." *The Apple Cart* employs it twice. In the first act Boanerges boasts to King Magnus of his secure position as a trade union official, acquired by demogogic assurances to his worker constituents that, having the vote, "theirs is the kingdom and the power and the glory." And in the play's waning moments Magnus himself remarks ruefully to Lysistrata: "The kingdom and the power and the glory will pass from us and leave us naked, face to face with our real selves at last."[5]

Again, it is an "echo from the Lord's Prayer" that Shaw gives to the "rascal" at the end of *Too True to be Good:* "—or whether in some pentecostal flame of revelation the Spirit will descend on me and inspire me with a message the sound whereof shall go out unto all lands and realize for us at last the Kingdom and the Power and the Glory for ever and ever. Amen."[6] In *Back to Methuselah* Franklyn Barnabus, in slightly variant phrasing, asks: " 'The power and the glory, world without end': have those words meant nothing to you?"[7]

The opening words of the Lord's Prayer—"Our Father which art in heaven"—also recur in Shaw's works, especially in the discussions of religion, where its theological adequacy is frequently challenged. A 1912 lecture takes aim at its male bias: "Nowadays we see that it is ridiculous to keep saying 'Our Father which art in heaven.' What about our Mother who art in heaven? . . . Clearly, if you have a personal God, one of the first difficulties is to determine the sex of that God."[8]

The Black Girl, in Shaw's story, after raising the same point with the Conjurer, adds another. Having suffered paternal beatings throughout her childhood, she adamantly refuses "to say 'Our father which art in heaven.' I always say 'Our grandfather.' "[9] On an entirely different tack, in the Preface to *Misalliance* Shaw argues the superfluity of mortal godparents by taking punning advantage of the circumstance that in England "the first article of belief is that every child is born with a godfather whom we call 'our father which art in heaven.' "[10]

A more favorable estimate of the same "father in heaven" concept is to be found in such late works as *Everybody's Political What's What?* and *Sixteen Self Sketches.* Credited as a contribution of Jesus, it is commended as representing a far more civilized view of God than the antecedent belief in Jehovah. This appraisal reflects the Shavian teach-

ing that the Bible, properly interpreted, records the evolution of the idea of God, "the first effort of civilized mankind to account for the existence and origin and purpose of as much of the universe as we are conscious of"—a progression in which an idealized "affectionate father" emerges as one of the more advanced stages.[11]

Still, it receives only a relative and qualified approval: the notion of a heavenly father itself needs to be superseded. Even the popular name "God" Shaw considers too limiting and anthropomorphic for the "great force in the universe," which for him "is something larger than a personal force." Nevertheless he does not wholly abandon the term. Rather, as he puts it, the "evolutionary process to me is God: this wonderful will of the universe, struggling and struggling," and developing ever higher forms of life, including human beings as its essential agents.[12]

In each of the instances thus far cited, the references to the Lord's Prayer are unmistakable. Less obvious, but of greater dramatic moment, is the allusive implication of the Prayer in one of Shaw's most complex plays, *Major Barbara*. The passage in the play most patently indebted to it turns up almost at the very end—more precisely, in the penultimate scene. There the dialogue between Barbara and Cusins builds to her exultant declaration of a new-found faith:

> I have got rid of the bribe of bread. I have got rid of the bribe of heaven. Let God's work be done for its own sake: the work he had to create us to do because it cannot be done except by living men and women. When I die, let him be in my debt, not I in his; and let me forgive him as becomes a woman of my rank.[13]

Shaw's instructive stage directions describe his heroine as "transfigured" when delivering this triumphant speech. In directing Annie Russell, the original Barbara, he called her attention to the "curious touch of aristocratic pride" evinced in these lines. Years later he advised a Danish actress not to hesitate carrying the end of the play "to the wildest limits of your inspiration."[14]

Certainly in style and fervor this transfiguration speech is suggestive of a prayer, though its content hardly seems designed to propitiate the divine. Absent is any supplication, petition, adoration, praise, or even thanksgiving. In their stead is a bold, apostate self-assurance, championing a heterodox meliorism. The stance is one of Promethean challenge, not unlike that espoused elsewhere by Shaw, and closely identified with his Superman.[15]

Yet this utterance has no difficulty in qualifying as prayer under Shaw's own later blanket prescription: "Prayer consoles, heals, builds the soul in us; . . . there are all sorts of prayers, from mere beggars'

petitions and magic incantations to contemplative soul building, and all sorts of divinities to pray to."[16] The rebuilding of souls—her own and others—is precisely what Barbara is contemplating.

Though not praying to any divinity, she is unquestionably embracing the Shavian theology, which translates "God" into the Life Force, Bergson's *élan vital,* or the "evolutionary appetite," defined as an unaccountable natural agency in the universe: "a mysterious drive towards greater power over our circumstances and deeper understanding of Nature, in pursuit of which men and women will risk death as explorers or martyrs, and sacrifice their personal comfort and safety against all prudence, all probability, all common sense."[17] As already indicated, Shaw frequently nourishes the mysticism of his Creative Evolutionism by couching its basically naturalistic teachings in seemingly incompatible supernaturalistic religious language.[18]

Closer inspection of Barbara's speech discloses verbal clues that link it to the Lord's Prayer: specifically, the words "bread," "heaven," "debt" (in one version of the Prayer), "forgive," and "God's work be done" (as a variant of "Thy will be done"). The intimation is strong then that she is offering a special Shavian reading of this principal Christian prayer.[19] Jesus, it is pertinent to recall, taught the Lord's Prayer to his disciples as part of the Sermon on the Mount (Matthew 6:9–13; a shorter version is in Luke 11:2–4). In like manner Barbara delivers her sermon-prayer on the crest of a Middlesex hill. The scriptural context persists into her next speech as well, as she draws upon the 23rd Psalm to envision "the unveiling of an eternal light in the Valley of The Shadow."[20] In the valley below, she is reminding us, lies the Undershaft "factory of death," as Cusins has dubbed it.

Thus in *Major Barbara,* as later in *The Apple Cart* and *Too True to be Good,* we hear a Shavian "echo" of the Lord's Prayer at the end of the play. In this instance, however, indications are compelling that the Prayer has been resonating all along, so that it would be a serious oversight to hearken solely to its climactic tones. Accordingly it will be necessary to inquire into what other reflections of the Prayer are discernible in the drama, and how they bear upon Barbara's later formulation. As we shall see, there is ample evidence that the Lord's Prayer—whether by intent or inadvertence—functions as a kind of ironic leitmotif to the development of a variety of Shavian themes in the play.

The Prayer itself, also known as Pater Noster, consists of the introductory address ("Our Father which art in heaven"), six petitions, and the appended doxology. Let us consider the applicability of each of these components to *Major Barbara.*

Our Father Which Art In Heaven

The father theme pervades *Major Barbara*. (The word "father" in one way or another, appears thirty times in Act I, and over half as often in each of the other two acts.) The first act is organized around the home-coming of the long absent father of the Undershaft family, Andrew Undershaft. The extended expository conversation between his wife, Lady Britomart, and their son, Stephen, insistently focuses anticipatory interest on this paterfamilias, who is constantly referred to and ad-dressed as "father" throughout the play. In rapid order we learn of his enormous wealth, formidable worldly power, and essential immunity from accepted political and legal constraints. A munitions potentate whose ruling authority in his nearly three-centuries-old firm was conferred upon him in the manner of an Antonine emperor, he as-sumes superhuman dimensions virtually from the outset. When he does appear on the scene and is introduced to the family, the comic identity confusions that ensue, and his candid acknowledgment of the awkwardness of his position as stranger-father, testify at once to his paternal atypicality.

A deft and dramatic transition from the human to the divine plane is effected when Lady Britomart ascribes daughter Barbara's unconven-tional Salvation Army behavior to having come of age with "no father to advise her":

> BARBARA. Oh yes she has. There are no orphans in the Salvation Army.
> UNDERSHAFT. Your father there has a great many children and plenty of experience, eh?
> BARBARA [*looking at him with quick interest and nodding*] Just so. How did you come to understand that? [pp. 87–88][21]

Immediately thereafter comes his claim of even closer affinity to the Army:

> UNDERSHAFT. . . . I am rather interested in the Salvation Army. Its motto might be my own: Blood and Fire.
> LOMAX [*shocked*] But not your sort of blood and fire, you know.
> UNDERSHAFT. My sort of blood cleanses: my sort of fire purifies.

Conveyed is something more than the lethal efficacy of his weaponry: an enigmatic intimation of purgative powers drawn from control of the most vital and deadly forces of nature. (In the next act he directly equates his money and gunpowder with command of life and death [p. 120].)

Fittingly, the ensuing exchange raises the question of Undershaft's

relation to heaven. His admission that he is a passable trombone player prompts Barbara to observe that the Army had helped many sinners play their way into heaven on that instrument. But Lomax persists in thinking cannon-making an insurmountable barrier. "Getting into heaven is not exactly in your line, is it?" he brashly asks Undershaft (p. 89). The latter's undismayed rejection of Christian morality in favor of a religious ethics that makes due provision for cannons and torpedoes only serves as a further goad to Barbara's salvationism. "There are neither good men nor scoundrels," she insists; "there are just children of one Father" (p. 90), voicing the "Christian formula" that Shaw takes to be an affirmation of "the scientific fact of human equality" (Preface, p. 48). From her Christian perspective these mortal offspring are all to be accounted sinners, sharing precisely the same opportunity for salvation. (A harsher side of this filial relationship to the divine comes into play in the second act when she invokes fear of Jenny Hill's "father in heaven" in reproving Bill Walker for striking that young Salvationist [p. 106].)

Reciprocal proselytizing challenges by father and daughter set the stage for the comic gibes at conventional religious services and prayer that bring the first act to a close. Singled out for the most pointed barbs—leveled by Cusins—is the General Confession in the Book of Common Prayer (pp. 92–93).

Beneath its surface gaiety, Act I of *Major Barbara* tellingly satirizes upper class British religion and morality. The play's approach to "Our Father which art in heaven" is therefore inevitably ironic. Comprehension of a heavenly father comes by way of a redoubtable earthly counterpart. A figure outwardly easygoing, patient in manner, and engagingly simple in character, according to Shaw's description, Undershaft is endowed with a *"capacious chest and long head"* in which are stored *"formidable reserves of power, both bodily and mental"* (p. 84). So depicted he is the very incarnation of contained explosive force—a living symbol of the bombs he manufactures. Lacking specifiable ancestry, unfettered by family ties, defiant toward social conventions, unconstrained by national boundaries, he is a being godlike in his resistance to finite containment. Among his other attributes is the capability of producing latter-day equivalents of thunder, lightning, and earthquake devastation—powers once held to be the peculiar province of deities.

Additional facets of the incalculable paternalism of Undershaft come to the fore as the play progresses. In Act II the dialogue once more neatly juxtaposes him and the divine Father. Upon learning that Peter Shirley is a Secularist, Barbara, after breezily surmising that her own father is a fellow unbeliever, swiftly puts the fitter in his cosmic place with a thought borrowed from Tennyson: "Our Father—yours and mine—fulfils himself in many ways" (p. 105).[22] The irony escapes

Barbara, but it is certainly true that *her own father* has many ways of fulfilling *himself*.

Revelation of some of the ways awaits her and the others. In the following act his wealth is shown to bring under his sway not only the workers in his factory, but also the community in which they reside. From that base he is able to manipulate public opinion and mold governmental policy. More immediately, he offers an object lesson in how to buy off a religious organization, however militant its opposition to his own objectives. When Mrs. Baines delightedly responds to his five thousand pound benefaction with a grateful "Thank God!" he unabashedly asks, "You don't thank me?" (p. 131). During this same act Cusins hails him as "Father Colossus," "Mammoth Millionaire," and eventually "Dionysos Undershaft"—each an appellation of awe; the first proclaiming his patriarchal prodigiousness, the second the immensity of his fortune, and the third identifying him with a life-force god. Evidence of an unfolding Undershaftian epiphany abounds in the play.

Still, if we take our cue from the parody prayer that serves as epigraph for this essay, we should have no trouble understanding that the divinity that hedges the cannon king need not inspire reverence. Indeed, his portrait as a potent world spirit is ambiguous and double-edged. A diabolical aura clings to his disreputable occupation, his trafficking in war and carnage. It also hovers about his canny stalking of the souls of Barbara and Cusins. The latter, privy to the intent of their adversary, calls him "an infernal old rascal," "Mephistopheles," "The Prince of Darkness," "clever, clever, devil," and "you old demon." Counterpoised is his benign aspect: as mystical prophet, model employer, implacable foe of poverty, and social catalyst. Benefactor and death merchant, he provides his employees with economic security in a thriving town where the prospect of being blown to kingdom come is a constant condition of life. Father Undershaft may dwell in heaven, but his celestial city sits on the brink of hell.

Pertinent to this sobering thought may be several tenets of Shavian religious doctrine articulated in his commentary on the teachings of Jesus. In the Preface to *Androcles and the Lion* Shaw cites with approval such sayings by Jesus as "I and my father are one," and "God is a spirit," recorded in the fourth gospel (John 10:30; 4:24). The former he generalizes into "you and your father are one." Subsequently he credits Jesus with "the most penetrating good sense" in declaring "that the reality behind the popular belief in God was a creative spirit in ourselves called by him the Heavenly Father and by us Evolution, Élan Vital, Life Force and other names."[23] To which must be added the concurrence of Jesus in the 82nd Psalm's affirmation that "ye are gods" (John 10:34).

Putting these ideas together, it would appear that Undershaft as Barbara's "father in heaven" is godly as a dynamic embodiment of the Life Force; we and he being one would make him an Everyman-god, or theomorphic Everyfather, in whom it is possible to discern larger-than-life reflections of ourselves.[24] In the heaven-hell linkage may well be mirrored the insight that our hopes are inseparable from our fears, and that realization of our highest aspirations is contingent upon the conquest of our deadliest perils.

These conclusions, it may be noted, are compatible with the message in the Lord's Prayer parody that the Life Force is, after all, not in heaven—heaven being, in fact, an earthly goal towards which this blind force needs to be directed.[25]

Hallowed Be Thy Name

The name of Undershaft is hallowed, that is, sanctified, holy.[26] The arms maker (and his predecessors) acquired the Undershaft cognomen from the parish and Church of St. Andrew Undershaft, so named because it once stood under the shaft of a maypole. Hence it is that Shaw devotes one section of the *Major Barbara* Preface to "The Gospel of St. Andrew Undershaft." The derivation of his name might incline us to doubt the seriousness of the canonization, were it not for the fact that late in life Shaw still spoke of Undershaft as "the millionaire saint" who "thunders his doctrine that poverty is . . . a social crime." Like a deity, as already seen, Undershaft also answers to a variety of names, at least one of which—"Dionysos"—can also lay claim to being "hallowed."[27]

Nor should we forget that eventually Cusins, in becoming the next Andrew Undershaft, will inherit as well the title of "saint" attached to the name. And if we take into account Shaw's receptiveness to a mother in heaven, Barbara's saintly qualities pertain here too, particularly since she bears the name of the legendary patron saint of armorers: Saint Barbara.

Thy Kingdom Come

Undershaft is the possessor not only of great powers, but of a principality as well. The worldly might of the firm of Undershaft and Lazarus emanates from the model factory town of Perivale St. Andrews. At the head of this microcosm he rules like a monarch. Adumbrations of his kingdom come early in the play, with disclosure of its concrete features withheld until well into the final act. Initially it is kept ominously unlocalized, attention focused more on the unimpeded, rampant spread of its operations. This impression is capsulized in the un-

welcome inscription inserted in Stephen's Bible, designating Undershaft and Lazarus as "Death and Destruction Dealers: address, Christendom and Judea" (p. 72). No less forbidding and foreboding is the address of the cannon works given by Undershaft himself later on in the first act: "In Perivale St. Andrews. At the sign of the sword. Ask anybody in Europe" (p. 91). Not to be overlooked is the way that both of these declarations situate the business within a religious setting. The first shows it quite at home in the Judaic-Christian world, and records that fact in a copy of the distinctive scripture of that world. The other is an Undershaftian rejoinder to Barbara that relegates Christian salvationism to a far narrower region and sphere of influence than commerce in weapons. Her Christian insignia, the cross, may be better known in Canning Town; his, the sword, commands awesome respect throughout Europe.

Undershaft manifests himself as ruler in his bold "*I* am the government" speech to Stephen (p. 151) in the first scene of the third act. But his own special kingdom comes to the fore in the following scene. His gospel of money and gunpowder there acquires a local habitation and a name: Perivale St. Andrews. "An acre in Middlesex is better than a principality in Utopia," avers Macaulay.[28] Better still, Shaw would seem to be saying, is a combination of the two, as he plants Undershaft's Utopian principality on Middlesex acreage. Cusins, anticipating with Barbara a hellish city, grudgingly acknowledges it to be a heavenly one— accepting a Labor Church as the desiderated cathedral that completes the picture. Heaven also figures in the recorded dictum of a predecessor Undershaft: "TO MAN THE WEAPON: TO HEAVEN THE VICTORY" (p. 168).

"Heavens! What a place!" marvels Sarah, upon encountering Perivale St. Andrews (p. 158). But the "place," as it is repeatedly and indeterminately referred to, is a highly problematical heavenly kingdom, being firmly founded on a factory of death. Nor does the Undershaftian political philosophy, which makes the bullet and courage to kill the essential criteria of government, seem particularly well suited to a heavenly realm. But if it does not entirely qualify as heavenly, it certainly does as an efficacious kingdom—a place producing the power that can effect change. Undershaft bids Cusins to turn his *oughts* into *shalls*, and to make war on war. It is the access to reality and power the establishment provides that finally induces the Professor of Greek to consent to become a maker of gunpowder. Barbara, acknowledging the reality of the place, perceives it to be "where salvation is really wanted," a hell that with appropriate courage can be raised to heaven, as man can be raised to God (p. 184). When all is said and done, the overdue, truly promising kingdom come will be that governed by King Adolphus and Queen Barbara.

Thy Will Be Done

Construed in Shavian terms, this undercurrent theme courses through the entire play. Undershaft, Shaw explains in the Preface, is a mystic with a "constant sense that he is only the instrument of a Will or Life Force which uses him for purposes wider than his own" (p. 31).[29] The industrialist himself, owning to being "a confirmed Mystic" (p. 110), alludes to this evolutionary force in Act III, when he admits "enigmatically" that what drives his business is a "will of which I am a part" (p. 169). The same will or Life Force has additional manifestations. It underlies Undershaft's "gospel" of money and gunpowder, which he intends to have Barbara preach and convert others to, and which (as adverted to earlier) he explicates to mean "Freedom and power. Command of life and command of death" (p. 120). Its morality—or more accurately, amorality—he expounds in "the true faith of an Armorer" (p. 168). As a "vital impulse towards perfection," a "divine spark," or "evolutionary appetite"[30]—other Shavian characterizations of the Life Force— it fuels his war on the crime of poverty. Looking backward, it is the driving force impelling his actions from the beginning. Likewise it is what kindles Cusins' claim to have "more power" and "more will" than the arms magnate, during their debate over "the moral question" (p. 169). No less is it at work motivating his mating with Barbara. And it animates the religious consciousness that imbues Barbara at the drama's end.

For, as Shaw was to observe later, the way the universal will or Life Force manifests itself is in the acts, and conflicts, of individual wills. "The strongest, fiercest force in nature," he declares, "is human will. It is the highest organization we know of the will that has created the whole universe."[31] That world will Shaw accommodates religiously as "God's will." Complicating adoption of this expression is his espousal of two apparently distinct conceptions of God; but these his doctrine does ultimately conjoin. First of all, God is the creative will or power that has brought us into existence and needs to use our capabilities in its titanic struggle with physical nature. Civilization, so understood, is the molding of nature "to our own purposes and will, and in doing that really molding it to the will of God." God has had us evolve hands and brains "to act and think for Him: in short, we are not in the hands of God; but God is in our hands. A ruler must not say helplessly 'Thy Will be done': he must divine it, find out how to do it, and have it done."[32] (The focus of the criticism, we may note, is once again on the specific language of the Lord's Prayer.)

Yet in another sense God for Shaw is "only an ideal towards which creative evolution is striving," and mankind, however imperfect, "merely its best attempt so far." All of us are "experiments in the direction of

making God. What God is doing is making himself, getting from being a mere powerless will or force." Shaw's God, it follows, is both the evolutionary process and the goal it seeks.[33] Hence his concept of divinity is itself evolutionary: God is the force striving to realize as its purpose the perfecting of its own being. God is imminent, not transcendent.[34]

God's will aims at God's work, which can only be done by human beings. God's work, then, is the proper vocation of mankind:

> If you don't do his work it won't be done; if you turn away from it, if you sit down and say, "Thy will be done," you might as well be the most irreligious person on the face of the earth. But if you will stand by your God, if you will say, "My business is to do your will, my hands are your hands, my tongue is your tongue, my brain is your brain, I am here to do thy work, and I will do it," you will get rid of otherworldliness, you will get rid of all that religion which is made an excuse and a cloak for doing nothing, and you will learn not only to worship your God, but also to have a fellow feeling with him.[35]

This passage furnishes illuminating commentary on Barbara's response to the Lord's Prayer. She would have God's work done "for its own sake"—work that can only be done by living individuals. Without saying so, she is abandoning the passive acquiescence in things as they are, implicit in the affirmation, "Thy will be done." Instead she is committing herself to action, to undertaking the truly human career of striving for divinity—a pursuit which puts her on a plane with the limited God or will of the Life Force.

Apposite to Barbara too are some remarks Shaw appended to the above passage. What he wants from religion, he tells us, is neither comfort nor happiness, but "a certain self-respect and force in the world," as well as courage. And that is what the conception of doing God's work inspires. It arouses the kind of faith that "really overcomes the power of death"—exactly the kind of faith to which Barbara is testifying.[36]

In Earth As It Is In Heaven

At the heart of Shaw's eschatology is the critical question of the relation of earth to heaven—and hell—in the special meaning these concepts acquire in his thought. The issues it raises receive a thorough dramatic airing in the philosophical dream sequence of *Man and Superman*. In a program note for the first staging of that "Don Juan in Hell" scene, the playwright explained that its underlying theology conceives of heaven, hell, and earth not as places, but as figurative representations of "states of soul." The soul, "the divine element common to all life," makes us

" 'do the will of God' " and value only our "divine activities," never our selfish ones. So regarded, any society may turn into a hell when the desire for selfish pleasure becomes its dominant motive; or into a heaven when its members constitute "a communion of saints" moved by "the passion of the divine will" to the avid pursuit of "divine contemplation and creative activity" (as is Don Juan).[37]

In the final pages of *John Bull's Other Island*, written between *Man and Superman* and *Major Barbara*, Father Keegan more simply identifies heaven and hell with "two conditions of men: salvation and damnation." And his parting words depict heaven as a triunity, particularly of State, Church, and people, culminating in "a godhead in which all life is human, and all humanity divine."[38]

The conceptions of heaven and hell in these works are undoubtedly germane to the vision of heaven (and of hell) that emerges during the last act of *Major Barbara*. In the play as a whole there is dramatic movement from the more conventional Christian connotations of these terms—especially as they function in the Salvation Army vocabulary—towards the more distinctively Shavian senses. This development parallels and mirrors the process of conversion Barbara undergoes.

The aspiration in the Lord's Prayer is for earth to emulate heaven. If we focus attention on the earth-heaven axis in *Major Barbara* we find Barbara proffering in the Salvation Army what her father later derides as "dreams of heaven" (p. 171). As we have seen, in the first act she envisions Undershaft's eventual entry into heaven as a trombone-playing sinner. In the next act she invites Bill to join in the pursuit of "brave manhood on earth and eternal glory in heaven" (p. 113). But her dissillusionment at the shortcomings of the Army's salvationism leads her at last to repudiate its portrait of heaven as representing only an unworthy bribe. Although in a weak moment she yearns like the Psalmist (Psalms 55:6) for "the wings of a dove" on which to "fly away to heaven" (p. 182), and be free of both her father and her husband-to-be, this escapist wish is a fleeting one. In the end, the new "way of life" she embraces is not Cusins' Euripidean idea of finding one's heaven by knowing that "to live is happy" (p. 117), but rather the Shavian one of working to raise both hell (and presumably earth) to heaven and man to god. The truly religious task, as the Lord's Prayer parody suggests, is to transform earth itself into heaven.

Give Us This Day Our Daily Bread

Hunger for "daily bread" is what draws Snobby Price and Rummy Mitchens to the Salvation shelter. They are finishing a meager meal of

bread, margarine, syrup, and diluted milk as Act II begins. Before long they are joined by the unemployed and starving fitter, Peter Shirley, who is brought the same meal by Jenny Hill. His qualms about accepting such charity she allays by assuring him that the food is a gift from the Lord, who "wasnt above taking bread from his friends" (p. 99).

Bread figures twice in Peter's bitter scolding of Bill Walker, after the latter's violent entrance upon the scene. Peter wants to know why "young whelps" like Bill are not content "with takin the bread out o the mouths of your elders that have brought you up and slaved for you, but you must come shovin and cheekin and bullyin in here, where the bread of charity is sickenin in our stummicks?" (p. 102). As their heated exchange continues, Peter disdainfully claims that he himself would have been able to stand up against Bill had he been eating for a week instead of starving for two months. Bill's retort is to charge him with lying, since "youve the bread and treacle in you that you cam eah to beg" (p. 104).

In his ensuing confrontation with Barbara, Bill, proudly dissociating himself from the "demmiged lot" who have come to the shelter to beg, spurns her "bread and scripe [scrape] and ketlep [catlap]" (p. 106), along with her God. A bit later, when Barbara bids Rummy toss the crumbs about for the birds, the older woman protests: "This aint a time to waste good bread on birds" (p. 110).

The gift of daily bread in the second act becomes a cardinal issue in the third. Undershaft dismisses as "cheap work" the Salvation Army practice of "converting starving men with a Bible in one hand and a slice of bread in the other" (p. 173). Using such tactics he would be prepared to convert West Ham to "Mahometanism."

For her part Barbara, in her final assessment of the pervasive power of Undershaft and Bodger, has come to the realization that "when we feed a starving fellow creature, it is with their bread, because there is no other bread" (p. 182). And the clinching lure of Perivale St. Andrews—what persuades her in the end to cast her lot with that community—is the opportunity it affords her to resume soul-saving, her "return to the colors" as Shaw calls it in the Preface (p. 37). Only no longer will her flock be "weak souls in starved bodies, sobbing with gratitude for a scrap of bread and treacle, but fullfed, quarrelsome, snobbish, uppish creatures" (p. 183). Nor will her father again be able to level the accusation that her converts "were bribed with bread" (p. 184). This is the prelude to her revised Lord's Prayer: "I have got rid of the bribe of bread. I have got rid of the bribe of heaven." On this day the giving of daily bread—at least in the form of charity—has been transcended as a pathway to human salvation. No wonder "vitality" supplants "bread" in Shaw's parody.

And Forgive Us Our Debts, As We Forgive Our Debtors (And Forgive Us Our Trespasses, As We Forgive Them That Trespass Against Us)

The first version above is that in Matthew 6:12, the parenthetical alternative is that in the Book of Common Prayer. Luke 11:4 reads: "And forgive us our sins; for we also forgive every one that is indebted to us." (In 1977 the Church of England approved a modernization of the Lord's Prayer as part of its Alternative Services Series. In this version the line has been altered to "Forgive us our sins as we forgive those who sin against us.")[39]

The original meaning of the Greek word translated "to sin" (*hamartia*) was "to go astray" or "to miss the mark," which is a rough equivalent of "to trespass." Literally, a "trespass" is a "passing across," and as such a "transgression."[40] "Debt," as used in the New Testament passages, is an offense, calling for expiation, reparation, or forgiveness. Hence it too denotes a trespass or sin. The thought expressed in this petition, then—whatever the phraseology—is forgiveness of sin, wrongdoing, or transgression. Though Shaw employs the "trespass" wording in his parody, it is the language of debt and repayment that permeates *Major Barbara*.[41] And as already remarked, it is the term "debt" that Barbara uses in her prayer.

Forgiveness of transgression is an insistent, recurrent theme throughout Bill Walker's discomfiting encounter with the Salvation Army and Barbara in Act II. When he hits Rummy Mitchens in the face, Jenny cries out, "Oh, God forgive you!" to which he reacts angrily: "You Gawd forgimme again and Aw'll Gawd forgive you one on the jawr thetll stop you prying for a week" (p. 101). It is the outpouring of forgiveness that distresses Bill, by his own admission: "Aw downt want to be forgive be you, or be ennybody," he tells Jenny upon returning from his humiliation at the hands of Todger Fairmile (pp. 126–27). Being forgiven reduces him to the "position of unbearable moral inferiority" that Shaw describes in the Preface (p. 44). The sovereign he offers Jenny as compensation for striking her is intended to balance accounts so that he will face "no more o your forgivin an prying." But he will not hear of diverting a shilling or two to his other victim, Rummy. Still hostile, unforgiving, and ready to retaliate, she has no access to his conscience. "It's this Christian gime o yours that Aw wownt ev plyed agen me," Bill grumbles; "this bloomin forgivin an neggin an jawrin that mikes a menn thet sore that iz lawf's a burdn to im" (p. 127). But soon that burden is lifted from him by the subtle machinations of Undershaft.

The four principal characters in the drama all have to come to terms

with wrongdoing and its forgiveness. In the first act we learn that Lady Britomart long ago refused to forgive her husband "for preaching immorality while he practised morality" (p. 76). Though she relents in the long run, in the last act she accuses him of being "wickeder than ever," voicing regret for having allowed him to come home again (p. 175).

It is his second act conduct, however, that prompts Barbara, in the Wilton Crescent scene of Act III, to tackle the forgiveness of misdeeds as a wider and more serious religious issue. Scoring her father for having undermined her redemptive efforts, she recounts that she had been guiding Bill's soul towards salvation, only to have it revert to drunkenness and derision when the Salvationists accepted Undershaft's money. "I will never forgive you that," she vows. "If I had a child, and you destroyed its body with your explosives—if you murdered Dolly with your horrible guns—I could forgive you if my forgiveness would open the gates of heaven to you" (p. 156). But his actions, in effect causing a human soul to turn lupine, she condemns as worse than murder. Undershaft parries her attack with the disarming suggestion that her ministrations could not have left Bill untouched.

Undershaft himself takes up the question of the value of forgiveness in jousting with Cusins, while pressing him to decide whether he will accept the invitation to become heir-designate to the gunpowder kingdom. Adolphus' hesitation because of "things in me that I must reckon with" the reigning armorer meets head on (p. 177). After disposing of two of these scruples in quick order, he proposes a third:

> UNDERSHAFT. . . . Come! try your last weapon. Pity and love have broken in your hand: forgiveness is still left.
> CUSINS. No: Forgiveness is a beggar's refuge. I am with you there: we must pay our debts. [p. 178]

The latter comment may be read as a pointed answer to the entreaty for forgiveness of debts in the Lord's Prayer.

The Preface contains explicit Shavian commentary on this assessment of forgiveness of wrongdoing. Insisting on "the inexorability of the deed once done," Shaw takes sharp issue with the Salvation Army and other "propangandists of the Cross":

> Forgiveness, absolution, atonement, are figments: punishment is only a pretence of cancelling one crime by another; and you can no more have forgiveness without vindictiveness than you can have a cure without a disease. You will never get a high morality from people who conceive that their misdeeds are revocable and pardonable, or in a society where absolution and expiation are officially provided for us all. [p. 43]

Punishment of the unsuccessful scoundrel only inures him to evildoing. In marked contrast, the successful scoundrel reaps Christian rewards: "He is not only forgiven: he is idolized, respected, made much of, all but worshipped" (pp. 45–46). This brings about changes in his conduct, but not in his character as scoundrel. Shaw is unsparing in his criticism of each of these ways that society deals with its miscreants. In order to achieve the reformed moral order he envisions, it will be necessary to eliminate both punishment and forgiveness: "If there is to be no punishment there can be no forgiveness. We shall never have real moral responsibility until everyone knows that his deeds are irrevocable, and that his life depends on his usefulness" (p. 61).

The last words about forgiveness and debt in the play are Barbara's in the previously quoted lines of her "prayer": "When I die, let him [God] be in my debt, not I in his; and let me forgive him as becomes a woman of my rank." The point to be made here is that what she says goes beyond the belief shared by Undershaft and Cusins that forgiveness is to be eschewed in favor of repayment of debt. Their view renounces human petitioning for forgiveness as a beggarly way of evading incurred obligations. Her approach to forgiveness raises humanity to the level of divinity. In relation to God—or the Life Force—she no longer seeks forgiveness: she would be the forgiver, not the forgiven—the creditor, not the debtor. As the parody puts it, she is willing to forgive the Life Force its trespasses, magnanimously crediting—even blessing—the "excellent intentions" these reflect. She is moving to a higher standard of morality, and with it to a more exalted evolutionary status.[42]

And Lead Us Not Into Temptation, But Deliver Us From Evil

The Mephistophelean Undershaft is the prime tempter in the drama, and the Faustian Cusins the character most keenly cognizant of the resources and stratagems arrayed against him and Barbara. Indeed, when the millionaire crowns his efforts to persuade the young Greek scholar to become his successor with an apt paraphrase of Plato's philosopher-king prescription, Cusins admiringly registers the effectiveness of the ploy: "Oh, tempter, cunning tempter!" (p. 178).

Actually Undershaft has successfully tempted the entire family—each member in a different way—primarily with the heavenly city enchantments of Perivale St. Andrews. In effect they all heed the Shavian admonition in the "Maxims for Revolutionists": "Never resist temptation."[43] The Lord's Prayer parody goes further: "Lead us into all sorts of temptations, and never say die." A clearer understanding of the intent of this counsel comes to us from an observation in one of Shaw's

religious speeches: "Temptation and inspiration mean the same thing exactly as firmness and obstinacy mean the same thing, only people use the one word when they want to be complimentary and the other when they want to be abusive."[44] Hence Undershaft, as tempter, is by the same token an inspirer.

Undershaft himself comments on temptation in his indictment of respectable people, like Jennie Hill or Stephen, for presuming competence to teach morality and religion. "You cant tell me the bursting strain of a ten-inch gun, which is a very simple matter," he remonstrates, "but you all think you can tell me the bursting strain of a man under temptation" (pp. 150–51). Apparently he would make no such claim, but his performance as a highly skilled tempter suggests that he could justifiably do so.

Concern with deliverance from evil is ubiquitous in *Major Barbara*. Lady Britomart addresses herself to it almost from the start, instructing her son in the proper aristocratic management of the wicked. He must learn to rise above the "state of dumb helpless horror" to which the middle classes are prone upon discovering that the world contains wicked people. "In our class, we have to decide what is to be done with wicked people; and nothing should disturb our self-possession" (p. 73). In imparting this lesson she depicts her estranged husband as a man committed to doing "every perverse and wicked thing on principle," in addition to always being "clever and unanswerable" in defense of "nonsense and wickedness" (p. 75). This portrait of Undershaft she then modifies by explaining that he was less disposed to wrongdoing than to wrong-speaking and wrong-thinking. Even his attractiveness to children she deplores, since it allowed him to fill their minds with wicked ideas, rendering them maternally "unmanageable" (p. 76).

Undershaft portrays himself in the same act as "a profiteer in mutilation and murder," the meat of his morality being, as Cusins interprets for Lomax, moral poison to others (pp. 89–90). This prompts Barbara, as mentioned before, to look upon her father as a sinner (like all the others) whom she might guide to salvation. But before she can venture on that undertaking, the intrusive misconduct of Bill Walker brings her a more immediate soul-saving challenge. Her promising campaign to salvage his soul is foiled when both of them learn how utterly dependent is the salvationist cause on the very forces of evil it is committed to combat. Those forces, represented by Bodger's whisky and the maiming munitions of her father, have in hand the money that confers decisive power over the institutions of society.

In the circumstances we should hardly look to such powers for deliverance from evil. Yet that is not entirely true. For there are evils from which Undershaft himself would like to deliver us. He wants to rid the

world of the crime of poverty, which he describes as a moral and physical poison, a blight on cities, a murderer of souls, a destroyer of liberty, and a killer of social happiness. Poverty and slavery he would eliminate by force—by "killing" them.

Cusins, in his final reflections on evil, concludes that power for good and power for evil are inextricably bound together, and that waging war on war is the way to deal with that particular evil. As for Barbara, she too has come to realize that "running away from" or "turning our backs on" wickedness is futile. Evil is inescapable; facing it is essential to life and salvation. Life, she perceives, is "all one," with no isolable "wicked side." "And," she would have Cusins know, "I never wanted to shirk my share in whatever evil must be endured, whether it be sin or suffering" (p. 183). The shunning of evil, instead of sharing it, she disdains as a middle class attitude—a sentiment recalling, but improving upon, her mother's.

The Lord's Prayer parody makes no mention of evil whatsoever, although its "never say die" may be a Shavian counsel of courage (or gumption) in facing and grappling with it.

For Thine Is The Kingdom, And The Power, And The Glory, For Ever. Amen.[45]

Evidence enough has already been adduced to establish Undershaft's secure claim to both kingdom and power. In the heavenly-hellish city of Perivale St. Andrews he rules with regal ease, never needing to issue orders to his men, relying instead on the jealous exercise of authority over underlings at each rung of the industrial and social ladder. There he is engaged in "organizing civilization," as he implies to Stephen (p. 160). The foundation of his kingdom is religious: a creed of power promulgated in the apocalyptic commandments of "the true faith of an Armorer."

Glory is Undershaft's not only as a prodigious economic and political force in the world, but in the end he acquires it as well in the enthusiastic tributes of the visitors to his model community.

In the denouement of *Major Barbara* the future of the kingdom and the power is being settled. The succession falls to Cusins, and through him to Barbara, after both come to terms with the "reality" of the place and its power. Cusins, "committed . . . to this place for ever" (p. 182), will undertake to direct its physical and spiritual power to "the general good" (p. 181). Her courage regained, Barbara too has found her "place" and her work. Their inheritance of the kingdom and the power she celebrates with a rousing "Glory Hallelujah!" (p. 184).

Adolphus Cusins, as successor, will become the next Andrew Under-

shaft. The Undershaft power and the glory, then, will endure in his kingdom come, where his will (and that of his step-sister wife, Barbara Undershaft) will be done. The long-standing dominion of "Andrew Undershaft"—the name of every overlord of Perivale St. Andrews since the reign of James I—may not last "for ever," but its continuation in the foreseeable future is assured. And certainly no one in the congregated family has any reason to withhold a confirming "Amen."

Near the end of the second act, Cusins shouts exultantly "We convert everything to good here" (p. 135). In effect, Shaw does much the same, converting the Lord's Prayer to his own inspiriting purposes. By a typical Shavian inversion it becomes humanity's prayer, invoking and extolling the divine potentialities of humankind.

Notes

1. Dr. Albert, Professor Emeritus of Philosophy at California State University, Los Angeles, is a member of the editorial board of *SHAW* and the author of a number of significant essays elucidating *Major Barbara*.

2. Bernard Shaw, in a letter to Gilbert Murray, September 22, 1913; British Theatre Association. Quoted by kind permission of the Trustees of the Shaw Estate and the British Theatre Association.

3. Preface, *Immaturity* (London: Constable, 1931), pp. xviii–xix. All subsequent references to Shaw's works (other than the plays and prefaces) are to this Standard Edition (London, 1931–1950), unless otherwise indicated.
Cf. "The Church Versus Religion" (1922), retitled "On Ritual, Religion, and the Intolerableness of Tolerance" in *Shaw on Religion*, ed. Warren Sylvester Smith (New York: Dodd, Mead, 1967), p. 164: "When I was a child . . . I composed my own prayers, ending up with the Lord's Prayer: rather, I think, as a gesture of politeness to its author, than as a prayer." Shaw advances this as evidence of his early independence of "the set forms of heavenly communion" and of all "ceremonial aid."

4. *Our Theatres in the Nineties* (1932), III, 276.

5. *The Bodley Head Bernard Shaw: Collected Plays with their Prefaces*, ed. Dan H. Laurence (London: Max Reinhardt, 1970–74), VI, 295, 373. All further references to Shaw's plays and prefaces are to this edition.

6. *Collected Plays*, VI, 528.

7. *Collected Plays*, V, 423. The phrase "world without end," which also rounds out Shaw's parody, is the liturgical close of various other prayers in the Book of Common Prayer. Its sole appearance in the King James version of the New Testament is in Ephesians 3:21; "forever and ever" is an equivalent translation of the original Greek wording.

8. "Modern Religion I" in *The Religious Speeches of Bernard Shaw*, ed. Warren S. Smith (University Park, Pennsylvania: Pennsylvania State Univ. Press, 1963), p. 42. See also Shaw's 1912 letter in *Shaw on Religion*, pp. 57–58, on the absurdity of "the Father," white

and male, as a basis for a common faith for all peoples. Cf. "What Is My Religious Faith?" in *Sixteen Self Sketches* (1949), p. 74, in which Shaw contends that the Catholic worship of the Madonna amounts to "a needed addition of The Mother to The Father in The Godhead."

9. *The Adventures of the Black Girl in Her Search for God* (London: Constable, 1932), pp. 26–28.

10. *Collected Plays*, IV, 17.

11. *Everybody's Political What's What?* (1944), p. 203; "Shame and Wounded Snobbery" in *Sixteen Self Sketches*, p. 26; *Adventures of the Black Girl*, Epilogue, p. 69; also p. 74, a passage unfortunately garbled as revised in the Standard Edition, 1934, p. 18.

12. *Religious Speeches*, p. 6. See also pp. 33–34 for his derogation of the word "God" in its "former meaning," followed on p. 35 by a reference to "the life-force that we call God." His practice in retaining the term Shaw explained in a 1907 letter: "When, in addressing an ordinary religious audience, I have occasion to speak of the force which they call the Will of God, and which I myself have called the Life Force, I use the term which is familiar and intelligible to them." *Bernard Shaw: Collected Letters 1898–1910*, ed. Dan H. Laurence (New York: Dodd, Mead, 1972), p. 873.

13. *Collected Plays*, III, 184. All further references to *Major Barbara* appear parenthetically in the text.

14. Sidney P. Albert, "Shaw's Advice to the Players of *Major Barbara*," *Theatre Survey*, 10 (1969), 8; "More Shaw Advice to the Players of *Major Barbara*," *Theatre Survey*, 11 (1970), 72.

15. See e.g., Preface, *Three Plays for Puritans*, in *Collected Plays*, II, 33; *Man and Superman*, in *Collected Plays*, II, 498, 502. Also *Back to Methuselah*, Postscript, in *Collected Plays*, V, 699–700: "My hero in fiction was the rebel, not the goodygoody citizen, whom I despised. This attitude became a habit which I have never been able to shake off quite completely."

16. *Everybody's Political What's What?*, p. 363. In like vein is his 1950 commendation of prayer as "a firstrate prescription for despairing pessimism." See Albert, "Reflections on Shaw and Psychoanalysis," *Modern Drama*, 14 (1971), 187, and n. 36.

17. *Sixteen Self Sketches*, p. 78.

18. On one of the numerous occasions when he used one of his favorite scriptural phrases, "the Word was made flesh" (John 1:14)—although altered this time to "the Word became Flesh"—Shaw added parenthetically: "these old religious catchwords are the plainest common sense to me." Eleanor Robson Belmont, *The Fabric of Memory* (New York: Farrar, Straus and Cudahy, 1957), p. 50.

19. Margery Morgan, in *The Shavian Playground* (London: Methuen, 1972), p. 146, has previously detected in these lines of Barbara a "new version of the Lord's Prayer," but adduces no supporting evidence.

20. There are a number of other fairly straightforward allusions to scriptural passages in *Major Barbara*. Among the lines alluded to are the following: Philippians 4:7; Matthew 26:15; Joel 2:1 or 2:15; Proverbs 25:25; Psalms 22:1 or Matt. 27:46 or Mark 15:34; Matt. 18:6 or Mark 9:42 or Luke 17:2; Matt. 24:28; and Psalms 55:6.

21. See Matt. 23:9: "And call no man your father upon the earth: for one is your Father, which is in heaven."

22. "The old order changeth, yielding place to new,/ And God fulfils himself in many ways,/ Lest one good custom should corrupt the world." Alfred, Lord Tennyson, *Idylls of the King*, "The Passing of Arthur," l. 408 (1869); also in *Morte d'Arthur* (1842). Shaw gave this Tennyson line to Elder Daniels in *The Shewing-up of Blanco Posnet*, (*Collected Plays*, III, 772), and made effective use of it in a variety of other contexts.

23. *Collected Plays*, IV, 505, 516, 563–64.

24. In the Appendix to *Androcles (Collected Plays*, IV, 639) Shaw states that for "the more modern sort of Anglican Theosophist to whom the Holy Ghost is the Élan Vital of Bergson"—as it is of course to him—"the Father and Son are an expression of the fact that our functions and aspects are manifold, and that we are all sons and all either potential or actual parents."

25. "Would you not be expecting this earth to be fulfilling its real destiny, to be transforming itself into the Kingdom of Heaven?" asks Shaw in "The Crime of Poverty," *Platform and Pulpit*, ed. Dan H. Laurence (New York: Hill and Wang, 1961), p. 95.

26. See Stella Brook, *The Language of the Book of Common Prayer* (New York: Oxford Univ. Press, 1965), pp. 39–40.

27. *Sixteen Self Sketches*, p. 25. In the Preface to *On the Rocks*, Shaw has Jesus say of God as heavenly father: "He has many names and his nature is manifold" (*Collected Plays*, VI, 621).

28. Lord Macaulay, "Lord Bacon," in *Critical and Historical Essays* (Boston: Houghton Mifflin, 1900), II, 466.

29. In this respect Undershaft is a true Shavian. Compare Shaw's own *confessio fidei:* "As for my own position, I am, and always have been, a mystic. I believe that the universe is being driven by a force that we might call the life-force. I see it as performing the miracle of creation, that it has got into the minds of men as what they call their will. Thus we see people who clearly are carrying out a will not exclusively their own." "The Religion of the Future," *Religious Speeches*, p. 33.

30. See *Misalliance*, Preface (*Collected Plays*, IV, 126); *Saint Joan*, Preface (*Collected Plays*, VI, 26–28).

31. *Misalliance*, Preface (*Collected Plays*, IV, 89).

32. *Religious Speeches*, p. 34; *Everybody's Political What's What?*, p. 329.

33. *Everybody's Political What's What?*, p. 329; *Religious Speeches*, p. 35; see also pp. 18–19: "The object of the whole evolutionary process is to realize God. . . . In a sense there is no God as yet achieved, but there is that force at work making God, struggling through us to become an actual organized existence."

34. See Allan Chappelow, *Shaw—"The Chucker-Out"* (London: George Allen and Unwin, 1969), pp. 137–39.

35. *Religious Speeches*, pp. 6–7; see also p. 34: "If we accept that conception we can see the limitations of our God and can even pity him."

36. *Religious Speeches*, p. 7. The latter thought has its echo in the *Major Barbara* Preface: "And is it not the very diagnostic of true salvation that it shall overcome the fear of death?" (p. 41). On religion as a source of courage see *The Intelligent Woman's Guide to Socialism and Capitalism* (London: Constable, 1928), p. 439: "All courage is religious: without religion we are cowards."

37. Court Theatre program, June 4, 1907, reprinted in Raymond Mander and Joe Mitchenson, *Theatrical Companion to Shaw* (New York: Pitman, 1955), pp. 89–90.

38. *Collected Plays*, II, 1020, 1021.

39. See *Encyclopedia Britannica*, 15th edition, Micropædia, s.v. "Lord's Prayer."

40. See Brook, *Language of the Book of Common Prayer*, p. 142. In the Old English version of the Book of Common Prayer, the word for "guilt" was used, later replaced by "trespasses" (pp. 38–39). See also *O.E.D.*, s.v. "trespass."

41. See Albert, "The Price of Salvation: Moral Economics in *Major Barbara*," *Modern Drama*, 14 (1971), esp. 310–12.

42. Cf. the peroration of a 1911 Shaw speech on Socialism: "If there is another life to come, if any man conceives that when this life is at an end that he will then go into the presence of God, who will ask him to give an account of his life, then he would not approach that God crawling, and asking for forgiveness for sins, and admitting he had

lived in a wicked and horrible way. He would hold up his head even before his God and say: 'When I was in your world I did your work in the world. I did more than your work in the world; I left the world in my debt. You are in my debt. Now give me my reward!" Chappelow, p. 129.

43. *Collected Plays*, II, 781.

44. *Religious Speeches*, p. 34. The devil, Shaw says, has been thought to be able to carry out his will only by tempting or inspiring people to do what he wanted. Shaw would have us view God, or the Life Force, similarly.

45. The Book of Common Prayer omits the first "and" from the doxology, and ends it "for ever and ever. Amen."

David Matual[1]

SHAW'S *THE SHEWING-UP OF BLANCO POSNET* AND TOLSTOY'S *THE POWER OF DARKNESS*: DRAMATIC KINSHIP AND THEOLOGICAL OPPOSITION

The Shewing-up of Blanco Posnet ranks among the least known, least read, and least frequently performed of Shaw's plays. It normally appears only in a more or less complete edition of his works, where, thanks to the awkwardness of its title and the brevity of the text, it is still likely to go unnoticed. Critical reception has only underscored its relative obscurity. Those sources which mention it at all do so in the most perfunctory manner. Among the critics who bother to devote space and time to it, reaction is somewhat mixed. Margery Morgan gives it qualified approval, noting that it represents a competent exercise in the convention of melodrama.[2] Homer Woodbridge goes a little further in his praise and brands the play "a very skilful piece of dramatic story-telling."[3] Stanley Weintraub even finds it a "curiously moving melodrama."[4] All of them, however, are quite cognizant of its shortcomings. In fact, negative remarks characterize the comments of most of their colleagues and of Shaw's contemporaries. H. L. Mencken, for example, called the play "a somewhat cheap effort to shock the pious" and ridiculed Shaw's inept reproduction of what he imagined to be American English.[5] In a direct attack on the play and an indirect swipe at the author, Rupert Brooke claimed that *Posnet* indicated "the beginning of senile decay in that brilliant intellect."[6] William Irvine's strictures are much more to the point and considerably harsher: "The conceptions of God, grace, and conversion are crudely and sentimentally melodramatic in the worst vein of decadent puritanism ... As a matter of fact, it must inevitably be disagreeable to any kind of audience. It repels believers by its blasphemies and unbelievers by its

theology."[7] Colin Wilson puts it more succinctly and bluntly than any-
one else when he dismisses *Posnet* as one of the worst plays Shaw ever
wrote.[8]

It is quite possible that *Posnet* would not have received the modicum
of attention it has if it were not for the fact that Shaw submitted it to
Leo Tolstoy—for approval, as it were—and even asserted that he had,
to some extent, been influenced by the Russian author's magnificent
peasant drama, *The Power of Darkness* (1886). His covering letter, dated
February 14, 1910, tells us a great deal about his purpose in writing the
play, the audience for which it was intended, its alleged connection
with *The Power of Darkness,* and the theological significance of Blanco's
sermonizing at the end of the melodrama.[9] As far as the author's pur-
pose and intended audience are concerned, Shaw's position is quite
close to that of Tolstoy, who wrote his drama with the frequently ex-
pressed intention of uplifting the down-trodden Russian masses both
morally and aesthetically. Shaw describes his play in the following
words: "In form it is a very crude melodrama, which might be played
in a mining camp to the roughest audience."[10] Up to this point his
letter may well have struck a sympathetic chord in Tolstoy. The disa-
greements, however, begin in the next section, when Shaw points out
the ineffectiveness of the sermons delivered by Blanco's hypocritical
brother, Elder Daniels:

> Elder Daniels will never convert Blanco Posnet: on the contrary, he
> perverts him, because Blanco does not want to be like his brother; and I
> think the root reason why we do not do as our fathers advise us to do is
> that we none of us want to be like our fathers, the intention of the
> universe being that we shall be like God.[11]

The word *fathers* is meant as an indirect allusion to Akim, the illiterate,
weak-minded *raisonneur* of *The Power of Darkness* and the father of the
protagonist, Nikita. Shaw's disparaging reference to him was a grievous
faux pas inasmuch as Akim was one of the characters dearest to Tol-
stoy's heart. Indeed, from Tolstoy's perspective, it is the father more
than anyone else who eventually leads the son to confess his sins pub-
licly and accept the penalty of the law. Shaw, however, is not at all
convinced of this. Preachments, in his view, only make the sinner more
stubborn and thereby retard the process of conversion. In his opinion,
the most effective witness to the truth in *The Power of Darkness* is the old
soldier, Mitrich. The scene between Mitrich and Nikita in Act Five is
for him the highlight of the play:

> One of the things that struck me in that play was that the preaching of
> the pious old father, right as he was, could never be of any use—that it
> could only anger his son and rub the last grains of self-respect out of

him. But what the pious and good father could not do the old rascal of a soldier did as if he was the voice of God. To me that scene where the two drunkards are wallowing in the straw, and the older rascal lifts the younger one above his cowardice and his selfishness, has an intensity of effect that no merely romantic scene could possibly attain; and in Blanco Posnet I have exploited in my own fashion this mine of dramatic material which you were the first to open up to modern playwrights.[12]

In the final section of the letter, Shaw points out that Blanco, in a rather crude form, to be sure, expresses the author's views on the nature of evil and on the fallible and evolving God who seeks to improve *homo sapiens* with each new generation. Since Tolstoy did not believe in a personal God or a God-creator, he did not find the concluding lines of Shaw's letter worthy of anything but the most casual attention.

His response to Shaw's remarks and his reaction to *Posnet* itself did not come until May of that year. The letter he finally wrote and sent, translated into English by his friend and collaborator, Vladimir Chertkov, was generally cordial and tactful:

> I have read your play with pleasure. I am in full sympathy with its subject. Your remark that the preaching of righteousness has generally little influence on people and that young men regard as laudable that which is contrary righteousness [sic] is quite correct. It does not however follow that such preaching is unnecessary. The reason of the failure is that those who preach do not fulfill what they preach, i.e., hypocrisy.[13]

In essence, Shaw is correct in underlining the uselessness of Elder Daniels' preaching because his blatant hypocrisy only delays the day of conversion, but he has no right to question the sermons of Akim, whose quintessential goodness inevitably has a salutary effect on his wandering son. Tolstoy is somewhat less discreet in his reactions to Shaw's concluding remarks about the character and the activity of God because no thinking person, he claims, believes in a loving creator and provider and because Shaw's ubiquitous humor tends in any case to trivialize all theological discussions.

That is the response Shaw received. What Tolstoy really thought of him, however, is only hinted at in his letter. Three years earlier, on January 12, 1907, he jotted down the following observation in one of his notebooks: "I've finished Shaw. *He has got more brains than is good for him.*"[14] In a diary entry for January 31, 1908, he used a much more sardonic tone: "I've been reading Shaw. His vulgarity is amazing. Not only does he lack a single thought of his own rising above the vulgarity of the urban throng, but he does not understand a single great idea of the thinkers of the past. The only thing that makes him special is that

he knows how to utter the tritest vulgarities in the most elegantly re-
fined, modern way, as if he were saying something unique and novel.
His main characteristic is a horrifying complacency matched only by his
complete philosophical ignorance."[15]

Tolstoy's true reaction to *Posnet* was equally ungenerous. On the
envelope of Shaw's letter he scribbled the words "intelligent-stupid," an
apparent indication of his view that while some of the ideas in the play
were good, they were obscured by an excess of foolishness. To one
associate he tersely described the play as "bad," while to another he
used such terms as "crude," "false," and "sentimental."[16]

Despite the less than amicable relationship between Shaw and Tol-
stoy and Tolstoy's refusal to acknowledge any genetic link between
Posnet and *The Power of Darkness*, there are unmistakable similarities
between the two plays. Some may be purely fortuitous and others quite
inconsequential, but the one-act melodrama is in several ways strongly
reminiscent of the five-act tragedy. The parallel is brought to mind in
the very settings of the plays. *Posnet* opens with the following stage
description: "A number of women are sitting together in a big
room. . . . The autumn sun is shining warmly through the windows and
the open door."[17] Similarly, Tolstoy's remarks before Act One, Scene
One of *The Power of Darkness* indicate that "the action takes place dur-
ing the fall in a large village."[18] On stage we see "Petr's spacious cot-
tage." In *Posnet* women are shucking nuts in the opening scene while in
Tolstoy's play Petr's wife and daughter are scutching hemp. In addition
to the general setting, certain motifs are common to both plays. Akim
and Mitrich make several references to the moral turpitude of village
life, and Blanco, whose favorite adjective seems to be "rotten," applies
that word both to his own life and to the circumstances in which others
live. One of his lines ("I left the town this morning before sunrise,
because it's a rotten town, and I couldnt bear to see it in the light" [p.
250]) not only echoes the theme of the moral decay of his surroundings
but with its interplay of light and darkness suggests the principal sym-
bolic motif of Tolstoy's drama. Moreover, the decidedly misogynistic
tone of *The Power of Darkness* is repeated in Blanco's contemptuous
remarks about "those scratching devils of women" (p. 256), who clamor
for his execution.

Yet the similarities of setting and tone are of secondary importance.
If strong parallels between the plays can be drawn at all, they must be
found in the characters themselves. The question, however, is: if Shaw
was consciously influenced by *The Power of Darkness*, which character or
characters played the most decisive role in the formation of his Blanco?
On the assumption that his letter to Tolstoy is to be taken at face value,
one would have to conclude that Mitrich is the main source of his

inspiration. It is Mitrich, he believed, with his coarseness and braggado-
cio, who persuades Nikita to repent, and not the pious Akim with his
powerless sermons.[19] Certainly the impudence of Mitrich's speech in
Act Five bears a certain likeness to the speech mannerisms of Blanco:
"A certain priest told me once that the devil is the worst bragger. As
soon as you start bragging, you get scared. And as soon as you get
scared of people, he grabs you and puts you where he wants to. But
I'm not afraid of people, so I'm all right. I sneeze at his beard and
shovel and his pig-mother. He won't do anything to me. Here, I say,
bite me" (p. 114). It is Mitrich's claim that people and their judgments
are not to be feared which most deeply impresses Nikita. When pressed
by the young protagonist for further encouragement, Mitrich replies:
"Why should you be afraid of them? They're just crap. Take a look at
them in the bathhouse. They're all made from the same dough. One's
belly is bigger; another's is smaller. That's the only difference among
them" (p. 114). Nevertheless, despite the devil-may-care attitude of the
retired soldier, there is little else which ties him to Blanco. If it is Shaw's
belief that Mitrich paves the way for Nikita's conversion, then whose
conversion does Blanco effect? To be sure, Feemy Evans, the town
prostitute, is deeply touched by the fact that Blanco has given up the
horse he had stolen in order to help a woman and her ailing child and
has thereby doomed himself to certain capture; and it is true that as a
result of his goodness, Feemy "goes soft" and testifies falsely in order to
save him. Yet she is hardly a major character in the play, and her
"conversion" is far from the center of the piece. Clearly the focus of the
action is Blanco himself and the events which guide him to his spiritual
transformation. In short, it is difficult to imagine why Shaw put such
stock in Mitrich—since the theme of the virtuous reprobate and the
moral efficacy of his actions was far from new in his plays. Further-
more, he is quite wrong in assigning Mitrich the crucial role in spurring
Nikita to confession and conversion. His folksy diatribe against fear
serves only as the immediate stimulus; the ultimate causes lie in the
promptings of Akim and the interrelationship between Nikita's heinous
actions and his profoundly sensitive nature. Indeed, the most interest-
ing similarities are those which exist not between the methods of moral
persuasion, but between the two heroes themselves.

When we first meet Blanco, Shaw labels him a "dandy." The same
word (in Russian, shchegol') appears in Tolstoy's description of Nikita.
From his first appearance Nikita lives up to our expectations of him: he
proves to be a thoroughly irresponsible young man with an insouciant
manner not unlike that of his Shavian counterpart. The image of the
"rope" is also common to the two men. When Blanco first appears, his
arms are bound by a rope; in Act Five of The Power of Darkness Nikita,

driven to despair by pangs of conscience, puts a rope around his neck
and prepares to hang himself. Both heroes are also given to reciting
lines of poetry at various points in their respective plays. Blanco, for
example, utters the following rhymed verses as a sarcastic sally against
the women of the town:

> Oh woman, in our hours of ease,
> Uncertain, coy, and hard to please—
> When pain and anguish wring the brow,
> A ministering angel thou.
>
> [pp. 249–50]

In Act Three of *The Power of Darkness,* in the midst of domestic turmoil,
Nikita recites a number of lines which sound like a mixture of precari-
ous contentment and *taedium vitae:*

> There are rolls on the stove,
> And porridge on the ledge,
> And we will live,
> And make merry,
> When death comes,
> We will die.
> There are rolls on the stove,
> And porridge on the ledge.
>
> [p. 81]

Apart from certain similarities between their modes of behavior, Ni-
kita and Blanco have apparently come to their present state by pursu-
ing a common course. In both cases, their moral downfall is attributed
to their relations with women. Although Elder Daniels is not the most
credible of witnesses, he nevertheless makes this detail of Blanco's biog-
raphy quite plain: "Did your holidays leave your character unspoiled?
Oh, no, no. It was theatres: it was gambling: it was evil company: it was
reading vain romances: it was women, Blanco, women" (p. 253). Nu-
merous details in *The Power of Darkness* point to the same source of
Nikita's dilemma. The biblical verses (Mt. 5:28–29) used as the epi-
graph to the drama contain the famous words about "lusting in the
heart," and the secondary title—*If the Claw Is Caught, the Whole Bird Is
Lost*—clearly refers to Nikita's gradual decline, which begins with his
seduction and abandonment of the peasant girl, Marina. His final line
in Act One—the concluding line of the act—attests to his ruinous ad-
diction: "I love these women like sugar. But sin with them and you're
in trouble" (p. 49).

The two heroes draw even closer to one another when one compares
the manner in which each arrives at the moment of his conversion. At
various moments in the play Blanco discourses on his attitude toward

God and toward the game which God allegedly enjoys playing with his creatures—particularly with those of his creatures who have strayed from the narrow path. To his brother he remarks: "He's a sly one. He's a mean one. He lies low for you. He plays cat and mouse with you. He lets you run loose until you think youre shut of Him; and then, when you least expect it, He's got you" (p. 254). Describing the moment of his capture, he says that he was caught "like a hare in a trap" (p. 273). The simile sounds very much like the secondary title of Tolstoy's drama, but there is an essential difference between them: for Blanco, the trap is set by God, while for Nikita, the trap is set by the devil. (Hence the theological dispute between Shaw and Tolstoy.) Blanco is being lured into a conversion; Nikita begins with fornication, falls into ever more serious sin, and ends up murdering his own child. The devil of lust has trapped him, and the forces of good—represented principally by Akim and Marina—must wage a vigorous struggle to reclaim his soul. Yet in the case of both conversions, despite theological disparities, the metaphor of the "trap" is pervasive.

The actual moment of Blanco's conversion is strikingly reminiscent of two of the principal elements in Nikita's. Blanco, in effect, allows himself to be captured when he gives up the horse to assist the woman and her child. The character in Tolstoy's play who corresponds to this mysterious woman is Marina. It is Nikita's abuse of her (in events antecedent to the main action of the drama) in Act One and her dramatic reappearance as a married woman in Act Five which give added momentum to a spiritual process already in progress. Realizing the evil he has done to Marina and contrasting her to the pernicious influences of his wife, Anisia, his step-daughter, Akulina, and his mother, Matrena, Nikita makes the following lament: "Oh, I saw her and I felt worse. The only life I had was with her. I've ruined my life for nothing; I've ruined myself. Where shall I go? Oh, mother earth, open wide!" (pp. 109–10).

The second element in Blanco's conversion which can be detected in *The Power of Darkness* is, of course, the role of the child. In Act Four, Nikita, who has fathered a child by Akulina, is persuaded by his wife and his eternally scheming mother to take the baby and kill it. The result is one of the most harrowing scenes in world drama, and Nikita's reaction to his crime only prolongs the agony of the moment: "What have they done to me? What have they done to me? How it squealed! And how the bones crunched beneath me! What have they done to me? And it's still alive, really alive! It's squealing. There, it's squealing" (p. 94). More than any other episode the scene of the infanticide brings the hero to his senses. In Act Five he is still talking about it and still imagining the cries of the child. Combined with the sermons of his

father, the meeting with Marina, and the advice given by Mitrich, the murder of his own offspring impels the fundamentally decent though weak Nikita to confess his sins to the entire community. Blanco's conversion, by contrast, comes about not through any mounting sense of guilt, but through a sudden awareness of his goodness. He comes to this self-understanding when he sacrifices his safety for the sake of the woman with the child. True, he curses himself for betraying his deservedly vile reputation, but he performs the deed nevertheless. At his trial, the woman describes him at his fateful moment of truth:

> The man looked a bad man. He cursed me; and he cursed the child: God forgive him! But something came over him. I was desperate. I put the child in his arms; and it got its little fingers down his neck and called him Daddy and tried to kiss him; for it was not right in its head with the fever. He said it was a little Judas kid, and that it was betraying him with a kiss, and that he'd swing for it. And then he gave me the horse, and went away crying and laughing and singing dreadful dirty wicked words to hymn tunes like as if he had seven devils in him. [p. 269]

When Blanco hears that, despite his best efforts, the child had died of the croup, he exclaims: "Dead! The little Judas kid! The child I gave my life for!" (p. 268). Shaw then adds parenthetically: "He breaks into hideous laughter." In Blanco's case, an act of kindness to the woman and the child makes him realize that God, or, to put it another way, the better side of his nature, has finally caught up with him. In Nikita's instance, acts of *cruelty* to a woman and a child clash so sharply with his essential self that his conscience ultimately brings him to his knees. The reactions to external stimuli are different, but the final result is presumably the same for both heroes.

Both *The Power of Darkness* and *The Shewing-up of Blanco Posnet* end with rather long, moralizing scenes in which Nikita confesses his sins and Blanco draws the moral conclusion from his experience. Nikita begs forgiveness of each of his victims individually (and in the process exposes the shame of Marina and Akulina) and finally turns to his father—clearly the central moral force of the drama—and says: "Dear father, you forgive me too, cursed though I am. You told me from the start, when I got involved in this debauchery, you said to me: 'When the claw is caught, the whole bird is lost.' Like a dog, I didn't listen to you, and it came out like you said. Forgive me, for the love of Christ" (p. 118). Blanco's remarks are less personal and more theological. He even announces his intention of drawing up the balance sheet of the play: "Boys, I'm going to preach you a sermon on the moral of this day's proceedings" (p. 272). And that is precisely what he does. Among other things, he expresses his contempt for conventional Christianity,

declares his self-loathing for allowing himself to "go soft," and analyzes the relationship between creator and creature in an important though execrably written passage:

> Whats this game that upsets our game? For seems to me theres two games bein played. Our game is a rotten game that makes me feel I'm dirt and that your all as rotten dirt as me. T'other game may be a silly game; but it aint rotten. When the Sheriff played it he stopped being rotten. When Feemy played it the paint nearly dropped off her face. When I played it I cursed myself for a fool; but I lost the rotten feel all the same. [p. 274]

At the conclusion he adds: "I played the rotten game; but the great game was played on me; and now I'm for the great game every time. Amen" (p. 275). The two speeches are radically different in content and tone (there is absolutely no humor in Tolstoy's play), but both heroes have arrived at the same end: Blanco on the path of good and Nikita on the path of evil.

The question of the extent to which Tolstoy's *The Power of Darkness* affected Shaw in *The Shewing-up of Blanco Posnet* defies a clear and precise answer. Some critics have simply assumed a considerable influence without further investigation.[20] Others, like Motyleva, see no similarity and judge *Posnet* to be "completely original both in subject matter and in form."[21] Still others are convinced that Shaw was more influenced by Shaw than by Tolstoy, that *Posnet* is a shorter, somewhat modified version of *The Devil's Disciple*. James Joyce held such a view: ". . . he has dug up the central incident of his *Devil's Disciple* and transformed it into a sermon. The transformation is too abrupt to be convincing as a sermon, and the art is too poor to make it convincing as drama."[22] Yet, Joyce and others notwithstanding, there seems to be little in common between *Posnet* and *The Devil's Disciple*. True, the theme of the virtuous reprobate figures prominently in both; but few of the details are parallel. Externally, *Posnet* is closer to *The Power of Darkness* than to Shaw's earlier play. It hardly seems justifiable, therefore, to rule out any influence on the part of Tolstoy. The similarities of plot and setting are simply too evident. In all probability, Shaw was indeed intent on writing a play in the vein of *The Power of Darkness*, and to that extent one can speak of influence. On the other hand, the influence was as much negative as positive. As Shaw's letter of February 14, 1910, reveals, he disagreed with the primal role of Akim in Tolstoy's drama, i.e., with the religious kernel of the entire play. If his Blanco is a mixture of Nikita's waywardness and Mitrich's defiance, then Akim must be compared with the loathesome Elder Daniels—a most unflattering comparison. *Posnet* is, at least in part, a *polemical*

piece, intended as a genteel response to the "error" of Tolstoy's drama. In Shaw's eyes, Akim is part of that abominable religious establishment that is utterly incapable of bringing about moral good. The good must come from the character himself, and in Shaw it is most likely to come from a character who is universally recognized as a blackguard. *The Shewing-up of Blanco Posnet* echoes *The Power of Darkness* in the details of its plot and setting, but its theological orientation underscores the basic and irreconcilable difference between Shaw and the Russian moralist.

Notes

1. David Matual is an Associate Professor of Russian at Wright State University in Dayton, Ohio.
2. *The Shavian Playground: An Exploration of the Art of George Bernard Shaw* (London: Methuen, 1972), pp. 2–3.
3. *George Bernard Shaw: Creative Artist* (Carbondale, Ill.: Southern Illinois Univ. Press, 1963), p. 81.
4. *Journey to Heartbreak: The Crucible Years of Bernard Shaw, 1914–1918* (New York: Weybright and Talley, 1971), p. 233.
5. Quoted in T. F. Evans, ed., *Shaw: The Critical Heritage* (London: Routledge & Kegal Paul, 1976), p. 203.
6. Ibid., p. 163.
7. *The Universe of G. B. S.* (1949; rpt. New York: Russel & Russel, 1968), p. 228.
8. *Bernard Shaw: A Reassessment* (New York: Atheneum, 1969), p. 166.
9. For an earlier reaction to *The Power of Darkness* and particularly for a polemic among Aylmer Maude, Max Beerbohm, and Shaw on the problems of translating foreign dramatists, see "Translating Drama: A *Saturday Review* Debate," *ShawR*, 4 (1961), 2–10.
10. *Bernard Shaw: Collected Letters 1898–1910*, ed. Dan H. Laurence (New York: Dodd, Mead, 1972), p. 900. For a thorough discussion of the relationship between Shaw and Tolstoy, see T. L. Motyleva, *O mirovom znachenii L. N. Tolstogo* (Moscow: Sovetskii pisatel', 1957), pp. 540–52.
11. *Shaw Letters 1898–1910*, p. 901.
12. Ibid., p. 900. The implicit opposition between Mitrich and Akim is a commonplace in Soviet criticism of *The Power of Darkness*. See, for example, K. N. Lomunov, *Dramaturgiia L. N. Tolstogo* (Moscow: Iskusstvo, 1956), pp. 137–38. Like Shaw, A. Ia. Gatenian gives Mitrich full credit for Nikita's conversion. See "Lev Nikolaevich Tolstoy," in *Klassiki russkoi dramy,* ed. N. A. Desnitskii (Moscow and Leningrad: Iskusstvo, 1940), p. 306.
13. Lev Nikolaevich Tolstoy, *Polnoe sobranie sochinenii*, ed. V. G. Chertkov et al., 90 vols. (Moscow: GIKhL, 1928–58), LXXXI, 254–55. The translation cited here is Chertkov's. All other translations from the Russian are my own.
14. Tolstoy, LVI, 179. The sentence in italics was written originally in English.
15. Ibid., pp. 97–98.
16. See Valentin Bulgakov, *L. N. Tolstoy v poslednii god ego zhizni* (Moscow: GIKhL,

1957), p. 183; N. N. Gusev, *Letopis' zhizni i tvorchestva L'va Nikolaevicha Tolstogo, 1891–1910* (Moscow: GIKhL, 1960), p. 755.

17. Shaw, *Complete Plays with Prefaces*, 6 vols. (New York: Dodd, Mead, 1963), V, 245. All subsequent page references to this volume will be given parenthetically in the text.

18. Tolstoy, *Sobranie sochinenii*, ed. N. N. Akopova et al., 20 vols. (Moscow: GIKhL, 1960–65), XI, 31. All subsequent page references to this volume will be given parenthetically in the text.

19. Mitrich is a very popular figure among Soviet critics. One of them even perceives a deep spirituality under the coarse exterior. See M. B. Khrapchenko, *Lev Tolstoy kak khudozhnik* (Moscow: Sovetskii pisatel', 1963), pp. 298–99. Lomunov compares him to the humble, heroic soldiers of the Caucasian tales, the Sebastopol stories, and *War and Peace*. See *Dramaturgiia L. N. Tolstogo*, pp. 130–31. But the principal reason for Mitrich's success in the Soviet Union is his comically naive and devastatingly apt descriptions of banks and other capitalist phenomena. I. N. Uspenskii calls him a "worker-satirist." See his "L. Tolstoy i russkoe krest'ianstvo," in *Izvestiia Akademii nauk SSSR: Otdelenie literatury i iazyka*, 12 (1953), 312. The pre-Soviet symbolist poet and critic Innokentii Annenskii, however, sees Mitrich as an image of "profound despair." See "Tri sotsial'nykh dramy—'Gor'kaia sud'bina,' Vlast' t'my,' 'Na dne,' " in *Knigi otrazhenii* (1906–1909; rpt. Munich: Wilhelm Fink, 1969), p. 126.

20. See, for example, Maurice Valency, *The Cart and the Trumpet: The Plays of George Bernard Shaw* (New York: Oxford Univ. Press, 1973), pp. 288–89; Eldon C. Hill, *George Bernard Shaw* (Boston: Twayne, 1978), p. 104.

21. *O mirovom znachenii L. N. Tolstogo*, p. 548.

22. Quoted in Evans, *Shaw: The Critical Heritage*, p. 199. See also Eric Bentley, *Bernard Shaw: 1856–1950* (New York: New Directions, 1957), p. 133; Irvine, p. 228.

Valli Rao[1]

BACK TO METHUSELAH: A BLAKEAN INTERPRETATION

I see the Past, Present & Future existing all at once
Before me. O Divine Spirit, sustain me on thy wings,
That I may awake Albion from his long & cold repose;
For Bacon & Newton, sheath'd in dismal steel, their terrors hang
Like iron scourges over Albion: Reasonings like vast Serpents
Infold around my limbs, bruising my minute articulations.

William Blake, *Jerusalem* Plate 15

I

The steadily increasing recognition that Shaw is a serious religious artist acts as a much-needed corrective to erroneous representations of him as a rationalist, or a comic writer, or a dramatist who merely plays with ideas and has no consistent point of view. Similarly, the critical recognition in the twentieth century that William Blake's art shows him to be a systematic and intelligent recreator of archetypes destroys the superstitious opinion of him, especially in the role of the author of the "Prophetic" books, as a mad mystic who rejected all things pertaining to materialism, form and order. As both writers have been increasingly recognized for the well-balanced artist-philosophers they are, critical opinion has correspondingly opened its eyes to the kinship between them that is emphasized by Shaw's own direct references to Blake in his writings and, more to the point as regards this essay, by a comparative study of their works.[2]

My purpose here is to show that the religious implications of *Back to Methuselah* are understood well when the play is analyzed in terms of Blake's *Jerusalem,* and when we see that a major concern of Shaw's play, like that of Blake's poem, is to recreate biblical stories so as to make them "live again"[3] for audiences of their time. *Back to Methuselah* is Shaw's magnum opus, and essential for understanding his religious

vision, as has been recognized by some critics.[4] In the main, however, it is still Shaw's least liked and least understood major play. Even critics who defend Shaw's art and philosophy in his other plays find *Back to Methuselah* acceptable only as his worst play.[5] A reading of *Back to Methuselah* in terms of Blake's magnum opus, *Jerusalem*, will, I hope, contribute towards a better understanding of the play that Shaw in 1944 chose as his "world classic."

II

> ... the votary of Creative Evolution goes back to the old and very pregnant lesson that in the beginning was the Thought; and the Thought was with God; and the Thought *was* God, the Thought being what the Greeks meant by "the Word". He believes in the thought made flesh as the first step in the main process of Creative Evolution. He believes in a New Jerusalem, and resolves, like Blake, that he will not cease from mental fight nor shall his sword sleep in his hand till he has built that paradise in England's green and pleasant land. [Postscript to *Back to Methuselah*]

Back to Methuselah (written between 1918 and 1920) and *Jerusalem* (written between 1804 and 1820) are protests against the deterministic and mechanistic religionlessness that led to the wars immediately preceding the writing of both works. Shaw and Blake fit that lack of religion into their visions of the world's history seen in terms of the biblical myth of man's fall from Eden and, most importantly, they show their warring contemporaries where to look for a vital religion that will redeem the world. The biblical story of man's fall and redemption is interpreted in an identical spirit by Shaw and Blake, and the "system" that Blake creates out of his reading of the story may be used profitably to analyze Shaw's understanding of it too. The Blakean interpretation of biblical archetypes involves so rich and strange a transformation of the orthodox understanding of them that a sketch of its main outline must be given before we go on to study *Back to Methuselah* in terms of *Jerusalem*.

The starting point in Blake's myth is that Albion (who represents all mankind) has his spiritual existence in the Word of God. In his unfallen spiritual wholeness he lives in Eden, where there are two regions, one the City of God (which is Jerusalem) and the other the "garden of God."[6] The two are analyzed by Northrop Frye: "a sunlit city and a moonlit garden, a golden summer of energy and a silver winter of repose."[7] The city of Eden symbolizes action and creation. Here the imagination of man revels in the mental Hunting and War which are "the two sources of Life in Eternity" (*J* 38:31; cf. *Milton* 35:2). The moonlit garden symbolizes contemplation, and admiration for what has

been created, and repose during which energy is gathered for further creation. This garden is the Garden of Eden described in Genesis, and called Beulah in Blake. It is, as we shall see, the place where the physical body of man, along with the world of nature, is created.

Both the active and the passive phases of Eden are essential for the imagination which creates. But in Beulah, creation is viewed as separate from creator, and there is the danger that if Albion reposes too long in this state, the passivity of his creative imagination will lead to spiritual sleep. The fall of man is Albion's fall from Edenic creativity to passive contemplation when he stays too long in Beulah. One important consequence of the fall is the illusory appearance of a non-human power outside Albion's mind, and Albion's worship of that power. He begins to worship an external God, forgetting that the kingdom of God is within him. With his fall, "the Starry Heavens are fled from the mighty limbs of Albion" (*J* 27). Albion's senses "behold what is within now seen without" (*The Four Zoas* II:54–55). In Eternity, Albion's emanation (his feminine counterpart) is part of him: "In Eternity Woman is the Emanation of Man; she has No Will of her own. There is no such thing in Eternity as a Female Will" (*A Vision of the Last Judgment,* p. 85; Keynes, p. 613). With the Fall, his emanation appears as an external Nature instead of as his creation. In this context, Frye writes:

> There are several accounts of the Fall in Blake . . . the invariable characteristic of them is Albion's relapse from active creative energy to passivity. This passivity takes the form of wonder or awe at the world he has created, which in eternity he sees as a woman. . . . Once he takes the fatal step of thinking the object-world independent of him, Albion sinks into a sleep symbolizing the passivity of his mind, and his creation separates and becomes the "female will" or Mother Nature, the remote and inaccessible universe of tantalizing mystery we now see. [*Fearful Symmetry,* p. 126]

In Eternity, Albion exists in a fourfold wholeness represented by the harmonious existence of the four Zoas in him. They are, in Blake's myth, "the Four Eternal Senses of Man" (*J* 36, 98) and "the Four Rivers of the Water of Life" (*J* 98). In *The Four Zoas,* Albion's fall is seen in terms of his dismemberment through the fall of his Zoas into disunity and war. Thomas R. Frosch explains how

> [Albion's] fall takes the form of a compartmentalization of his body into the fundamental energies, or Zoas, that together, like a chariot, once bore his existence "from Eternity to Eternity." Now, in their fragmentation, these energies—Orc-Luvah (the emotional faculty and the sense of smell), Los-Urthona (the imagination and the sense of hearing), Urizen (the analytical intellect and the sense of sight), and Tharmas (the sense

of touch and the body as a functioning unit)—go their separate ways as the clashing dimensions, categories, and ideologies of fallen history, as well as its emotional conflicts and its wars. When the Giant Forms renounce their participation in Albion's unity, the capability of each is reduced to his own selfhood, or spectre, and the cosmic man is left powerless, asleep on his rock, the geographical England, in the middle of the ocean. . . . Blake associates each Zoa with a female form, or emanation, who embodies the achievement of his energy: Vala, the relationship of Luvah; Enitharmon, the creation of Los; Ahania, the comprehension of Urizen; and Enion, the act of Tharmas. In their unfallen integration, these four are the members of Jerusalem, the emanation of Albion's risen body, or his total liberty and fulfillment. But when the Zoas separate from Albion and from each other as spectres, the emanations fall away from Jerusalem to become what Blake calls shadows . . . once the emanation is separated from the Zoa, she assumes a life and initiative of her own, gaining primacy over the spectre, who is suddenly confronted with an otherness completely independent of himself: the shadow of Jerusalem, or man's creative liberty, is Rahab-Babylon, or man's enslavement to nature.[8]

A fallen Zoa in his spectral state represents qualities which are directly opposed to those he represents in his unfallen state. Urizen, as Nights III and IV of *The Four Zoas* detail, falls from a state of intellect or reason to its opposite, false reason or ratiocination. Luvah, who represents man's "capacity for love and joy" (*Fearful Symmetry*, p. 274) initiates the fall when he externalizes and loves passively his emanation Vala, the goddess Nature whose name Blake used as the original title of *The Four Zoas*. Tharmas in Eden is man's power to create life. At his fall in Beulah, his emanation Enion separates from him and he becomes the Spectre of Tharmas who draws man toward total material chaos, the waters of death and annihilation. The fourth Zoa, Urthona, appears in the fallen world as Los. The development of Blake's concept of Los, and Los's relationship with his emanation Enitharmon (who represents the Female Will) and his Spectre (the Spectre of Urthona, as he is generally called), is a good illustration to demonstrate how Blake's vision, like Shaw's, is never static: they work and rework their archetypes continually, according to their developing visions.

The early Blake and Shaw view the Female Will as the power that keeps man imprisoned in the natural world and prevents his return to spiritual life in Eden.[9] Gradually, as their artistic visions mature, Blake and Shaw work their way to the view that the natural world represents not merely the destructive Female Will who prevents man's ascent to the unfallen world; they see her as also being the redemptive power who, by keeping man in the fallen, natural world of time and space, prevents him from falling beyond the natural world into chaos or Non-

Entity, and allows for evolution towards the unfallen world. These two aspects of the Female Will are first clearly discerned by Blake and Shaw by the time they have written *The Four Zoas* (ca. 1796–1807) and *Man and Superman* (1901–1903) respectively.

In *The Four Zoas*, Blake comes to see Los as the regenerative power in the world of time and space, where he works to rebuild the body of Albion from the fallen natural life he now is, back to eternal life. The world of space is represented by Enitharmon, that of time by the Spectre of Urthona, and *The Four Zoas* sees that both are constructive only insofar as they work in subservience to Los; conversely, Los is constructive only when he works in control of Enitharmon and the Spectre, making them co-operate with his will and do his bidding. When not subservient to Los, Enitharmon works with the Spectre of Urthona. Then she represents the independent Female Will who, in the form of the material world that stretches endlessly in space and surrounds man, strives to maintain endlessly recurring cycles of natural life bound to the "vegetable world" as Blake calls it in his *Descriptive Catalogue* (Keynes, p. 570). Violet in *Man and Superman* is the Shavian counterpart of the independent Female Will in *The Four Zoas*. Her attitude to her lover and husband Hector is the attitude of the Female Will who wants man to be a child in her hands for ever: she wants Hector as a domestic pet rather than as a working man ("Do you mean to work? Do you want to spoil our marriage?" she asks, in Act II), spending his energy in passive worship of her as the goddess Vala rather than in the active pursuit of man's aspirations towards spiritual life.

In contrast to the independent Female Will who wants to keep man in nature for ever, is Enitharmon in *The Four Zoas* when she works with Los to provide protective spaces for the fallen Albion: in this circumstance, natural life becomes an act of mercy which protects man from further fall (towards chaos) and which allows for the redemption of man back to eternal life. This is the situation in which Los, in Chapter I of *Jerusalem*, builds the redeeming world of Generation to limit man's fall into the unmeasurable and indefinite chaos where Albion's members murder one another; and we will see that it is also the spirit in which Part I of *Back to Methuselah*, "In the Beginning" (set in the Garden of Eden), deals with the establishment of the redemptive miracle of natural sex, birth and death in the midst of unbounded time and space and war.

According to the Blakean myth, when natural life is a redemptive factor in the fallen world then the spirit of Jesus, working through Los, establishes the Limit of Opacity and the Limit of Contraction, which are the lowest limits to which man can fall in death and life respectively

(see *The Four Zoas* IV: 271–73; *Milton* 29; *J* 35, 42). Los "binds" Urizen and gives him the form of Satan or death, the lowest form to which life can sink before being renewed again. The Limit of Contraction is Adam, or life on the natural plane, the lowest limit to which Albion can descend in his fallen life. Fallen man, living and dying as the physical body, is Orc or Luvah, and natural life is maintained in successive Orc-Urizen cycles of life and death in the world of Generation. One of the crucial ways in which natural life, maintained by the Female Will under Los's guidance, provides the point of redemption from flesh to spirit, is that it allows for the evolution of Jesus "in the Robes of Luvah" (that is, as fallen man), who comes to the fallen world to redeem the sleeping Albion (see *The Four Zoas* VIII: 182–97; 260–65). Ann White-field and Ana in *Man and Superman* are representative of the benevolent Female Will working with Los (that is, for the Shavian Life Force), and the breeding of the superman is the counterpart of the birth of Jesus in our world of Generation.

Every one of Los's imaginative creations, achieved with the help of his emanation and spectre, contributes to the building of Golgonooza. Golgonooza is Los's City of "Art & Manufacture" (*Milton* 24) and "it contains, or consists of, the physical bodies of man and woman."[10] Los is the artistic and evolutionary urge in mankind, and to say that he must work with his spectre and emanation, in time and space, means that in the fallen world these forces must work with material and natural forces, the spiritual must find expression through the material, and eternity must work through time and space for there is no other outlet for it as long as the world is a fallen one. We have so far discussed chiefly Los's building of Golgonooza with the help of his emanation. Blake conceives of the notion of the Spectre of Urthona for the first time as he writes *The Four Zoas* (Shaw's "New Man" Enry Straker is the parallel in *Man and Superman)*, and in the process of writing the poem he deepens his understanding of this concept, see-ing the vital importance of the fact that Los must work in space (with Enitharmon) as well as in time (with the Spectre of Urthona). Golgo-nooza is always built with the help of both spectre and emanation, but the emphasis shifts from Los's relationship with his emanation to Los's relationship with his spectre, between the writing of *The Four Zoas* and *Jerusalem.* We will note later how a similar shift is involved in Shaw's use of the superman myth in *Man and Superman,* and the longevity myth in *Back to Methuselah.*

For the sake of understanding the significance of the myth of longev-ity in *Back to Methuselah,* it is valuable to understand clearly the role of the Spectre of Urthona in Los's schemes for the redemption of the fallen Albion. Frye in *Fearful Symmetry* (pp. 292–99) provides a basic

account of the Spectre of Urthona as clocktime and as the will, an account which is useful for understanding the parallel between Los's working with his spectre in *Jerusalem* and Franklyn's working with Conrad in *Back to Methuselah.* Frye explains how Los represents an imaginative concept of time and his spectre represents an abstract concept of time, clocktime: the Spectre of Urthona "is that aspect of existence in time which is linear rather than organic or imaginative. If one had to pin the conception down to a single word, one might call Blake's Spectre of Urthona the will" (*Fearful Symmetry,* p. 292). The Spectre, Frye goes on to explain, is an instrument which, when not controlled by Los as man's Imagination, is automatically attached to Luvah as man's Selfhood (the state of Satan or death, as *Milton* 29 and *Jerusalem* 33 and 48 inform us):

> . . . there is a perpetual conflict between the imagination [Los] and the will [The Spectre of Urthona] to prevent the latter from deserting to the Selfhood, and there can be no free will . . . as the will must be attached to one or the other . . . The Spectre of Urthona, properly controlled, is the obedient demon who brings his master Los the fire and metals and other physical needs of culture, and brings the artist his technical skill. Whenever Los has a higher status for man in view the Spectre produces the appropriate tools, an alphabet, a printing press, a wheel or a compass. But once separated from creative and imaginative ends, the instrumental becomes an end in itself. . . . Energy becomes linear and formless, directed along the clock time of fallen life, and as that time is pitifully short, the Spectre crowds Los out, takes charge of civilization and drives it along in a steadily accelerating stampede of hysterical fear. [*Fearful Symmetry,* p. 294]

We have noted that the creation of Straker in *Man and Superman* represents the Shavian recognition of the concept of the Spectre of Urthona. He is a symbol of the Spectre of Urthona not under the control of the Imagination, and as such attached to the natural man. Straker driving furiously over unending stretches of miles with his terrified employer in the back seat is a perfect symbol of the Spectre of Urthona racing through clocktime. Straker is the Spectre who is not guided by Los to use his ability; a good craftsman left without guidance, the height of his destiny is breaking motoring records, a symbol of the suicidal waste of energy with which the Spectre, to complete the quotation from Frye above, "drives [civilization] along in a steadily accelerating stampede of hysterical fear . . . [a fear which] is fundamentally the panic inspired by clock time, the Chronos who devours his children" (*Fearful Symmetry,* p. 294). We have not space here to discuss how Blake's changing attitude to Urizen and the Spectre of Urthona in *The Four Zoas* is also part of Shaw's developing vision in *Man and Super-*

man, as Ramsden and Straker, opponents of Tanner-Orc, are trans-
formed into the Statue who is subservient to Juan-Los in the Hell
Scene. It is appropriate to note here, however, that the idea of the
Spectre of Urthona as an instrument that works for both Los and the
Selfhood, an idea that is one of the central themes in *Jerusalem* and *Back
to Methuselah,* has its germ in *The Four Zoas* and *Man and Superman.*

The state of Selfhood or Satan is represented in *Back to Methuselah* by
Neo-Darwinism and in *Jerusalem* by Newtonian materialism, and the
attempt in both works is to make the Spectre of Urthona serve man's
imaginative and evolutionary appetite rather than the Newtonian or
Darwinian Selfhood. Shaw champions the religion of Creative Evolu-
tion against the Neo-Darwinian religion of Circumstantial Selection (as
Shaw prefers to call what is usually called Natural Selection) prevalent
in his day, just as Blake in *Jerusalem* puts the case for his vision of
Christianity against the Newtonian and Lockian Deism that prevailed in
his day. Essentially, Shaw's and Blake's attitudes to Newton and Darwin
as the Selfhood are identical.[11] Neither rejects his antagonist outright.
Both accept the observations of their antagonists, Blake that there ex-
ists in the fallen world a vast spatial Nature around man, and Shaw that
natural life and habits evolve in time. But both point to the absence of
an intelligent agency in their antagonists' philosophies regarding Na-
ture, and both try to show how they could be modified so as to provide
men with a sense of religious purpose and faith which alone can, in
Shaw's and Blake's views, lead to a better world.

In the Preface to *Back to Methuselah,* Shaw calls Darwinian Natural
Selection "nothing less than the bottomless pit, now [with Neo-
Darwinism] become a very real terror."[12] The angel of the bottomless
pit, called Apollyon in Revelation (9.11), is one of the dark disasters
that appear before the dawn of apocalypse. Bunyan's account in *The
Pilgrim's Progress* of how Apollyon nearly overcomes Christian in the
Valley of Humiliation, before Christian at the last minute wounds
Apollyon with his own sword, no doubt influenced both Shaw and
Blake, with their Apollyon being, in Shaw's case Neo-Darwinism and in
Blake's case Newtonian Deism. Los sees

> . . . the finger of God go forth
> Upon my Furnaces from within the Wheels of Albion's Sons,
> Fixing their Systems permanent, by mathematic power
> Giving a body to Falsehood that it may be cast off for ever,
> With Demonstrative Science piercing Apollyon with his own bow.
> [*J* 12]

Apollyon's bow is a symbol of the Spectre of Urthona who belongs
naturally to the Selfhood (Apollyon) but may be used with equal skill by

Los (Bunyan's Christian). In the context of *Back to Methuselah,* the biologist August Weismann (that is, his theory of Death as a result of Circumstantial Selection) is by nature Neo-Darwinian but used skilfully by Shaw *against* Neo-Darwinism, as we shall see in the course of this essay.[13]

Los's working with the Spectre of Urthona and the Selfhood to give "a body to Falsehood that it may be cast off for ever" involves the triumph of materialism up to the point where it defeats itself by revealing itself as error and its opposite as truth. This is one of the ways through which Jesus redeems Albion, in Blake's myth. We have seen that in the fallen world, eternity must work in time and space, and Jesus' coming to the world as natural man is symbolic precisely of this. Jesus is killed as an Orc figure and then the body crucified on the "Tree of Mystery" (*The Four Zoas* VIII: 326) is worshipped as God, although it represents the material body of death which is in reality the Selfhood and Antichrist (*J* 89). Blake sees the dead body on the cross as worshipped first by the orthodox religionist in the name of Mystery, then by the Deist in the name of natural religion and natural morality, and lastly worshipped unashamedly and openly in the name of Antichrist and complete materialism. When it is clearly seen as Antichrist, then Albion clearly recognizes its opposite, Christ. Such a recognition is based on the principle which Frye calls an "analogy" (based on Blake's use of the term "Divine Analogy" in *Jerusalem* 49:58, 85:7) to explain how

> the Selfhood sets up a parody of the imagination. The physical fight of the hero parodies the mental fight of the artist; the jealous wife and teasing mistress parody the emanation; money and morality parody the community of minds; the ghost or nightmare parodies the vision. This pattern of superficial resemblance combined with profound contrast, the illustration of the doctrine that truth clarifies error into the negation of itself, reaches its culmination in the parody of Christ [the living Word of God] by Antichrist [the dead body on the cross]. [*Fearful Symmetry,* p. 78]

Much of Chapter 11 of *Fearful Symmetry* (see pp. 382–403) is devoted to explaining clearly the significance of the "analogy" as "a parody or inverted form of the imaginative world" and a "mirror-image, 'Vegetable Glass' as Blake calls it [*A Vision of the Last Judgment,* pp. 69–70], of the world of mental reality." The more clearly this Vegetable Glass reflects an error, the more clearly it reveals the opposite truth, and when it clearly reflects Antichrist, it clearly reveals the Christ of whom Antichrist is an "analogy" or demonic parody. Then the dead body of Jesus is seen as representing the Selfhood of man, whose ultimate form Blake identifies as the biblical Covering Cherub (*J* 89, 96). In *Jerusalem,*

the Covering Cherub's form discloses that behind its militant front is contained Rahab, the independent Female Will who is the natural world at the heart of Antichrist, and who is an "analogy" of Jerusalem, the bride of Christ.

At the end of *Jerusalem,* Albion is redeemed from worship of the dead Satanic body which he had mistaken for the true Jesus. He sees that the true God is not the historical Jesus who was crucified as Orc and whose physical resurrection is believed in by the orthodox religionist; he is, rather, the Holy Word whose agent in the fallen world is Los, the creative spirit of man which recreates the spirit of the prophet Jesus in the life of man. A clear vision of Antichrist leads to a clear vision of Christ and to apocalypse which, in Blake, involves the transformation of the natural world into the spiritual world. A relevant point is that in *Europe* (written in 1794) Blake makes Newton blow the trumpet which heralds the Last Judgment and the end of the natural world (*Europe,* Plate 13). This is representative of the fact that complete materialism must, at its extreme, will its own destruction and herald its opposite. We will see towards the end of this paper how the bodies of the longliving Ancients in Part V of *Back to Methuselah* form the "analogy" of the immortal spiritual body and how longevity, when carried to its extreme, reveals to the Ancients that the time has come for getting rid of the limitations of the natural body. In Blakean terms, the secret of Shaw's use of the longevity myth lies in this, that longevity as the Spectre of Urthona is necessary for Los's evolutionary work in time: it must be used by Los for the redemption of mankind although it belongs naturally to the Longlivers. The Longlivers themselves represent the apparent triumph of the Darwinian Selfhood, although in reality they constitute an "analogy" of the "eternal life" (p. 243) towards which mankind strives in *Back to Methuselah.*

<center>III</center>

In *The Quintessence of Ibsenism* Shaw had distinguished between the will as "Original sin" when doing mischief and as "Divine grace" when doing good (*Major Critical Essays,* p. 20). This distinction explains roughly the difference between Circumstantial Selection and Creative Evolution, a difference which is brought out in *Back to Methuselah,* and reinforced by Shaw's explanations in the Preface to the play. Explaining the Darwinian Evolutionist's theory that giraffes have long necks because at a critical point the short-necked ones grew weaker and died as they could not reach foliage, and the long-necked ones survived as they had food (and therefore their progeny had the strength to grow even longer necks, to reach more food), Shaw writes:

This process, by which the species gains, say, an inch in reach, will repeat itself until the giraffe's neck is so long that he can always find food enough within his reach, at which point, of course, the selective process stops and the length of the giraffe's neck stops with it. Otherwise, he would grow until he could browse off the trees in the moon. And this, mark you, without the intervention of any stock-breeder, human or divine, and without will, purpose, design or even consciousness beyond the blind will to satisfy hunger. It is true that this blind will, being in effect a will to live, gives away the whole case; but still, as compared to the open-eyed intelligent wanting and trying of Lamarck, the Darwinian process may be described as a chapter of accidents. [Preface, pp.xxxix–xl]

The will, in Circumstantial Selection, is thus seen as attached to the natural appetites of a physical body, or as Blake would term it, the Selfhood. This attitude to the will restricts it to being the tool of man as a creature preoccupied solely and greedily, and blindly, with day-to-day survival in a world of accidents. Mental effort is reduced to unconscious reactions, man to a "mere automaton," and a case may be made for even "the evolution of an automatic Jesus or Shakespear" (p. xlvii).

The Creative Evolutionist's belief is that "the will to do anything can and does, at a certain pitch of intensity set up by conviction of its necessity, create and organize new tissue to do it with" (p. xvi). "The old saying, 'Where there is a will, there is a way,' condenses Lamarck's theory of functional adaptation [now called Creative Evolution] into a proverb" (p. lvii). This will is the will in the control of the Blakean Divine Imagination as opposed to the Selfhood. Shaw explains the working of this in himself as a creative writer:

> . . . I do not regard my part in the production of my books and plays as much greater than that of an amanuensis or an organ-blower. An author is an instrument in the grip of Creative Evolution [the Will of God], and may find himself starting a movement to which in his own little person [the Selfhood], he is intensely opposed. [p. 257][14]

Similarly, Blake sees his Saviour "dictating the words" of *Jerusalem*, and asks him to annihilate the Selfhood in him (*J* 5). Both Shaw and Blake consider themselves in the line of prophets inspired to reveal the Word of God.

Self-control is control of the will that automatically and naturally attaches itself to Luvah as the Selfhood. The Creative Evolutionist stresses self-control as the greatest of all qualities for survival:

> Uncontrolled qualities may be selected for survival and development for certain periods and under certain circumstances. For instance, since it is the ungovernable gluttons who strive the hardest to get food and drink,

their efforts would develop their strength and cunning in 'a period of
such scarcity that the utmost they could do would not enable them to
overeat themselves. But a change of circumstances involving a plentiful
supply of food would destroy them. . . . But the self-controlled man
survives all such changes of circumstance, because he adapts himself to
them, and eats neither as much as he can hold nor as little as he can
scrape along on, but as much as is good for him. . . . [Self-control is] a
highly developed vital sense, dominating and regulating the mere appe-
tites. To overlook the very existence of this supreme sense; to miss the
obvious inference that it is the quality that distinguishes the fittest to
survive; to omit, in short, the highest moral claim of Evolutionary Selec-
tion: all this, which the Neo-Darwinians did in the name of Natural
Selection,[15] shewed the most pitiable want of mastery of their own sub-
ject. . . . [Preface, pp. li–liii]

This concept of the will as an instrument working for the Imagina-
tion and thus providing for Creative or Christian Evolution takes us to
the heart of the parallel between Chapter II of *Jerusalem* and Part II of
Back to Methuselah, "The Gospel of the Brothers Barnabas," the first
part of the play to be written. The identification of the Spectre of
Urthona as a symbol of linear time or clocktime, and the identity of
that with the will (which, in the abstract, exists in linear time but not in
space) is evident in *Back to Methuselah* as in *Jerusalem*.

England during the Napoleonic wars and England during World
War I are both, figuratively, in the terminology of *Jersualem*, Albion
"sick to death" (*J* 40). Los calls for help for the diseased Albion. Re-
sponse comes from the four chief Cathedral Cities, who represent the
Church of England (as Foster Damon explains in *A Blake Dictionary*, p.
71). They are the English version of the four Zoas (see *J* 59) and
contain within them the rest of the twenty-four Cathedral Cities, who
correspond to the twenty-four elders around God's throne in Revela-
tion. In their eternal form they are one in Jesus (*J* 40), but in their
earthly form they come trembling and unwilling to suffer for Albion's
sake. Their counterpart in *Back to Methuselah* is Bill Haslam, a good-
natured but totally helpless clergyman in "The Gospel of the Brothers
Barnabas," who has watched the 1914–18 war with the same helpless
attitude in which he sits through the long conversation during which
the Barnabas brothers attempt to convert the politicians to a responsi-
ble religion.

When the Cathedral Cities fail to help, Los, who of course has him-
self been part of the four chief Cathedral Cities or Zoas, rages against
them. Similarly, Franklyn Barnabas, the ex-clergyman, is critical of the
Church after having been a clergyman himself. The Cathedral Cities,
urged by Los's words, try forcibly to bring back Albion from Ulro (the

Blakean hell) to Eden, against his will. They do not succeed, as "the Will must not be bended but in the day of Divine Power,"[16] that day being the day when "Jesus shall appear" (*J* 44:18–19, 30) at his Second Coming. Meanwhile Albion's life must continue in the world of Generation for

> Such is the nature of the Ulro, that whatever enters
> Becomes Sexual & is Created and Vegetated and Born.
> [*J* 44:21–22]

And Los as the "Spirit of Prophecy" is appointed to watch over all in the state of Generation. Los's attempt at persuading the Cathedral Cities to force Albion against his will into Eden is a mistaken and premature move: he cannot jump clocktime (that is, ignore the Spectre of Urthona) and establish the City of God. What he must do is control the will of man imaginatively in the fallen world. The Spectre of Urthona, as will and clocktime, thus plays a crucial part in the scheme of redemption. Los cannot do anything constructive without him (as we have seen in Section II above); he must continually work to draw him away from the Selfhood, and insofar as Los and not the Selfhood controls the Spectre of Urthona, the latter allows for evolution in time—Creative Evolution, as Shaw calls it when he speaks of control of the will.

This is what Los is shown doing in the remainder of Chapter II of *Jerusalem,* and it is what Shaw's prophet Franklyn Barnabas does when he preaches the necessity of willing to live longer. Franklyn and his biologist brother Conrad, in Part II of *Back to Methuselah,* make "their famous attempt to persuade our political leaders in the first years after the war to discard their obsolete party programs and raise the slogan of Back to Methuselah" (as Shaw summarizes it in "A Glimpse of the Domesticity of Franklyn Barnabas").[17] Franklyn is an "impressive-looking gentleman of 50" with an "air of personal distinction" and of clerical dignity, Conrad has "much less style in his bearing and carriage" (p. 37). Franklyn and Conrad attempt to make "this withered thing religion, and this dry thing science" come alive in their religion of Creative Evolution, and in this process they bear the same artist-craftsman relationship to each other that Los and his Spectre bear when they work together at Los's forge to awaken Albion. The Spectre is Los's "own brother and other self"[18] and Los's "craftsmanship,"[19] and the "Reasoning Power" (*J* 10) who must be subservient to the creative and imaginative power of Los if he is to work for the benefit of mankind, as he does when he helps Los to construct Golgonooza and the "Spaces of Erin" (the whole world of Generation) in *Jerusalem* (see *J* 6–12) and as Conrad works in Part II of *Back to Methuselah* with Franklyn-Los.

The Los-Spectre relationship is also echoed by Franklyn-Conrad in "A Glimpse of the Domesticity of Franklyn Barnabas" and again in the Shaw-Weismann relationship in the Preface. In the opening sentence of his introduction to "A Glimpse of the Domesticity of Franklyn Barnabas," Shaw clearly speaks of Franklyn as the chief exponent of the longevity theory, with his "gruff brother Conrad, the biologist" as helper. And Mrs Etteen, the husband-stealer who is interested in Franklyn's religion, tells Immenso Champernoon (G. K. Chesterton):

> Conrad never saw the scope of his idea [of longevity] any more than Weismann, from whom he got it. He saw how it affected science: he knew that he had to die when he was just beginning to discover what science really is, and had just found out that the experience of people who die at seventy is only a string of the mistakes of immaturity. He had the skeleton of the great faith; but it was Franklyn who put the flesh on it. [p. 258]

In the Preface Shaw explains how his theory of Voluntary Longevity was based on a suggestive observation by Weismann (pp. xvi–xvii), and also how the same Weismann was capable of blind cruelty when his philosophy was dissociated from imagination (see pp. xlix–l). How this is parallel to the unimaginative malevolence of Barnabas in Part III, and the malevolence of the Spectre when separate from Los's imaginative control, we will discuss later.

Shaw could not have chosen a better legend than that of longevity through subconscious willing to emphasize, in the first place, the Blakean notion that any scheme for redemption must involve Los with the Spectre of Urthona; and, in the second place, that Creative Evolution occurs only insofar as the Spectre of Urthona is attached to Los rather than to the natural man. Lengthening life to three hundred years is symbolic of a first step in emancipation from the natural cycle of life-and-death, of growing from an infancy dependent on Mother Nature to an adulthood where Nature is man's emanation and totally controlled by him (this is the aim of Creative Evolution, Shaw says in the Postscript; see p. 263). Shaw does not say that because man lives longer he grows wiser. He says that the longer life must be wrested from Nature because man's mind has more potential for wisdom and he needs a longer existence in physical time and space to realize his potential. Adam, with his mental capacity, was bored with the length of his life, as he had not enough intellect to occupy his time, which meant that the longer life only symbolized the power of the Spectre of Urthona over him, so that death was a blessing. As man's mind becomes more capable of thought, he finds that death comes too soon, and that he must extend his natural life-span. In Blakean terms, this means that

as the power of Los grows, Enitharmon (space) and the Spectre Clock-time must be increasingly subject to him. We have seen briefly in Section II that the same Blakean notion underlies the superman myth in *Man and Superman,* and now we are in a position to see that the legend of longevity is an alternate form of the Creative Evolutionist's belief in the breeding of the Superman: both involve the building of Golgonooza by Los working with his spectre and emanation. It is also worth noting here that in *Back to Methuselah* Shaw does not ignore the superman myth that a higher breed of man must be born of Woman. In the context of the entire play, Lilith is the Mother who strives to bring forth Adam, and then watches over the Adamic man's transformation, through various stages, into a Thought vortex. The woman plays her constructive part in the scheme of Longevity, as we see, for example, if we extend our quotation from "The Domesticity of Franklyn Barnabas," where Mrs Etteen says Conrad "had the skeleton of the great faith; but it was Franklyn who put the flesh on it. And it was I, the woman, who made that flesh for him out of my own. That is my relation to Franklyn."[20]

Once we have grasped the importance of the role of the Spectre of Urthona in Los's scheme for redemption, the theme of longevity in *Back to Methuselah* does not puzzle us as it has puzzled many critics. J.L. Wisenthal is apologetic on behalf of Shaw:

> The principal function of the idea of longevity in the cycle, it seems to me, is not so much to say that we can and should extend our lives as to provide a basis for the related satirical point that we behave like children. [*The Marriage of Contraries,* pp. 196–97]

Margery Morgan seems to defend the play on the ground that Shaw did not really mean the Longevity theory to be taken seriously, and that the play is a Swiftian satire against it (see *The Shavian Playground,* pp. 221–24).

St. John Ervine is more sharply critical of matter having anything to do with spirit:

> Is not G.B.S., in demanding an extension of the duration of life on the ground that we do not live long enough to learn how to live sensibly, falling into the mechanistic heresy which he denounced in the neo-Darwinians? The Swiss mystic, Amiel, remarks in his *Intimate Journal* that "numbers make law, but goodness has nothing to do with figures." He might have said the same about length of years. [*Bernard Shaw,* p. 484]

The reply to such criticism may be found in Blake: "Eternity is in love with the productions of time" (*The Marriage of Heaven and Hell,* Plate 7). As Frye writes:

[The] merging of imagination and time is the axis on which all Blake's thought turns. . . . Blake is to be sharply distinguished, if not from all mystics, at least from that quality in mysticism which may and often does make the mystical merely the subtlest of all attempts to get along without a redeeming power in time. [*Fearful Symmetry*, p. 299]

This quality is what Shaw in *The Quintessence of Ibsenism* calls the spiritual rationalism which reasons about "nothing" (see *Major Critical Essays*, p. 22).

Kenneth Lawrence is kinder than Ervine, but the same feeling of the incompatibility of spirit and matter leaves him uneasy with the longevity theme. He tries to explain away the idea of longevity by saying

Shaw (at first) began to see that there was simply not enough stretch to the fabric to make it [human material] fit. For Creative Evolution to be really creative it would need to use larger units of human life. . . . This was Shaw's preliminary notion; later, the idea of quantitative change would ultimately give way to the notion of qualitative change. Shaw's developing concept of the Life Force at first lights upon Longevity as a possible answer to its unsatisfied demands for higher forms. . . . That [the term of 300 years] is arrived at fortuitously and happens to people quite unlikely to fulfill the Life Force and its plans (Haslam and the Maid) is an index of the arbitrariness of this power, its nature as *Nature*. . . . Ultimately . . . Longevity fails . . . for it is deposited in a frail vessel, the human body, which remains matter for as long as it lives, be it seventy or seven hundred years. The conflict between spirit and matter is prior to the proposed solution of longevity.[21]

Robert Hamilton gets close to the Blakean interpretation but rejects it in a fit of rational literalism:

. . . Shaw's position amounts to this—that he has sought to persuade us at great length and with great eloquence throughout the Cycle of five long plays that we need greater longevity in order to build a better world, the ultimate end of which is that the inhabitants will want to die. . . . They want to get rid of the body, that is, to die, so that they may enter into eternal Life. But this is precisely the aim of the Christian— except that he expects to die after three-score years or so instead of thousands. Shaw himself seems to recognize this in a speech he puts into the mouth of the Elderly Gentleman. . . . However, in defence of his general position, Shaw would probably answer that on the premise of Creative Evolution the Life Force can only evolve *in time*, and that the Ancients, *through their longevity*, have at last reached the stage in time in which ultimate Mind is possible. But this does not help us much. You are not going to persuade people to live longer in order that thousands or millions of years hence the Force that created them may get a Mind—

even if you can get over the absurdity that in order to create them it must have a purpose that already presupposes a Mind.[22]

As should be obvious to us by now, no conscious preoccupation on the part of the Selfhood with longevity can enable a man to live longer. Shaw writes in his blurb for the Penguin edition of *Back to Methuselah:*

> ... he [Shaw] pointed out ... that if men become convinced in their subconsciousness that a longer life time is necessary to the survival of the race they will live longer. Thereupon people—again those who had not read this book—jumped to the conclusion that by willing greedily enough to live for ever they could perhaps do so. They would probably be the first to perish. In Shaw's illustrative cycle of plays no one of the persons who find themselves, very embarassingly, in the prime of life at ninety has had the least conscious foreknowledge of what was happening to them.[23]

Shaw is making sure that he has locked the gate on his legend of longevity, so that Don Quixote cannot take a literal stroll in it and harm himself. The play makes the point emphatically. Burge and Lubin want to know the "secret" elixir of longevity—sour milk, lemons, powder, bottle, tabloid? (pp. 72, 81). Savvy secretly wishes it would happen to her and is jealous when Conrad says it might happen to the parlormaid (pp. 82, 86). But it happens to none of the hopefuls. (In Act III, we learn that Lubin, in fact, is shot because he forms the conviction that he is going to live 300 years and "began to tell people the truth.") Franklyn and Conrad themselves can neither wish themselves into being one of the Elect nor prophesy to whom it might happen (p. 82). Their out-of-proportion dismay at the unexpected intrusion of Haslam (and the parlormaid) at the crucial juncture when they are discussing that the length of human life should be 300 years is, retrospectively viewed, comment on their shock at the unexpected choice of the Life Force. The Life Force can use the most commonplace people for its purpose and transfigure them into nobility.

Shaw's idea in "The Gospel of the Brothers Barnabas" is, as he explained, "to exhibit the Church, marriage, the family, and parliament under shorthand conditions before reproducing them [in the later acts] under long-lived conditions."[24] The institutions, and their products, are shown to be ignorantly evil and inefficient, and Franklyn Barnabas explains that this is because "Life is too short for men to take it seriously" and organize themselves in a more responsible manner. The result, again in Franklyn's words, is "A world without conscience: that is the horror of our condition." He explores this world of 1920 especially in his conversation with the politicians, and the parallel is there

with Los-Blake's exploration of war-ridden England a century before.
Los searches the interiors of Albion's bosom, entering the caves of
despair and death to find the oppressors of Albion, the tempters and
the Accusers, and to persuade them against vengeance and towards a
fair peace with France (*J* 31). He watches the "collapse of man's hope in
the nightmare of history," as Harold Bloom comments (*The Poetry and
Prose of William Blake,* ed. Erdman; p. 854). War breaks out "in rivers of
blood over Europe" and Los hears the mingling cries of the Victim and
his Punisher, "enslaved and tormented to him whom he has murder'd,
bound in vengeance & enmity." The poet's hand records the tragedy:

> Shudder not, but Write, & the hand of God will assist you!
> Therefore I write Albion's last words: "Hope is banish'd from me."
>
> [*J* 47]

The merciful Saviour receives Albion in his arms of tender mercy and
reposes him on the Rock of Ages (*J* 48). The Divine Lord builds a
Couch of repose, with sixteen pillars, the inspired books of the Bible,
and as Wicksteed observes, "though the Scripture story of Man's long
history be little better than a 'Tomb' unless 'Spiritually discerned,' it is a
Tomb that preserves the bones that the living mind can restore to
life."[25] Los also tells the sick Albion of the Limits of Opacity (Satan) and
Contraction (Adam), and that there is no Limit of Translucence (*J* 42).
Franklyn says that the war went England's way, but the peace went its
own way; the statesmen of Europe proved incapable of governing, and
they will all helplessly watch another war soon. Present civilization is
failing, says Conrad, and Franklyn adds that they are relapsing into
barbarism (pp. 70–71). Hope lies in the Bible, the "most scientific
document we possess at present" (p. 73), understood not in a funda-
mentalist sense as Burge interprets it (p. 77) but as "inspired human
language." Franklyn explains the war in terms of man's fall as he "came
crashing down all the steps of this Jacob's ladder that reached from
paradise to a hell on earth" (pp. 75–76). He tells Lubin and Burge of
the Life Force's limitless potential for achievement: "As there is no limit
to power and knowledge there can be no end" (p. 74; see also Preface,
p. liv, for Shaw's similar view of the powers of the Life Force). This is
the Blakean notion that "there is no Limit of Expansion; there is no
Limit of Translucence" (*J* 42). Franklyn explains the Limits of Opacity
and Contraction:

> Adam and Eve were hung up between two frightful possibilities. One
> was the extinction of mankind by their accidental death [Albion's fall
> into the abyss of Non-Entity or total material chaos]. The other was the
> prospect of living for ever [in unending or indefinite time, that is, in the
> power of the Spectre of Urthona]. They could bear neither. They de-

cided that they would just take a short turn of a thousand years, and meanwhile hand on their work to a new pair. Consequently, they had to invent natural birth and natural death [the Blakean Limits of Contraction and Opacity], which are, after all, only modes of perpetuating life without putting on any single creature the terrible burden of immortality . . . the moment [Adam] invented death . . . the [Garden of Eden] was no longer worth the trouble. It was then that he let the thistles grow. Life was so short that it was no longer worth his while to do anything thoroughly well. [pp. 73–75]

IV

Part I of *Back to Methuselah* elaborates on Shaw-Franklyn's version of Adam and Eve in the Garden of Eden. Act I of Part I shows that, unlike the Miltonic version, and like the Blakean one, man has lost the divine vision before the first chapter of Genesis.[26] Shaw's garden of Eden is Blake's fallen Beulah, where indefinite time and endless space (the "analogy" of Edenic eternity and infinity) torment a poor Adam shut in the "narrow doleful form" of the physical body (*J* 49:32). In such a state,

The Visions of Eternity, by reason of narrowed perceptions,
Are become weak Visions of Time & Space, fix'd into furrows of death.
[*J* 49:21–22]

Shaw's Adam and Eve discover accidental death in a fawn, and are instinctively repelled by the body of Death. They know that, logically, they will cease to be, sooner or later. They also know that this must not happen: a voice inside them puts that thought into their heads. Adam despairs at the thought of Death leading to Non-Entity, but at the same time he broods over the horror of personal immortality as the individual Adam he is at present. He wants to be born again and better. Eve, the female principle in the human psyche, does not think about herself ("what is the use? I am what I am: nothing can alter that") but about the material well-being of Adam. And before the end of the first scene she discovers the secret of genital sexuality and reproduction which will enable man to survive as a race even if he dies as an individual.

The Serpent in "In the Beginning," who shows Eve the way to the sexual world of Generation from Beulah, is representative of Nature herself.[27] Her "glowing" new colors and "magnificent amethystine hood" (p. 6) are a symbol of material life and wealth. The coils of her body, twining "in apparently endless rings through the branches of a tree" (p. 3) symbolize the continual Orc cycles of natural life bound to vegetation, like Blake's serpent temple which is an "image of infinite shut up in finite revolutions" (*Europe*, Plate 10). The tree itself is that of

the Knowledge of Good and Evil, a symbol of the vegetable world and, as Frye explains, of the tree of Mystery on which Jesus as Orc is crucified.[28]

Shaw's Serpent is, like Blake's, the form of mysterious nature (note Shaw's description of her voice as "a strange seductively musical whisper"). She is the Female Will who can be Tirzah (when restricting the senses of man) as well as Enitharmon (when working with Los), her ambivalent role being perhaps defined by her "double tongue" (p. 6). She seems a version of Lilith, the archetypal Female Will in *Back to Methuselah* about whom she tells Eve many things: Lilith existed before Adam and Eve, and was alone, there was no man with her; she saw accidental death and was impelled to renew herself; she strove and willed unbearably to produce Eve *and Adam,* because the burden of creating, she discovered, was too much for one; still, she made sure that Adam should be in Eve's power through his desire; Lilith renewed life through the power of her desire, imagination, will, and creativity: in a word, her power of conception; she took care to keep the power of creation from Adam, because "if he could do that [create his own kind] he could do without Eve." She may be viewed as Vala who causes Albion's original fall into passivity and who subsequently, Pandora-like, brings both hope and disaster to the fallen Albion.[29]

On the whole, Shaw shows the Serpent, like Lilith in her single personal appearance at the end of *Back to Methuselah,* as benevolent Nature.[30] As the earth mother, Lilith is closer to Blake's benevolent, protective emanations such as Los's Enitharmon, Enion, Eno and Erin, than to Tirzah and Rahab.[31] Shaw shows that his Lilith and Serpent are not restrictive and jealous Tirzah-figures who try to keep man under their dominion for ever. They point the way to man to a higher life which they themselves cannot achieve, and long for man's achieving it. Lilith has looked after and protected men for many ages because she wants them to reach out towards "the whirlpool in pure intelligence . . . though I know well that when they attain it they shall become one with me and supercede me, and Lilith will be only a legend and a lay that has lost its meaning" (pp. 253–54). The wise and intelligent serpent who has discovered the method of reproduction which enables snakes to survive as a species, wants the relatively childish and unintelligent Eve to learn it too, because she wants man, as a higher species than snake, to survive: "I must have something to worship. Something quite different to myself, like you. There must be something greater than the snake."

Insofar as the Serpent works to build Generation as a constructive thing she is Los's helpmate Enitharmon as he builds Erin's Spaces and Golgonooza in Chapter I of *Jerusalem.* Los of course cannot build them

without his emanation's help anymore than he can without his spectre's: he must work in space as well as in time to achieve practical efficiency, as we have seen. Los sees that

> . . . the Religion of Generation, which was meant for the destruction
> Of Jerusalem, [must] become her covering till the time of the End.
> O holy Generation, Image of regeneration!
> O point of mutual forgiveness between Enemies!
> Birthplace of the Lamb of God incomprehensible!
>
> [*J* 7]

So he creates the "Spaces of Erin" (Lilith's world, in terms of *Back to Methuselah*) in his Furnaces, and "the Spaces of Erin reach'd from the starry heighth to the starry depth."[32] He gives Vala, the vegetable shadow of Jerusalem, a Body, even though she is essentially evil: God will work through Generation (*J* 12). He builds the city of Golgonooza in the midst of the fallen world (*J* 12, 13) and he gives his Sons and Daughters a vegetable existence (*J* 14). The Serpent's invention of the art of Words in *Back to Methuselah* is also under the direction of Los:

> Los built the stubborn structure of the [English] Language, acting against
> Albion's melancholy, who must else have been a Dumb despair.
>
> [*J* 40]

In both Shaw and Blake, the entry into Generation, on the one hand a redemptive scheme of mercy, is on the other hand a step in the Fall. Shaw's Adam drops further into passivity and procrastination, and decides to clear the garden of thistles "tomorrow." Life is more complicated than in Beulah: he and Eve experience the passions of jealousy, murder, fear, kinship, love, anger. Adam broods on the uncertain future, breeding the new misery of fear. The remedy, says the Serpent, is Hope. But while Eve is willing to be a "builder in hope" as the builder in Golgonooza is (*J* 12:43), Adam must have certainty, for fear is stronger in him than hope: "Hope is wicked. Happiness is wicked. Certainty is blessed. . . . Whatever I fear to do is wicked." He binds the future with his resolve to have certainty, by deciding that he will live a thousand years, and that he and Eve will be married to each other all that time. He then leaves, because he is afraid to listen to the secret, which the Serpent whispers to Eve (the secret being how to make Adam "give his desire and his will" to Eve). Shaw describes her reaction: "Eve's face lights up with intense interest, which increases until an expression of overwhelming repugnance takes its place. She buries her face in her hands." For, in the words of *Jerusalem*, the "places of joy & love [are] excrementitious" (*J* 88).

V

Albion's Spectre from his Loins
Tore forth in all the pomp of War:
Satan his name: in flames of fire
He stretch'd his Druid Pillars [of human sacrifice] far.
Jerusalem 27:37–40

The second act of Part I of *Back to Methuselah*, set in Mesopotamia a few centuries after Adam's decision to enter Generation, introduces us to his eldest son, Cain, the first murderer. Cain corresponds to the eldest son of Albion, Hand, in *Jerusalem*. Hand is the Spectre of Albion (*J* 36:23) who is "the Great Selfhood, Satan, Worship'd as God by the Mighty Ones of the Earth" (*J* 33; see also *J* 90:40–43 for Hand and the other Spectral Sons as the Selfhood and Satan).[33] He organizes war, the crucifying impulse (as Los shows his Spectre in *J* 8, 9). He is pictured on Plate 26 as a "marching crucifix" (Erdman's description in *The Illuminated Blake*) in flames; and on Plate 50 as the Selfhood, the three-headed monster described in Plate 70 as the "Three Forms named Bacon & Newton & Locke," and containing within him Rahab who "Sat, deep within him hid, his Feminine Power unreveal'd." As we noted in Section II, the ultimate form of the Selfhood is the Covering Cherub or Antichrist, a "Warlike Mighty-one" with the harlot Rahab inside him (*J* 89).

Cain revolts against the clay and the natural life which content his father. He wants to be something better than a mere digger: for him, there is no joy like fighting, and "he who has never fought has never lived." But he cannot be on a higher plane of evolution than Adam because he, like Hand, knows how to fight only with the physical sword and not with Los's "spiritual sword" (*J* 9) which builds Golgonooza and Jerusalem. Hand (and Cain) as the warrior who fights the physical fight, and the prophet inspired by the Holy Word (and the Shavian Life Force) who fights the "Mental Fight," together with the Blakean (and Shavian) Adam who stands between the other two, represent the "Three Classes" of men Blake adapts from the Miltonic concept of the Elect, the Reprobate and the Redeemed. It is worth defining these terms in some detail here, as they help to understand Cain's relationship with Adam as well as, later on, the character of the Elderly Gentleman in Part IV of *Back to Methuselah*.

In Blake, the Elect is "the Reasoning Negative" (*Milton* 5:14), a negation of moral virtue, but with no positive qualities of its own (Frye explains this point in *Fearful Symmetry*, pp. 197–98). Representatives of the Elect class, among whom are Satan in *Milton* and Hand in *Jerusalem*

(and Cain in *Back to Methuselah),* have no existence in Eternity, they are Negations who disappear at the apocalypse. They "cannot Believe in Eternal Life/Except by Miracle & a New Birth" *(Milton* 25). The Reprobate, represented by Rintrah in *The Marriage of Heaven and Hell* and in *Milton,* "never cease to Believe [in Eternal Life]." Theirs is the prophetic spirit which is called reprobate by orthodox religionists. The Redeemed class of men, to whom Adam belongs, "live in doubts & fears perpetually tormented by the Elect" *(Milton* 25). They are redeemed from that situation by the Reprobate, who is the true Contrary of the Redeemed while the Elect is only his Negation. As Frye explains, the Adamic man has the elements of the prophetic spirit in him, but it is mixed with fear which leads him to use those elements in passively conforming to social and religious ills *(Fearful Symmetry,* pp. 189, 198). The job of the Reprobate prophet is to separate the elements of the prophetic spirit and the elements of cowardly subservience in the Redeemed—then the Adamic man is redeemed as part of the Reprobate, and his errors are seen for what they are (part of the Negation) and cast out.

The Negation, as Los says, can be organized only "as a distorted & reversed Reflexion [of the truth in Eden] in the Darkness/And in the Non Entity" *(J* 17) and, when revealed as the Covering Cherub, his "Brain incloses a reflexion/Of Eden all perverted" *(J* 89). Cain's idea of war is a hellish parody of the Edenic war of Ideas. He wants his mother Eve to create more children so that he can fulfil the "glorious poem" he has imagined:

> I will divide them into two great hosts [he means not heavenly but earthly armies]. One of them I will lead; and the other will be led by the man I fear most and desire to fight and kill most. And each host shall try to kill the other host. Think of that! all those multitudes of men fighting, fighting, killing, killing! The four rivers running with blood! [The four are the four Zoas *(J* 98) but reflected perversely in the Covering Cherub *(J* 89).] The shouts of triumph! the howls of rage! the curses of despair! the shrieks of torment! That will be life indeed: life lived to the very marrow: burning, overwhelming life. [p. 21]

Cain proudly boasts that while Adam is a mere convenience for Eve, digging and sweating for her like any beast of burden, he is a mighty warrior who is the "master of Woman, not her baby and her drudge." Eve angrily counters him, pointing out that in reality he is much more the slave of his wife Lua than Adam is hers. The detailed description of Lua's enslaving of Cain that Eve launches on (pp. 22–23) establishes Lua as Rahab hidden behind the Covering Cherub's warlike exterior.[34]

The State Rahab is the "System of Moral Virtue" *(J* 39:10) and Cain is steeped in that system. He justifies his brand as God's sign of appro-

val and protection; speaks of his Voice as the Voice of God, and Lilith's
and Adam's Voice as that of the Devil; quotes Tennyson in saying that
"[his] strength [in fighting] is as the strength of ten because [his] heart
is pure," turned "upward to the sun, to the clear clean heavens." Cain is
a Darwinian believer in the survival of the fittest, and "the Selfish
Center" (*J* 71:7) which mocks the Christian belief that we are members
of one another. As he tells Adam:

> ... I am not a child to be afraid of a Voice. The Voice thought I was
> nothing but my brother's keeper. It found that I was myself, and that it
> was for Abel to be himself also, and look to himself. He was not my
> keeper any more than I was his: why did he not kill me? There was no
> more to prevent him than there was to prevent me: it was man to man;
> and I won. I was the first conqueror. [p. 25]

The connection between Darwinism and war that Shaw emphasizes in
the Preface is made clear here too, and perhaps explains why the
warrior Napoleon's full name (in Part IV) is Cain Adamson *Charles*
Napoleon.

Eve sees that through Cain and his like, "death is gaining on life."
The diggers and the fighters both fall short of her dream of another,
divine, life. Her hope rests in the Reprobate prophetic spirit of Los, in
those children who have the potential to be creative artists: poets,
sculptors, musicians, mathematicians, astronomers, and prophets, who
are likeable despite their many faults. In them is Eve's hope that one
day man will evolve beyond material to spiritual wholeness, and live
long enough to eat manna, food drawn from heaven:

> Man need not always live by bread alone. There is something else. We
> do not yet know what it is; but some day we shall find out; and then we
> will live on that alone; and there shall be no more digging nor spinning,
> nor fighting nor killing. [p. 33]

VI

> [The Deist] is in the State named Rahab. . . . Deism, is the Worship of
> the God of this World by the means of what you call Natural Religion
> and Natural Philosophy, and of Natural Morality or Self-Righteousness,
> the Selfish Virtues of the Natural Heart. This was the Religion of the
> Pharisees who murder'd Jesus. . . . Those who Martyr others or who
> cause War are Deists. . . . [*Jerusalem* 52]

In the British Islands in A.D. 2170, the statutory expectation of life
that a man is entitled to is seventy-eight. Now, in Part III, people like
Bill Haslam and the Parlormaid find they have subconsciously willed
themselves to a life-span of three centuries, and have to fake their own

death—by drowning—at regular intervals, because "It is socially impossible not to do what everybody else does. One must die at the usual time." Haslam has, during the 283 years he has lived so far, served his country under the names and in the capacities of Archbishop Haslam, Archbishop Stickit,[35] President Dickenson, General Bullyboy, and is Archbishop of York when the discovery of his longevity is made. The Parlormaid has risen to become the Domestic Minister of the Islands, and is called Mrs Lutestring. Both are in the prime of life; he has "complete authority and self-possession," she is "grave, swift, decisive, awful, unanswerable" and has "the walk of a goddess"; and President Burge-Lubin as well as Confucius are a little afraid of their presence. In Blakean terms, they represent the initial strength and purity of a newly arisen Orc-Urizen cycle, before it starts degenerating.[36] In the context of "The Thing Happens," the Blakean concept of Deism is represented by Barnabas, who is "rather like Conrad Barnabas" ("a descendant of the great Conrad Barnabas," Burge-Lubin informs us, on p. 125) but curt, harsh, querulous and malevolent. He is like Conrad without Franklyn, Weismann as a Neo-Darwinian, Los's Spectre out of Los's control. Barnabas has estimated that the average duration of human life is seventy-eight, and is horrified at any suggestion that his Act may have to be amended. He considers the Archbishop's and Mrs Lutestring's living so long an "unnatural horror" and, raving with a hatred towards them akin to de Stogumber's against Joan,[37] he says he is "going to raise the country against this horror" (p. 125). He wants them put to death or at least sterilized so as to make ineffectual their proposed marriage: "They will do it in cold blood because their children will live three hundred years. It mustnt be allowed" (p. 123). He wants them killed because it is his instinct to kill them: "What reason can you give for killing a snake? Nature tells you to do it" (p. 125). The difference of course is that whereas the snake is a lower species than man, the Longlivers belong to a higher order of man than those men who die naturally at seventy-eight or so: their living longer symbolizes their power over nature and their ability to overcome her natural laws. This power enables Mrs Lutestring, when Barnabas tries to bar her way out of the room, to walk "straight at the Accountant General, who instinctively shrinks out of the way as she leaves the room" (p. 124). He is left raging, but helpless, unlike the murderers of Jesus and Joan who have the power to kill their victims.

The Archbishop and Mrs Lutestring may be viewed as versions of the Christ figure, superior to their fellowmen who consider them unnatural law-breakers, and yet powerful enough to resist any official death sentence or torture. A contrasting Christ figure is the Elderly Gentleman in Part IV who, to be more precise, is a Christ-as-Job figure,

where both Jesus and Job depict in their lives the story of Israel-Jacob's existence as Luvah or the natural, Adamic, man. The death of the Elderly Gentleman is an example of the death of Luvah, a victim of natural circumstances as Job and the historical Jesus were.[38]

In Baghdad, the capital of the British Commonwealth in A.D. 3000, the Elderly Gentleman has lived as perfectly upright and respectably prosperous a life as Job in the Land of Uz.[39] He has come to visit the land of the Longlivers, along with other Shortlivers such as the Prime Minister of the British Middle East, Mr Badger Bluebin (referred to as 'The Envoy' throughout Part IV), who intends to consult the Oracle in that land as his predecessor did fifteen years before. The Longlivers bear the relation of gods to the Shortlivers (as Wisenthal points out in *The Marriage of Contraries*, p. 212) and the Elderly Gentleman's experience in their land is akin to Job's experience once his god has entered the scene (Illustration II onwards in Blake's *Job*).

The Elderly Gentleman, as Adamic man, belongs to the Blakean Redeemed class, the redeemed or saved part of whom joins the Reprobate, and the unredeemed part of whom is revealed, with the Elect, as error or Negation. This is clearly shown in the Elderly Gentleman: at his best he is superior to anything else in Part IV, the isolated Reprobate figure crying in the wilderness of lost souls;[40] at his worst his identity is one with the Envoy, who glosses facts to deceive himself and others.[41] It is appropriate that both the Elderly Gentleman and the Envoy are descended from Burge-Lubin (the Redeemed Adam of Part III, and himself descended from Burge and Lubin of Part II) since they are a splitting of the Adamic state into redeemed and unredeemed. The Envoy, at the end of the Part, returns to his country to continue the unredeemed Adamic life; the Elderly Gentleman gives meaning to his life, even in death, as Bernard F. Dukore points out.[42]

In examining the experience that the Elderly Gentleman goes through, it is important to bear in mind that he, like Job, is an individual as well as the whole body of humanity; and what Frye writes of Job is equally true of the Elderly Gentleman:

> [The] ambiguity between Job as individual and Job as social being or patriarch is of a kind central to all mythical structures of this descent-and-return shape [of the community of man]. . . . The general critical principle involved here is that in a descent-and-return mythical structure the individual descends; the community returns. Temptation, alienation, despair, decisive choice, death itself, are ordeals that only the individuals can carry to their limit. But only a re-created society, like the one that crystallizes in the final scene of a comedy around a hero's marriage, can fully experience the sense of a brave new world. . . . Job's renewed state is not a subjective one. This ambiguity of "human body," which may be

an individual or a society, is involved in the contrast between the natural body which dies and the spiritual body which rises again. ["Blake's Reading of the Book of Job," pp. 230–31]

In the "Tragedy of an Elderly Gentleman" the tragedy is of the individual who faces up to the ordeals of alienation from the other Shortlivers as well as from the Longlivers, despair at the realization of the enormous gap between Shortlivers and Longlivers, and the decisive choice to stay among the Longlivers, even at the cost of death, rather than return to the Shortlivers' world of unreality and lies. But the destiny of the Elderly Gentleman as a representative of the Adamic race is not tragic. His noblest qualities are the ones that will be resurrected in the spiritual existence the Ancients reach out for. The positive inspiration for man's evolution from the physical to the spiritual is the Elderly Gentleman's faith in the divine spark and the Holy Ghost, not the rational and agnostic attitude which the Longlivers have cultivated by A.D. 3000.

We must constantly remember that the Longlivers are far from being the last word in evolution. The connecting role they play between the Elderly Gentleman and the Ancients is similar to the role of the Overlords in Arthur C. Clarke's *Childhood's End,* as they play gods to the earth's inhabitants until the time is mature for the latter to evolve into the Overmind. The Longlivers are no more and no less powerful than the Overlords and both, like Undershaft in *Major Barbara,* represent the Blakean Satan who stands for the ultimate in material civilization and who, when given complete form, is the "analogy" of Christ, and mirrors man's way to spiritual regeneration. The world of *Childhood's End* in its "Golden Age" ruled by the Overlords is free from "ignorance, disease, poverty and fear"[43] in the same way as are the land of the Longlivers in *Back to Methuselah* and the town of Perivale St. Andrews in *Major Barbara.* All three represent material utopias, essential up to a certain stage of evolution, at which point their inhabitants have to look beyond them for salvation. The Overlords are caught in a "biological dead-end," as Daniel J. Leary describes it, beyond which men must aspire.[44] In *Back to Methuselah,* longevity itself can lead only to a metabiological dead-end, as the Ancients find. And in *Major Barbara,* Undershaft's town of well-nourished bodies can be saved only with the help of Barbara's spiritual strength.

Neither Shaw in *Back to Methuselah* (and *Major Barbara*) nor Clarke in *Childhood's End* views the figure of Satan with any of the fear with which it is traditionally viewed. Clarke's Overlords are, however, divested of all evil, whereas Shaw presents the admirable as well as the sinister side of his Longlivers. They are models of the ideal in many

ways, as Dukore notes in *Bernard Shaw, Playwright* (pp. 253–54). They do not waste time in sentimental trivia, they are practical in their approach to problems, they are growing out of the habit of substituting metaphor and image for reality, they are frank and face truth bravely, they have no conception of money or private property, they have no possessive mother-figure in their society, they are orderly and know how to conduct affairs of government efficiently, and warriors such as Napoleon are no heroes to them. They are also models of the false anthropomorphic gods that men worship, and their attitude to the Shortlivers can be one of intolerant bullying and deliberate mystification. Zozim, for instance, reduces the Elderly Gentleman to a state of discouragement and humiliation where he cries out in echo of the humble psalmist praying to his God (see Psalms 39.4,5): "Behold, thou hast made my days as it were a span long; and mine age is as nothing in respect of thee" (p. 186).

Again, the Longlivers pretend that they have outgrown the use of images and metaphors in speech. Yet Shaw betrays them by showing them using much figurative language, including images they pretend not to understand when the Shortlivers use them. The 170-year-old Woman, Fusima, implies clearly that she does not understand non-literal images used by the Elderly Gentleman. Yet in her conversation with him she herself uses figurative expressions, as when she says she is "in the dark" (p. 136) about his usage of language. She reduces him to tears by taking literally his expression "the remedy is in your own hands" (p. 137); and yet the metaphor must still exist among the Long-livers, as we see when Zozim tells Zoo, "Bless you for taking [the Elderly Gentleman] off my hands!" (p. 144). Both Fusima and Zozim pretend not to understand the word "decent" (pp. 137, 143); but Zozim himself uses the word "delicate" (on p. 143) to mean exactly what the Elderly Gentleman's usage of "decent" conveys. The word "decent" in fact survives into A.D. 31,920 (see p. 209).

Zoo mocks the Elderly Gentleman's sensible, even if full-of-metaphor, speech on civilization, by "laughing heartily at him" (p. 157). She misconstrues all he says by interpreting it literally, abuses him as "you little ephemeral thing," interrupts him offhandedly again, reduces him to exhaustion and defeat, and then brutally insists on beginning yet another argument, though he would rather be silent. She, in fact, uses her superior power to behave as Job's god behaves in Shaw's *The Black Girl*, when he calls the Black Girl "you ridiculous little insect" and wants to compel her to stay and "argue" with him for the sake of his entertainment (*The Black Girl*, pp. 25–26).

The Longlivers use their "Vril" or power of Awe to keep the Shortlivers-Yahoos in subjection, as Shaw explains in *Everybody's Politi-*

cal What's What? (pp. 285–87). The "artificial awe" created by the Oracle scene, and by the imposing Druidic robe Zozim wears as well as the robe of purple Zoo wears, are all part of the Longlivers' attempts to impress the Shortlivers and keep them in subjection even while they themselves are intensely aware of and contemptuous of the "mummery" and farce involved in the whole ritual. That "You must rule ignoramuses according to their ignorance" (to borrow Shaw's phrase in *What I Really Wrote about the War,* p. 104) does not make the Longlivers any less responsible for their mummery, which is as openly irreligious as Undershaft's provision for Shinto and Jain temples, Salvation barracks, and a Labor Church in Piety Square in his Antichristian town (see *Major Barbara,* film version, pp. 136–41). The Oracle herself is dressed to look mysterious and awesome. She is

> draped and hooded in voluminous folds of a single piece of grey-white stuff. Something supernatural about her terrifies the beholders, who throw themselves on their faces. Her outline flows and waves: she is almost distinct at moments, and again vague and shadowy: above all, she is larger than life-size, not enough to be measured by the flustered congregation, but enough to affect them with a dreadful sense of her supernaturalness. [p. 188]

She is, in this perspective, no other than Blake's mysterious Rahab, the Shadowy Female who dominates Adamic man. We note that she is also called the pythoness (p. 187), and as such is the natural Female Will, and the malevolent counterpart of the Serpent, in Part I, who is benevolent Nature. Her killing of the Elderly Gentleman is the equivalent of the killing of Jesus-Luvah by Natural Morality and the Female Will, detailed in Chapter III of *Jerusalem* (Plates 63–67).

VII

> I know of no other Christianity and of no other Gospel than the liberty both of body & mind to exercise the Divine Arts of Imagination, Imagination, the real & eternal World of which this Vegetable Universe is but a faint shadow, & in which we shall live in our Eternal or Imaginative Bodies when these Vegetable Mortal Bodies are no more. . . . is the Holy Ghost any other than an Intellectual Fountain? . . . What are the Treasures of Heaven which we are to lay up for ourselves, are they any other than Mental Studies & Performances? . . . What is Mortality but the things relating to the Body which Dies? What is Immortality but the things relating to the Spirit which Lives Eternally? What is the Joy of Heaven but Improvement in the things of the Spirit? What are the Pains of Hell but Ignorance, Bodily Lust, Idleness & devastation of the things of the Spirit? . . . Let every Christian, as much as in him lies, engage

himself openly & publicly before all the World in some Mental pursuit
for the Building up of Jerusalem. [*Jerusalem* 77]

Shaw's Ancients in Part V of *Back to Methuselah*, seeking the improve-
ment of things spiritual, intellectual and mental, and the power to
annihilate the natural body, are the Blakean Christians of "As Far as
Thought can Reach." Men by A.D. 31,920 have conquered Nature in
many ways, as we learn during the course of this part of the play, and
are reaching out towards the final conquest which will enable the trans-
figuration of the naturally limited body into the spiritually expanded
body. We have already seen how the Newly Born is from birth much
more independent of the Mother. She will quickly grow into the
rhythm of art and sport and sexual and dancing pleasures that the
youngsters, such as those we see at the beginning of the act, enjoy.
Their childhood of four years (corresponding to the years twenty to
seventy as we know them today) is spent in this Beulah of beauty and
harmony. As they grow out of childhood, they grow closer to Blake's
Eden, rather than to Generation, our adult world of Experience. In the
growing-up of Chloe, the four-year-old maiden, we see how the young-
sters outgrow the passions that Adam in Part I had latent in him and
that intensified when he accepted the world of Generation as the stage
next to Beulah. Their sign of maturity is that they grow tired of their
childish life of the senses, especially with regard to sexual love, as we
see in Chloe's responses to her erstwhile lover Strephon. They begin to
understand what Jerusalem tells Vala:

> . . . Humanity is far above
> Sexual organization & the Visions of the Night of Beulah
> Where Sexes wander in dreams of bliss among the Emanations,
> Where the Masculine & Feminine are nurs'd into Youth & Maiden
> By the tears & smiles of Beulah's Daughters till the time of Sleep is past.
>
> [*J* 79]

The youngsters outgrow sleep ("Sleep is a shameful thing: I have not
slept at all for weeks past," says Chloe) as they outgrow their pretty
Grecian dresses and passions such as jealousy and possessiveness in
love. They wander all night, fulfilling their awakening passion for
thought: "thinking, thinking, thinking; grasping the world; taking it
to pieces; building it up again; devising methods; planning experi-
ments to test the methods; and having a glorious time" (p. 204). They
also outgrow, Chloe explains, their passions for dance, music, archi-
tectural beauty, words and poetry, which have so far satisfied their
artistic sense but which fail to satisfy their adult passion for a more
sophisticated and direct "rhythm of life" as the He-Ancient calls it
(p. 200).

This growing out of art as man matures out of Nature is the theme of the remainder of Part V. It may be understood in terms of Blake's account in *Jerusalem* Chapter IV, of Golgonooza and Los giving way before the City of God and the spiritually awakened Albion. Let us examine in some detail this climactic point in the Blakean and Shavian vision of Christian Evolution, starting with the entrance in Part V of the sculptors Martellus and Arjillax, together with Ecrasia, a nymph with an "authoritative bearing" and "beauty and imposing tone." Ecrasia, who figures prominently through Part V as the champion of Fine Art, and beauty in Nature, is the Shavian parallel in this part of the independent Female Will in *Jerusalem* Chapter IV, who tries to keep man in the power of Nature as mankind's goal of redemption from flesh to spirit comes nearer: sometimes seen as the independent Enitharmon (*J* 87, 88, 91, 93), sometimes as the Daughters of Albion seen individually (such as Gwendolen and Cambel in *J* 80), and sometimes as the Daughters united as One in Rahab (*J* 84, 85). Arjillax has till now held Ecrasia in high esteem, and regarded favorably her view that the business of the artist is to create beauty. He has even, as she reminds him, "modelled me as the genius of art presiding over the infancy of your master here, Martellus" (p. 215). But now he is bored with sculpting "ideally beautiful nymphs and youths" (as Ecrasia calls them; Arjillax calls them "smirking nymphs and posturing youths") and has taken to making "horribly realistic studies" of Ancients, as Ecrasia accusingly tells the other youths and maidens. Arjillax is growing up, and growing out of worship of her, and she is angry and critical. He will not be brought to her feet again, however, in spite of scornful or persuasive arguments. He tells the story of the supernatural being called the Archangel Michael, a mighty sculptor and painter who graduated from painting on the ceiling of a temple the newly born in all their childish beauty, to painting a company of ancients, in those days called prophets and sybils. This tale, he says, is not to be believed literally but as a legend. He slaps his chest and points to the Temple of Love (where he is going to exhibit his sculptures) and says he is the man and that temple is the place.

Martellus, who is older than Arjillax, has grown one stage further. He, too, made busts of Ancients, but destroyed them because he could not "give them life." He then collaborated with another youth, a scientist named Pygmalion, to create a pair of artificial human beings. Martellus modelled the living dolls, in whom Pygmalion succeeded in fixing "high-potential Life Force," the highest he could achieve in the laboratory. The result is a male automaton, Ozymandias, and a female automaton, Cleopatra. Martellus remarks, before they are exhibited onstage, that these "two most wonderful works of art in the world"

will "inspire a loathing that will cure you of the lunacy of art for ever" (p. 220).

The automata are vain, susceptible to flattery, and, since they are composed of reflexes, they can do nothing original. In true Darwinian spirit they proclaim the predetermined, inevitable, unalterable, logical nature of the Universe and of their own nature and actions. The youths and maidens are indeed, as Martellus had foretold, filled with shame and loathing as they watch the automata behave with no self-control: they go through the reflexes of telling lies, boasting, cringing in fear, and selfishly wanting each other killed, before the Ancients instill some fellow-feeling into them. Ultimately they die, discouraged of life. The She-Ancient gives instructions that the two "abominations" are to be burnt, and then she and the He-Ancient take the opportunity to lecture to the youngsters on the limitations of "dolls," as they call works of art and images, among which they include the physical body. The exhibition of Martellus' "prehistoric" creatures as automata becomes significant when their automatic nature is taken by the Ancients as an example of the automatic nature of all bodies, including their own in A.D. 31,920.

We have seen in our earlier discussion of Los and his Spectre that one of Los's tasks in Golgonooza is "Giving a body to Falsehood that it may be cast off for ever,/With Demonstrative Science piercing Apollyon with his own bow" (*J* 12). Martellus as artist is the Los figure (like Franklyn Barnabas) who, working with Pygmalion as the Spectre of Urthona (Pygmalion is of course the Part V version of the scientist Conrad Barnabas) has done precisely this. And in the larger context of the play, Shaw as artist has worked with Weismann's theory of longevity up to the point where men are capable of seeing the natural body as "mere machinery" and of discarding its limiting dominion for the larger life of the soul. In terms of *Jerusalem*, this is the point where Albion awakes and is capable of annihilating the Covering Cherub and living eternally in the Body of Jesus. Along with the annihilation of the natural body and the natural world, Los and Golgonooza also must vanish: for they are the redeeming power of creativity and art *within nature* and when their task of redeeming man from nature is achieved, they are, simultaneous with the nature of which they are a part, annihilated as separate entities outside Man. This crucial point about Los and Golgonooza has been explained clearly by Thomas R. Frosch and Jerome J. McGann. McGann explains how

> Los himself goes to Eternal Death along with all his invented worlds, in order to advance the redemption of Albion. When the risen Albion says to Jesus, the Divine Vision: "I see thee in the likeness & similitude

of Los my Friend" (*J* 96:22), we understand that art itself has finally
been redeemed to the Divine Vision. This entails the annihilation of
"art" for "Vision". . . . Golgonooza, Los's city, is not Jerusalem but the
means toward it, and the function of his city of art is to reveal the
whorish aspects of all creation. Golgonooza too must go to Eternal
Death, for it stands not only as the promise of Jerusalem, but also as
the last great temptation to retreat from vision. Golgonooza is the
house whose windows of the morning open out to the worlds of eter-
nity, where Jesus dwells. We were never meant to live in it, or with it,
but through it.[45]

Frosch explains how Golgonooza is "fallen art, built in nature . . . [and]
is potentially the point of entry to a new world" but does not in itself
contain Jerusalem (he quotes *J* 12:43–44 in support), nor is it identical
with Eden (*J* 12:52).

> In Blake, the goal of art is the moment at which it becomes unnecessary,
> because the whole of life has taken on the character of art. . . . It is the
> job of the fallen artist to reorganize the natural body, to awaken it to its
> self-induced limitations and its real potentialities, until it regains the
> capacity to arise and enter Eden by itself. In this transformation, what
> we now recognize as art disappears: when Albion enters the furnaces,
> Los drops out of the poem, consumed with all else in his Sublime Uni-
> verse. [*The Awakening of Albion*, p. 159]

The Ancients, coming close to Eden, find that art, like nature, does
not satisfy them any longer: neither can create unfallen life, which is
what the Ancients are striving towards. The He-Ancient, as a child,
"sought perfection in friends, in lovers, in nature, in things outside
myself. Alas! I could not create it: I could only imagine it." This realiza-
tion leads him "to the truth that you can create nothing but yourself."
In Blakean terms, the creative power of Tharmas is separated from the
creative imagination of Los in a fallen world where Albion's members
are outside himself, in an externalized nature; true creativity can take
place only in oneself, and Eden can be created when Albion rises and
absorbs the natural world and all the Zoas into himself. The She-
Ancient as a child was an artist and strove "to create perfection in
things outside myself. I made statues: I painted pictures: I tried to
worship them." But she found there "was no life in them" and turned
from art. Now she is able to tell the youngsters:

> . . . art is the magic mirror you make to reflect your invisible dreams in
> visible pictures. You use a glass mirror to see your face: you use works of
> art to see your soul. But we who are older use neither glass mirrors nor
> works of art. We have a direct sense of life. When you gain that you will
> put aside your mirrors and statues, your toys and your dolls. [p. 242][46]

The "last doll to be discarded" is the body which images the soul, for now the Ancients are strong enough to want to live directly the life of the soul. As the He-Ancient declares:

> This is my body, my blood, my brain; but it is not me. I am the eternal life, the perpetual resurrection; but [*striking his body*] this structure, this organism, this makeshift, can be made by a boy in a laboratory, and is held back from dissolution only by my use of it. Worse still, it can be broken by a slip of the foot, drowned by a cramp in the stomach, destroyed by a flash from the clouds. Sooner or later, its destruction is certain. [p. 243]

The Ancients want a body not subject to Circumstantial Selection. They explain how they contemplated the creative power in themselves and concentrated their will for fifty years, so as to gain power over their bodies. They gained the power of shaping their bodies into any form they desired. They experimented by transforming themselves into various fantastic monsters, before, as the She-Ancient tells, "suddenly it came into my mind that this monstrous machinery of heads and limbs was no more me than my statues had been me, and that it was only an automaton I had enslaved." In Blakean terms, they saw the Covering Cherub revealed, "magestic image/Of Selfhood, Body put off, the Antichrist accursed" (*J* 89). Now they no longer waste their creative power in making superfluous bodily organs. Their preoccupation is one concerned with deliverance from the body. "Whilst we are tied to this tyrannous body we are subject to its death, and our destiny is not achieved." Their destiny is "To be immortal. . . . The day will come when there will be no people, only thought. . . . And that will be life eternal." Their striving is to be a vortex—"the whirlpool in pure intelligence" as Lilith puts it—the power over natural things, as the He-Ancient explains (p. 248).

A great many questions arise from critics as to the desirability or purpose of the Ancients' embracing a life of Thought (which is what the Greeks meant by the "Word" of God, Shaw explains in the Postscript to *Back to Methuselah*, p. 267) as distinct from the life of Flesh as we know it. We will here look at only a few, and see whether a Blakean interpretation might help clear some confusion. Margery Morgan thinks Shaw is pushing to logical extremes "the pull away from nature, the desire to escape human limitations," with the result that the Ancients are "grotesque images of misshapen creatures, lapsed into noncommunicating isolation, absorbed in a contemplation that seems no better than self-absorption" (*The Shavian Playground*, p. 237). According to a Blakean reading, self-absorption is the "Selfish Center" (*J* 71), the attribute of Satan (*J* 33), the Selfhood's parody of the Eternal Man's

expanded center, and the very quality that man gets rid of when he gets rid of his natural body and acquires the enlarged vision of spiritual existence. As *Jerusalem* 57 describes, "Wonder seiz'd all in Eternity, to behold the Divine Vision open/The Center into an Expanse, & the Center rolled out into an Expanse." Blake's critics have distinguished the reality from the parody in a way that might be useful in distinguishing the Ancients' "isolation" from the Selfhood's isolation in the natural body. As one critic writes:

> To have one's center in oneself is not the same as being selfish. The selfish center is formed without, Blake reminds us. When one is self-centered or selfish, he is contracted into a tiny involved mass outside of himself and consequently outside of others. When he has his center within himself, its circumference expands into eternity to include others.[47]

It is important to realize that Shaw, in postulating a life of the Spirit as distinct from natural life, may not be labelled a "dualist" who ranges mind against matter or spirit against flesh, or soul against body.[48] As Shaw writes to Ervine, his position is rather that "the passion of the body will finally *become* [my emphasis] a passion of the mind" (*Bernard Shaw,* p. 384). In the words of Blake's *Milton,* Generation is to be "swallow'd up in Regeneration" (*M* 41). Frosch's book *The Awakening of Albion* aims to show that the Blakean Eden is one where the five natural senses are not discarded so much as expanded to compose the risen spiritual body of Albion, where sexuality is not confined to genitality but expanded to include all the body. As Blake says in *Jerusalem:*

> For the Sanctuary of Eden is in the Camp, in the Outline,
> In the Circumference, & every Minute Particular is Holy:
> Embraces are Cominglings from the Head even to the Feet,
> And not a pompous High Priest entering by a Secret Place.
> [*J* 69]

In Eden, Frosch remarks, "imagination and sexual love reassume their identity, just as soul and body or perception and creation" (p. 176).

C.E.M. Joad and A.M. Gibbs are unsatisfied with Shaw's giving no hint of what the Ancients contemplate.[49] I suppose the only answer one can give to the question all of us must ask Shaw—"What does one do as an intellectual vortex; is the exercise of becoming one pointless?"—is that the sleeping man cannot imagine what he will do when he awakes; and yet creative activity (which is a state of wakefulness as opposed to the passivity of eternal sleep, where fitful dreams are the only, and sometimes distorted, hints of conscious reality) is pleasurable and god-like. Shaw does imagine one of the activities of the awakened man in *Farfetched Fables* (1948–49). He brings on stage a disembodied vortex

who has incarnated himself as a body and appears, to a sixth form
class, as a youth clothed in feathers. In response to clamorous question-
ing from the students and teacher, he tells them:

> I am an embodied thought. I am what you call the word made flesh. . . .
> Evolution can go backwards as well as forwards. If the body can become
> a vortex, the vortex can also become a body. . . . I am curious to know
> what it is like to be a body. Curiosity never dies. . . . [pp. 129–30]

In *Jerusalem*, Plate 98, Blake writes of the risen Albion, and one of his
activities consists in this, that "Time, place, age and death are 'created'
for momentary interest, as a story is, and then put away":[50]

> And they conversed together in Visionary forms dramatic which bright
> Redounded from their Tongues in thunderous majesty, in Visions
> In new Expanses, creating exemplars of Memory and of Intellect
> Creating Space, Creating Time according to the wonders Divine
> Of Human Imagination throughout all the Three Regions immense
> Of Childhood, Manhood & Old Age; & the all tremendous
> unfathomable Non Ens
> Of Death was seen in regenerations terrific or complacent, varying
> According to the subject of discourse & every Word & Every Character
> Was Human according to the Expansion or Contraction,
> the Translucence or
> Opakeness of Nervous fibres: such was the variation of Time and Space
> Which vary according as the Organs of Perception vary & they walked
> To & fro in Eternity as One Man reflecting each in each & clearly seen
> And seeing: according to fitness & order.

One thing is certain. Life in Eden is not a static paradise in either
Shaw or Blake. What Frosch writes of Blake's paradise is equally true of
the goal for which the Ancients reach out (and which Raphael, the
disembodied thought, has achieved in *Farfetched Fables*):

> . . . there is no finality in this accomplishment [of replacing the natural
> world by Jerusalem, a world of emanation, the bride and creation of
> Albion], for Blake's paradise is not the end-point of a linear develop-
> ment, but a state of perpetual creative activity. Eden itself moves, going
> from Eternity to Eternity, creation to creation. [*The Awakening of Albion*,
> pp. 151–52]

Albion moves "forward irresistible from Eternity to Eternity," as *Jerusa-
lem* 98 informs us. This is the gist of the final lines of Lilith's speech,
that Mankind should dread stagnation of all things, that when the
Ancients attain redemption from flesh they will supersede her, that of
Life only there is no end. "The power and the glory, world without
end," as Franklyn Barnabas had quoted in Act II, means that there is
no Limit of Translucence.

Notes

1. Valli Rao is a tutor in English at the Flinders University of South Australia, Adelaide.

2. Among critics who deal in varying degrees with the Shaw-Blake relationship are Charles A. Berst, "The Devil and *Major Barbara,*" *PMLA,* 83 (1968), 79; Renée M. Deacon, *Bernard Shaw as Artist-Philosopher: An Exposition of Shavianism* (London: A.C. Fifield, 1910), pp. 100–104; Irving Fiske, "Bernard Shaw's Debt to William Blake" (London: The Shaw Society, 1951; reprinted as "Bernard Shaw and William Blake" in R.J. Kaufmann, ed., *G.B. Shaw: A Collection of Critical Essays,* Twentieth Century Views [Englewood Cliffs, N.J.: Prentice-Hall, 1965] pp. 170–78); Northrop Frye, *Fearful Symmetry: A Study of William Blake* (1947; rpt. Princeton, N.J.: Princeton Univ. Press, 1974), pp. 35, 111; Charles Gardner, *Vision and Vesture: A Study of William Blake in Modern Thought* (1929; rpt. New York: Kennikat, 1966), pp. 143–55; Daniel J. Leary, "Shaw's Blakean Vision: A Dialectic Approach to *Heartbreak House,*" *Modern Drama,* 15 (1972), 89–103; Margery Morgan, *The Shavian Playground: An Exploration of the Art of George Bernard Shaw* (London: Methuen, 1972), pp. 134–35; J. L. Wisenthal, *The Marriage of Contraries: Bernard Shaw's Middle Plays* (Cambridge, Mass.: Harvard Univ. Press, 1974).

It is well to clarify here that the purpose of this essay is not to demonstrate that Shaw consciously borrowed concepts from the Blakean myth, nor that Shaw had read Blake. My purpose is to show that Shaw's plays (especially *Back to Methuselah*) lend themselves to illuminating analysis and interpretation in the light of the Blakean myth. Of course, Shaw had read Blake; and that he regarded Blake with consistent admiration, and studied him throughout his writing career, is evident from Shaw's own writings. Readers who are interested in Shaw's direct references to Blake may consult the Appendix to my thesis, "Bernard Shaw's Religious Vision: A Blakean Interpretation of his Plays" (Doctoral thesis, Flinders University of South Australia, Adelaide, 1978), pp. 266–83; and my article "Vivie Warren in the Blakean World of Experience," *Shaw Review,* 22 (1979), 123–24.

3. I borrow this expression from Shaw's film version of *Major Barbara,* where it is used to explain the interpretation of the Israelites' passage through the Red Sea in terms of the Socialist revolution (*Major Barbara: A Screen Version* [Harmondsworth, Middlesex: Penguin, 1945], p. 142).

4. Among these are Harry M. Geduld, "An Edition of Bernard Shaw's *Back to Methuselah*" (Doctoral thesis, Univ. of London, 1961); Daniel Leary and Richard Foster, "Adam and Eve: Evolving Archetypes in *Back to Methuselah,*" *Shaw Review,* 4 (1961), 12–25; Raymond S. Nelson, "*Back to Methuselah:* Shaw's Modern Bible," *Costerus,* 5 (1972), 117–23.

5. See, for example, Jacques Barzun, "From Shaw to Rousseau," in *The Energies of Art* (New York: Harper, 1956); Eric Bentley, *Bernard Shaw: A Reconsideration* (1957; rpt. New York: Norton, 1976), p. 104; Leon Hugo, *Bernard Shaw: Playwright and Preacher* (London: Methuen, 1971), pp. 206–208; J. L. Wisenthal, *The Marriage of Contraries,* p. 214.

6. *Jerusalem* 38:25. Unless otherwise specified, my references to Blake's works are to *Blake: Complete Writings,* ed. Geoffrey Keynes (1957; rpt. Oxford Univ. Press, 1972). I use the abbreviation *J* for *Jerusalem* in parenthetical and footnote documentation.

7. *Fearful Symmetry,* p. 230. I am greatly indebted to Frye's book for elucidations of many of Blake's concepts.

8. *The Awakening of Albion: The Renovation of the Body in the Poetry of William Blake* (Ithaca: Cornell Univ. Press, 1974), pp. 33–34.

9. This aspect of the Female Will is represented by such Blakean figures as Vala, Rahab (who is "Vala drawn down into a Vegetated body" and whom Blake indentifies

with the biblical Whore of Babylon), and Rahab's daughter Tirzah, the Prude who controls man by denying him his sexual desires and who thereby directs man's energies into war: "I must rush again to War, for the Virgin has frown'd & refus'd" (*J* 68:63). See my article "Vivie Warren in the Blakean World of Experience," *Shaw Review*, 22 (1979), 123–34, for the early Blakean and Shavian view of the Female Will.

10. Foster S. Damon, *A Blake Dictionary: The Ideas and Symbols of William Blake* (1965; rpt. London: Thames and Hudson, 1973), p. 162.

11. Blake's Newton represents an attitude that thinks of the world as a completely material, three-dimensional, mechanistic and impersonal place. For a perceptive explanation of the nature of the "Newton" whom Blake attacks, see Peter Fisher, *The Valley of Vision: Blake as Prophet and Revolutionary*, ed. Northrop Frye, Univ. of Toronto Department of English Studies and Texts, No. 9 (Toronto: Univ. of Toronto Press, 1961), p. 109.

12. *Back to Methuselah: A Metabiological Pentateuch* (London: Constable, 1931), p. xli. Unless otherwise specified, all my references to Shaw's works are to the Constable Standard Edition (London: Constable, 1931–50).

13. For a compact discussion of Shaw's manipulation of Weismann's views on the nature of death, see Louis Crompton, *Shaw the Dramatist* (Lincoln: Univ. of Nebraska Press, 1969), pp. 172–73.

14. Criticism such as St. John Ervine's in *Bernard Shaw: His Life, Work and Friends* (New York: William Morrow, 1956), which opines that Shaw in such passages is allying himself with those who banish mind from the world, arises from a lack of distinction between the Will attached to the Selfhood and the Will attached to the Imagination.

15. Compare *J* 54, where the Spectre of Albion, boasting that he is "Bacon & Newton & Locke," mocks Jesus for preaching "an unknown Eternal Life" without empirical foundation in a world which he sees as constituting only "craving lust & devouring appetite."

16. The Shavian counterpart to this adage is that "the human animal, as he exists at present" is not capable of "solving the social problems raised by his own aggregation, or, as he calls it, his civilization" (Preface to *Back to Methuselah*, p. x).

17. "A Glimpse of the Domesticity of Franklyn Barnabas" is a continuation of Part II of *Back to Methuselah* which was discarded from the play and published separately in *The Black Girl in Search of God and Some Lesser Tales* (pp. 213–59).

18. As Harold Bloom says in his Commentary to *The Poetry and Prose of William Blake*, ed. David V. Erdman (1965; rpt. Garden City, N.Y.: Doubleday, 1970), p. 845.

19. David V. Erdman's commentary to Plate 7 of *Jerusalem* in *The Illuminated Blake: The Complete Illuminated Works of William Blake* (1974; rpt. London: Oxford Univ. Press, 1975).

20. It is interesting to note that as man evolves further, the Mother figure gets correspondingly less possessive in her hold over him. Eve in Act I controls her husband and sons with a maternal possessiveness which is Mother Nature's clutching, constrictive hold of her children. In Act II, Savvy (short for Savage; her real name is Cynthia, no doubt an allusion to the moon Goddess of Chastity) is a Tirzah-figure like Vivie Warren in *Mrs Warren's Profession*: both Vivie and Savvy have had a University education, have intellectual pretensions, smoke, and play tennis; and though Savvy, unlike Vivie, gets married, she has no children (as we learn in Act III, p. 115), which is consonant with her image as a 1920 Eve who has, Tirzah-like, urged men to war (p. 85) and who represents an acme of barrenness. With the acceptance on man's part of a life-span of 300 years, things begin to improve. Mrs Lutestring in Act III, though still "Dianesque" (p. 110), is much more liberal than Eve or Savvy-Cynthia, and she wants no strangling hold over the children that she and the Archbishop will have for the sake of the race: "I never was very

fond of children, except that one girl who woke up the mother passion in me" (p. 118). Her attitude to children leads to Zoo's in Act IV, matter-of-fact and business-like: "I specialize in babies. My first was such a success that they made me go on" (p. 147). She is amazed that the Elderly Gentleman's mother bothered about him after he was ten years old. He protests that it was natural, as she was his mother, and asks Zoo "What would you have had her do?" Zoo replies: "Go on to the next, of course. After eight or nine children become quite uninteresting, except to themselves. I shouldnt know my two eldest if I met them" (p. 148). The She-Ancient in Act V is a Mother figure who delivers the Newly Born from her egg, gives her a quick medical examination to make sure she is healthy, gives her also a brief talk on childhood and adulthood, and then leaves her to discover the world for herself.

21. "Bernard Shaw: The Career of the Life Force," *Modern Drama*, 15 (1972), 139–40.

22. "The Philosophy of Bernard Shaw: A Study of *Back to Methuselah*," *London Quarterly & Holburn Review*, July 1945, 339.

23. I quote from the typescript in the British Library, Add. MS. 50631, fols. 131–32, dated Christmas 1938.

24. Shaw's words are quoted in Stanley Weintraub, ed., *Bernard Shaw 1914–1918: Journey to Heartbreak* (London: Routledge & Kegan Paul, 1973), p. 299.

25. Joseph Wicksteed, *William Blake's Jerusalem* (London: The Tranion Press for the William Blake Trust, 1953), p. 198. Wicksteed is quoting from *J* 48:36–39.

26. Blake's *Milton*, Plate 13, tells us that "The sin was begun in Eternity." In *A Vision of the Last Judgment*, Blake writes: "Many suppose that before the Creation [of natural life, described in Genesis] All was Solitude & Chaos. This is the most pernicious Idea that can enter the Mind, as it takes away all sublimity from the Bible & Limits All Existence to Creation & Chaos, To the Time & Space fixed by the Corporeal Vegetative Eye . . ." (Keynes, p. 614).

27. As in *J* 29: "the vast form of Nature like a serpent roll'd" between Luvah and Vala; cf. also Ahania's lament to Urizen in *The Four Zoas* III, Keynes p. 294. Natural man is sometimes described in Blake as serpentine, as George Mills Harper points out, quoting *Tiriel*, "men bound beneath the heavens in a reptile form," Keynes p. 110; *The Book of Urizen*, Keynes p. 236; and *The Song of Los*, Keynes p. 246 (*The Neoplatonism of William Blake* [Chapel Hill: Univ. of North Carolina Press, 1961], p. 236). See also *Fearful Symmetry*, pp. 136–37. For the serpent as a sexual symbol see Damon's interpretation in *A Blake Dictionary*, p. 366, and *Fearful Symmetry*, pp. 445–46.

28. See *Fearful Symmetry*, p. 136. Fisher points out that the serpent is "a form which Blake associates with eating the fruit of the Tree of the Knowledge of Good and Evil" (*The Valley of Vision*, p. 146). In *Back to Methuselah*, the Serpent says she "chose wisdom and the knowledge of good and evil" (p. 252). She tempts Eve to "bite the apple you dread" (p. 9).

29. Harry M. Geduld, "The Lineage of Lilith," *Shaw Review*, 7 (1964), 58–61, traces the legends associated with Lilith as a demonic female as well as the " female incarnation of the Evolutionary Appetite." See p. 60 for the link between the evolutionary breeding of the Superman in *Man and Superman*, and the legend of Lilith in *Back to Methuselah*, and particularly, the link between Ann Whitefield and Lilith.

30. J. B. Kaye shows how Shaw's Lilith as the evolutionary appetite interprets the meaning of the "Good and ‏לילת‎ [Lilith]" serpent in Blake's *The Laocoön (Bernard Shaw and the Nineteenth Century Tradition* [Norman: Univ. of Oklahoma Press, 1958], pp. 126–27).

31. Eno in *The Four Zoas* is, as Frye puts it, "a daughter of Beulah or inspiration [through whose eyes] Blake sees the whole of existence projected in the form of a single

drama of fall, redemption and apocalypse" (*Fearful Symmetry*, p. 270). Lilith's speech at the end of *Back to Methuselah* puts the play in the same perspective to her. Lilith's strong identity with Erin is clear when her speech is compared with *J* 11, pp. 48–50, 74, 86, and 94.

32. As Stevenson explains, Blake "visualizes the island of England as the giant Albion, stretched out in sleep, so he sees the neighbouring island Ireland as a beautiful woman, Erin, who sits by him, watches over him, and shields him from the full force of the destructive Atlantic waves" (*The Poems of William Blake*, ed. W.H. Stevenson, text David V. Erdman [London: Longman, 1971], p. 646). The parallel with Lilith, guarding mankind, is obvious.

33. The Spectre of Albion is to be distinguished from Los's Spectre (who is the Spectre of Urthona), in the same spirit as Darwin is to be distinguished from Weismann. The Spectre of Albion is identified with Luvah in *J* 47:3. Luvah in turn "is named Satan because he has enter'd that State: a World where Man is by Nature the enemy of Man" (*J* 49).

34. Arthur H. Nethercot remarks that "Lua was a Roman goddess, associated with Saturn, to whom captured arms were devoted" (*Men and Supermen: The Shavian Portrait Gallery* [1954; rpt. New York: Blom, 1966], p. 300).

35. We remember that the bird in Haslam's garden had, in Act II, advised him to "stick it or chuck it" as a clergyman (p. 40).

36. For details of the stages through which the Orc cycle proceeds, see *Fearful Symmetry*, p. 211.

37. Wisenthal points out the similarity between Barnabas and de Stogumber (*The Marriage of Contraries*, p. 212).

38. Frye explains how Job and Jesus in their death represent the death of the natural man: "One thing that Blake clearly saw in the story of Job was a microcosm of the whole biblical story. . . . Job occupies the place of Adam or Israel or Blake's own Albion, the symbolic figure of humanity. . . . " ("Blake's Reading of the Book of Job," *William Blake: Essays for S. Foster Damon*, ed. A.H. Rosenfeld [Providence: Brown Univ. Press, 1969], pp. 221–34). In *Fearful Symmetry*, Frye explains how "the career of Jesus is visualized in the Gospels as a recreation or epitome of the story of Israel" (p. 370) and how the point of the crucifixion scene in Chapter III of *Jerusalem* is "to show that Jesus also [like other human beings sacrificed in religion and war] was killed as a Luvah in the role of the dying Albion" (p. 398).

39. This is the state of Innocence shown in Illustration I of Blake's *Illustrations of the Book of Job* (first copy made about 1820). Job's innocence is well interpreted by S. Foster Damon in *Blake's Job: With an Introduction and Commentary by S. Foster Damon* (Providence: Brown Univ. Press, 1966), p. 12.

40. We see an example of the Elderly Gentleman at his best in the noble speech on his body as the temple of the Holy Ghost (pp. 151–52), which is as full of faith as Job's affirmation "For I know that my redeemer liveth . . . And though after my skin worms destroy this body, yet in my flesh shall I see God" (Job 19.25,26). We also note that Job's unheeded plea to his friends—"But ye should say, Why persecute we him, seeing the root of the matter is found in me?" (Job 19.28)—*is* responded to by Zoo as she remarks, at the end of the Elderly Gentleman's speech, "Bravo, Daddy! You have the root of the matter in you. You will not die of discouragement after all" (p. 152). For further examples of the Elderly Gentleman at his best, see pp. 153–54, 157, 182, 184–85, 186, 188, 193.

41. We see the Elderly Gentleman at his worst in such moments as when he indulges in nostalgic idealization of the past (p. 148); and when, deplorably, he forms an audience to the Envoy (pp. 190–91); and in his notion of a civilized country as one where he can travel comfortably and there are good hotels (p. 142); and when he speaks condescendingly of the "agricultural laborer" and the "lower classes" (p. 138).

42. *Bernard Shaw, Playwright* (Columbia: Univ. of Missouri Press, 1973), p. 256.

43. *Childhood's End* (1954; rpt. London: Sidgwick & Jackson, 1970), p. 83.

44. "The Ends of Childhood: Eschatology in Shaw and Clarke," *Shaw Review,* 16 (1973), 76. Leary's article compares the situation of the Overlords with those of the Serpent and Confucius in *Back to Methuselah.*

45. "The aim of Blake's Prophecies and the Uses of Blake Criticism," pp. 19–20 in *Blake's Sublime Allegory,* ed. Stuart Curran & Joseph Anthony Wittreich, Jr. (Madison: Univ. of Wisconsin Press, 1973).

46. H.M. Geduld notes the allusion to 1 Corinthians 13.12: "For now we see through a glass, darkly; but then face to face . . . " ("Shaw's Philosophy and Cosmology," *California Shavian,* 1, No. 4 [May 1960]). There is also an implicit reference to 1 Corinthians 13.11: "When I was a child, I spake as a child, I understood as a child, I thought as a child: but when I became a man, I put away childish things." Eugene Tanzy, in an article which on the whole does not, in my opinion, do justice to Shaw's views on evolution, comments very appropriately on the role of art in Part V: "In the end, Shaw's artists turn their backs on art itself. This is not a Shavian repudiation of the means by which he worked. Art lasts, for Shaw, as long as man lasts. Art remains until the consummation of the world, but no longer—as long, that is, as we are compelled, as St. Paul put it, to see through a glass darkly. Art is needed to lead man to the perfect vision; it ceases to have any function once the ultimate stage is reached . . ." ("Contrasting Views of Man and the Evolutionary Process: *Back to Methuselah* and *Childhood's End,*" in Joseph D. Olander and Martin Harry Greenberg, eds., *Arthur C. Clarke* [London: Paul Harris, 1977], p. 183).

47 R.L. Grimes, "Time and Space in Blake's Major Prophecies" *(Blake's Sublime Allegory,* p. 76).

48. Among critics who explicitly label Shaw a dualist of this sort are Joad, Gibbs, and Crompton. See C.E.M. Joad, *Shaw* (1949; rpt. Folcroft Library Editions, 1971), p. 177; A.M. Gibbs, *Shaw* (Edinburgh: Oliver & Boyd, 1969), p. 78; L. Crompton, *Shaw the Dramatist,* p. 187.

49. C.E.M. Joad, wondering what the Ancients think about, writes: "It is, perhaps, the absence of any answer to the question in Shaw which has seemed to some people to leave his whole philosophy hanging, as it were, in the air, a philosophy of Life arising from a nothingness and developing in a vacuum in pursuit of a purpose which is left undefined" (*Shaw and Society: An Anthology and a Symposium,* ed. C.E.M. Joad [1951; rpt. Folcroft Library Editions, 1970], p. 243. A.M. Gibbs writes: "In the final analysis there is a teasing circularity about the superman philosophy. . . . Shaw can only postpone the answer to C.E.M. Joad's question as to what the contemplative supermen are supposed to contemplate, until the superman arrives to tell us" (*Shaw,* pp. 36–37).

50. So W.H. Stevenson paraphrases in his edition of *The Poems of William Blake,* p. 839.

Daniel Leary[1]

TOO TRUE TO BE GOOD AND SHAW'S ROMANTIC SYNTHESIS: A RELIGION FOR OUR TIMES

"By religion," Shaw writes, "I mean a common faith that binds men together."[2] In the preface to *Back to Methuselah,* he proffered Creative Evolution as "the religion of the twentieth century, newly arisen from the ashes of pseudo-Christianity, of mere scepticism, and of the soulless affirmations and blind negations of the Mechanists and Neo-Darwinians."[3] As an answer to the determinism of the Mechanists and the instinctive aggression of the Neo-Darwinians, Creative Evolution depended not on an accidental biological sport that might produce a Superman but on a symbolic death to self and rebirth to "a common faith" on the individual level and an actual convergence "that binds men together" on the social level.

In Shaw's plays, Creative Evolution became a romantic vision, a complex synthesis with which he continued to experiment through the years even to the time of the late plays when the problems of the modern world seemed to reduce his tentative solutions to absurdity. I first consider Shaw's romantic synthesis as it appears in the body of his work but particularly in *Too True to be Good* and then focus specifically on *Too True* which both in techniques employed and in problems faced is strikingly of our time. This latter material falls into two sections: one deals with death-birth transformations in the play as well as between the play and the audience; the other section is concerned with the psychic compartmentalization which prevents the romantic synthesis from taking place.

I call Shaw's vision romantic because for all his "hard-as-nails" realism his attack on Darwinism was based on a world view that was essentially romantic, if by a romantic we mean one who animates matter, who sees, feels, imagines life in the lifeless or wills will into the will-less, who sees no limits and who believes that wishing will make it so, believes that the bare, stubborn, irreducible facts of nature can be re-

duced, overcome, willed away by the focusing, the converging of powers in individual man and in mankind: in short, Shaw is a romantic if by a romantic we mean one who displaces Narcissus with Pygmalion. In Shaw, this romantic notion of converging, of binding together, takes the form of a four-fold synthesis which may have developed from his readings in Shelley and Blake, especially in Blake. He seems to share their vision of a Titanic figure—Prometheus for Shelley, Albion for Blake—that has been nailed down, not by an external principle of evil, but by his own separated faculties, gone wrong in isolation from each other, and whose coming together at the close of *The Four Zoas* and *Prometheus Unbound* offers a symbolic recreation of individual man and a fulfilling of humankind's possibilities. The Shelley-Prometheus theme I find quite early in Shaw's treatment of Siegfried in *The Perfect Wagnerite*, but it is elusive. The Blakean influence is closer to the surface. In the preface to *Man and Superman*, Shaw names both Blake and Shelley as "writers whose peculiar sense of the world I recognize as more or less akin to my own," but Blake is listed with Hogarth, Bunyan and Turner—"these four apart"—while Shelley is included in a more general grouping (II, 519–20). It is, however, the romanticism in Shaw and not the influences upon him with which I am concerned. Perhaps it is enough to take Shaw at his word: "I am, and always have been, a mystic. I believe that the universe is being driven by a force that . . . has got into the minds of men as what they call their will."[4]

This non-rationalistic, non-materialistic vision of reality is presented clearly by the Serpent in *Back to Methuselah* who explains to Adam and Eve that "Imagination is the beginning of creation. You imagine what you desire, you will what you imagine and at last you create what you will" (V, 348). *Back to Methuselah* addresses itself to the possibility that if man desired his own death in the beginning, he should be able to emancipate himself from the natural cycle of life and death by reversing that desire, seizing once again control of Mother Nature and reducing her to his emanation. This four-fold faculty concept of desire, imagination, will, and creation had been on Shaw's mind at least twenty years earlier when he had his Don Juan proclaim that the ideal man is "he who seeks in contemplation to discover the inner will of the world, in invention to discover the means of fulfilling that will, and in action to do that will by the so-discovered means" (II, 664). What is wrong with man in the neo-Darwinian period is not that these faculties are not to be found but that they are usually misdirected and almost invariably have no scope in which to develop. Desire may not be Inner Will but only a longing for another person or another person's possessions; Imagination may not be contemplation but only a playing with art for art's sake; Will may not be the directing of the intellect toward invention but only a drive to intimi-

date the wills of those around one; Action may not be a movement toward excellence but only a rehearsed response.

Desire is instinctive and as with all the faculties works on the individual as well as the racial level. In the plays Shaw usually assigns desire to one of the female characters, presumably because woman is biologically more involved in the birth process. Enlightenment comes when she perceives that her desire is but a reflection of a collective desire, that of becoming a force of nature rather than an egotistic bundle of wishes. Imagination is the capacity to dream things that never were, to have intuitions about human nature and destiny that at exalted moments have inspired the great religious and revolutionary movements of history. In psychological terms it is intentionality, the tentative goal that is always becoming, always about to be attained since that goal changes with the growth of the individual. In artistic terms imagination is seen, for example, in the possibilities projected by the plays we are considering here. The vision of possibilities, of things as they could or should be, certainly can be narrowed by awareness of the limitations of human action, but what is between vision and action is an existential gap, a revolutionary and transforming act of will. Will—the power to choose—is activated by the Serpent in *Back to Methuselah* when she encourages Adam with the message-question "Why not?" Since Will in this sense seems to be connected with intelligence, with the power to consider pros and cons before we leap, we often see male characters talking away their powers of will unless they can join them with female desire. This Bergsonian reconciliation of the intellect-instinct opposites dramatically presented in the uniting of male and female is synthesis in the true Hegelian sense and is found in some form in most of Shaw's plays. The synthesis of faculties I call attention to is obviously not a polarity resolved, but a converging of complementary parts to form an integrated whole. However, in the course of the paper we will see Shaw using Hegelian synthesis as a major method of opening possibilities for the ultimate convergence.

From an idealistic point of view, no fourth faculty is necessary in this convergence. Desire, Imagination and Will are Action. The man informed on the individual and racial levels by all three attains a new dimension of freedom in which, detached but not separated from his community, he finds himself in a world where what he wants to do and what he has to do are the same things. From this perspective we have a Shaw who like Plato in the *Republic* was interested not in creating an external Utopia but in demonstrating the analogy between the ideal state and the elements of the ideal man's mind. The crucial difference is that Plato emphasized "reason" as the faculty controlling desire and will whereas Shaw perceived reason, at least in the male-female

struggle, as ancillary to will, and he replaced it with Imagination. Reason, however, seems mercurial in Shaw. It is never given the full status of a faculty but subsumed at different times by any one of the four faculties and ideally—perhaps a foreshadowing of the longed-for convergence—at times informs all four. The notion of passionate intellect and intellectual passion certainly was part of Shaw's way of experiencing the exceptional man since the time of *Man and Superman* and I believe well before.

Though I emphasize the romantic Shaw, it would be a distortion to ignore the executive power, the faculty of Action that is necessary if man is to realize the dream of the ideal man's mind in a material world. Creative Action is the result of the three preceding powers being incorporated in one human—or eventually the body politic—dedicated to advancing the purpose of ultimate reality. Still there is something wry in Shaw's presentation of these characters of informed Action. They are usually servants who are aware of all that is going on about them, enjoy the spectacle, are refreshed by their work, but accomplish little. Consider, for example, the perfect waiter William in *You Never Can Tell*, the freed slave Britannus in *Caesar and Cleopatra*, the managing matron Britomart in *Major Barbara*, the shrewd Nicola in *Arms and the Man*. In such characters of Action Shaw gives us figures compartmentalized in an idea of efficiency or integrated beings who are neutralized by a fragmented society. They experience the same frustrations as do the characters associated with the other functions. Either tragedy or absurdity results when characters, unwilling or unable to unite their dominant faculty with other faculties around them, compartmentalize rather than harmonize.[5]

Only a Superman would incorporate all the functions working in harmony and Shaw gives us but three examples of such an edifying character: Caesar in *Caesar and Cleopatra*, Saint Joan, and Private Meek in *Too True*. Even they are limited. Reserving comment on Meek till later, consider Caesar and Joan. Caesar, though he casts himself in the role of a Pygmalion-teacher, cannot persuade, cajole, or intrigue others into uniting their four faculties. *Caesar and Cleopatra* touches on tragedy at the moment when Caesar stands in the midst of his four followers and finds that none of them can see the wrong done in the murder of Pothinus. Cleopatra's desire is for revenge, Apollodorus' imagination is captured by the idea of glorious honor, Rufio's will is directed toward the removal of the enemy, and Britannus, the able servant, the man of quiet efficiency, can think only of taking action to protect Caesar.

Like Caesar, Joan's tragedy lies not in the schemes of her enemies but in the blindness of those closest to her. Her tragedy takes place in the cathedral of Rheims, not at the Rouen Inquisition. In the last four

lines of Scene V, Joan is rejected by Charles whom she had inspired with the desire for kingship, by Dunois whose imagination had taken fire at Joan's first kingfisher flash, by the Archbishop whom she thought shared her will, and by La Hire who, with the sound instincts of a commoner, admits even in the moment of his rejection that she moves him to take action. As they intone their negative litany—to be ritualized in the Epilogue—her departing blessing echoes in the cathedral ambulatory: "God be with me." She has taken action by leaving them in their fragmented "glum silence" to realize her own desire in assuming leadership of an army fighting for a unified France, leaving them to unite her will with a transcendent one. Having become her own archbishop, general, king, she blesses herself in an action that will fire the imagination of "the common people . . . for ever and ever" (VI, 154–55).

Unlike Caesar, Joan is not aware of the dynamics of what is happening. It may be that in her combining of the faculties she operates on an unconscious level with intellect absorbed into desire and imagination rather than into the will. In the preface to *Saint Joan,* Shaw moves from the observation that among other geniuses "Blake saw visions and heard voices" to "the dramatization by Joan's imagination of . . . the evolutionary appetite" (VI, 24–26). But he cites Socrates as well, who directed his will toward "arguments, operating slowly and peacefully on men's minds, whereas Joan was a woman of action" (VI, 17). Intellect apparently can be an alternative to, perhaps another version of, Action rather than the essentially human way of coping with the world or of becoming aware of one's impact on the world. Joan, Socrates, and Christ—those last two mentioned in the preface along with some twenty other geniuses-saints-teachers—live "for ever and ever" in the imaginations of the common people. Both the Galateas and the Pygmalions wait "How long, O Lord, how long?" for the touch, for the response.

I have found similar foursomes in other plays between *Caesar* and *Joan* but they do not have a central figure, a Superman, who combines their qualities. Consider *Man and Superman.* It is in the dream sequence that we find most clearly the desire of the devil which is part death wish and part pleasure principle, the imagination of Ana which moves her to envisage a father for the Superman, the will of Juan which leads him to resolve to get out of hell. The Statue, seen as a father figure, represents organized society and the usual actions taken in that society whether they be punishing the renegade or turning heaven into hell. Similar fourfold patterns exist in *Major Barbara, John Bull's Other Island* and *Heartbreak House.* In all of them Shaw seems to be seeking for more than a Superman. He is working out a pattern for a viable society in a

time when society seemed to be floundering. Thus, in *Major Barbara*, Undershaft explains that Barbara, Cusins, and he "must stand together above the common people: how else can we help their children to climb up beside us?" (III, 121). Barbara represents a spiritual desire that is closely linked with the Life Force; Cusins has an imaginative outlook informed by his knowledge of Greek culture and the vision of the philosopher-king; Undershaft has the will to draw them all together. Only Action seems to be missing, but then there is Lady Britomart. Like Britannus in *Caesar and Cleopatra* she represents a continuing tradition and a sense of order. The play closes with Barbara seeking her mother's practical advice on how to make the factory city livable.

The various faculties of man and the demarcations between them are topics of conversation in all three acts of *Too True*. In Act I, Aubrey commands Sweetie to "obey me instantly.... In our firm I am the brain: you are the hand" (VI, 446). In Act II Aubrey confides that Sweetie was not his "intellectual equal" though there was "extraordinary sympathy between our lower centres" (VI, 474). He goes on to explain that "Our lower centres act: they act with terrible power that sometimes destroys us; but they dont talk. Speech belongs to the higher centres" (VI, 477). Mops, however, asserts that the higher centers are not exclusively male: "Hear my higher centres shouting.... We [are] three inefficient fertilizers" (VI, 422–23). The Sergeant in Act III confirms this sexual equality: "Men and women have a top storey as well as a ground floor" (VI, 495). Still, he leaves no doubt that it is her "ground floor" that stimulates his "top storey."

The basic division seems to be the usual Shavian one in which Aubrey is classified among men who "are not real: they are all talk, talk, talk" (VI, 482), while the very "real" woman Sweetie goes out and nabs her Sergeant. However, in terms of the four faculties, Sweetie is elementary desire uncomplicated in her insistence on immediate gratification but subject to confusion in the objects of that desire. At the close of the play, Shaw singles out Mops as "his own favorite ... the woman of action" (VI, 528), but some half dozen times throughout the play she refers to the action around her as her dream. She is Imagination seeking "real life," a fitting projection of human possibilities. Aubrey may identify himself with "brains," but his gift is for preaching, for exhorting others to change. It is his Will that initially moves Mops' "will" and it is his inability to find a worthy religion to devote his sermons to that accounts for the abysses opening around all the characters. The fourth faculty, the ability to act, is conveyed negatively in the inability of the various representatives of society—the colonel, the doctor, the parents—to act efficiently. Only Private Meek combines all four faculties. He is able to do, as the Colonel observes, "everything that is nat-

ural to a complete man . . . helping himself and everyone else" (VI, 516). But even he is enmeshed in absurdity because of his involvement with society.

Shaw claimed in the preface to *Back to Methuselah* that Creative Evolution "cannot become a popular religion until it has its legends, its parables, its miracles" (V, 332). But the legends and parables he offered in his dramas serve dual purposes: not only do they incorporate iconography, hagiography, and mythology which are already part of western lore and thus more readily assimilable into a "common faith," but they are presented in a way calculated to shock audiences into binding together, to open them to the possibility of conversion in all their faculties. Thus in *Man and Superman* and *Back to Methuselah* he used Don Juan and the Bible, but in the midst of his proselytizing his dramatic instinct took over and undercut his message; he deflated his rhetoric with a devil who managed to score telling points or an Elderly Gentleman who elicited more sympathy than a stage full of Longlivers. In both *Caesar and Cleopatra* and *Saint Joan*, Shaw has history and legend, time and the timeless collide. In Caesar we have a legendary, god-like leader who is constantly deflated by the realities of time and matter. Joan, in mythic timelessness, is selfless in her prophetic purpose, while in historical time striving for that purpose she is willfully opposed to regal and sacerdotal forces. This tension is at the heart of *Saint Joan*. In fact Shaw at one point used as his title-page epigraph a line from the Book of Job—later transferred to the preface (VI, 55–56)—which expresses this duality: "Though He slay me, yet will I trust in Him: but I will maintain my own ways before Him" (13:15). With the Epilogue Shaw managed both to cancel the tragedy of the historically "incinerated" Joan by juxtaposing it with a vision of the legendary canonized one and to undercut the religiously edifying effect of the legend by presenting his saint as in near despair before the world she came to save.[6]

In the final plays, though Shaw was still offering parables for his time, the undercutting becomes virtually an uprooting. The elements of the four-fold dream are certainly there, only now he could write in the preface to *On the Rocks* (1933): "I do not present my creed of Creative Evolution as anything more than another provisional hypothesis" (VI, 606). The parable Shaw was offering was a Hegelian dialectic in which his faith confronted nothing with the possibility of a mediating and reconciling synthesis which immediately might be only a new concept, an awareness, but eventually might be a rebirth, the gathering of Albion's fragments. Shaw was attempting to change—to convert—his audience by exposing them to the unexpected. In the final sermon of *Too True*, Aubrey addresses the audience directly as he had done in the Act I

clothes-speech and reports "our souls . . . in rags" giving "glimpses of the reality that was hidden" (VI, 526).

Years before Shaw provided the same existential insight in *The Glimpse of Reality* (1909) in which the anti-hero Ferruccio says of his confrontation with death:

> I have come up against . . . something real: something that does not care for me. . . . There is nothing like a good look into the face of death . . . for shewing you how little you really believe and how little you really are. . . . When I believe in everything that is real as I believed for that moment in death, then I shall be a man at last. [III, 833]

The reality seen by Ferruccio is at the heart of the mystery of every one of Shaw's heroes—Blanco Posnet, Saint Joan, Caesar, Barbara, the Elderly Gentleman in *Methuselah*, Father Keegan, all of whom realize, as does Dick Dudgeon in *The Devil's Disciple*, that the devil, the nothingness, the death in oneself, must be confronted. Whenever Shaw used the term "heartbreak" he had in mind this possibility of spiritual rebirth.

As we shall see, the pattern of death and possible rebirth in the four faculties governs the characterization and contents of *Too True*, but the play's form—and formlessness—is also affected by the same pattern in a way that goes beyond the footlights. Shaw wanted his audience to experience the Ferruccio reaction. In *Too True*, which was subtitled in the second proof "A Collection of Stage Sermons,"[7] Shaw wanted to rouse the desire, imagination, and will of his audience, to upset them, to open discontinuities, gaps, which might prompt unexpected responses. His sermon-play was an attempt to dramatically employ the rhetorical, psychological technique he used so often in his religious speeches—that is, of undercutting the audience into laughter, asking them why they were laughing, pausing to permit their uneasy self-consciousness to become palpable, and then returning with a heightened intensity to the issue of redirecting our money-and-mammon-oriented society to "a community in which life is given every possible chance."[8]

In *Too True* we laugh at Aubrey, the Prince Charming who awakens a Sleeping Beauty only to have the wind knocked out of him. We laugh at the Colonel who awakens a "Medea" (VI, 521)[9] to the facts of her living daughter and the two children she killed—two Pygmalions whose Galateas (as usual in Shaw) awaken their awakeners. The reversals lead nowhere and our laughter is unresolved. We laugh at the romantic tale of three young people achieving liberation only to have our laughter trail off as we realize they don't know what they want, can't imagine where to direct their wills and function solely as inferior fertilizers.

Little wonder the 1931 audience pronounced the play unpleasant and meaningless—neither good nor true. With his mix of absurdity and denunciation resulting in the choked laugh, Shaw was creating a Brechtian distance between the play and its viewers, compelling them to experience the prostitution of their own lives. Sweetie in her role as Countess explodes when Aubrey talks about self-respect: "You are a thief and so am I. I go a little further than that, myself; and so would you if you were a woman" (VI, 475). But Aubrey has gone further than Sweetie. He is a prostitute murderer—a war hero who did not want to kill but did so to win the favor of his mother and his country. The play conveys the impression of a world filled with characters whose desires are manufactured, whose wills are bent, characters who sell themselves for money or respect. Mops complains of the "parasities," the "tourists agencies, steamboat companies, railways . . . servants, all trying to get my money by doing all the things for me that I ought to do for myself" (VI, 510). The real prostitution here is the abdication of responsibility even more clearly seen in the docile acceptance of the authority of professionals who themselves are irresponsible: the doctor who justifies his role in the sick room with "Why should she cure herself . . . when she can afford to pay the doctor to cure her?" (VI, 438); the Colonel who accepts the K.C.B. that was earned by Private Meek; the chaplain who, according to the Sergeant, sells out by trying to appear like a "real sport" (VI, 498). Their claims to cure, protect, and save prevent the patient from taking those actions for herself. And then there is the professional love of the mother that would cure, protect, and save, all in one, that becomes prostitution by being an act without desire, imagination, and will leading to spiritual death in both mother and daughter. Even after her spectacular recovery, Mops only gradually becomes aware of the inverted prostitution inherent in robbing herself of riches she did not earn to support herself and her fellow thieves in a totally irresponsible life in death.

Shaw wanted his audience to have a glimpse of their involvement in this prostitution. A dozen years before Sartre, he was demonstrating that we become what society sees us as. Every time Shaw broke a mythic, comic, or dramatic pattern, every time he shifted from absurd presentation to realistic evaluation, every time the anticipated laugh was frustrated, the audience was given a glimpse of the reality that their own desires, imaginations, and wills were part of the act, that their conditioned responses, their standardized expectations, were part of what was wrong with those characters up there. In *Too True* and many of the other late plays Shaw was intensifying the effect he sought in Act IV of *John Bull's Other Island* where he divided the stage into two areas occupied by emotionally separate groups. One side was convulsed at the tale of the death of a pig; the other side was domi-

nated by Keegan, whose grim concern for life combats this irresponsible laughter on stage and off. Shaw wanted his audience to experience what they did with their laughter, wanted them to be aware that their audience responses were much the same as society's Medusa stare freezing individuals into roles, that as audience it was playing its role in attempting to avoid, to neutralize, the Pygmalion touch of the dramatist.

The deaths and rebirths in *Too True* are introduced in an extravaganza style by the Microbe who is sick unto death but is reborn in a magical transformation. Clearly an alter ego for Mops, he changes as she changes, but note his Act I curtain line: "The play is now virtually over; but the characters will discuss it at great length for two acts more" (VI, 456). Grammatically the "it" refers to "play" but "change" is the word understood. His change reflects on all the changes that will take place in the following two acts and his announcement affirms that the implications of change—and change into what—must be explored. His final reminder about the exit doors being all in order nicely illustrates Shaw's breaking through conventions, producing laughter, uneasiness, second thoughts. The Microbe's presence, or the mood his presence creates, persists through the play, and though superficially amusing, there is a note of self-mockery, a sense of absurdity, and a questioning of the very possibility of change that subtly affects every variation in the acts that follow.

The Microbe's transformation from a "bloated moribund Caliban" to a "dainty Ariel" (VI, 453) links these rebirths to the psychological, moral changes of *The Tempest*. *Too True's* romantic-mystical assumption is Shakespearean in its basic premise that "We are such stuff as dreams are made on." Mops' dream starts in a darkened sick room with one parasite talking to another—the Microbe to the Doctor—and ends with a preacher whose theme is "nothing" addressing "impenetrable fog." The middle act, though it takes place in a romantic setting open to sky and sea, is no more substantial. If Mops is a romantic, she is Blakean rather than Wordsworthian, for nature to her is a bore—"only the same old sky everywhere" (VI, 510)—unless it is permeated with human meaning, unless it is infused with human imagination. In this play of sermons, it seems that only language has meaning and therefore the nonlinguistic universe is lacking in meaning and even in reality. The Elder ends in despair before this abyss whose meaninglessness encompasses everything from the atoms and their particles to the stars. Mops ends by seeing the infinite possibilities of such a world. "Dream," "faith," and "change" are the words that ring out time after time in the first act preparing the audience for a world in which anything is possible. It is the obtuse Colonel, the representative of society, who is given the Act II

curtain line, "Humanity always fails me: Nature never." For Shaw, the only real nature is human nature and the faculties it contains. The death and rebirth of those faculties and the interplay of those deaths and rebirths on the audience *are* the play. The death of desire is described by Sweetie. Her vitality demands criminal excitement, a Bonnie and Clyde excitement, that takes joy in the planning and the expectation of a robbery and perhaps "of being tried and being in all the papers" (VI, 479). In the first act, when she is in the room with the pearls, it is not the jewels but their picture she studies, the picture which she brought to Aubrey's attention thus activating the other faculties. Her desire derives from the pleasure of feeling all her senses alive in the face of danger more than it does from the possession of the objects of that desire. Sweetie gives expression to the death of desire and its possible rebirth when she exclaims "I'm bored with this business. I need a change" (VI, 473). Her hero is Harry Smiler, a man of action, who shot a "cop in Croydon . . . for nothing but the feeling that he'd fired the thing off and done somebody in with it" (VI, 479). Aubrey observes that "With all the miracles of the universe to stagger his imagination and employ his mind," Harry Smiler's crime demonstrates "low vitality" (VI, 479). It is a twisted version of Ferruccio's confrontation with the reality of death. Sweetie's desire is finally directed toward vitality and rebirth at the close when she focuses on that solid and concerned citizen, Sergeant Fielding, whose very name suggests a happy eighteenth-century blending of gusto and conscience.

Sweetie, "brilliantly undressed for bathing" in Act II (VI, 464) was a 1931 object of desire. Aubrey could claim that "naked bodies no longer shock us" (VI, 525), but Sweetie, strutting about in her bathing costume in a drama by the Nobel Prize winner whose plays are notoriously talky, must have been disturbing to the first night audience, might have aroused interest in those who would like to be like her or in those who would like to have had her, and may have given second thoughts to a few as she openly revealed the narrow range of her appetites. In Act III the "brilliantly dressed" (VI, 493) Sweetie accepts the conscientous Sergeant but clearly does so because, like *Misalliance*'s Hypatia, she lusts for a specific body. The 1931 conventions prohibit Shaw from going further. It is clear he wanted his audience to see, to experience their desires, and perhaps in the Bible-Bunyan-quoting Sergeant to envision the promise of redirection, of rebirth.

Mops' death of the imagination and rebirth in Act I is a theatrical extravaganza almost as absurd as the Microbe's, but, known as the Patient to the end, she continues to live with variations on that death throughout the play and the rebirth is still going on at play's close. In Act I, Mops resolves "to make the most of this dream" (VI, 452) she is

living, to live it generously with her full imaginative powers, permitting herself spontaneous and uninhibited statements and reactions. For her as for Shaw the outer reality is meaningless unless it is related to the freedom and growth of the spirit. Her continuing and increasing contact with the Life Force and its imaginative powers has taken her from her sick room, released her from mother and relatives—"there is no room for them in my dream" (VI, 509)—made her aware of others around her, caused her to fall in love with Aubrey and then to outgrow that personal and romantic attachment, thus disappointing the expectations of the audience. Instead she experiences an overpowering frustration with the purposelessness of her life: "My dream," she sighs, "has become a nightmare" (VI, 508). Her last reference to the dream she is living underscores her disgust with the neo-Darwinian religion of survival of the most acquisitive: "I didnt know that our respectability was uppish snobbery and our religion gluttonous selfishness. . . . I have found myself out thoroughly—in my dream" (VI, 511–12). Her imaginative development has been like that of the newly born in *Back to Methuselah* and her consciousness of spiritual starvation links her with another developing imagination—also depicted in a kind of dream play—that of Ellie Dunn in *Heartbreak House*.

Aubrey seems to be a character in search of a will. As a lover, he submits to the wills of Sweetie and Mops and is rejected when they grow bored. As a hero he submits to his mother's will, another Medea, one responsible for the death of his brother. As a preacher he lacks faith. However, he keeps talking about sex, war, and religion, and like the Microbe he speaks out of the frame of the play directly to the audience. His Act I sermon while Mops is changing—"changing" in both senses, one of Shaw's favorite dramatic puns—introduces the death of will and its rebirth. It begins with a comment on clothes and, by extension, on the material desires of Mops' social world, moves to the imaginative possibilities for "the aspiring soul" that escapes from this prison home, continues by observing the paralysis of will that a girl in the role of a lady must submit to, and ends with evangelical exaltation, saints, nations and the importance of facing death to achieve life: "Henceforth my gates are open to real life, bring what it may" (VI, 454).

Earlier in the act, Aubrey had been the instiller of Will into the Patient as he roused her with an echo of the Serpent's "Why not" call to infinite possibilities: "Why not," cries Aubrey, "fight for freedom to do what you like" (VI, 449–50). He rouses her imagination and the audience's and disappoints their easy imaginative projections. Mops exclaims in her initial delight with Aubrey, "A shallop! . . . Kidnapped! Brigands! Ransomed! . . . You are a perfect film hero" (VI, 448; 452).

But at the end of the act, Aubrey forgets the pearls and permits Mops to become—like her mother—what Blake would have called a destructive Female Will: "He's a fool. . . . I shall be able to do as I like with him" (VI, 455). For the 1931 audience, Aubrey must have been a vision of the robber-lover—Douglas Fairbanks, suddenly undercut as a bumbling clown.

In Act II Mops violently turns on Aubrey claiming that she is only "exercising . . . the freedom you made possible for me" (VI, 483). His will inspired her but now it seems useless, without a goal. Aubrey shares her disenchantment, her death, and does not seem to experience rebirth. When he cries out in his final speech "I have lost my nerve and am intimidated" (VI, 527) he seems to be speaking for the best of his generation who, brought up Christians, had been taught to hate and kill, to be "bold, unscrupulous, acquisitive, successful and rich" (VI, 506), and who now found their wills atrophied by disbelief in cut-throat Christianity. He recognizes his gift as a summoner of others' wills, his calling as a preacher, but before "the men of action, the fighters, strong in the old uncompromising affirmations which give them status," he has nothing positive to say. With their compartmentalized minds and programmed responses, they "can reach out and strike death blows with steadfastly closed minds. Their way is straight and sure; but it is the way of death" (VI, 527).

Private Meek offers a comic, military version of the death and rebirth of Action in his handling of the native uprising when his natural leadership is reborn at the call of danger. However, Meek comes to us complete, unexplained, unexamined. We know nothing about his past except his confession of being a "tramp before I enlisted" (VI, 460). It is an indication of Mops' growth in imagination that in Act II she is able to discard her "perfect film hero" and admit to being intrigued by this military Charlie Chaplin who disguises his very cool-headed efficiency beneath an appearance both dignified and absurd.[10] Meek's one major action includes all four faculties: it stems from his desire to save human lives and involves a battle of wills against hostile natives who are figments of Aubrey's imagination. When these non-existent brigands attack, they are repelled by Meek's imaginative use of non-existent cannon. The whole encounter is as harmless as the imaginary disease associated with the Microbe of Act I and on the non-comic level suggests once again that the actions man takes are psychic ones, neither purely rational nor merely materialistic.

Setting aside for a time our allegorical schema, it is in the change of Mops and her mother that we see the death and rebirth of the fourth faculty. Mops in her Act I reaction to the burglar and Mrs. Mopply in her Act III response to the Colonel's assault are the play's comic show-

case specimens of change under fire. Immediately after the violence done to them, they recognize the real death in their lives, the meaninglessness of the roles they have had thrust on them. When Mops leaves to change, she is involved, in Aubrey's words, in an action that "will change your entire destiny" (VI, 447). The change, however, is not the animated cartoon change of the Microbe since hers is a continual becoming. Her mother's change, however, is instantaneous: "Lets forget that there are such miserable things in the world as mothers" (VI, 522). Mother Mopply's change is as allegorically significant as the exit of Father Bagot. The actions of Mops and her mother lead to a final act rebirth as Mops' disease-prone imagination and Mrs. Mopply's Blakean Female Will are transformed into a vision of and a drive toward a community of free women. This uniting of will and imagination is an expression of alienation from the nuclear family—a wakening from a dream, a growing consciousness of having been used rather than being realized—which is manifested in a spreading distrust of family and society.

The self-destructive trait in man that could prevent his further evolution is his deliberate narrowing of his scope: on the individual level his tendency to compartmentalize his capacities and on the social level to separate himself from his fellow human beings. Thus the Elder finds he is falling into the abyss of madness because his self-willed intellectual fortress has compartmentalized him from all evolutionary variations. At play's close he withdraws from society totally by retreating into a grotto.

The danger of compartmentalization on an individual level is a theme that Shaw dealt with explicitly thirty years earlier when he had Undershaft assure Barbara that "I am not one of those men who keep their morals and their business in water-tight compartments" (III, 89) and when he had Peter Keegan explain that Broadbent managed to be a good-natured exploiter because he never let the right side of his mind know what the left side was thinking. Compartmentalization is the social problem that led to Shaw's cry for "a common faith that binds men together." Undershaft seems to understand that a truly viable society would be one in which the real ruler of the state and the man of ideas and the woman of the people influence one another profoundly. Such an integrated society is Peter Keegan's dream of a land "where the State is the Church and the Church the people: three in one and one in three" (II, 1021).

In *Too True* the compartmentalizations deal with truths that society prefers to ignore. In Act I we are presented with the unhealthiness of a closed society that has virtually stifled a rich young girl's imagination

and turned a sexually vital young woman and an independent, strong-willed young man into thieves. At the close of the play, the rich girl is still "the Patient," still functioning with her powers not yet fully realized, but her references to Florence Nightingale and Joan of Arc suggest the line of her development. She intends to abandon the personal search for freedom and happiness and resort to community life, to a sisterhood and the socialism that implies. Just as the community use of her pearls in Act I has given some promise of health for the three of them, so the answer to purposelessness, at least for Mops, is The Union of Federated Sensible Societies, a land where, as the Elder puts it, "property is not respected" (VI, 523). The implications of Mops' comic and foreshortened physical recovery in Act I are seen in the light of Act III to be that the only hope for the psychological well-being of the upper classes is to share their wealth with the other levels of society. Moving beyond individuals and classes, Shaw suggests that only in a society that respects human relations and communications, rather than property, will mankind regain control of its nature and experience the cure of its chronic frustration. The German Measles which the "Patient" suffers from began with the guns of August in 1914, and unless the seeking for power and wealth is controlled she will, Shaw prophetically warns, come down with an even more severe case.

In Act II compartmentalization takes another form. Aubrey lectures on the upper and lower centers. He identifies the lower centers with Sweetie, presumably, that is, with creaturely desires, and claims that since the war "the lower centres have become vocal. . . . They speak truths that have never been spoken before—truths that the makers of our domestic institutions have tried to ignore" (VI, 478). But sexual candor is no more shocking than Mops' higher-center awareness, prompted by desperate boredom, that "We do nothing but convert good food into bad manure" (VI, 482). Aubrey, caught between the shocking id of Sweetie and the demanding superego of Mops, becomes a cringing ego trying to avoid the truths of both. Yet when he speaks of "the light in our . . . souls" and the "innermost uppermost life" (VI, 454), he points the way toward unification and health. We recall the doctor of Act I who described sickness as a loss of belief in oneself. Aubrey's will is every bit as sick as was Mops' imagination in Act I. In Act II the three characters become a living demonstration of the lack of harmony between the conscious and the unconscious, the unwillingness to come to an understanding of one's own hostilities, fears, needs, and abilities; in a word, the unwillingness to be a unified being.

The compartmentalization becomes a concrete reality in the two grottoes of Act III. The Sergeant studies his Bunyan and his Bible in the one called "the Abode of Love" while the Elder pontificates from the

nearby grotto inscribed "Saint Pauls." They seem to be visual projections of the top storey and ground floor that according to the Sergeant are found in every man and woman, projections too of Aubrey's higher and lower centers of Act II. Whether they be floors or centers the grottoes forcefully convey the lack of communication the play uncovers between the classes, the sexes, and, on an individual level, the faculties. The Colonel's rank prevents him from talking to his men; the role of Countess prevents Sweetie from meeting the men; his grottoed superiority prevents the Elder from talking to anybody. Only Meek manages to communicate with everyone, shifting as occasion requires from native dialect, to citations from the Articles of War, to practical advice, to Pig Latin.

The lack of communication between the Sergeant and the Elder goes beyond class barriers. It is as total a philosophic-religious separation as any in the play. The Sergeant is a man becoming aware of the forces within him. The secure world of dogmatic belief has collapsed and he accepts the challenge. The Elder, on the other hand, contemplates a universe in which his closed world of "rational Determinism" has collapsed and he is thrown into despair. Both face an abyss and make their choice. It is there before us in the grottoes: the pentecostal flame of hope or Koheleth's "All is vanity."[11]

Dominating the stage of Act III, the grottoes come to loom over the entire play as a vivid illustration and crucial explanation of compartmentalization. In those grottoes we have symbolically represented the three faiths by which Western thought has interpreted the world in which it finds itself. The medieval, Judeo-Christian concept of a Father in the sky mindful of us all is weighed by the Sergeant and found wanting. The Elder, in his turn, contemplates a universe of unpredictable electrons and planets and dismisses both the post-Renaissance scientific tradition by which nature is interpreted as a mechanism and the modern Neo-Darwinism which would explain all natural phenomena in terms of process, "the operation of Natural Selection." They are the three faiths Shaw cites on the opening page of this paper: Christianity, Mechanism and Neo-Darwinism. Each grotto depicts the abyss faced by the other. In the grim, vengeful Elder, the Sergeant can see the Jupiter of Shelley, the Old Nobodaddy of Blake, that must be toppled. In the incongruous pairing of the Sergeant and Sweetie, the Elder faces the uncontrollable evolutionary possibilities of "a Noah's ark" full of "fantastic and laughable creatures" (VI, 501). The Elder's announcement of the passing of those two paradigms—machine and process—may, at least in the case of the second, have been premature, but it was Shaw's way of suggesting that the time was ripe for a new paradigm, a new religion.

Shaw could not accept a world view that replaced a vital drive with a machine or an accidental process. In Blakean terms, the Elder is Urizen in his cave with his calibrating compasses symbolizing man's programmatic isolation of the cognitive process from desire, imagination, and will. Shaw attacked these rational explanations of the world because they used reason to remove mind from creation. Again using Blakean terminology, I believe Shaw saw reason as being a limiting single vision and considered mind, not as merely cognitive, but as a four-fold vision which included all the human faculties. Thinking was not a scientific process of impartial evaluation of data but a human combination of desire, imagination, and will, subject, however, to souring into rationalization if not acted on.

The names of the grottoes return us to the death-rebirth experience. In the preface to *Androcles and the Lion,* "Saint Paul" suggests Christianity without Christ, strict doctrine without understanding. The Elder experiences spiritual death in the intellectual abyss opening before him because he is too rigid to permit his rebirth. He is contrasted not only with the Sergeant but with Mrs. Mopply, whom the Elder describes as "Another victim! She, too, is falling through the bottomless abyss" (VI, 521). She exuberantly agrees, admitting that she doesn't know her head from her heels, and seizes the opportunity to begin living a "real life."

"Abode of Love" is written beneath the Greek inscription "Αγαπεμ-ονε." According to the *Encyclopedia Britannica* (11th edition), both names were used to identify the home in Spaxton of the Agapemonites, a turn-of-the-century group dedicated to spiritual marriage. "Agape" in their name links them with the early Christians and their ritual love feast. In both groups, the feast was eucharistic and physical, based on a shared faith and confirmed by shared property. Ideally, these groups would have been Christian communists, spiritual and physical, living in a way that might have encouraged a converging of faculties.

This reference to the community of true believers may suggest another meaning to the ribaldry chalked in beneath the names: "NO NEED TO WASTE THE ELECTRIC LIGHT." I am thinking of "that sacred aura" which, Aubrey tells us, "surrounds every living soul like [a] halo" (VI, 454) and of the "yonder shining light" (VI, 496) the Sergeant recalls from his Bunyan. However, that spiritual interpretation must be tempered with an admission of the justice of the graffiti. Sexual scandal swirled about both the early Christian community and their latter-day followers. There is no question in view of Sweetie's presence in that grotto that it is also a shrine to Eros in which perhaps will take place the marriage of true body with true mind.

In the "Abode of Love," the Sergeant does what Mops could not do in Act I. He assumes responsibility for his own salvation and refuses to

rely on the experts as found in *The Pilgrim's Progress* and the Bible. Confronted with Sweetie's obvious sexuality he entertains thoughts of marriage, noting that Sweetie "has no conscience but I have enough for two" (VI, 518). He sees the possibility of their fragmentation being resolved in union. This is the beginning of Creative Evolution—at least desire and will are converging. In their simple biological attraction to one another, they suggest consciousness becoming increasingly and complexly aware of itself. Put more simply, they seem to be reenacting the story of Adam and Eve, though in Blakean terms it is not the total integration of Eden they promise but only the domestic comfort of Beulah.

The major compartmentalization continues to be the playing of roles. No individual can be a person until he or she is able to see through the parts played because of the demands of society. Professional roles are difficult enough to see through but the roles of child and parent, man and woman, are more difficult still. Mops longs for a world without parents and her mother admits that she found herself wishing Mops would die. While Freud was making his point that children could only be healthy if they rebelled against their parents, Shaw concurred and went one step farther by maintaining that parents could only be healthy if they rebelled against their children.

The sisterhood being formed by Mops and her mother has cultural as well as sexual implications. Culturally the departure links them with Peter Keegan and his renunciation of an age that continues to move forward technologically but has failed to incorporate its imaginative humanism in its development. Sexually and culturally, Mops would be acclaimed by radical feminism for her determination to live without men. Her next change, presumably, will be to a life that transcends sexual roles, presaging the breakdown of the nuclear family. As Shaw observed, "Our society, being directly dominated by men, comes to regard Woman . . . as a means instead of an end [which] is to deny that person's right to live. . . . Unless Woman repudiates her womanliness, her duty . . . to everyone but herself, she cannot emancipate herself."[12] Even though Mops repudiates the patriarchal society and sets off to organize a matriarchy, I find it reassuring that while Aubrey is delivering his curtain sermon, it takes Mrs. Mopply to drag off the patient, who, according to the stage directions, is listening to Aubrey *"with signs of becoming rapt in his discourse"* (VI, 525). Her imagination can still be intrigued by the articulate will of the preacher.

The breakdown of sexual compartmentalization is the most promising aspect of role repudiation in the play. Just as Mops rejects being a daughter, sweetheart, wife, mother, Aubrey rejects the role of man, or man of action, hero, son, responsible head of family. The son of an

atheist, he is a preacher, becomes a gentleman, and continues to be aware that he was never more absurdly cast than in his role as wartime aviator, a role imposed on him by his nation and his parents. Recalling the bombs he dropped on villages and his strafing of a crowd of civilians, he condemns the compartmentalization required by such action: "You cannot divide my conscience into a war department and a peace department" (VI, 505). The Reverend Aubrey has become as unpredictable as that other fool-preacher of the final plays, Phosphorus Hummingtap in *The Simpleton*. Phosphorus' name, as he points out, links him with fertilizers, and the refrain that trails him through the play—"Let life come to you"—seems a variation on Aubrey's Act I sermon on being open "to real life."

This linking of fertilizers and volatile characters is suggestive. Both Aubrey and Mops are breaking through their roles. In his final sermon Aubrey observes that the characters have outgrown their "religion" and their "strength of mind and character" (VI, 527). The house they find themselves in may be heartbreaking but it is also "a fiery forcing house" (VI, 527) in which their disenchantments feed new possibilities. Recall Undershaft's referring to a huge white pile in his factory city as "sulphates to fertilize your fields" or "nitrates to make explosives."[13] Again it is a matter of rebirth or death.

The one man of action, in fact the one human being who manages to keep his faculties in balance, is Private Meek, who refuses to accept the pigeon-holing of a role. His uniform fits him no better than he fits the army. On the surface, he is all wrong and offends the Colonel by his very presence. Yet to the natives he is a unifier, the "Lord of the Western Isles" (VI, 461) who is also able to understand them and their language. All compartment walls are down for him. He explains that by refusing the role of officer "I have a freer hand" (VI, 490). Modelled on Shaw's friend T. E. Lawrence—Lawrence of Arabia—Meek is a man in harmony with his nature, whose capacities of desiring, imagining, willing, and acting are reduced to absurdity in a world where "genius" is employed in cashing letters of credit, discouraging non-existent brigands, and obtaining the K.C.B. for an incompetent Colonel. From Meek we hear no theories, dreams, or desires—no sermons. All has been absorbed in his work, which at play's close is "repatriating the expedition."

In the comedy that is *Too True to be Good*, Meek does not succeed in his evolutionary effort of effecting the expedition's transfer to the Union of Federated Sensible Societies, nor does he persuade the Colonel to head Boetia's centers of water color painting, but the pattern of service in creative and satisfying work as part of a community effort is, however tentatively, suggested. The disheartening curse of repetition

may be broken. Sexual patterns and parent-offspring relationships are open to change: Sweetie and the Sergeant accept each other on trial with the hope that their "levels" may lead to pleasure and purpose; the reborn Mops and her reborn mother accept each other on trial and go off to find themselves in founding a socialist nunnery; Aubrey, freeing himself of his father's deterministic pessimism and acknowledging that "my gift has possession of me," continues his culturally arousing Jeremiad. It is the time-honored comedy of youth successfully rebelling against the establishment only to eventually become the establishment. But "Is NO enough?" asks Aubrey, and he answers, "For a boy, yes: for a man, never" (VI, 527). In the tragedy that is *Too True to be Good*, rebellion is not enough. Only a change, a convergence, a revolution, a "Why-not" apocalypse, will free modern man from his neo-Darwinian, aggressive paradigm and his self-desired, willed, imagined, and executed destruction.

Notes

1. Daniel Leary is Professor of English at the City College of the City University of New York.

2. *Collected Letters, 1874–1897*, ed. Dan H. Laurence (New York: Dodd, Mead, 1965), p. 269.

3. *Collected Plays with Their Prefaces*, ed. Dan H. Laurence (New York: Dodd, Mead, 1970–1974), V, 332. Subsequent citations of Shaw's plays are from this edition, with volume and page number indicated in the text.

4. "The Religion of the Future," *The Religious Speeches of Bernard Shaw*, ed. Warren Sylvester Smith (New York: McGraw-Hill, 1965), p. 33.

5. In his chapter on "Executive Power," Alfred Turco, Jr., writes of "Shaw's respect for persons who succeed by mastering their circumstances within the conventional system." *Shaw's Moral Vision: The Self and Salvation* (Ithaca: Cornell University Press, 1976), p. 80.

6. For a full treatment of myth and history in *Saint Joan*, see Charles Berst's chapter on that play in his *Bernard Shaw and the Art of Drama* (Urbana: University of Illinois Press, 1973), pp. 259–92. The quotation from Job in *Saint Joan's* preface first appeared on the title page of the second rough-proof rehearsal copy printed in February 1924.

7. Stanley Weintraub, *Private Shaw and Public Shaw* (New York: Braziller, 1963), p. 220.

8. *The Religious Speeches*, p. 78.

9. I agree with Margery M. Morgan who sees "Medea [as] the mother-figure Shaw has chosen to preside over his play." See her chapter on *Too True* in *The Shavian Playground* (London: Methuen, 1972), pp. 258–71.

10. My references to *Too True* and the movies are prompted by remarks Professor Dan H. Laurence made during a discussion of Shaw's late plays at the Modern Language

Association meeting in December, 1979. I am grateful to him and to others who participated in that discussion.

11. The unity-calculated disunity Frederick P. W. McDowell finds in the play informs my entire article. See his "The 'Pentecostal Flame' and the 'Lower Centers': *Too True to be Good*," *Shaw Review*, 2 (1959), 27–38.

12. *The Quintessence of Ibsenism* (New York: Brentano's, 1908), p. 39.

13. *Major Barbara: A Screen Version* (New York: Penguin Books, 1946), p. 121.

Warren Sylvester Smith[1]

THE ADVENTURES OF SHAW, THE NUN, AND THE BLACK GIRL

In the spring of 1924, when Shaw was already sixty-eight, he and his wife, Charlotte, first called on Dame Laurentia McLachlan, the Benedictine sister who was to become Abbess of Stanbrook Abbey near Worcester. They spoke with her through a grille in the guest parlor, for the Benedictines are an enclosed order with minute regulations governing all aspects of the nuns' lives. Normally an enclosed nun would spend her whole life within the precincts of her house without ever crossing the threshold of the great enclosure door. Nor could any outsider be admitted beyond the grille except for emergencies. Dame Laurentia, who became an authority on the Gregorian chant, was sent to give instruction at other houses, but for these excursions she had to obtain a papal dispensation. She had, as Shaw later observed, an "unenclosed mind," but through his visits and letters over the next twenty-five years more of the secular outside world found its way into Stanbrook than she might have bargained for.

The quarter-century friendship was of necessity mostly carried on by correspondence—often stormy. Fortunately most of Shaw's letters were preserved in the Abbey, and after the Abbess' death in 1953 the sisters included some of them in their book, *In a Great Tradition*, a life of Dame Laurentia.[2] The existence of the letters had been known through the memoirs of Shaw's secretary, Blanche Patch,[3] and the sisters had allowed a prior publication of them in the July and August, 1956, issues of the *Atlantic*. A few passages have been excised from the letters where "reverence forbids quotation, for the profanation of divine names and ideas becomes revolting and unbearable" (*IGT*, p. 255). These passages will no doubt be restored in the forthcoming volumes of *Bernard Shaw, Collected Letters* being edited by Dan H. Laurence.[4] Sometime after the publication of *In a Great Tradition* sixteen of Dame Laurentia's letters to Shaw, having been bequeathed to the British Mu-

seum under the terms of Shaw's will, became available. So we now have enough of the exchange for some insight into a fascinating episode.

Margaret McLachlan, from a Scottish Catholic home, the youngest of six children and admittedly spoiled, had seen little of the world before she entered the convent as a novitiate at eighteen and took the name of Laurentia. She had been briefly to school at Edinburgh and was later enrolled at Stanbrook. But most of her education, like Shaw's, had been informal. She was a delicate and precocious child, with a good library at her disposal, and an elder brother who was a priest and who enjoyed teaching her.

The first meeting of the Shaws with Laurentia had been prepared by their mutual friend, Sir Sydney Cockerell. His association with Stanbrook went back to 1907, and for all Laurentia's enclosed life it formed a window through which she looked out on the non-Catholic world. As an agnostic humanist and disciple of Ruskin, Sir Sydney kept up a friendly argument with her, citing the standard scientific objections to the Ascension, the Resurrection, Hell, and the Doctrine of Infallibility. And she gave the standard Catholic replies, explaining, with loving patience and humor, that these dogmas set the searching mind free.

In Shaw, however, she was to find herself confronted not with unbelief, but with a rival religion. The nun, ten years Shaw's junior, knew little of Shaw's work before Cockerell gave her a pre-publication copy of *Saint Joan*. This she thought "a wonderful play" though she took exception to some of the aspects of Joan's trial. Shaw found great delight in the fineness of her mind, and their extended arguments about Catholicism brought, for a time, obvious enjoyment to them both.

Charlotte initiated the correspondence and arranged for the first meeting on 24 April 1924. The Shaws talked pleasantly through the bars with Laurentia and discussed *Saint Joan*; "Mr. Shaw gave good reasons for his treatment of *Saint Joan* with regard to the points which I questioned," she reported to Cockerell. But apparently Cockerell later gave her an ambivalent report of the meeting.

> S.C.C. told me that after Shaw's first visit he received an enthusiastic report of it, and he asked Shaw when he was coming again. "Never," said G.B.S. Then he reflected and asked, "How long has she been there?" "Nearly fifty years." "Oh, that alters the case, I'll go whenever I can."

Laurentia thought that the conversation indicated "that the life here, and therefore the Church, does attract him," and she prayed for "grace to help this poor wanderer so richly gifted by you" (*IGT*, p. 236).

The Shaws visited again during the summer. Shaw purchased *The Letters of St. Teresa of Avila*, recently translated and printed at Stan-

brook. On 1 October he inscribed a copy of *Saint Joan* "To Sister Laurentia from Brother Bernard." It was her first look at the Preface. She was pleased, but had a few demurrers. She was in no way deferential to him. "When he next shakes my bars I shall make some further remarks," she wrote Cockerell.

It was Shaw's Christmas letter (23 December 1924) that really began their long theological debate, which continued with some interruptions until his death twenty-six years later. She had sent him a paragraph from the *Book of Wisdom*—the portion selected for the Epistle of the Mass appointed for the Feast of Saint Joan—to show that the attitude of the Church was one that honored Joan's special insight. She also had sent him *The Godly Instructions and Prayers of Blessed Thomas More Written in the Tower of London 1535*. The letter that accompanied these gifts is lost, but we can surmise a good deal of its contents from Shaw's reply.

He explained that his own writing was for a wider public than just Catholics or just Christians, and that God allows different people their own iconographies.

> Christ in his metaphor of the tares and the wheat, has given us a very plain warning to let Allah and Brahma and Vishnu alone, as if our rash missionaries pluck them out of the Arab and Hindu soul, they will pluck all the religion out of that soul as well. . . . It was therefore necessary for me to present Joan's visions in such a way as to make them completely independent of the iconography attached to her religion.

But this did not make them the less miraculous. It does not matter whether you believe that her messengers were real persons or illusions.

Shaw reminds Laurentia that there is a strong element of rationalism running through Catholicism, but for both Catholics and non-Catholics rationalism is not sufficient. "I exhausted rationalism when I got to the end of my second novel at the age of twenty-four," he writes her, "and should have come to a dead stop if I had not proceeded to purely mystical assumptions."

As to the reading material she had sent him—he was "amazed and delighted" with the passage from the *Book of Wisdom*, but he found it difficult to accept much of Thomas More. He found "the Psalm part of it a mere literary exercise," and thought Psalms generally were "classic examples of fool's comfort."

> Comforting people by telling them what they would like to believe when both parties know that it is not true is sometimes humane and always to be let off with a light pennance [sic] as between two frail mortals; but it should not be admitted to the canon.

Even here at the beginning of the argument it is clear that Shaw is somewhat torn between his desire to be fully candid and the need to be

gentle in his persuasion. "I must stop, or I shall begin by kicking my cloven hoof too obviously for your dignity and peace; but I mean well, and find great solace in writing to you instead of to all the worldly people whose letters are howling to be answered" (*IGT,* pp. 240–41). I have no letters between this one and 1930, but it is evident that Laurentia presented Shaw with a unique dilemma. Shaw carried on a voluminous correspondence with all sorts of people. His letters are often brilliant (he seemed always to be writing for a larger audience), but he let his guard down with very few. Now here was a woman with whom he might really be able to communicate, someone who seemed to understand him at a very deep level. Cockerell, indeed, reported that he "never saw [Shaw] so abashed by anyone but William Morris," and that he "seemed to admit that he was in the presence of a being superior to himself" (*IGT,* pp. 242–43). Yet she was not a woman of the world—he could not discuss politics or the London theatre with her. The subject matter must inevitably be, no matter how it was styled, religion. And how long could this world-famous heretic and iconoclast remain within the affectionate embrace of this daughter of the Church, who was, though liberal in outlook, essentially and devoutly orthodox?

Shaw used the Christian imagery skillfully, always retaining his own interpretations. The Benedictine writers of the book note that Shaw had "an extraordinary feeling for Christian tradition," and this is true, but deceptive. Shaw's conception of the Holy Ghost, for instance, was that of an impersonal Life Force, and far removed from that of a good Catholic; yet he uses the term freely throughout his later work.

Sister Laurentia was able to respond to Shaw's iconoclasm with patience and restraint. She was able to perceive the essential simplicity and humility of "Brother Bernard." They had other things in common: music, although strangely they did not discuss it, even though one was an accomplished music critic and the other the leading authority on the Gregorian chant. They both were disciplined ascetics. And humor. Margaret McLachlan chose the religious name of Laurentia after Saint Laurence the martyr partly because he could joke while he was being tortured! ("Stripped and bound to a gridiron to roast over a slow fire, he mocked his tormentors. 'Turn me over. I'm done on this side' " [*IGT,* p. 95].) The humorist of Ayot St. Laurence, too, had learned to laugh while he was being roasted, as he explains in his 1921 Preface to *Immaturity.* ("If you cannot get rid of the family skeleton, you may as well make it dance.")[5] But it is not likely that the nun realized that she was being drawn into so fundamental a conflict.

One day in December of 1930 Shaw called but found her too ill to see him. He was genuinely distressed and wrote at once to say that he had telepathically divined that something was wrong, and to assure her

that "whatever corresponds in a heathen like me to prayers" have been sent out in her direction. Laurentia recovered, but remained in delicate health.

In the following March the Shaws set out on a tour of the mid-East with a party that included Dean Ralph Inge, the controversial Anglican Dean of St. Paul's. She wrote Shaw: "Before you start for the Holy Land I want to send you my blessing and ask you to take me, my spirit, with you, and let it run about in the Holy Places which I know without having seen them." And she asked him to bring her back "some little trifle from Calvary." By this time she was addressing him "Brother Bernard" and signing herself "Sister Laurentia."[6]

Shaw took her request seriously. On the 15th he sent her a hurried note as they were leaving Jerusalem for Nazareth, promising to write her more fully when he got back to ship. His long descriptive letter was begun on St. Patrick's Day, continued on shipboard as they sailed for Cyprus and Rhodes, but not completed until the 26th. The Sister had every reason to be pleased with it. It is one of Shaw's best letters, both for its keen observation and for its personal charm. His easy and accurate references to the Bible and to early Church history made him an ideal tourist's guide. They arrived in the Holy Land at night, and his first view of it was at dawn: "On this first hour you do not improve. It gives you the feeling that here Christ lived and grew up, and that here Mary bore him and reared him, and that there is no land on earth quite like it."

But when the guides start pointing out the spots where Jesus did this or that, Shaw is as repelled as Laurentia would also have been. She would certainly have endorsed his view that "it is better to have Christ everywhere than somewhere, especially somewhere where he probably wasn't." Shaw managed to send her a few olive leaves from the Mount of Olives, but the "trifle" from Calvary he could not provide, since he was convinced that no one knew which of the many hills surrounding Jerusalem was the true one.

Instead he is bringing her, he says, two little stones from Bethlehem— "a scrap of the limestone rock which certainly existed when the feet of Jesus pattered about on it and the feet of Mary pursued him to keep him in order" (*IGT*, pp. 245–51). One of the stones is for Laurentia personally. The other is to be thrown blindfold into the Stanbrook garden, so there will always be a stone from Bethlehem there, but no one will know which one it is and be tempted to steal it. (Laurentia did not remind him, as she might have, that the Holy Family probably left Bethlehem before Jesus was old enough to do any pattering about.) The entire letter was calculated to please her. It maintained a light tone and a sceptical attitude without ever being really irreverent. Laurentia could hardly have

objected to anything except to the closing sentences where Shaw ascribes the Book of Revelation to an obvious drug addict.

Even to this, however, she responded with good humor: "It is well for you that you did not live in the Middle Ages. You would have been boiled in a cauldron of oil for your remarks on the Apocalypse!" Otherwise her reply (beginning on the 18th of April, but not finished until the 21st) was all affection and gratitude. "You have made me feel that I have seen the Holy Land through your eyes, and have revealed a great deal more than I should have seen with my own." It is well, she agrees, that Christ cannot be located in Palestine—that there is no Christian Mecca. But "this childish mania for labeling everything seems to be universal." Part of Catholicism's poor showing in Palestine she blames on the fact that the Church "is largely represented by Franciscans who are more devotional than liturgical, and who do not abound in taste."[7]

Shaw sent her at least one other gift during this tour, though we do not have the letter that accompanied it. On 21 April she wrote, "Your letter has come with the little souvenir of St. Francis." The Bethlehem stone for the garden arrived on the 12th of June. Shaw wished to deliver the other one personally. On his return, however, he found that Laurentia was seriously ill, probably in part from overwork, and had been ordered to bed by her doctor. In the meantime he took advantage of an unexpected opportunity to visit the Soviet Union for nine days, where he spent his seventy-fifth birthday and had a much-publicized interview with Stalin. ". . . the oddest place you can imagine," he wrote her. "They have thrown God out the door; and he has come in again by all the windows in the shape of the most tremendous Catholicism" (*IGT*, p. 251).

There was a further reason for the delay of the delivery of the second stone. It was not until the 18th of September, when the Shaws were again in Malvern for the Festival, that they asked if they could be received at the Abbey. On the following Saturday they appeared with the long-promised icon. It was more of a presentation than anyone at the Abbey had anticipated. The Shaws had had the silversmith, Paul Cooper, set the stone in a silver reliquary surmounted by the figure of the infant Jesus, his left hand supporting the globe, his right raised in blessing. Most of the outside world would have been even more surprised than the Benedictines at this Shavian display of Christian iconography. One can only assume that it was Charlotte with whom Cooper had consulted on the matter of the design. But for Laurentia this must have been one more piece of evidence (along with the wonderful letter from the Holy Land, the olive leaves, and the souvenir of St. Francis) that G.B.S. was really a devout Christian who had not yet

sufficiently conquered his pride to make a confession. Apparently she was not aware of Shaw's earlier pronouncements on religion, such as his prefaces to *Androcles and the Lion* and *Back to Methuselah*. Though she would have been perfectly free to find out more about the religious views of her confidant than what he told her in his letters (most literate readers of the English language already knew them), the fact of the moment was that she was surprisingly innocent. Shaw in his letters was careful, as always, to say nothing that he could not in some sense believe; yet we must hold him responsible for a kind of protective duplicity. He obviously wanted to retain this friendship as long as he could. Perhaps Laurentia, too, sometimes purposely looked the other way. Inevitably she would have to confront the real Shavian heresy, and she was not prepared for it.

At this moment, however, she and her sisters were simply carried away with the beauty of the gift, and she warned him that "by making such a gift to a place like this you expose yourself to the danger of being prayed for very earnestly. . . . You have made yourself our debtor & must take the consequences."[8]

Shaw replied that he did not in the least mind being prayed for. He thought of prayers as wireless messages floating around in the ether. "I suppose if I were God I could tune into them all. . . . If the ether is full of impulses of good will to me so much the better" (*IGT*, p. 253).

Sir Sydney Cockerell, who dropped by to admire Cooper's artistry, suggested that the reliquary should have an inscription saying that it was from Bernard Shaw to Sister Laurentia, and explaining its purpose. Laurentia passed the suggestion along to Shaw, whose response must certainly rank with the most disarming ever penned:

> Dear Sister Laurentia
>
> . . . Why can it not be a secret between us and Our Lady and her little boy?
>
> What the devil—saving your cloth—could we put on it?
>
> Cockerell writes a good hand. Get him a nice bit of parchment and let him inscribe it with a record of the circumstances for the Abbey archives, if he must provide gossip for antiquarian posterity.
>
> We couldn't put our names on it—could we? It seems to me something perfectly awful.
>
> "An inscription explaining its purpose"! If we could explain its purpose we could explain the universe. I couldn't. Could you? If Cockerell thinks he can . . . let him try, and submit the result to the Pope.
>
> Dear Sister: our finger prints are on it, and Heaven knows whose footprints may be on the stone. Isn't that enough?
>
> Or am I all wrong about it?
>
> > faithfully and fraternally
> > Brother Bernard [*IGT*, pp. 252–53]

One hardly needs to report that the reliquary remains uninscribed.
At the end of October her health is still not good. But the prayers for
Brother Bernard's soul continue. "Do you know I began to pray for
you before I ever saw your face? I then called you (to the Lord) 'Bernard Shaw,' but now you are 'Brother Bernard.' "[9]

Now there is a break in the correspondence, and we must piece
together the sequence of events as best we can. As of January 1932,
Sister Laurentia became the Mother Superior—the "Lady Abbess" of
Stanbrook. Also at the beginning of 1932, the Shaws set off on another
trip, this time to South Africa. Shaw claimed that he made these trips
only to indulge Charlotte, that he did not enjoy them himself; but once
on the journey—as is obvious from his letters from the Holy Land and
Russia—he developed all the symptoms of an enthusiastic tourist. The
South African sojourn, however, was marred by a serious accident.

Shaw, with Charlotte and another companion, was driving a rented
car to Port Elizabeth. Shaw was not known as a good driver—he had
had a number of minor accidents with vehicles. In this case he mistook
the accelerator for the brake, and plunged off the road and over a
bank. He and his companion were uninjured, but Charlotte, who was
in the back seat with the luggage, was badly bruised, her shin punctured, and her wrist sprained. It took more than a month for her
recuperation.

Shaw used this time to write, not a play, but a fable modeled on the
form of Voltaire's *Candide*. *The Adventures of the Black Girl in Her Search
for God* follows the path of a simple but highly curious native girl who
has been told by the missionaries, "Seek and ye shall find." She quickly
finds, and destroys with her knobkerry, the savage gods of Moses and
Job, and pauses not much longer for the despairing Ecclesiastes or the
howling prophet, Micah. She disposes, too, of the god of science—who
resembles Ivan Pavlov—and comes upon the kindly Jesus (called "the
conjurer") to whom she is attracted. She leaves him with reluctance
when she finds that even he cannot give her satisfactory answers. But
after further adventures with a caravan of white explorers, she comes
upon the conjurer again. This time he is not alone.

He is lying on the ground, stretched out on a large wooden cross,
while an artist, who specializes in gods and goddesses, carves a statue of
him. While this is going on, an "Arab gentleman" (Mahomet) sits
nearby and argues with the conjurer about the necessity for violence in
government, the compatibility of art and religion, and polygamy. " 'I
am so utterly rejected of men,' " complains the conjurer, " 'that my only
means of livelihood is to sit as a model to this compassionate artist who
pays me sixpence an hour for stretching myself on this cross all day.' "

"He himself lives by selling images of me in this ridiculous position. People idolize me as the Dying Malefactor because they are interested in nothing but police news. When he has laid in a sufficient stock of images, and I have saved a sufficient number of sixpences, I take a holiday and go about giving people good advice and telling them wholesome truths. If they would only listen to me they would be ever so much happier and better. But they refuse to believe me unless I do conjuring tricks for them; and when I do them they only throw me coppers and sometimes tickeys, and say what a wonderful man I am, and that there has been nobody like me ever on earth; but they go on being foolish and wicked and cruel all the same. It makes me feel that God has forsaken me sometimes."[10]

Weary of searching, the Black Girl discovers at last the wise old gentleman (Voltaire) who advises her that the best place to seek God is in a garden. "You can dig for Him here." "And shall we never be able to bear His full presence?" she asks. "I trust not," he answers. "For we shall never be able to bear His full presence until we have fulfilled all His purposes and become gods ourselves."[11] On the advice of the philosopher she marries a red-bearded Irish socialist, and learns to be content in rearing children and leading a useful life. When she again has time to think of searching for God "her strengthened mind had taken her far beyond the stage at which there is any fun in smashing idols with knobkerries."[12]

Apparently sometime before April, when the proofs were to be ready, Shaw had dropped some hints to Laurentia about the story, and these were enough to disturb her. So on 14 April 1932 he began a long letter to her: "Your letter has given me a terrible fright. The story is absolutely blasphemous, as it goes beyond all the churches and all the gods. I forgot all about you, or I should never have dared." He then proceeded to outline the story fully and candidly. The final episode of the Black Girl and the Irishman had not yet been added, but he mentioned that he was considering it.

> Perhaps I should not disturb the peace of Stanbrook with my turbulent spirit; but as I want you to go on praying for me I must in common honesty let you know what you are praying for. I have a vision of a novice innocently praying for that good man Bernard Shaw, and a scandalized Deity exclaiming "What! that old reprobate who lives at Whitehall Court, for whom purgatory is too good. Don't dare mention him in my presence."

Then he changes the subject to her election, which, he feels can only be a nominal change "for you would boss the establishment if you were only the scullery maid." But he adds a postscript:

Shall I send you the story or not? It is very irreverent and iconoclastic, but I don't think *you* will think it fundamentally irreligious. [*IGT*, pp. 254–56]

She demanded to see the book, and dutifully Shaw sent her the bundle of first proofs. On the flyleaf he wrote:

An Inspiration
Which came in response to the prayers of the nuns
of Stanbrook Abbey
and
in particular
to the prayers of his dear Sister Laurentia
for
Bernard Shaw
[*IGT*, p. 257]

Apparently her response (though not extant) was prompt and outraged. And apparently, too, Shaw sent her, before the end of the month, a somewhat mollifying reply, enclosing a little two-page play. The scene is in God's office in heaven when an argument is taking place between God, Gabriel, and the Recording Angel. God is obviously disturbed at the prayers coming up from Stanbrook Abbey about that fellow Shaw. God has given Shaw a job to do, and the Abbess won't let him do it. The scene closes in on the Almighty's thunderous anger.

Whether it was the implication in the playlet that she was to have the last word, or whether she concluded from Shaw's missing letter that Brother Bernard would do nothing to hurt her, she seems to have mistaken Shaw's cajolery for surrender. In any case, on 3 May she writes:

You have made me happy again by your nice little play, and I thank you from my heart for listening to me. I have read most of the book and I agree with many of your ideas, but if you had published it I could never have forgiven you. However you are going to be good and I feel light and springy again & proud of my dear Brother Bernard. You shall have more prayers by way of reward! Perhaps you will be naughty enough to set more value on my very deep gratitude. . . . I simply cannot find words to thank you for your answer to my letter, but you *know* how grateful I am.

It is impossible to believe that Shaw intentionally led her to believe that he would halt the publication of *The Black Girl*. What reply he made to her letter of 3 May we do not know. But the book, with the delightful engravings of John Farleigh, appeared as a Christmas book in early December, and required five printings totaling 200,000 copies before

the end of the year. It may be that there were those who merely glanced at the title and the illustrations and were later embarrassed at the Christmas gift they had chosen for a devout relative or acquaintance!

The Abbess reacted vigorously and uncompromisingly. We do not have her letter of response, but her Benedictine sisters assure us that to the end of her life she could hardly bring herself to mention the book. The scene with Jesus, the image-maker, and Mahomet she considered blasphemy of the most painful kind. She had held both GBS and Cockerell in Christian fellowship, and though she had probably abandoned hope of converting Sir Sydney, she actually harbored a dream of bringing Shaw finally into the Church. Now she could only say that unless Shaw withdrew his hateful work from circulation he would no longer be welcome at the Abbey. Nevertheless, in December, Shaw sent her a copy of the published book inscribed:

> Dear Sister Laurentia,
> This black girl has broken out in spite of everything. I was afraid to present myself at Stanbrook in September.
> Forgive me
> G. Bernard Shaw
> December 14, 1932 [*IGT*, p. 260]

Two days later he was aboard the *Empress of Britain* to begin a tour around the world. But the religious argument pursued him. The Abbess's outraged letter caught up with him in Siam. On shipboard he made several unsuccessful attempts to compose a reply. Finally, when he thought he had done the best he could, the notebook in which the letter was drafted disappeared from his deck chair, apparently acquired by "some devoutly Shavian thief." He decided to let the matter rest until he was back at home the following summer. He recounted this misadventure to Laurentia in his letter of 29 June, and tried to reassure her that whoever stole the notebook would not be able to read his shorthand, and, in any case, would not dare to publish it.

> I will not try to reproduce the letter: the moment has passed for that. Besides, I am afraid of upsetting your faith, which is still entangled in those old stories which unluckily got scribbled up on the Rock of Ages before you landed there. So I must go delicately with you, though you need have no such tenderness with me; for you can knock all the story books in the world into a cocked hat without shaking an iota of *my* faith.
> Now that I think of it, it was a venial sin to write me such a cruel letter, and I think you ought to impose on yourself the penance of reading *The Black Girl* once a month for a year. I have a sneaking hope that it might not seem so very wicked the tenth or eleventh time as you thought it at first. You must forgive its superficial levity. Why should the devil have all the fun as well as all the good tunes? [*IGT*, p. 261]

But the old charms no longer worked. "The fact is our points of view are so different, that talking, or writing, round the subject can be of little use," she wrote him. If he wishes to get back into her good grace he must withdraw *The Black Girl* from circulation, and make a public act of reparation for the dishonor the book has done to Almighty God.

> I still have such faith in your greatness of mind & heart, as to believe you capable of such an act, and to ask of you what I should not dream of proposing to a small mind. Do suppress the book & retract its blasphemies, and so undo the mischief it has wrought. I ask you this first & foremost in the interest of your own soul. I have made myself in some sense responsible for that soul of yours, and I hate to see you dishonor it. . . . If you had written against my father or mother, you would not expect to be forgiven or received with any favour until you had made amends. Let me implore you to do this one thing & withdraw the book, even if you cannot find in your heart to imitate St. Augustine & so many other great minds who have given their retractions to the world.[13]

Here, perhaps, the argument should have rested. But Shaw was not able to let it go. Within ten days he was replying:

> You are the most unreasonable woman I ever knew. You want me to go out and collect 100,000 sold copies of *The Black Girl*, which have all been read and the mischief, if any, done; and then you want me to announce publicly that my idea of God Almighty is the antivegetarian deity who, after trying to exterminate the human race by drowning it, was coaxed out of finishing the job by a gorgeous smell of roast meat. Laurentia: has it never occurred to you that I might possibly have a more exalted notion of divinity, and that I dont as a matter of fact believe that Noah's deity ever existed or ever could exist?

And he insisted on the right to his own brand of mysticism:

> . . . what happened was that when my wife was ill in Africa God came to me and said "These women in Worcester plague me night and day with their prayers for you. What are you good for, anyhow?" So I said I could write a bit but was good for nothing else. God said then "Take your pen and write what I shall put into your silly head." When I had done so, I told you about it, thinking that you would be pleased, as it was the answer to your prayers. But you were not pleased at all, and peremptorily forbade me to publish it. So I went to God and said "The Abbess is displeased." And God said "I am God; and I will not be trampled on by any Abbess that ever walked. Go and do as I have ordered you". . . . "Well" I said "I suppose I must publish the book if you are determined that I shall; but it will get me into trouble with the Abbess; for she is an obstinate unreasonable woman who will never let me take her out in my car; and there is no use your going to have a talk with her; for you might as well talk to the wall unless you let her have everything her own

way just as they taught it to her when she was a child." So I leave you to settle it with God and his Son as best you can; but you must go on praying for me, however surprising the result may be.

Your incorrigible

G. Bernard Shaw [*IGT*, pp. 262–63]

But Brother Bernard could not be forgiven. And so for a year or so the relationship languished.

Now what follows sounds like impossible melodrama, and since one of the actors was a skillful creator of melodrama, how can we ever be sure that the incident was not created? Or that the Abbess, taking a page from Shaw's own book, decided to play out her part of the scene as well? In Molnar's *The Guardsman* the husband is never quite sure— nor is the audience—whether his wife has recognized him when he masqueraded as her seducer, and so he can never know whether she has failed the test of constancy which he has so elaborately arranged.

In September of 1934 Dame Laurentia was celebrating the fiftieth anniversary of her vows. A little folder went out through the mail to announce the jubilee. On the inner page was inscribed:

IN MEMORY OF SEPT. 6
1884 – 1934
DAME LAURENTIA McLACHLAN
ABBESS OF STANBROOK
[*IGT*, p. 265]

Now either Shaw honestly misread the card, or his Irish sense of anti-climax overcame him and he *decided* to misread it. In any case it was nearly a month later till he dispatched "To the Ladies of Stanbrook Abbey:"

> Through some mislaying of my letters I have only just received the news of the death of Dame Laurentia McLachlan. . . . I never passed through Stanbrook without a really heartfelt pang because I might not call and see her as of old. . . . When my wife was lying dangerously ill in Africa through an accident I wrote a little book which, to my grief, shocked Dame Laurentia so deeply that I did not dare to show my face at the Abbey until I was forgiven. She has, I am sure, forgiven me now; but I wish she could tell me so. In the outside world from which you have escaped it is necessary to shock people violently to make them think seriously about religion; and my ways were too rough. But that was how I was inspired. [*IGT*, pp. 265–66]

The very next day, Laurentia wrote, "As you see, I am not dead," and explained the meaning of the announcement.

> At such a time my mind recalled old friends, you among them. Madame de Navarro said you proposed writing to me, but no letter came, so I

took the first step. When next you are in the neighborhood you must come & see me again, and I will tell you some of the wonderful ways in which my nuns have honoured & delighted me on my Jubilee Day.

She is still praying for him, and hopes that her prayers "will have nothing but good results in future." But she signs herself formally: "Sr. Laurentia McLachlan."[14]

Shaw promptly wrote to Cockerell to confess his "super-Howler" and responded to the Abbess:

> Laurentia! Alive!!
> Well!!!!!
> Is this a way to trifle with a man's most sacred feelings?
> I cannot express myself. I renounce all the beliefs I have left. I thought you were in heaven, happy and blessed. And you were only laughing at me!
> It is your revenge for that Black Girl.
> Oh Laurentia Laurentia, Laurentia, how *could* you.
> I weep tears of blood.
>
> Poor Brother Bernard [*IGT*, p. 266]

And so a reconciliation of sorts was made. Shaw was allowed once more to visit Stanbrook, and the correspondence resumed. But the breach was never wholly healed. In January of 1935 he sent her, at her request, the proofs of *The Simpleton of the Unexpected Isles*, with the warning on the flyleaf that "if you can get over the first shock of its profanity you may find some tiny spark of divinity in it. You may ask why I write such things. I dont know: I have to. The devil has me by one hand and the Blessed Virgin by the other" (*IGT*, p. 268).

Laurentia had little trouble finding the divinity, but she was not about to excuse the profanity. Once again she asked him not to let the work be published. Strangely, what disturbed Laurentia the most in *The Simpleton* was not the eugenics experiment that was being carried out in the Unexpected Isles, nor Shaw's parody of the Day of Judgment, but an Island's priest's insistence that Christianity was as polytheistic as any Oriental religion.

> THE PRIEST. God has many names.
> THE LADY TOURIST. Not with us, you know.
> THE PRIEST. Yes: Even with you. The Father, the Son, the Spirit, the Immaculate Mother—[15]

"Whatever happens," she wrote, "you absolutely must omit the allusion to the Immaculate Mother. . . . You know, as well as I do, that we do not worship her as God." Beyond that the play might be harmless to "strong minds but it is almost certainly dangerous for weak ones." He has given the devil enough innings, she thinks, and it is now time to let

Our Lady take him by *both* hands. And she reminds him of his age. "However you may parody the Day of Judgment, you know the particular one for each of us can't be very far off and, my Dear Brother Bernard, you will not be able to plead ignorance as the excuse of the evil that your books may do" (*IGT*, pp. 268–69). Shaw was then approaching seventy-nine. She was sixty-nine.

But the "Immaculate Mother" remained in the published play, and there was no evidence in Shaw's reply that he had any concern about meeting his Maker. Instead he challenged the legitimacy of her Catholicism. "Why in the name of all the saints does she fly out at me when I devoutly insist that the Godhead must contain the Mother as well as the Father?" Does he say Hail Mary? Of course he does, but he says it in his own natural and sincere way, whenever She turns up in any of the foreign shrines or temples that he visits: "Hallo, Mary!"

> When I write a play like *The Simpleton* and have to deal with divinity in it She jogs my elbow at the right moment and whispers "Now Brother *B*. dont forget *me*." And I dont. . . . When you are old, as I am, these things will clear up and become real to you. . . . It is in these temples [of the Jains] that you escape from the frightful parochiality of our little sects of Protestants and Catholics, and recognize the idea of God everywhere, and understand how the people who struggled hardest to establish the unity of God made the greatest number of fantastically different images of it, producing on us the effect of a crude polytheism. [*IGT*, pp. 271–72]

This time there were no threats that he would be banished from Stanbrook or that the letters would cease. But as they both became older and as health became more precarious the visits dwindled off, and the correspondence became a birthday exchange or a "thank you" for the latest book. He visited her at the end of August 1935, and found her "shining in all your old radiance before the cloud of illness came upon you," and he confesses that he "felt ever so much better for your blessing." But he is careful never to leave too great an impression of piety: "There are some people, who, like Judas Iscariot, have to be damned as a matter of heavenly business; . . . but if I try to sneak into paradise behind you they will be too glad to see you to notice me" (*IGT*, p. 273). Of *The Millionairess* she had no complaints. It "entertained me immensely."[16] From her letter of 20 August 1938 it is apparent that they have both been ill. She wants an inscribed copy of the new play (probably *Geneva*). There are hints that Stanbrook needs money. I can find no record that Shaw made financial contributions to the Abbey, though it is possible that he may have.

Charlotte's failing health finally brought an end to the Shaws' travels. She died in September of 1943 at the age of eighty-six. Laurentia's note of 29 August 1944 thanks him for "the admirable portrait of Mrs.

Shaw, whom I am not likely to forget." A few days later Shaw sends her
a note on her Diamond Jubilee, written on the flyleaf of his new work,
Everybody's Political What's What? "The saint who called me to the reli-
gious life when I was eighteen was Shelley. But you have lived the
religious life: I have only talked and written about it. . . . You would
still know me if you met me. I wish you could. I count my days at
Stanbrook among my happiest."

In her reply (19 September) she reaffirms that

> Sixty years of enclosed life leaves me happier than ever for having
> chosen this path—though as Tagore sang: "We cannot choose the best.
> The Best chooses us." If people knew the freedom of an enclosed nun! I
> believe you can understand it better than most people & I only wish we
> shared the faith that is its foundation.

During the week of his ninetieth birthday (26 July 1946) Shaw re-
ceived over a hundred congratulations each day. Not many received a
personal reply, but to Laurentia he wrote,

> Saving your reverence, I do not give a damn for congratulations. But
> prayers touch me and help me. It is good for me to be touched. Stan-
> brook prayers must have some special charm; for I never forget them.
> [*IGT*, p. 274]

At ninety-two he wrote her a fairly long letter recounting the visit of
Gene Tunney, and had obvious pleasure in transmitting the story of
how the former heavyweight champion of the world went back to his
Catholic faith and prayed for help when his wife was stricken with
double appendicitis on an island in the Adriatic, and how "Next morn-
ing very early there landed in the island the most skilful surgeon in
Germany, the discoverer of double appendices. Before ten o'clock Mrs.
Tunney was out of danger and is now the healthy mother of four
children" (*IGT*, p. 275).

To the outside world Shaw's longevity seemed evidence that he was
indeed one of the supermen of whom he had written in *Back to Methu-
selah,* and his birthdays became more and more of an event to be noted
and celebrated. His house was surrounded by photographers and re-
porters, and he became the protesting recipient of cakes, letters, phone
calls and gifts, including "piles of medals of the Blessed Virgin, with
instructions that if I say a novena she will give me any help I ask from
her; and I have to reply that we are in this wicked world to help her
and not to beg from her" (*IGT*, p. 276). Nevertheless Laurentia added
one more medal to the pile. On the 8th of August 1950, just three
months before his death, she sent him a little bag of lavender from the
harvest that had just come in (and which the nuns bagged for sale).
"There is a little medal of Our Lady buried in the lavender, but you
will not object to that."

Even the nonagenarian epistles are newsy, friendly, and occasionally disputatious, and he continued to send her copies of everything he published. If the mistaken announcement of 1934 was a ruse on his part, or on the part of both, it was played out to the end. Dame Laurentia survived him by three years. She died at age eighty-seven.

The relationship between Shaw and Laurentia remained almost unknown until after the Benedictine Sisters released some of the correspondence in the years following the Abbess's death. Shaw's liaisons with women, after his philandering years in the 1880's, were mostly on paper. His most passionate love-letters were written in the 1890's to Ellen Terry, whom he saw only across the footlights. The Terry letters, too, are full of cajoling and scolding and lecturing—about acting, art, theatre management, and personal behavior—with Sir Henry Irving cast as the villain who held her captive at the Lyceum. The affair with Stella Campbell may have had more substance, but that correspondence is chiefly an account of carefully contrived pursuits and escapes. In the course of both of these exchanges the female respondents married other men—to Shaw's ill-concealed relief.

The correspondence with Laurentia may have been something of a supersession for those stormy days of his middle years. They are not as obviously love-letters—but, in a sense, what else are they? Throughout the religious argument there is always apparent the surge of affection and the need for her approval. Though he would not yield to her pleas to alter his published work, he changed his entire theological vocabulary to remain in her good graces. In none of his religious writings or speeches does he come as close to the orthodox vocabulary of the Church as he does for her sake. His attitude toward prayer, as expressed in these letters, may have been sincere, but it would have surprised most of his associates, and is revealed nowhere else in quite the same way.

Shaw, the great feminist, was always somewhat afraid of *real* women—beginning with his own mother. He needed the feminine response to complement his own masculine assertiveness; but he feared the softness and sentimentality to which he knew he was vulnerable, but which were counter to the Shaw message. In this regard Dame Laurentia was an ideal respondent. Even more than Ellen Terry, she was inaccessible.

And for her part, once she had admitted this beguiling Irishman into her confidence, she found that she could not do without him. Her relief when Shaw resumed the correspondence at her "death" notice is palpable. Though she extols the enclosed life, this breath of heresy from the freethinking world nourished her and brightened her life. And her natural warmth responded to the blandishment that was safely on the other side of the grille.

Certainly her prayers and her concern for Shaw's immortal soul were genuine. But even towards the end she must sometimes have felt uneasy when she recalled what he had told her at the height of the *Black Girl* controversy: "You must go on praying for me, *however surprising the result may be.*"

Notes

1. Professor Emeritus of General Education in the Arts at The Pennsylvania State University, Warren S. Smith is author of *The London Heretics, 1870–1914*, and editor of *The Religious Speeches of Bernard Shaw* and *Shaw on Religion*.

2. New York: Harpers, 1956. (Page references to this volume hereafter will be incorporated into the text.) See my review, *Shaw Bulletin*, 2, No. 3 (1957), 21–23.

3. *Thirty Years with G.B.S.* (London: Victor Gollancz, 1951).

4. Volumes I and II (Dodd Mead, 1965, 1972) presently take us through 1910.

5. The Standard Edition, p. xxiv.

6. Letter dated 1 March 1931. All the letters from Dame Laurentia McLachlan are A.L.S. and are from the Manuscript Collection of the British Museum (Add. Mss. 50543). They are used by permission of the present Abbess of Stanbrook (February 1978).

7. Letter dated 18–21 Apr. 1931. In an earlier letter, erroneously dated "27 iii 30" instead of "27 iii 31," she thanks Shaw for the olive leaves and wonders whether she could bear to visit the Holy Land "under modern conditions." This letter also indicates the degree of intimacy that had developed between the correspondents. In his September letter Shaw had shared with her his concern about the possible publication of the Ellen Terry-Bernard Shaw Correspondence, complaining that the letters had fallen into the hands of an American speculator who was under the impression that he had purchased the rights to publication. Laurentia replies:

> [Miss] Christopher [St. John] tells me that *the* letters are coming out. From your letter in September I gathered that you had no choice left in the matter. At any rate their appearance brings great contentment to Bedford St., and your generosity a certain ease for which I am very grateful. I hope Christopher will now be free to use her talent to some purpose.

8. 12 Oct. 1931.

9. 30 Oct. 1931.

10. *The Black Girl in Search of God and Some Lesser Tales*, Standard Edition (London: Constable, 1934), p. 54.

11. P. 70.

12. P. 72.

13. 13 July 1933.

14. 4 October 1934.

15. *The Bodley Head Bernard Shaw: Collected Plays with their Prefaces*, ed. Dan H. Laurence (London: Max Reinhardt, 1970–74), VI, 777.

16. 9 September 1935.

BIBLIOGRAPHY

Charles A. Carpenter[1]

SHAW AND RELIGION/PHILOSOPHY: A WORKING BIBLIOGRAPHY

The following is a selective list, with some annotations, of works by and about Shaw that students of his religious and philosophical ideas may find illuminating. It is not a formal record of all related items, but a working bibliography of the subject. In searching for material, in deciding what to exclude, and in arranging and annotating the items, I have kept in mind the full spectrum of scholars, from old-guard Shavians to undergraduates, who might launch an investigation of the whole topic or a major aspect of it. Advanced scholars will want to feel that they have not overlooked anything significant; for them, I have tried to discover and record all directly pertinent, substantial, and/or interesting treatments of the subject by Shaw and his commentators.[2] Students making their first foray into Shavian religion/philosophy will need the most vital and useful material highlighted in some way; for their benefit, I have used an asterisk rating system to supplement the necessarily broad classified arrangement and the minimal annotations: two asterisks denote an indispensable item, one an important item.[3] These features are designed to make the list all that the non-specialist needs and at least a good springboard for the specialist.

The bibliography is arranged somewhat uniquely. In part one, works by Shaw, the main section comprises what Shaw might have called a skeleton history of petty tentatives. It is a chronological list of his writings—whether plays, prefaces, essays, or letters—which more or less significantly reflect his unfolding religious and philosophical ideas. Accompanying this, in part two, is another chronological section covering roughly the same period: a selective list of relevant commentaries published before 1950. This section charts the critical response that Shaw provoked as his views developed and found new modes of expression. It is not limited to "studies"; many polemical and journalistic items are

included, as are several "takeoffs" on *Man and Superman, Saint Joan,* and (especially) *The Adventures of the Black Girl in Her Search for God.*[4] Parts three and four of the bibliography are more selective lists of commentaries published since 1950, the first focusing on Shaw's thought, the second on his drama.[5] The full classification scheme:

 I. By Shaw
 A. Collected Writings
 B. Sources of Shaw Comments
 C. Chronology of Selected Writings
 II. Commentaries, 1904–1949: A Chronology
 III. Commentaries, 1950–1979, on Shaw's Religious/Philosophical Thought
 A. General and Miscellaneous
 B. Shaw and Aspects of Christianity
 C. Shaw and British Thinkers
 D. Shaw and Other Thinkers
 IV. Commentaries, 1950–1979, on Shaw's Religious/Philosophical Drama
 A. General and Miscellaneous
 B. *Passion Play* (*Household of Joseph*)
 C. *Man and Superman*
 D. *Major Barbara*
 E. *The Shewing-up of Blanco Posnet*
 F. *Androcles and the Lion*
 G. *Back to Methuselah*
 H. *Saint Joan*
 I. *The Simpleton of the Unexpected Isles*
 J. Other Plays

 Since this is meant to be a convenient checklist, not a descriptive bibliography à la Dan Laurence's impending Soho volume, I have given sufficient rather than exhaustive bibliographical data. For elusive items, I have taken more pains to note available reprints than to locate details of original publication. Apart from obvious abbreviations such as "repr." and "publ.," I have used only the following:

 DA *Dissertation Abstracts*

 DAI *Dissertation Abstracts International*

 ShR *Shaw Review*

Notes

1. Dr. Carpenter is Professor of English at the State University of New York, Binghamton, former *Shaw Review* Bibliographer and present compiler of the *Modern Drama* annual bibliography. He is author of *Bernard Shaw & the Art of Destroying Ideals*.

2. In searching for Shaw material, however, I have made no attempt to uncover unpublished or highly obscure items (the only special collection I used was Cornell's); the great majority of items listed are readily available in reprinted if not original form. As for commentaries, I have not ventured beyond those in Roman-alphabet languages, but I have aimed at international coverage. Useful for this purpose was the mistake-ridden but sumptuous chronological checklist of studies in Jean-Claude Amalric's recent *Bernard Shaw: Du réformateur victorien au prophète édouardien*.

3. If one's topic is quite specific, of course, other items will become more or less vital. These "ratings" reflect simply an estimate of usefulness to the student, not a judgment of comparative quality or value.

4. Post-1950 takeoffs include Aleister Crowley's *Crowley on Christ* (1953), first published in typewritten form as "The Gospel According to St. Bernard Shaw"; Harold F. Rubinstein's play, *Bernard Shaw in Heaven* (1954), called by the author "a Fantasia on Unearthly Themes in the Shavian manner"; Brigid Brophy's novella, *The Adventures of God in His Search for the Black Girl* (1973); and the magazine *The Complete Christian: The Direct Voice of the Aquarian Age* (1963–?), with its enigmatic masthead: "Editor: George Bernard Shaw. Medium and Twin-Editor: Saint Patricia [Patricia Steele]."

5. Essays on Shaw's religious/philosophical plays are excluded unless they deal overtly, and at some length, with their religious and philosophical aspects.

I. By Shaw

A. Collected Writings

The Bodley Head Bernard Shaw: Collected Plays with Their Prefaces. Ed. Dan H. Laurence. London: Reinhardt, 1970–74. 7 vols. (Includes "Index to the Entire Edition," comp. A. C. Ward, VII, 681–854, an elaborate name and topic index to all the plays, their prefaces, and other Shaw comments on the plays printed in this edition. See esp. Atheism, Bible, Butler, Christianity, Church of England, Creative Evolution, Darwin, Evolution, God, Holy Ghost, Inquisition, Jesus, Life Force, Nietzsche, Protestantism, Roman Catholicism, Shelley, Tolstoy, Utopia.)

The Complete Prefaces of Bernard Shaw. London: Hamlyn, 1965. 948 pp. (Prints a variety of prefaces, not just those to the plays. In the full index, see esp. Baptism, Bible, Butler, Christianity, Darwinism, Evolution, God, Jesus Christ, Life Force, Mahomet, Nietzsche, Religion, Roman Catholic Church, Salvation, Shelley, Sin.)

Shaw: An Autobiography, Selected from His Writings by Stanley Weintraub. New York: Weybright & Talley, 1969–70. 2 vols. (The "Biographical Index" at the end of Volume II refers to many Shaw statements on religious and philosophical topics. See esp. I, 29–40, 77–81; II, 130–46, 157–68.)

Collected Letters. Ed. Dan H. Laurence. London: Reinhardt, 1965, 1972. 2 vols. so far. I:

1874–1897; II: 1898–1910. (Includes scattered comments on religion, ethics, ideals, the Life Force, Nietzsche, Butler, *Man and Superman, Major Barbara, The Shewing-up of Blanco Posnet*, etc. See esp. I, 268–69, 726–27; II, 161–63, 759–62, 858–59, 900–902.)

*"The Nun and the Dramatist." In *In a Great Tradition: Tribute to Dame Laurentia McLachlan, Abbess of Stanbrook, by the Benedictines of Stanbrook*. London: Murray, 1956, 231–78; first publ. in *Cornhill Magazine*, No. 1008 (1956), 415–58. (Letters and conversations on religion, 1924–49, with special emphasis on *Saint Joan* and *The Adventures of the Black Girl in Her Search for God*. See also R. J. Minney, "Shaw and Religion," *Recollections of George Bernard Shaw* [English ed.: *The Bogus Image of Bernard Shaw*], Englewood Cliffs, N.J.: Prentice-Hall, 1969, 81–93, which stresses Shaw's relationship with Dame Laurentia.)

**Platform and Pulpit*. Ed. Dan H. Laurence. New York: Hill & Wang, 1961. 302 pp. (Includes reprints of four talks of a religious nature, listed chronologically below.)

**The Religious Speeches of Bernard Shaw*. Ed. Warren S. Smith. University Park: Pennsylvania State Univ. Pr., 1963. 104 pp. (Reprints eleven speeches or reports of speeches, most listed chronologically below.)

Shaw on Religion. Ed. Warren S. Smith. New York: Dodd, Mead, 1967. 240 pp. (Excerpts from plays, prefaces, essays, etc., plus several pieces—three hitherto unpublished—that Shaw intended for a volume to be entitled *Religion and Religions*. Relevant items listed chronologically below.)

B. Sources of Shaw Comments

Chappelow, Alan. *Shaw—"The Chucker-Out": A Biographical Exposition and Critique*. London: Allen & Unwin, 1969; see esp. "On Christian Economics," 130–61.

Henderson, Archibald. *George Bernard Shaw: His Life and Works: A Critical Biography*. New York: Boni & Liveright, 1911. 528 pp.

———. *Bernard Shaw: Playboy and Prophet*. New York: Appleton, 1932. 872 pp.

*———. *George Bernard Shaw: Man of the Century*. New York: Appleton-Century-Crofts, 1956. 969 pp. (Authorized biographies, overlapping but not reduplicating one another, which contain a wealth of Shaw quotations; see indexes.)

Patch, Blanche. "The Mystic." *Thirty Years with G.B.S.* New York: Dodd, Mead, 1951, 219–40. (By Shaw's secretary, who quotes him extensively.)

Rattray, R. F. *Bernard Shaw: A Chronicle*. Luton: Leagrave Pr., 1951. 347 pp. (In the index, see esp. Butler, Christianity, God, Life Force, mysticism, philosophy, prophecy, religion.)

Winsten, Stephen. *Jesting Apostle: The Life of Bernard Shaw*. London: Hutchinson, 1956. 231 pp. (In index, see Shaw–Religion. Winsten's *Days with Bernard Shaw*, New York: Vanguard Pr., 1949, includes scattered Shaw comments; see pp. 95–96 and index.)

See also II, 1931: Harris; 1939: Eyrignoux; 1949: Irvine. III.C: Brome; Fiske; McMillan. IV.E: Laurence.

C. Chronology of Selected Writings

1875 Letter to the editor of *Public Opinion* (Dublin) on the popularity of the evangelists Moody and Sankey. Printed in R. F. Rattray [I.B], 25–26, and in Archibald Henderson [I.B, 1956], 47–48.

1878 *Passion Play: A Dramatic Fragment, 1878* [provisionally entitled *Household of Joseph*]. Ed. Jerald E. Bringle. Iowa City: Windhover Pr. (Univ. of Iowa), 1971. Unpaged (c. 60 pp.); repr. in *The Bodley Head Bernard Shaw* [I.A], VII, 487–527.

My Dear Dorothea: A Practical System of Moral Education for Females Embodied in a Letter to a Young Person of That Sex. Ed. Stanley Weintraub. New York: Vanguard Pr., 1956. 55 pp. (Written 1878; first publ. here.)

1891 **The Quintessence of Ibsenism.* London: Walter Scott, 1891. 2nd ed. 1913; 3rd ed. in *Major Critical Essays.* London: Constable, 1932, 1–150. (Elucidates "Ibsen's attack on ideals and idealism." See esp. "The Two Pioneers," 13–24, "Ideals and Idealists," 25–31, and "The Lesson of the Plays," 117–25; see also the section on *Emperor and Galilean,* 49–59.)

1892 "Shaming the Devil About Shelley." *Albermarle Review,* Sept. 1892; repr. in *Pen Portraits and Reviews.* London: Constable, 1932, 236–46, and in Dan H. Laurence, ed. *Selected Non-Dramatic Writings of Bernard Shaw.* Boston: Houghton Mifflin, 1965, 315–22.

1895 *The Sanity of Art.* First publ. as "A Degenerate's View of Nordau" in *Liberty* (New York), July 1895. 2nd ed. 1908; repr. in *Major Critical Essays.* London: Constable, 1932, 281–332. (Defends the "artist-philosophers" against the "Philistines." See esp. 301–9 and the section "Protestant Anarchism," 309–12.)

1896 *"On Going to Church." *Savoy,* No. 1 (Jan. 1896), 13–27; repr. as Shavian Tract No. 5 (1956); also repr. in Stanley Weintraub, ed. *The Savoy: Nineties Experiment.* University Park: Pennsylvania State Univ. Pr., 1966, 3–15, and in *Selected Non-Dramatic Writings* [see I.C, 1892], 378–90.

1897 *The Devil's Disciple: A Melodrama* (written 1896).

1898 *The Perfect Wagnerite: A Commentary on The Ring of the Niblungs.* London: Grant Richards, 1898. 2nd ed. 1901; 3rd ed. 1913, repr. in *Major Critical Essays.* London: Constable, 1932, 151–279. (Describes the "urgent and searching philosophic and social significance" of Wagner's *Ring.*)

1900 "The Conflict Between Science and Common Sense." *Humane Review,* April 1900, 3–15. (That is, between science and religion.)

1901 Preface to *Three Plays for Puritans.* (Sections include "Why for Puritans?" and "On Diabolonian Ethics.")

"Notes to *Caesar and Cleopatra.*" In *Three Plays for Puritans.* (Shaw said the Notes include the outlines of a complete Shavian philosophy.)

1903 ***Man and Superman: A Comedy and a Philosophy* (written 1901–2; publ. 1903; Comedy performed 1905, Hell scene 1907).

*Preface to *Man and Superman:* "Epistle Dedicatory to Arthur Bingham Walkley."

1904 **John Bull's Other Island.*

1905 ***Major Barbara: A Discussion.*

*Preface to *Major Barbara.*

1906 "The Religion of the British Empire." Address recorded in *Christian Commonwealth,* 29 Nov. 1906; repr. in *Religious Speeches* [I.A], 1–8.

1907 Preface to *John Bull's Other Island.* (Includes sections on Irish Protestantism and Catholicism.)

*"The New Theology." *Christian Commonwealth,* 23 and 30 May 1907; repr. in *Religious Speeches* [I.A], 9–19, and in Stanley Weintraub, ed. *The Portable Bernard Shaw.* Harmondsworth: Penguin Books, 1977, 304–15.

"Don Juan in Hell." Program note for 1907 performance; repr. in Raymond Mander and Joe Mitchenson, eds. *Theatrical Companion to Shaw.* New York: Pitman, 1955, 89–90; in *The Bodley Head Bernard Shaw* [I.A], II, 800–803; and in *The Portable Bernard Shaw* [see previous item], 243–45. (Shaw's interpretation of the Hell scene.)

1908 Preface to *Getting Married.* (Brief sections, "Christian Marriage" and "Divorce a Sacramental Duty.")

"A Retort on Mr Chesterton." *New Age*, 10 Dec. 1908, 129–30; repr. in *Shaw on Religion* [I.A] as "On Miracles: A Retort," 42–48.

"His Reply to Our Article on 'G.B.S. and Jesus Christ.' " *Freethinker*, 28 (1908), 689–90 (see II: Foote).

1909 **The Shewing-up of Blanco Posnet: A Sermon in Crude Melodrama.*

"Dialogue of the Devil & St Augustine." Scenario for a play Shaw wanted G.K. Chesterton to write, printed in *Collected Letters* [I.A], II, 877–82.

"The Ideal of Citizenship." Address printed in R.J. Campbell. *The New Theology.* London: Mills & Boon, 1909, Appendix; repr. in *Platform and Pulpit* [I.A], 74–82, and in *Religious Speeches* [I.A], 20–28.

1910 Preface to *Misalliance:* "Parents and Children." (Relevant sections: "The Sin of Athanasius," "Antichrist," "The Impossibility of Secular Education," "Natural Selection as a Religion," "Moral Instruction Leagues," and "The Bible.")

1911 "The Religion of the Future." Reported address given 30 May 1911, recorded in a Heretics Society pamphlet, 11 July 1911, which also prints press reactions (9–14); repr. in *Religious Speeches* [I.A], 29–37.

"A Foreword to the Popular Edition of *Man and Superman*." *Man and Superman: A Comedy and a Philosophy.* London: Constable, 1911, 5; repr. in *The Bodley Head Bernard Shaw* [I.A], II, 531–32. (Brief but cogent statement on the Hell scene.)

1912 **"Modern Religion." *Christian Commonwealth*, 3 April 1912, Supplement; repr. in *Religious Speeches* [I.A], 38–49.

"The Idea of God: Mr G. Bernard Shaw's Surrejoinder to Mr Campbell." *Christian Commonwealth*, 17 July 1912, 683; repr. in *Shaw on Religion* [I.A] (as "God Must Be Non-Sectarian and International"), 54–59.

"[The Protestants of Ireland.]" *Christian Globe*, 22 Feb. 1912; repr. in *The Matter with Ireland.* Ed. Dan H. Laurence and David H. Greene. New York: Hill & Wang, 1962, 68–70.

"[What Irish Protestants Think.]" Address printed in a pamphlet with that title, 1912; repr. in *Religious Speeches* [I.A], 50–53, and in *The Matter with Ireland* [see previous item], 71–74.

1913 ***Androcles and the Lion: A Fable Play* (performed 1912 in Germany, 1913 in England).

"Androcles: How Divines Differ About Shaw." Letter to editor of London *Daily News*, 29 Sept. 1913; repr. in *The Bodley Head Bernard Shaw* [I.A], IV, 645–48.

Program note for first English performance of *Androcles and the Lion*, printed in Raymond Mander and Joe Mitchenson. *Theatrical Companion to Shaw.* New York: Pitman, 1955, 151–52.

1915 "Facts About *Major Barbara*." Press release printed in *The Sun* (New York), 26 Dec. 1915; repr. in *The Bodley Head Bernard Shaw* [I.A], III, 193–97.

1916 ** Preface to *Androcles and the Lion:* "On the Prospects of Christianity." See also the afterword.

"Quot Homines, Tot Christi." *New Statesman*, 17 June 1916; repr. in *Shaw on Religion* [I.A], 80–83. ("As many men as there are Christs.")

1919 Preface to *Heartbreak House.* (Includes section "Church and Theatre.")

**"Modern Religion." 1919 address printed in *New Commonwealth*, 2 Jan. 1920, Supplement; repr. in *Platform and Pulpit* [I.A], 110–30, and in *Religious Speeches* [I.A], 60–80.

"Jesus." In Frank Harris. *Stories of Jesus the Christ.* New York: Pearson, 1919, 28–30. (Letter replying to Harris's critique of his Preface to *Androcles and the Lion.*)

1921 ***Back to Methuselah: A Metabiological Pentateuch* (publ. 1921; written 1918–20; performed 1922 in USA, 1923 in England).

**Preface to *Back to Methuselah:* "The Infidel Half Century." (On Creative vs. Darwinian Evolution.)

1922 *"On Ritual, Religion, and the Intolerableness of Tolerance." Unpubl. essay, dated 1922, printed in *Shaw on Religion* [I.A], 148–71.

"Again the Dean Speaks out." *Nation*, 9 Dec. 1922; repr. in *Pen Portraits and Reviews*. London: Constable, 1932, 153–60. (Review of W. R. Inge's *Outspoken Essays, Second Series*.)

"A Catechism on My Creed." *St. Martin-in-the-Fields Review*, May 1922; repr. in *Shaw on Religion* [I.A], 128–31.

1923 ***Saint Joan: A Chronicle Play* (written 1923; performed 1923 in USA, 1924 in England).

1924 **Preface to *Saint Joan.*

"Mr. Bernard Shaw Talks About St. Joan." *Outlook*, 137 (1924), 311–13; repr. in *Saint Joan Fifty Years After* [IV.H], 8–14, and in *Saint Joan*. Ed. Stanley Weintraub. Indianapolis: Bobbs-Merrill, 1971, 169–75. (Interview with Walter Tittle.)

"Shaw on *Saint Joan.*" Letter to Editor, *New York Times*, 13 April 1924, Sec. 8, p. 2; repr. in *Saint Joan Fifty Years After* [IV.H], 15–22.

1925 "Where Darwin Is Taboo: The Bible in America." *New Leader*, 10 (July 1925); repr. in *The New Leader Book*. London: New Leader, 1925, 7–9; repr. in *Shavian*, 2, ii (1960), 3–9.

1925? *"The Infancy of God." Unpubl. essay printed in *Shaw on Religion* [I.A], 132–42. (Speculatively dated.)

1925? "A Note on the Prayer Book." Unpubl. essay printed in *Shaw on Religion* [I.A], 143–47. (Speculatively dated.)

1928 "Socialism and the Churches." *The Intelligent Woman's Guide to Socialism and Capitalism*. New York: Brentano's, 1928, 429–43.

"[Personal Immortality.]" *Daily News*, 6 June 1928; repr. in *Shaw on Religion* [I.A], 181–83.

1928? *"The Mystical Bernard Shaw." In Paul Green. *Dramatic Heritage*. New York: French, 1953, 112–31. (Essay-interview of late 1928 or early 1929.)

1930 "Religion and Science." Toast to Albert Einstein printed in *Religious Speeches* [I.A], 81–88.

1931 "Saint Joan." *Listener*, 51 (3 June 1931), 79–81; repr. in *Platform and Pulpit* [I.A], 208–16; in *The Bodley Head Bernard Shaw* [I.A], VI, 218–29; and in *Saint Joan*. Ed. Stanley Weintraub. Indianapolis: Bobbs-Merrill, 1971, 179–88. (Radio talk.)

1932 ***The Adventures of the Black Girl in Her Search for God*. London: Constable, 1932; repr. in *Short Stories, Scraps and Shavings*. London: Constable, 1934, 235–88, and in *The Portable Bernard Shaw* [see I.C, 1907], 636–76. (Shaw's religious allegory, supplemented by his untitled speculation on its meaning, printed as an afterword.)

**Too True to be Good: A Political Extravaganza* (written 1931).

1933 "[Charles Bradlaugh and Today.]" Address printed in *Bradlaugh and To-day: Speeches Delivered at the Centenary Celebration at Friends House, Euston Road, London, on September 23, 1933. . . .* London: Watts, 1933, 30–37; repr. in *Religious Speeches* [I.A], 89–93.

"The Law of Change Is the Law of God." In W. R. Titterton. *Have We Lost God?* London: Grayson & Grayson, 1933, 73–77.

1934 Preface to *Too True to be Good*. (Includes sections: "Need for a Common Faith," "Why the Christian System Failed," and "Supernatural Pretensions.")

*Preface to *On the Rocks*. (Stresses the religious and ethical implications of politically motivated killing; includes a 10-page dialogue between Jesus and Pilate.)

A Shavian Meets a Theologian: An Interesting Interview, 1934. Athlone, Cape Town: Islamic Publications Bureau, 195? 12 pp. (Shaw managed few words in this encounter with Maulana Mohammad Abdul Aleem Siddiqui, a Muslim divine.)

1935 **The Simpleton of the Unexpected Isles: A Vision of Judgment* (written 1934).

Preface to The Simpleton of the Unexpected Isles: "Preface on Days of Judgment."

1937 "[Religion and War.]" *Listener,* 10 Nov. 1937 (as "As I See It"), and *Vital Speeches of the Day,* 15 Nov. 1937 (as "So Long, So Long"); repr. in *Shavian,* Dec. 1953 (as "Shaw Speaks on War"), in *Platform and Pulpit* [I.A] (as "This Danger of War"), 282–86, and in *Religious Speeches* [I.A] (as "Religion and War"), 94–99.

1943 "I Believe." In Ernest W. Martin, ed. *In Search of Faith: A Symposium.* London: Drummond, 1943, 9–11. (Brief statements on beliefs in God, immortality, and the Resurrection.)

1944 "Religious Summary." *Everybody's Political What's What?* London: Constable, 1944, 357–63.

1945 "Postscript: After Twentyfive Years." *Back to Methuselah: A Metabiological Pentateuch.* London: Oxford Univ. Pr., 1945, 283–300; repr. in *The Bodley Head Bernard Shaw* [I.A], V, 685–703. (Written for World's Classics edition. Argues that the play "is a world classic or it is nothing.")

"What Is My Religious Faith?" In *Rationalist Annual, 1945.* London: Rationalist Press Assn., 1945, 3–7; repr. in *Sixteen Self Sketches.* London: Constable, 1949, 73–79.

1948 "Three Riddles for Shaw," by Hayden Church. *Saturday Review of Literature,* 31 (30 Oct. 1948), 21. (Shaw's written answers to questions on survival after death, prayer, and creation.)

1950 *Farfetched Fables* (written 1948).

Creative Evolution: Definitions. By H. C. Duffin; rewritten by Shaw. London: Shaw Society, 1950. 8 pp. (Shaw Society Tract No. 1.)

"If I Were a Priest." *Atlantic Monthly,* 185 (May 1950), 70–72. (Review of W. R. Inge's *Diary of a Dean.*)

1951 *Preface to Farfetched Fables* (written 1948–49). (Much on the Life Force and Christianity.)

II. Commentaries, 1904–1949: A Chronology

1904 Ellis, Havelock. "Bernard Shaw." *From Marlowe to Shaw: The Studies, 1876–1936, in English Literature of Havelock Ellis,* ed. John Gawsworth. London: Williams & Norgate, 1950, 291–96. (1904 essay, prompted by *Man and Superman,* on Shaw as artist-prophet.)

1905 France, Wilmer C. "The Philosophy of George Bernard Shaw." *Bookman,* 28 (1905), 428–31.

1907 *Jackson, Holbrook. "The Philosopher." *Bernard Shaw.* London: Grant Richards, 1907, 195–233.

1908 Foote, G. W. " 'G.B.S.' and Jesus Christ." *Freethinker,* 28 (1908), 657–58. (Shaw's reply, 689–90.)

1909 *Chesterton, G. K. *George Bernard Shaw.* London: Bodley Head, 1909, esp. "The Puritan," 24–43, "The Philosopher," 165–254, and in post-1930 printings, "The Later Phases," 255–96.

Henderson, Archibald. "The Philosophy of Bernard Shaw." *Atlantic Monthly,* 103 (1909), 227–34.

1910 Deacon, Renée M. *Bernard Shaw as Artist-Philosopher: An Exposition of Shavianism.* London: Fifield, 1910. 106 pp. (See esp. "Philosophy of Life," 72–82.)

Rogers, A. K. "Mr. Bernard Shaw's Philosophy." *Hibbert Journal,* 8 (1910), 818–37.

1911 Henderson, Archibald. "Artist and Philosopher." *George Bernard Shaw* [I.B], 447–80.

1912 Cestre, Charles. "Le fond." *Bernard Shaw et son oeuvre.* 2nd ed. Paris: Mercure de France, 1912, 236–89.

Kennedy, J. M. "George Bernard Shaw." *English Literature, 1880–1905.* London: Swift, 1912, 154–205. (Some stress on the ideas in *Man and Superman* and *Blanco Posnet.* By a Nietzsche scholar.)

1913 Richter, Helene. "Die Quintessenz des Shawismus." *Englische Studien,* 46 (1913), 367–469, esp. "Der Antimoralist," 398–429.

1914 Duffy, Rev. P. Gavan. "Shavian Religion." *Century,* 87 (1914), 908–14. (His "valuable contribution to the welfare of religion.")

McCabe, Joseph. "The Shavian Philosophy." *George Bernard Shaw: A Critical Study.* New York: Kennerley, 1914, 58–91.

1915 Lord, Daniel A. "Martyrs According to Bernard Shaw." *Catholic World,* 100 (1915), 577–90. (An attack on *Androcles.*)

Upward, Allen. *Paradise Found; or, The Superman Found Out.* Boston: Houghton Mifflin, 1915. 99 pp. (Three-act play featuring "Mr. Bernard Shaw, The Superman," members of the "Most Noble Order of Hereditary Fabians" and of the "Anti-Shavian League," etc.)

1916 Burton, Richard. "The Poet and Mystic." *Bernard Shaw, the Man and the Mask.* New York: Holt, 1916, 211–37. (Stresses the Life Force.)

Dell, Floyd. "Shaw and Religion." *Seven Arts,* 1, i (1916), 82–88.

Freeman, John. "George Bernard Shaw." *The Moderns: Essays in Literary Criticism.* London: Scott, 1916, 1–51. (See esp. the critique of the Preface to *Androcles,* 45–51.)

Lord, Daniel A. "George Bernard Shaw." *Catholic World,* 102 (1916), 768–80; 103 (1916), 24–37. (An attack on Shaw's religious views.)

MacCarthy, Desmond. "Mr. Shaw on Christianity." *Shaw.* London: MacGibbon & Kee, 1951, 114–19. (Negative 1916 review of the Preface to *Androcles.*)

1917 Phillips, Hubert. "The Shavian Ethics and Philosophy." *Methodist Review,* 99 (1917), 548–60.

Slosson, Edwin E. "George Bernard Shaw: Dramatic Critic of Life." *Six Major Prophets.* Boston: Little, Brown, 1917, 1–55.

1920 Duffin, Henry C. "Religious Matters." *The Quintessence of Bernard Shaw.* London: Allen & Unwin, 1920, 148–74; see also "Immorality and Heresy," 35–61.

1921 Eliot, T. S. "[London Letter:] Mr. Bernard Shaw." In William Wasserstrom, ed. *A Dial Miscellany.* Syracuse: Syracuse Univ. Pr., 1963, 48–50. (1921 essay on Creative Evolution prompted by the publication of *Methuselah.*)

1922 Chubb, Percival. "Bernard Shaw's Religion and Its Latest Phase in *Back to Methuselah.*" *Standard* (American Ethical Union), 9 (1922), 1–7. (Stresses the Preface.)

Ervine, St. John. "Bernard Shaw." *Some Impressions of My Elders.* New York: Macmillan, 1922, 189–239; see also 249–53. (Part discusses Shaw's religion in relation to his plays since *Heartbreak House* and in comparison to that of H. G. Wells.)

1923 Wood, Herbert G. "G. Bernard Shaw and Religion." *Contemporary Review,* 123 (1923), 623–28.

1924 Shanks, Edward. "The Philosopher." *Bernard Shaw.* London: Nisbet, 1924, 100–115.

1925 Braybrooke, Patrick. *The Genius of Bernard Shaw.* Philadelphia: Lippincott, 1925?, 69–94. (On *Man and Superman* and *Androcles.*)

Collis, John S. "Divination: God: The Divinity that Shapes Our Ends: Shaw's Message to Normal Man." *Shaw.* London: Cape, 1925, 41–49.

Eulenberg, Herbert. *Gegen Shaw: Eine Streitschrift, mit einer Shaw-Parodie des Verfassers.* Dresden: Reissner, 1925. 77 pp. (Reaction to *Saint Joan.*)

Jung, Werner. *La "Jeanne d'Arc" de Bernard Shaw.* Brussels: La Renaissance d'Occident, 1925. 41 pp.

Lichtenstein, Serafine. "Untersuchung des Verhältnisses von Shaws *Saint Joan* zu ihren Quellen." Diss., Graz, 1925.

Robertson, J. M. *Mr. Shaw and "the Maid."* London: Cobden-Sanderson, 1925. 115 pp. (An attempt to "save History from Mr. Shaw" by showing how he mishandled facts.)

Whitehead, George. *Bernard Shaw Explained: A Critical Exposition of the Shavian Religion.* London: Watts, 1925. 156 pp.

1926 Aas, L. "Det filosofiske grundlag: Bernard Shaws hovedidéer." *Bernard Shaw og hans verker.* Oslo: Gyldendal, 1926, 172–85.

Peper, Elisabeth. "George Bernard Shaws Beziehungen zu Samuel Butler dem Jüngeren." *Anglia,* 50 (1926), 295–316. Publ. diss., Königsberg.

1928 Ervine, St. John. "The Shavian Belief." *Yale Review,* 18 (1928), 290–301.

Tetauer, Frank. "Filosofie Shawových her a předmluv." *Příspěvky k dějinám řeči a literatury* [Studies in English by members of the English Seminar of the Charles Univ., Prague], 3 (1928), 73–175; English summary, 176–79. (The philosophy of human life as expressed in the plays and prefaces of Shaw.)

Turner, W. J. "G. Bernard Shaw." In Edgell Rickword, ed. *Scrutinies.* London: Wishart, 1928, 132–43. (Shaw as "the last and purest of the Rationalists.")

Vančura, Zdněk. "Filosofie vývoje u H. G. Wellse a G. B. Shawa." *Příspěvky k dějinám řeči a literatury* [see 1928: Tetauer], 3 (1928), 1–21; English summary, 22–24. (The philosophy of evolution in Wells and Shaw.)

1929 Belgion, Montgomery. "According to Mr. Bernard Shaw." *Our Present Philosophy of Life.* London: Faber & Faber, 1929, 51–122, esp. sections 5–7: "The Life Force or Creative Evolution," "Creative Evolution as Religion," and "The Claim to Inspiration."

Vančura, Zdněk. "Rozpor ve filosofii Bernarda Shawa." *Časopis pro Moderní Filosofii,* 30 (1929), 273–76. (A discrepancy in Shaw's philosophy.)

Wagenknecht, Edward. "Bernard Shaw's Religion." *A Guide to Bernard Shaw.* New York: Appleton, 1929, 69–85.

1930 Braybrooke, Patrick. "Bernard Shaw and Christianity." *The Subtlety of George Bernard Shaw.* London: Palmer, 1930, 135–60; see also "Shaw and the Salvation Army," 163–83.

Colbourne, Maurice D. "A Religious Man." *The Real Bernard Shaw.* [4th ed.] London: Dent, 1949, 265–82. (1930 essay on Shaw's religious opinions.)

Stewart, Herbert L. "The Puritanism of George Bernard Shaw." *Royal Society of Canada: Proceedings and Transactions,* 24, ii (1930), 89–100.

1931 *Ellehauge, Martin. *The Position of Bernard Shaw in European Drama and Philosophy.* Copenhagen: Levin & Munksgaard, 1931. 390 pp., esp. "Vitalism," 239–94, and "Religious, Legendary, Historical, and National Drama," 295–342.

Harris, Frank. "Religion." *Bernard Shaw: An Unauthorized Biography Based on First Hand Information.* New York: Book League of America, 1931, 353–70. (Includes Shaw letters on *Androcles.*)

Pollard, Harold. "The Philosophy of Bernard Shaw." *Philosopher*, 9 (1931), 12–26.

1932 Henderson, Archibald. *Bernard Shaw* [I.B]: "Ireland's Irreligion," 33–39; "Ireland's Religion," 40–48; and "Artist—Humanitarian—Philosopher," 668–89.

1933 Kazi, Mr. and Mrs. I. I. *Adventures of the Brown Girl (Companion to the Black Girl of Mr. Bernard Shaw) in Her Search for God.* London: Stockwell, 1933. 112 pp.

Matthews, Walter R. *The Adventures of Gabriel in His Search for Mr. Shaw: A Modest Companion for Mr. Shaw's Black Girl.* London: Hamilton, 1933. 61 pp.

Maxwell, Charles H. *Adventures of the White Girl in Her Search for God.* London: Lutterworth Pr., 1933. 23 pp.

Walker, Leslie J. *The Return to God: A Catholic and Roman View.* London: Barker, 1933. 223 pp. (Began as a retort to Shaw's *Black Girl.*)

1934 Hyman, Marcus. *The Adventures of the White Girl in Her Search for Knowledge.* London: Cranley & Day, 1934. 64 pp.

Lehmann, Wilhelm. "George Bernard Shaws Verhältnis zu Romantik und Idealismus." Diss., Bonn, 1934.

1935 Closset, F. "L'Idealiste." *G. Bernard Shaw: Son oeuvre.* Paris: La Nouvelle Revue Critique, 1935, 53–74.

Collis, John S. "A Symbol: Bernard Shaw and the Celtic Twilight." *Farewell to Argument.* London: Cassell, 1935, 11–23. (Stresses *John Bull's Other Island.*)

Davis, Elmer H. "Shaw and the Inner Light." *By Elmer Davis,* ed. Robert L. Davis. Indianapolis: Bobbs-Merrill, 1964, 210–15. (Excerpts from a 1935 essay.)

Mirsky, Dmitri. *The Intelligentsia of Great Britain,* tr. Alec Brown. London: Gollancz, 1935, 48–56. (A Russian view of Shaw and Butler.)

1937 Hackett, J. P. *Shaw: George Versus Bernard.* London: Sheed & Ward, 1937. 224 pp., esp. chapters II, 27–45, and VI, 136–66. (Roman Catholic point of view.)

1938 Caudwell, Christopher [pseudonym of Christopher St. John Sprigg]. "George Bernard Shaw: A Study of the Bourgeois Superman." *Studies in a Dying Culture.* London: Lane, 1938, 1–19. (Shaw's belief in "the primacy of pure contemplation" and its implications.)

1939 Eyrignoux, Louis. "La dette de Shaw envers Samuel Butler: Deux documents." *Études Anglaises,* 3 (1939), 361–64. (Includes Shaw letters—in English—to Eyrignoux.)

1940 Sörensen, Edith D. *G. B. Shaws Puritanismus.* Diss., Hamburg, 1940. 101 pp.

1942 Rowland, John. "The Truth About Bernard Shaw." *Rationalist Annual, 1942,* 94–97. (A rationalist finds that Shaw's main function is that of a heretic.)

1944 Collis, John S. "Religious Problems in the Plays of Bernard Shaw." *Aryan Path,* 15 (April 1944), 162–67.

Tintner, Anny. "Shaw und Platon." Diss., Vienna, 1944.

1945 Hamilton, R. "The Philosophy of Bernard Shaw: A Study of *Back to Methuselah.*" *London Quarterly and Holborn Review,* 14 (1945), 333–41.

1946 Gillis, James M. "What Shaw Really Taught." *Catholic World,* 163 (1946), 481–89. (Critique of his moral views.)

Inge, William R. "Shaw as a Theologian." In Stephen Winsten, ed. *G.B.S. 90: Aspects of Bernard Shaw's Life and Work.* London: Hutchinson, 1946, 110–21.

*Joad, C. E. M. "Shaw's Philosophy." In *G.B.S. 90* [see previous item], 57–76; repr. in Joad's *Shaw.* London: Gollancz, 1949, 172–206 (see also 43–51), and in Louis Kronenberger, ed. *George Bernard Shaw: A Critical Survey.* Cleveland: World, 1953, 184–205.

1947 **Bentley, Eric. "Vital Economy" and "The Fool in Christ." *Bernard Shaw 1856–1950.* Rev. ed. New York: New Directions, 1957 [first publ. 1947], 44–92, 183–219.

Eastman, Fred. *Christ in the Drama: A Study of the Influence of Christ on the Drama of England and America.* New York: Macmillan, 1947, 42–60. (Stresses *Androcles* and *Saint Joan.*)

Guardia, Alfredo de la. "La creación intelectual de Shaw: Comedia de la Evolución Creadora." *El teatro contemporáneo.* Buenos Aires: Schapire, 1947, 259–306.

1948 Clarke, Winifred. *George Bernard Shaw: An Appreciation and Interpretation.* Altrincham: Sherratt, 1948. 40 pp. (Adulatory view of Shaw as the greatest moral teacher of the age.)

Rébora, Piero. "Drammi religiosi: Cristianesimo ed evoluzionismo." *Bernard Shaw, comico e tragico.* Florence: Vallecchi, 1948, 184–204; see also 205–39.

1949 Dunkel, Wilbur D. "Bernard Shaw's Religious Faith." *Theology Today,* 6 (1949), 369–76.

Irvine, William. *The Universe of G.B.S.* New York: McGraw-Hill, 1949. 439 pp. (In index, see Creative Evolution, Life Force, and Religion. Text includes scattered comments by Shaw.)

Jones, W. S. Handley. "One of Our Conquerors" and "The Works and Faith of Bernard Shaw." *The Priest and the Siren, and Other Literary Studies.* London: Epworth Pr., 1953, 44–78; first publ. in *London Quarterly and Holborn Review,* 174 (1949), 10–19, 136–45.

III. Commentaries, 1950–1979, on Shaw's Religious/Philosophical Thought

A. General and Miscellaneous

*Albert, Sidney P. "Bernard Shaw: The Artist as Philosopher." *Journal of Aesthetics and Art Criticism,* 14 (1956), 419–38. ("The philosophy in his art, and the art in his philosophy.")

Amalric, Jean-Claude. *Bernard Shaw: Du réformateur victorien au prophète édouardien.* Paris: Didier, 1977, esp. "La Philosophie de Shaw," 293–321, and "Métaphysique et religion," 345–84.

Anderson Imbert, Enrique. "Religión" and "Etica." *Las comedias de Bernard Shaw.* México: Universidad Nacional Autonoma de México, 1977, 71–87.

*Barr, Alan P. *Victorian Stage Pulpiteer: Bernard Shaw's Crusade.* Athens: Univ. of Georgia Pr., 1973. 188 pp.

Batson, Eric J. "The Religion of Bernard Shaw." *Aryan Path,* 34 (1963), 113–18.

Best, Brian S. "Development of Bernard Shaw's Philosophy of the Responsible Society." Diss., Wisconsin. *DAI,* 32 (1971), 3292A. (Studies the relation between social and Creative evolution.)

Brown, Ivor. "Things Believed." *Shaw in His Time.* London: Nelson, 1965, 165–81.

Carpenter, Charles A. "Shaw's Ethical Aims." *Bernard Shaw & the Art of Destroying Ideals: The Early Plays.* Madison: Univ. of Wisconsin Pr., 1969, 9–13.

Castelli, Alberto. "Bernard Shaw e la religione." *Scuola Cattolica,* 79 (1951), 163–70.

Couchman, Gordon W. "Bernard Shaw and the Gospel of Efficiency." *ShR,* 16 (1973), 11–20. (Links this "gospel" to Creative Evolution.)

Denninghaus, Friedhelm. "Determinism and Voluntarism in Shaw and Shakespeare." *ShR*, 19 (1976), 120–31. (Translation by John J. Weisert of pp. 175–86 of his book; see next item.)

———. "Die historischen Voraussetzungen der sozial-deterministischen Anthropologie und der utopisch-eschatologischen Geschichtsphilosophie Shaws." *Die dramatische Konzeption George Bernard Shaws*. Stuttgart: Kohlhammer, 1971, 186–216.

Dietrich, Richard F. "Shaw and the Passionate Mind." *ShR*, 4, ii (1961), 2–11. (His fusion of vitalism and pragmatism. Parts discuss *Caesar and Cleopatra*, *Saint Joan*, and *The Apple Cart*.)

Dutli, Alfred. *Der Kosmos eines Ketzers: Die religiöse Bedeutung des Evolutionsgedankens bei Bernard Shaw*. Zurich: Artemis, 1950. 141 pp. Part I: "Metabiologie, die Religion des 20. Jahrhunderts"; part II: "Der Weg der Menschheit."

Fremantle, Anne. "Shaw and Religion." *Commonweal*, 67 (1957), 249–51.

Geduld, Harry M. "Shaw's Philosophy and Cosmology." *California Shavian*, 1, iv (1960), 1–8; repr. in 5, v (1964), 11–19. (Philosophical ideas in *Methuselah*.)

Helvey, James R. "Bernard Shaw as Devil's Advocate." Diss., North Carolina. *DAI*, 39 (1979), 4273A. (The role as it serves his faith, the Life Force.)

Henderson, Archibald. "The Life Force." *George Bernard Shaw*. [I.B, 1956], 761–73.

Hodess, J. "George Bernard Shaw and the Jews." *Zion Magazine*, 2, i (1950); repr. in *California Shavian*, 5, vi (1964), 13–17. (Reminiscences.)

Hubenka, Lloyd J. "The Religious Philosophy of Bernard Shaw." Diss., Nebraska. *DA*, 27 (1966), 477A. Part I: Shaw's criticism of Christianity; part II: Shaw's theory of Creative Evolution.

Hugo, Leon. "The Life Force." *Bernard Shaw, Playwright and Preacher*. London: Methuen, 1971, 50–64.

Joad, C. E. M. "Shaw the Philosopher." In Joad, ed. *Shaw and Society: An Anthology and a Symposium*. London: Odhams, 1953, 233–49. (1951 Fabian memorial lecture.)

Kochanowski, Egon. "Evolution und Übermensch bei Bernard Shaw im Anschluss an das Denken des 19. Jahrhunderts." Diss., Kiel, 1951.

Laurence, Dan H. "Shaw's Life Force: The Superpersonal Need." *Shaw Society Bulletin*, 47 (Dec. 1952), 14–17.

Lindblad, Ishrat. "Shaw's Theory of Creative Evolution." *Creative Evolution and Shaw's Dramatic Art*. . . . Uppsala: Uppsala Univ., 1971, 37–64. Diss.

Masur, Gerhard. *Prophets of Yesterday: Studies in European Culture, 1890–1914*. New York: Macmillan, 1961, 275–86. (Part on his philosophy.)

*Mills, Carl H. "Shaw's Theory of Creative Evolution." *ShR*, 16 (1973), 123–32.

Nathan, Rhoda B. "Bernard Shaw and the Inner Light." *ShR*, 14 (1971), 107–19. (Shaw as species of Quaker.)

Nelson, Raymond S. "The Church, the Stage, and Shaw." *Midwest Quarterly*, 11 (1970), 293–308. (Shaw's campaign to reform the theatre spiritually.)

Nethercot, Arthur H. "Bernard Shaw, Philosopher." *PMLA*, 69 (1954), 57–75. (Charts his references to philosophers.)

Pastalosky, Rosa. "Su ideario filosófico." *George Bernard Shaw: Su ideario político, filosófico y social*. Sante Fe, Arg.: Castellvi, 1963, 25–64.

Pettet, Edwin B. "Shavian Socialism and the Shavian Life Force: An Analysis of the Relationship Between the Philosophic and Economic Systems of George Bernard Shaw." Diss., New York Univ. *DA*, 12 (1952), 622–23.

———. "Shaw's Socialist Life Force." *Educational Theatre Journal*, 3 (1951), 109–14.

Pilecki, Gerald A. "Creative Evolution and Its Political Implications." *Shaw's Geneva: A Critical Study of the Evolution of the Text in Relation to Shaw's Political Thought and Dramatic Practice*. The Hague: Mouton, 1965, 90–99.

Roppen, Georg. "George Bernard Shaw." *Evolution and Poetic Belief: A Study in Some Victorian and Modern Writers.* Oslo: Oslo Univ. Pr., 1956, 352–402. (His "evolutionary Utopia.")

Rosset, B. C. *Shaw of Dublin: The Formative Years.* University Park: Pennsylvania State Univ. Pr., 1964. 388 pp., esp. 259–64 on Shaw's religious background.

Roy, Emil. "World-View in Shaw." *Drama Survey,* 4 (1965), 209–19.

Roy, R. N. *Bernard Shaw's Philosophy of Life.* Calcutta: Mukhopadhyay, 1964. 165 pp., esp. "The Philosophy of Creative Evolution," 115–54.

Schonauer, Franz. "G. B. Shaws Puritanismus." *Eckart* (Wittenberg), 25 (1956), 312–20.

Schwanitz, Dietrich. "Shaws Weltanschauung." In Kurt Otten and Gerd Rohmann, eds. *George Bernard Shaw.* Darmstadt: Wissenschaftliche Buchgesellschaft, 1978, 185–213. (Expanded from pp. 140–54 of his publ. diss.; see IV.A.)

Seidel, Christian. "Die 'Life Force.' " *Die Entwicklung eines Fabiers (George Bernard Shaw).* Munich: Ludwigs-Maximilians-Univ., 1961, 181–92. Part of diss.

Simon, Louis. "Doctrines and Aspirations." *Shaw on Education.* New York: Columbia Univ. Pr., 1958, 1–17, esp. 11–16; see also "Ways and Aims," 110–33, and "The Meaning of Life," 246–58.

Smith, J. Percy. "Evolution of a Believer." *The Unrepentant Pilgrim: A Study of the Development of Bernard Shaw.* Boston: Houghton Mifflin, 1965, 129–63. (Stresses pre-1900 Shaw.)

Smith, Warren S. "Introduction." *The Religious Speeches of Bernard Shaw* [I.A], xiii–xxiii.

———. *The London Heretics, 1870–1914.* New York: Dodd, Mead, 1968, 270–79; rev. in Smith, ed. *Bernard Shaw's Plays.* New York: Norton, 1970, 333–41.

*Turco, Alfred. *Shaw's Moral Vision: The Self and Salvation.* Ithaca, NY: Cornell Univ. Pr., 1976. 297 pp.

Walker, Kenneth. "The Philosophy of Bernard Shaw." *World Review,* 29 (July 1951), 18–21.

*Whitman, Robert F. *Shaw and the Play of Ideas.* Ithaca, NY: Cornell Univ. Pr., 1977. 293 pp. ("An unashamed attempt to spread the gospel according to George Bernard Shaw." Pp. 30–190 trace the growth of Shaw's ideas.)

Williams, Raymond. "Shaw and Fabianism." *Culture and Society, 1780–1950.* New York: Columbia Univ. Pr., 1958, 179–85. (Fabian social evolution vs. Shavian personal evolution.)

Winkgens, Meinhard. "Shaw und Sternheim: Der Individualismus als Privatmythologie." *Arcadia,* 12 (1977), 31–46.

Zirkle, Conway. *Evolution, Marxian Biology and the Social Scene.* Philadelphia: Univ. of Pennsylvania Pr., 1959, 337–46. (Creative Evolution as "Marxian biology.")

B. Shaw and Aspects of Christianity

*Abbott, Anthony S. *Shaw and Christianity.* New York: Seabury, 1965. 228 pp.

Adam, Ruth. "About God." *What Shaw Really Said.* London: Macdonald, 1966, 21–36.

Appasamy, S. P. "God, Mammon and Bernard Shaw." *Commonwealth Quarterly,* 2, vii (1978), 98–112.

Hickin, R. A. "The Christian Debt to George Bernard Shaw." *London Quarterly and Holborn Review,* 179 (1954), 46–50.

McKinley, R. D. "George Bernard Shaw and the Atonement." *Dalhousie Review,* 46 (1966), 356–65. (His "Crosstianity.")

Nelson, Raymond S. "Shaw: Turn-of-the-Century Prophet." *Arlington Quarterly,* 2, i (1969), 112–19. (His views of God, sin, and salvation.)

Oatridge, Norman C. *Bernard Shaw's God: An Anglican Looks at the Religion of GBS.* Haywards Heath: P. Smith, Boltro Pr., 1967. 174 pp.

Scholer-Beinhauer, Monica. "George Bernard Shaw und das Wunder." *Literatur in Wissenschaft und Unterricht,* 2 (1969), 149–58.

Smith, Warren S. "Bernard Shaw and the Quakers." *Bulletin of the Friends Historical Association,* 45 (1956), 106–18.

———. "The Bishop, the Dancer, and Bernard Shaw." *ShR,* 3, i (1960), 2–10. (Controversy on the moral and religious aspects of stage censorship.)

———. "Christian Socialism, With and Without Shaw." *ShR,* 12 (1969), 36–39. (Expanded review of Peter Jones's *The Christian Socialist Revival, 1877–1914.*)

Weintraub, Rodelle. "Shaw's Jesus and Judas." *ShR,* 15 (1972), 81–83. (Expanded review of Bringle's edition of Shaw's *Passion Play.*)

C. Shaw and British Thinkers

Bissell, Claude. "The Butlerian Inheritance of G. B. Shaw." *Dalhousie Review,* 41 (1961), 159–73.

Brome, Vincent. "G. K. Chesterton versus Bernard Shaw." *Six Studies in Quarrelling.* London: Cresset Pr., 1958, 137–69. (Touches on religious issues; includes excerpts from letters and speeches.)

Demaray, John G. "Bernard Shaw and C. E. M. Joad: The Adventures of Two Puritans in Their Search for God." *PMLA,* 78 (1963), 262–70.

DeVries, Ella Mae S. "Thomas Carlyle and Bernard Shaw as Critics of Religion and Society." Diss., Nebraska. *DAI,* 37 (1977), 4365A–66A.

Donaghy, Henry J. "Chesterton on Shaw's Views of Catholicism." *ShR,* 10 (1967), 108–16.

———. "A Comparison of the Thought of George Bernard Shaw and G. K. Chesterton." Diss., New York Univ. *DA,* 27 (1967), 3868A.

Duerksen, Roland A. "Shelley and Shaw." *Shelleyan Ideas in Victorian Literature.* The Hague: Mouton, 1966, 166–97; repr. from *PMLA,* 78 (1963), 114–27.

Fiske, Irving. *Bernard Shaw's Debt to William Blake, with Foreword and Notes by G.B.S.* London: Shaw Society, 1951. 19 pp. (Shavian Tract No. 2); repr. as "Bernard Shaw and William Blake" in R. J. Kaufmann, ed. *G. B. Shaw: A Collection of Critical Essays.* Englewood Cliffs, NJ: Prentice-Hall, 1965, 170–78.

Furlong, William B. *GBS/GKC: Shaw and Chesterton, the Metaphysical Jesters.* University Park: Pennsylvania State Univ. Pr., 1970. 206 pp.

Goodykoontz, William F. "John Bunyan's Influence on George Bernard Shaw." Diss., North Carolina, 1956.

Gordon, David J. "Two Anti-Puritan Puritans: Bernard Shaw and D. H. Lawrence." *Literary Art and the Unconscious.* Baton Rouge: Louisiana State Univ. Pr., 1977, 153–70; repr. from *Yale Review,* 56 (1966), 76–90.

*Kaye, Julian B. "Some Exponents of Nineteenth-Century Religion." *Bernard Shaw and the Nineteenth-Century Tradition.* Norman: Univ. of Oklahoma Pr., 1958, 49–70. (Shaw in relation to Comte, Mill, and Arnold. See also the two succeeding chapters.)

Levin, Gerald. "Shaw, Butler, and Kant." *Philological Quarterly,* 52 (1973), 142–56.

McMillan, Scott. "G.B.S. and Bunyan's Badman." *ShR,* 9 (1966), 90–101. (Reprints Shaw's annotations.)

*O'Donnell, Norbert F. "Shaw, Bunyan, and Puritanism." *PMLA,* 72 (1957), 520–33.

Peart, Barbara. "Shelley and Shaw's Prose." *ShR,* 15 (1972), 39–45. (Stresses Shelleyan ideas in the Preface to *Methuselah.*)

Rodenbeck, John von B. "Bernard Shaw's Revolt Against Rationalism." *Victorian Studies*, 15 (1972), 409–37.

Stokes, E. E. "Bernard Shaw's Debt to John Bunyan." *ShR*, 8 (1965), 42–51.

Tindall, William Y. *Forces in Modern British Literature, 1885–1956*. New York: Random House, 1956, 159–63 and passim. (Shaw as a religious "convert" of Butler.)

D. Shaw and Other Thinkers

Barzun, Jacques. "Shaw and Rousseau: No Paradox." *Shaw Bulletin*, No. 8 (1955), 1–6. (Develops his comparison in "G.B.S. in Twilight," *Kenyon Review*, 5 [1943], 321–45.)

Brashear, William R. "O'Neill and Shaw: The Play as Will and Idea." *The Gorgon's Head: A Study in Tragedy and Despair*. Athens: Univ. of Georgia Pr., 1977, 88–103; repr. from *Criticism*, 8 (1966), 155–69. (Part on the influence of Schopenhauer and Nietzsche.)

Bridgwater, Patrick. "Man and Superman (H. G. Wells and Bernard Shaw)." *Nietzsche in Anglosaxony*. Leicester: Leicester Univ. Pr., 1972, 56–66.

Deane, Barbara. "Shaw and Gnosticism." *ShR*, 16 (1973), 104–22.

Geduld, Harry M. "Bernard Shaw and Leo Tolstoy." *California Shavian*, 4, ii (1963), 1–9; 4, iii (1963), 1–4. (Their agreements and conflicts on religious and moral topics, using *Man and Superman* as a touchstone.)

Herrin, Virginia T. "Bernard Shaw and Richard Wagner: A Study of Their Intellectual Kinship as Artist Philosophers." Diss., North Carolina, 1955.

Krutch, Joseph W. "G.B.S. Enters Heaven (?)." *Saturday Review*, 35 (May 24, 1952), 19–21; repr. in Lauriat Lane, ed. *Approaches to Walden*. San Francisco: Wadsworth, 1961, 96–100. (A "dialogue of the dead" between Shaw and Thoreau contrasting their philosophical beliefs.)

Leary, Daniel J. "The Heralds of Convergence: Teilhard and Shaw." *Voices of Convergence*. Milwaukee: Bruce, 1969, 1–32; rev. of "The Evolutionary Dialectic of Shaw and Teilhard: A Perennial Philosophy." *ShR*, 9 (1966), 15–34.

Levine, Carl. "Social Criticism in Shaw and Nietzsche." *ShR*, 10 (1967), 9–17.

Radford, Frederick L. "The Idealistic Iconoclast: Aspects of Platonism in the Works of Bernard Shaw." Diss., Univ. of Washington. *DAI*, 32 (1971), 450A–51A.

Rankin, H. D. "Plato and Bernard Shaw: Their Ideal Communities." *Hermathena*, 93 (May 1959), 71–77.

Rix, Walter T. "Nietzsches Einfluss auf Shaw: Ein Beitrag zum Verständnis der Shawschen Geisteswelt." *Literatur in Wissenschaft und Unterricht*, 4 (1971), 124–39. ("Forschungsbericht.")

*Smith, Warren S. "Serendipity or Life Force? The Darwinians, Teilhard de Chardin and *Back to Methuselah*." *Teilhard Review*, 14, i (1979), 2–22. (Similarities and differences in the theories of evolution of the later Darwinians.)

Stockholder, Fred E. "G. B. Shaw's German Philosophy of History and the Significant Form of His Plays." Diss., Univ. of Washington. *DA*, 25 (1964), 1221. (Influences of the theories of Schopenhauer, Nietzsche, and Marx.)

*Thatcher, David S. "George Bernard Shaw." *Nietzsche in England, 1890–1914*. Toronto: Univ. of Toronto Pr., 1970, 175–217.

Wilson, Colin. "Bernard Shaw." *Religion and the Rebel*. Boston: Houghton Mifflin, 1957, 242–89; see also "Shaw's Existentialism." *Shavian*, 2, i (1960), 4–6. (Developing comments in *The Outsider*, Wilson discusses Shaw as the existentialist "Outsider," heir of Newman, Law, and Kierkegaard.)

IV. Commentaries, 1950–1979, on Shaw's Religious/Philosophical Drama

A. General and Miscellaneous

Barr, Alan P. "Bernard Shaw as a Religious Dramatist." Diss., Rochester. *DA*, 25 (1964), 1902–3.

Baskin, Ken A. "Shaw and Death: A Mythology for Creative Evolution." Diss., Maryland. *DAI*, 38 (1977), 798A. (Examines five plays as a "mythology for Creative Evolution: *Man and Superman, Major Barbara, Heartbreak House, Methuselah*, and *Saint Joan*.)

Bhakri, A. S. "Shaw's Dramas in Relation to His Social and Philosophical Ideas." Diss., Leeds, 1956.

Brown. G. E. "Shaw and Evolution" and "The Religious Plays." *George Bernard Shaw*. London: Evans, 1970, 43–65 (on *Man and Superman, Methuselah*, and *The Simpleton*), 66–92 (on *Major Barbara, Androcles*, and *Saint Joan*).

*Brustein, Robert. "Bernard Shaw." *The Theatre of Revolt: An Approach to Modern Drama*. London: Methuen, 1965, 183–227. (Stresses the effect of Shaw's "messianic philosophy" on his plays, esp. *Man and Superman* and *Methuselah*.)

Cannon, Betty Jo. "The Dialectic of Shavian Comedy: Shaw's Comic Art Viewed from the Perspective of His Aesthetic and Philosophical Ideas." Diss., Colorado. *DAI*, 38 (1977), 2771A. (Includes extended comparison of Shaw and Sartre.)

Clayton, Robert B. "The Salvation Myth in the Drama of Bernard Shaw." Diss., Berkeley, 1961.

Dickson, Ronald J. "The Diabolonian Character in Shaw's Plays." *Univ. of Kansas City Review*, 26 (1959–60), 145–51.

*Dukore, Bernard F. *Bernard Shaw, Playwright: Aspects of Shavian Drama*. Columbia: Univ. of Missouri Pr., 1973, esp. "The Absurd and the Existential," 216–61. (Considers many plays from *Man and Superman* to *Too True to be Good*.)

Ganz, Arthur. "The Ascent to Heaven: A Shavian Pattern (Early Plays, 1894–1898)." *Modern Drama*, 14 (1971), 253–63. (The ultimate goal of Creative Evolution as a withdrawal from life, evidenced in some early plays.)

Henderson, Archibald. "Dramas of Man's Ascent" and "The Artist-Philosopher at Work." *George Bernard Shaw* [I.B, 1956], 578–91 (on *Man and Superman, Major Barbara*, and *Blanco Posnet*), 592–604 (on *Androcles, Methuselah*, and *Saint Joan*). (Includes many Shaw statements and letters.)

Hummert, Paul A. "Bernard Shaw's Marxist Utopias." *ShR*, 2, ix (1959), 7–26. (Marxian Socialism as "the real companion of Creative Evolution," according to *Methuselah, The Simpleton*, and *Farfetched Fables*.)

Hutchinson, P. William. "A Comparative Study of the Professional Religionist as a Character in the Plays of George Bernard Shaw." Diss., Northwestern. *DA*, 29 (1969), 4129A.

Kane, Sara W. "The Life Force in Action: The Relationship Between Shaw's Theory of Creative Evolution and His Plays." Diss., Boston Univ. *DAI*, 38 (1978), 7325A–26A.

Knörrich, Otto. "G. B. Shaw: Mystiker der Ratio." *Neueren Sprachen*, 3 (1961), 110–20. (Stresses the "biologism" of *Methuselah* and *Saint Joan*.)

Lawrence, Kenneth. "Bernard Shaw: The Career of the Life Force." *Modern Drama*, 15 (1972), 130–46. (*Man and Superman, Methuselah*, and *The Simpleton* as thesis dramas.)

Lindblad, Ishrat. *Creative Evolution and Shaw's Dramatic Art, with Special Reference to Man and Superman and Back to Methuselah*. Uppsala: Uppsala Univ., 1971. 134 pp. Diss.

Nelson, Raymond S. "Religion and the Plays of Bernard Shaw." Diss., Nebraska. *DA*, 29 (1968), 574A.

Rama Rao, Sarvepalli. "The Religious and Philosophical Plays." *The Values of Shavian Drama and Their Validity.* Tirupati: Sri Venkateswara Univ., 1967?, 146–57. Diss.

Sauvageau, David R. "Shaw, Brecht, and Evolution: The Early Plays." Diss., Minnesota. *DAI*, 38 (1977), 1383A.

Schwanitz, Dietrich. "Utopisches Drama und Restbestände des Absurden." *George Bernard Shaw: Künstlerische Konstruktion und unordentliche Welt.* Frankfurt am Main: Thesen Verlag, 1971, 56–66. Diss. (Treats *Methuselah, The Simpleton, Farfetched Fables,* and "Absurde Einakter.")

Stone, Susan C. "Myth and Legend in the Drama of Bernard Shaw." Diss., Colorado. *DAI*, 31 (1971), 4796A.

Stoppel, Hans. "Shaw and Sainthood." *English Studies*, 36 (1955), 49–63; repr. in Weintraub, ed. *Saint Joan Fifty Years After* [IV.H], 166–84. (Shaw's "ideal human figure" from 1910 to 1930 is "the prophetic and fighting Saint.")

Stresau, Hermann. "Der Prediger Bernard Shaw: Vom religiösen Traktat in dramatischer Form." *Deutsche Universitätszeitung* (Göttingen), 7, xvi–xvii (1952), 10–15.

Talley, Jerry B. "Religious Themes in the Dramatic Works of George Bernard Shaw, T. S. Eliot, and Paul Claudel." Diss., Denver. *DA*, 25 (1964), 3750.

*Weales, Gerald. *Religion in Modern English Drama.* Philadelphia: Univ. of Pennsylvania Pr., 1961, 54–79.

Weimer, Michael J. "Shaw's Conversion Plays, 1897–1909." Diss., Yale. *DAI*, 34 (1974), 7253A. (Relates conversions to Creative Evolution.)

Whalen, Jerome P. "Some Structural Similarities in John Bunyan's *The Pilgrim's Progress* and Selected Narrative and Dramatic Works of George Bernard Shaw." Diss., Pittsburgh. *DA*, 29 (1969), 3986A. (Compares *The Adventures of the Black Girl* and eight plays.)

*Whitman, Robert F. *Shaw and the Play of Ideas.* Ithaca, NY: Cornell Univ. Pr., 1977. 293 pp. (Pp. 191–288 relate Shaw's "gospel" to his plays, stressing *Man and Superman, Major Barbara, Blanco Posnet, Androcles, Methuselah, Saint Joan,* and *The Simpleton.*)

B. *Passion Play (Household of Joseph)*

Bringle, Jerald E. "Introduction." In Shaw. *Passion Play* [I.C, 1878], 9pp.

Lindblad, Ishrat. "*Household of Joseph:* An Early Perspective on Shaw's Dramaturgy." *ShR*, 17 (1974), 124–38.

C. *Man and Superman*

Barnett, Gene A. "Don Juan's Hell." *Ball State Univ. Forum*, 11 (Spring 1970), 47–52.

*Berst, Charles A. "*Man and Superman:* The Art of Spiritual Autobiography." *Bernard Shaw and the Art of Drama.* Urbana: Univ. of Illinois Pr., 1973, 96–153.

Gibbs, A. M. "Comedy and Philosophy in *Man and Superman.*" *Modern Drama*, 19 (1976), 161–75. (Interrelations of theme and structure.)

McDowell, Frederick P. W. "Heaven, Hell, and Turn-of-the-Century London: Reflections upon Shaw's *Man and Superman.*" *Drama Survey*, 2 (1963), 245–68. (Stresses its philosophical content.)

Mills, Carl H. "The Intellectual and Literary Background of George Bernard Shaw's *Man and Superman.*" Diss., Nebraska. *DA*, 26 (1965), 2727–28.

Nelson, Raymond S. "Shaw's Heaven, Hell, and Redemption." *Costerus*, 6 (1972), 99–108; see also his "Shaw's Heaven and Hell." *Contemporary Review*, 226 (1975), 132–36.

Potter, Robert. "Some Responses to *Everyman:* Shaw, Yeats, and von Hofmannsthal." *The English Morality Play*. London: Routledge & K. Paul, 1975, 225–31 (226–28 on *Man and Superman*).

*Valency, Maurice. *The Cart and the Trumpet: The Plays of George Bernard Shaw*. New York: Oxford Univ. Pr., 1973, 200–236.

*Wisenthal, J. L. *The Marriage of Contraries: Bernard Shaw's Middle Plays*. Cambridge: Harvard Univ. Pr., 1974, 22–56.

See also II, 1912: Kennedy; 1925: Braybrooke. IV.A: Baskin; Brown; Brustein; Lawrence; Lindblad; Whitman.

D. *Major Barbara*

Baker, Stuart E. "Logic and Religion in *Major Barbara:* The Syllogism of St. Andrew Undershaft." *Modern Drama*, 21 (1978), 241–52.

*Frank, Joseph. "*Major Barbara:* Shaw's 'Divine Comedy.' " *PMLA*, 71 (1956), 61–74; repr. in Rose A. Zimbardo, ed. *Twentieth Century Interpretations of Major Barbara*. Englewood Cliffs, NJ: Prentice-Hall, 1970, 28–41; see also Stanley Weintraub. " 'Shaw's Divine Comedy': Addendum." *Shaw Bulletin*, 2, v (1958), 21–22.

Hoeveler, Diane L. "Shaw's Vision of God in *Major Barbara*." *Independent Shavian*, 17, i–ii (1978–79), 16–18.

Jewkes, W. T. "The Faust Theme in *Major Barbara*." *ShR*, 21 (1978), 80–91.

Leary, Daniel J. "Dialectical Action in *Major Barbara*." *ShR*, 12 (1969), 46–58. (The play's action is "a comprehensive effort to discover a viable morality.")

Morgan, Margery M. "Shaw, Yeats, Nietzsche, and the Religion of Art." *Komos*, 1 (1967), 24–34. (Compares *Major Barbara* with Yeats's *The Resurrection* via Nietzsche's *Birth of Tragedy*.)

Morsberger, Robert E. "The Winning of Barbara Undershaft: Conversion by the Cannon Factory, or 'Wot Prawce Selvytion Nah?' " *Costerus*, 9 (1973), 71–77.

*Watson, Barbara B. "Sainthood for Millionaires: *Major Barbara*." *Modern Drama*, 11 (1968), 227–44; repr. in Warren S. Smith, ed. *Bernard Shaw's Plays*. New York: Norton, 1970, 358–75.

See also II, 1930: Braybrooke. IV.A: Baskin; Brown; Whitman.

E. *The Shewing-up of Blanco Posnet*

Laurence, Dan H., ed. "The *Blanco Posnet* Controversy." *Shaw Bulletin*, No. 7 (1955), 1–9. (Reprints, with comments, elusive statements by Shaw, Yeats, and Joyce on the censorship of the play.)

Nelson, Raymond S. "Blanco Posnet—Adversary of God." *Modern Drama*, 13 (1970), 1–9.

See also II, 1912: Kennedy. IV.A: Whitman.

F. *Androcles and the Lion*

*Berst, Charles A. "*Androcles and the Lion:* Christianity in Parable." *Bernard Shaw and the Art of Drama* [see IV.C], 175–95.

Meisel, Martin. "Christian Melodrama and Christmas Pantomime." *Shaw and the Nineteenth-Century Theater*. Princeton: Princeton Univ. Pr., 1963, 324–48.

*Nelson, Raymond S. "Wisdom and Power in *Androcles and the Lion*." *Yearbook of English Studies*, 2 (1972), 192–204.

Stone-Blackburn, Susan. "Unity in Diversity: *Androcles and the Lion*." *ShR*, 21 (1978), 92–99.

Ward, A. C. "Introduction to *Androcles and the Lion*," "Notes on the Preface . . . ," and "Notes on *Androcles and the Lion*." In Shaw. *Androcles and the Lion*. Ed. A. C. Ward. London: Longmans, Green, 1957, 161–208.

See also II, 1925: Braybrooke; 1947: Eastman. IV.A: Brown; Whitman.

G. *Back to Methuselah*

Bailey, J. O. "Shaw's Life Force and Science Fiction." *ShR*, 16 (1973), 48–58. (Stresses the play.)

Cole, Susan A. "The Evolutionary Fantasy: Shaw and Utopian Fiction." *ShR*, 16 (1973), 89–97.

Crawford, Fred D. "Shaw Among the Houyhnhnms." *ShR*, 19 (1976), 102–19. (On parts IV and V.)

Denninghaus, Friedhelm. "Der utopische Kern der sozialen deterministischen Dramas." *Die dramatische Konzeption George Bernard Shaws*. Stuttgart: Kohlhammer, 1971, 166–74.

Geduld, Harry M. "An Edition of Bernard Shaw's *Back to Methuselah*—Preface, Play and Postscript; Being Introduction, Notes and Full Textual Apparatus, with a Survey of the Stage-History of the Play, a Study of the Philosophical, Dramatic and Topical Aspects and a Consideration of the Place of *Back to Methuselah* in Relation to Shaw's Thought and Dramatic Work as a Whole." Diss., Birkbeck College, London Univ., 1962.

———. "The Lineage of Lilith." *ShR*, 7 (1964), 58–61.

———. "Place and Treatment of Persons in *Back to Methuselah*." *California Shavian*, 5, vi (1964), 1–12.

———. "Sources and Influences of Shaw's Pentateuch." *California Shavian*, 5, iii (1964), 1–10. (The play and the Utopian tradition.)

Hummert, Paul A. "Creative Evolution." *Bernard Shaw's Marxian Romance*. Lincoln: Univ. of Nebraska Pr., 1973, 131–47.

Knepper, Bill G. "*Back to Methuselah* and the Utopian Tradition." Diss., Nebraska. *DA*, 28 (1967), 681A.

*Leary, Daniel J., and Richard Foster. "Adam and Eve: Evolving Archetypes in *Back to Methuselah*." *ShR*, 4, ii (1961), 12–23, 25.

———. "The Ends of Childhood: Eschatology in Shaw and [Arthur C.] Clarke." *ShR*, 16 (1973), 67–78. (Parallels between *Methuselah* and *Childhood's End*.)

*Nelson, Raymond S. "*Back to Methuselah*: Shaw's Modern Bible." *Costerus*, 5 (1972), 117–23.

Reitemeier, Rüdiger. "Sündenfall und Übermensch in G. B. Shaws *Back to Methuselah*." *Germanisch-Romanische Monatsschrift*, 16 (1966), 65–76.

Rostand, Jean. "Étude sur G.-B. Shaw et sa métabiologie." In Shaw. *Retour à Mathusalem: Pentateuque Métabiologique*. Tr. Augustin and Henriette Hamon. Paris: Aubier, 1959, 7–15.

Smith, Warren S. "Future Shock and Discouragement: *The Tragedy of an Elderly Gentleman*." *ShR*, 18 (1975), 22–27.

Stone, Susan C. "Biblical Myth Shavianized." *Modern Drama*, 18 (1975), 153–63. (On *Methuselah* and *The Simpleton*.)

Valency, Maurice. *The Cart and the Trumpet* [see IV.C], 349–68.

Weightman, John. "Worshipping the Life Force, Disliking Life." *Encounter*, 33 (Oct. 1969), 31–33.
*Wisenthal, J. L. *The Marriage of Contraries* [IV.C], 193–217.
See also II, 1945: Hamilton. III.A: Geduld. IV.A: Baskin; Brown; Brustein; Hummert; Knörrich; Lawrence; Lindblad; Schwanitz; Whitman.

H. *Saint Joan*

*Berst, Charles A. "*Saint Joan:* Spiritual Epic as Tragicomedy." *Bernard Shaw and the Art of Drama* [see IV.C], 259–92.
Martz, Louis L. "The Saint as Tragic Hero: *Saint Joan* and *Murder in the Cathedral.*" In Cleanth Brooks, ed. *Tragic Themes in Western Literature.* New Haven: Yale Univ. Pr., 1955, 150–78; repr. in Weintraub, ed. *Saint Joan Fifty Years After* [see below], 144–65.
Rohmann, Gerd. "Shaws metabiologisches Testament in *Saint Joan.*" In Kurt Otten and Rohmann, eds. *George Bernard Shaw* [see III.A: Schwanitz], 494–507.
Rudman, Harry W. "Shaw's *Saint Joan* and Motion Picture Censorship." *Shaw Bulletin*, 2, vi (1958), 1–14.
Searle, William. "Bernard Shaw and the Maid: A Vitalist View." *The Saint & the Skeptics: Joan of Arc in the Work of Mark Twain, Anatole France, and Bernard Shaw.* Detroit: Wayne State Univ. Pr., 1976, 97–138.
Ward. A. C. "Introduction to *Saint Joan,*" "Notes on the Preface to *Saint Joan,*" and "Notes on *Saint Joan.*" In Shaw. *Saint Joan.* Ed. Ward. London: Longmans, Green, 1957, 175–208.
*Weintraub, Stanley, ed. *Saint Joan Fifty Years After, 1923/24–1973/74.* Baton Rouge: Louisiana State Univ. Pr., 1973. 259 pp. (Reprints two Shaw pieces on the play and 23 other essays or excerpts.)
Wisenthal, J. L. *The Marriage of Contraries* [see IV.C], 172–92.
See also II, 1925: Jung; Lichtenstein; Robertson; 1947: Eastman. III.A: Dietrich. IV.A: Baskin; Brown; Knörrich; Stoppel; Whitman.

I. *The Simpleton of the Unexpected Isles*

Dukore, Bernard F. "Shaw's Doomsday." *Educational Theatre Journal*, 19 (1967), 61–71.
Leary, Daniel J. "About Nothing in Shaw's *The Simpleton of the Unexpected Isles.*" *Educational Theatre Journal*, 24 (1972), 139–48. (The play anticipates absurd drama.)
McDowell, Frederick P. W. "Spiritual and Political Reality: Shaw's *The Simpleton of the Unexpected Isles.*" *Modern Drama*, 3 (1960), 196–210.
*Nelson, Raymond S. "*The Simpleton of the Unexpected Isles:* Shaw's 'Last Judgment.' " *Queen's Quarterly*, 76 (1969), 692–706.
Stone, Susan C. "Biblical Myth Shavianized." *Modern Drama*, 18 (1975), 153–63. (On *Methuselah* and *The Simpleton.*)
See also IV.A: Brown; Hummert; Lawrence; Schwanitz; Whitman.

J. Other Plays

Nelson, Raymond S. "Shaw and Buchanan." *English Literature in Transition, 1880–1920*, 12, ii (1969), 99–103. (Compares Robert Buchanan's "Prince of Pity," the Devil, with Dick Dudgeon.)

————. "Shaw's Keegan." *ShR*, 13 (1970), 91–95. (His Eastern mysticism and its roots in Edward Carpenter.)

Roll-Hansen, Diderik. "Sartorius and the Scribes of the Bible: Satiric Method in *Widowers' Houses*." *ShR*, 18 (1975), 6–9. (Biblical references in the play.)

Stockholder, Fred E. "A Schopenhauerian Reading of *Heartbreak House*." *ShR*, 19 (1976), 22–43.

Whitman, Robert F. "The Passion of Dick Dudgeon." *ShR*, 21 (1978), 60–71.

REVIEWS AND CHECKLIST

REVIEWS

Shaw's Women

Margot Peters, *Shaw and the Actresses*. New York: Doubleday, 1980. 461 pp. $17.50.

It is extraordinary how persistent is the legend of Bernard Shaw the bloodless, asexual vegetarian. University students seem to absorb it with their mother's milk. Yet, compared with a literary figure as apparently virile and robust as Charles Dickens, the real, unlegendary Shaw seems almost a libertine. Even if, as he himself reported, he was sexually continent up to the age of twenty-nine, "except for the involuntary incontinences of dreamland," his subsequent amorous history from his seduction by Jenny Patterson to his marriage to Charlotte Payne-Townshend (and perhaps beyond) was sufficiently crowded with incident to absolve him from any charges of bloodlessness. Hesketh Pearson reports him as saying, "I liked sexual intercourse because of its amazing power of producing a celestial flood of emotion which, however momentary, gave me a sample of what may one day be the normal state of being for mankind in intellectual ecstasy." On the other hand, he apparently told G. K. Chesterton that he thought of the sexual act as monstrous and indecent and could not understand how any self-respecting man and woman could face each other in the daylight after spending the night together. The attraction and revulsion expressed in these statements may seem like typically Shavian self-contradiction, but perhaps they are simply an articulation of a very common human experience. Not perverse Shaw, but the perverse human condition.

Margot Peters' book *Shaw and the Actresses* might better have been called "Shaw and the Women," since in writing it she seems to have been concerned mostly with explicating his relations with the various women in his life. Much space is devoted to Jenny Patterson, Annie Besant, Bertha Newcombe, Mrs. Hubert Bland (E. Nesbit), Charlotte Shaw (none of them actresses) and Molly Tompkins (only briefly and unsuccessfully an actress), and there is mention also of such other non-actresses as Alice Lockett, May Morris and Erica Cotterill. In her

introduction, Professor Peters states that these figures are included in order to explore "the wider question of Shaw's attitude to women," and that ultimately she has been concerned with "the impact of women in general, the actress specifically, on Shaw's art." In this respect, the book is simultaneously illuminating and disappointing.

Professor Peters has considerable narrative gifts and no one before has, I think, so painstakingly and clearly put together the details of Shaw's involvement with Janet Achurch, Ellen Terry, Mrs. Patrick Campbell, Florence Farr, Elizabeth Robins, Lillah McCarthy and Lena Ashwell. Some of the ground has, of course, been raked over before; some of it still remains obscure. What, for instance, happened to Janet Achurch's second pregnancy? Just how intimate was Achurch with Shaw? What, too, went on between Shaw and Molly Tompkins "on the Bavento road"? All in all, however, it would be hard to imagine a more complete account of the actual incidents of Shaw's life as it touched upon the lives of these extraordinary and talented women. Professor Peters' scholarship is sound and unobtrusive, and her style, except for such occasional infelicities as the misuse of "hopefully," is easy and readable. What is disappointing, however, is the analysis of, "the impact" of these women "on Shaw's art." The essential point that Professor Peters makes about Shaw, himself, seems valid enough. It is that, unconsciously, Shaw was only comfortable in a relationship where he played the chaste Oedipus to an unviolated Jocasta. In other kinds of attachment, he fluctuated between fevered fascination and cold revulsion. When it comes to applying these insights to Shaw's depiction of women on the stage, Professor Peters is parsimonious with her examples. Candida, Julia Craven, Vivie Warren, Ann Whitefield and Lady Cicely Wayneflete are the characters most often referred to, but one is left wishing in each case for a greater depth of analysis, both in terms of what influence particular actresses, or particular women for that matter, had on their creation, and in terms of how they reflect Shaw's general perception of women. Some consciousness of this lack, at least in part, may account for the strangely telegraphic paragraphs on pages 404 and 405, in which the inspiration for various characters is hastily laid out.

Another area which might have been explored further, at the expense of some of the more trivial details of Shaw's bicycle accidents or shopping expeditions to Jaeger's, is the performance styles of the actresses in question and their interpretation of particular Shavian roles. Where Professor Peters does deal with these matters, she often does so chiefly by paraphrasing Shaw's own letters to the actresses, and the counterbalancing of these views, sometimes deliberately overstated, by other contemporary appraisals is not altogether adequate.

There are also in the book a number of small but troubling errors. These begin on the dust jacket, where Jenny Patterson is referred to as Jenny Carpenter. Others follow inside. Jenny Patterson's letter to Shaw, dated October 18, 1887, is misquoted on page 44. The list of founding members of the Independent Theatre on page 75 suggests that Henry Arthur Jones and Arthur Wing Pinero were somehow importantly associated with that enterprise and omits Frank Harris, who was on the Independent Theatre's original committee. Lack of punctuation makes nonsense of a sentence on page 259 about Irving's production of *Robespierre*. Careless paraphrasing of a letter on page 265 makes it sound as if Shaw made £750 do the work of £950 and more.

It would be unfair, however, to leave the impression that the several inadequacies outweigh the book's real qualities. The expectations raised by the title may not be met in a completely satisfying way, but what Professor Peters does offer is an unusually thorough, informative and even moving account of the difficulties surrounding the process of having any kind of relationship with a genius whose primary concern is the fulfillment of his life's purpose.

Tony Stephenson[1]

1. Tony Stephenson is a professor of theatre at York University, Toronto. His special interest is the theatre world of Shaw's early dramatic years.

Money and Politics

Bernard F. Dukore, *Money and Politics in Ibsen, Shaw and Brecht.* Columbia: University of Missouri Press, 1980. 151 pp. $15.95.

The title of this intelligent book, *Money and Politics,* is not so much misleading as it is somehow inadequate. Money and politics are discussed at length—especially money—but far more broadly and deeply this study of Ibsen, Shaw, and Brecht deals with such formidable matters as the roots of revolution, the crumbling of the Western world, and "The World as Brothel" according to *Mrs. Warren.* An appropriate title would also have been "The Theatre of Revolt," if Robert Brustein had not already used it; or to paraphrase Mr. Shaw, "An Intelligent Person's Guide to the Decline of Capitalism."

Money, nevertheless, is the thread holding together most chapters, even though the texture is not too tightly woven. What is bedrock in these chapters is a concern with exploitation and power, estrangement and self-fulfillment, slavery and freedom. Politics appears here and

there, mostly in later chapters, and is generally set on the larger stage of political action and class conflict. Professor Dukore's analysis, however, appears non-Marxist; such human values as independence, self-realization, and freedom underlie the economic structure, which while essential to these playwrights, seems secondary to the values just mentioned. Brecht may be an exception and certainly Marxists would argue that this approach is upside down. Yet in Dukore's opinion Ibsen regards self-fulfillment as primary for Nora, as does Shaw see independence the quest for Liza Doolittle. Money may or may not lead to each; in any case it cannot guarantee either one.

Money and Politics is really about the radicalism of these three seminal playwrights. While Brecht is the obvious Marxist, Shaw the more gentle Fabian, and Ibsen the agonizing anarchist, each is equally radical and in his own way revolutionary. Ibsen's attack on moribund institutions in *A Doll's House* and *Ghosts* is as undermining as Brecht's pronouncements in *Mother Courage* and *The Good Woman of Szechwan*. Indeed, Shaw is an evolutionary socialist but Dukore is correct to take seriously Lenin's comment: "Shaw is a good man fallen among Fabians"; and Lenin further, "he may be a clown for the bourgeoise in a bourgeois state, but they would not think him a clown in a revolution"; or Emma Goldman seeing *Major Barbara* as "one of the most revolutionary plays . . . in any other dramatic form the sentiments uttered therein would have condemned the author to long imprisonment for inciting sedition and violence."

Bernard Dukore teaches drama and theatre at the University of Hawaii in Honolulu and among his recent works are *Bernard Shaw, Playwright* and *Where Laughter Stops: Pinter's Tragicomedy*. He clearly knows his authors and the analysis of eighteen plays in *Money and Politics* is uniformly excellent. His format, however, is neat and orderly to the point of monotony. It is academic throughout and better suited to the lecture hall than to the general but informed reader. Trinitarian forms seem to obsess Prof. Dukore. The book contains six principal chapters with the theme of each illustrated by three plays, one from each author. Every chapter opens with a short paragraph in which the three plays are introduced, then the three works themselves are analysed in turn (pretty much in narrative form), and finally the three are again summarized in a conclusion. By chapter six the reader is somewhat dismayed that this marvelous symmetry has not been broken. Readability is sustained, nevertheless, by a small number of quotations and a very few footnotes.

There are many insights throughout these chapters, and none is better than "Scrap it—Money and Morality in *An Enemy of the People, Major Barbara,* and *St. Joan of the Stockyards.*" When the fiery capitalist,

Andrew Undershaft, in *Major Barbara* tells his daughter Barbara that because her "morality or . . . religion . . . or what not, doesn't fit the facts," she should "scrap it and get one that does," he is really laying the groundwork for Shaw's radical position—that is to say, scrap the entire economic system of capitalism because it doesn't fit the facts and replace it with the new system of socialism which does meet the twentieth-century demands for more jobs, higher wages and better working conditions.

More on *Barbara* in a moment, but first to preserve the order of the argument: Ibsen's *An Enemy of the People* was written twenty-five years before Shaw's play and asserts an earlier position on money and morality. The confrontation in *Enemy* between Mayor Peter Stockmann and his brother Dr. Thomas Stockmann is one of money against morality, where material and business interests (the Mayor) are pitted against truth, conscience and the nobility of spirit (the Doctor). While wealth rules the many, the good doctor holds to his minority position, morality, the two sides remaining irreconcilable. Dr. Stockmann's (and Ibsen's) individualism is total in the classic sense but does not lead to a revolutionary position in the modern sense. This is not the case with Shaw and Brecht. Ibsen in fact was contemptuous of political platforms and social programs.

The seeds of revolution can be found in Shaw, Fabian though he remained. In the dialectic offered by Dukore, Shaw's position repudiates the money/morality gap left by Ibsen and mediates the revolutionary social change called for in Brecht. Undershaft in *Major Barbara* accomplishes the fusion of money and morality and lifts both the discussion and the historical moment to a higher level, thus paving the way for the Marxist solution. This millionaire munitions maker *and* mystic—foreshadowing Captain Shotover in *Heartbreak House*—views salvation as comprising both "money and gunpowder." And for Shaw who sees jobs as the necessary first step in social progress, even the capitalist munitions factory which does provide these necessities is a step in the *right* direction. Barbara turns her back on the old-time religion and finally embraces capitalism as such a first step; by so doing the debris of individualism and moralism is cleared away and the next phase, socialism, is ushered in. As Dukore writes, Barbara along with her Greek professor, Adolphus Cusins, "hopes to build upon Undershaft's social advance, to turn the capitalism of Perivale St. Andrews—and by extension England—into a socialist democracy."

While it is true that Brecht in *St. Joan of the Stockyards* divorces money from morality, the two will eventually be joined by the moral power of the Communist party when the revolution succeeds (which in fact it does not in this play). The outcome of this fusion will be social justice,

that is to say, the sharing of wealth, the end of exploitation, and the fulfillment of human needs through meaningful labor. Toward the conclusion of this *St. Joan*, Joan moves from one level of morality to another in her recognition that nonviolence, her earlier position, no longer works; in the new historical situation violence becomes essentially moral. Joan comes to realize that she "failed to help those who needed help," and she can help them now only through a morality of violence.

This short summary of one chapter hardly does justice to Prof. Dukore's detailed and skillful analysis. Still it may give some indication of how the theme of money and morality leads into other complex issues of the twentieth century.

I have barely mentioned politics which, per se, seem to play a lesser role in this study than money, even though political issues and themes are mighty concerns to the playwrights and their characters. Aristocracy, democracy, socialism, and communism are all hashed over, but not often politicians or politics as we know them—except with Bernard Shaw and most appropriately in his late play, *On the Rocks*. Here while complaining that most people today do not have both a voice and a choice, Shaw raises *his* voice: "Give them a choice between qualified men . . . not windbags and movie stars and soldiers and rich swankers and lawyers on the make."

Calvin G. Rand[1]

1. Dr. Rand, a founder of the Shaw Festival in Niagara-on-the-Lake, Canada, is President of the American Academy in Rome.

John R. Pfeiffer[1]

A CONTINUING CHECKLIST OF SHAVIANA

I. Works by Shaw

Shaw, Bernard. *Arms and the Man*, in *Bernard Shaw, Early Texts: Play Manuscripts in Facsimile* series. Introduction by Norma Jenckes. New York: Garland; for issue in 1981. Reviewed in next volume.

———. *Caesar and Cleopatra*. See *The Man of Destiny* below.

———. *Candida* and *How He Lied to Her Husband*, in *Bernard Shaw, Early Texts: Play Manuscripts in Facsimile* series. Introduction by J. Percy Smith. New York: Garland; for issue in 1981. Reviewed in next volume.

———. *Captain Brassbound's Conversion*, in *Bernard Shaw, Early Texts: Play Manuscripts in Facsimile* series. Introduction by Rodelle Weintraub. New York: Garland; for issue in 1981. Reviewed in next volume.

———. *The Collected Screenplays of Bernard Shaw*. Edited with an introduction by Bernard Dukore. Athens: University of Georgia Press, 1980. Reviewed in next volume.

———. *The Devil's Disciple*, in *Bernard Shaw, Early Texts: Play Manuscripts in Facsimile* series. Introduction by Robert F. Whitman. New York: Garland; for issue in 1981. Reviewed in next volume.

———. *The Doctor's Dilemma*, in *Bernard Shaw, Early Texts: Play Manuscripts in Facsimile* series. Introduction by Margery M. Morgan. New York: Garland; for issue in 1981. Reviewed in next volume.

———. Excerpts and photocopy samples of letters and postcards to Molly Tompkins, in *Fine Books & Autograph Letters*, auction sale catalogue of Southeby Parke Bernet Inc.; sale date: October 1, 1980. Advertises a collection of "about 48 autograph letters signed, 25 typed letters signed (many with long autograph additions) and 47 autograph postcards signed, c. 170 pages, Adelphi Terrace, Whitehall Court, Ayot St. Lawrence, and elsewhere, 27 December 1921 to 26 March 1949. Includes photocopy of September 1945 autographed photo of GBS, and a May 1, 1932, autograph letter quipping about dogs, parrots and a play by Lawrence. The collection, "with a few unimportant exceptions" was issued as *To a Young Actress*, edited by Peter Tompkins, New York, 1960.

1. Professor Pfeiffer, *SHAW* Bibliographer, welcomes information about new or forthcoming Shaviana: books, articles, pamphlets, monographs, dissertations, reprints, etc. His address is Department of English, Central Michigan University, Mount Pleasant, Michigan 48859.

———. Excerpts from a February 2, 1905, letter to Mr. John Hodge, in sale catalogue #1030 of Francis Edwards Limited, London, 1980. Four pages mostly on political topics, from Adelphi Terrace.

———. *Heartbreak House*, in *Bernard Shaw, Early Texts: Play Manuscripts in Facsimile* series. Introduction by Stanley Weintraub and Anne Wright. New York: Garland; for issue in 1981. Reviewed in next volume.

———. *How He Lied to Her Husband*. See *Candida* above.

———. *Major Barbara*, in *Bernard Shaw, Early Texts: Play Manuscripts in Facsimile* series. Introduction by Bernard F. Dukore. New York: Garland; for issue in 1981. Reviewed in next volume.

———. *The Man of Destiny* and *Caesar and Cleopatra*, in *Bernard Shaw, Early Texts: Play Manuscripts in Facsimile* series. Introduction by J. L. Wisenthal. New York: Garland; for issue in 1981. Reviewed in next volume.

———. *Mrs Warren's Profession*, in *Bernard Shaw, Early Texts: Play Manuscripts in Facsimile* series. Introduction by Margot Peters. New York: Garland; for issue in 1981. Reviewed in next volume.

———. *The Philanderer*, in *Bernard Shaw, Early Texts: Play Manuscripts in Facsimile* series. Introduction by Julius Novick. New York: Garland; for issue in 1981. Reviewed in next volume.

———. *Widowers' Houses*, in *Bernard Shaw, Early Texts: Play Manuscripts in Facsimile* series. Introduction by Jerald E. Bringle. New York: Garland; for issue in 1981. Reviewed in next volume.

———. *You Never Can Tell*, in *Bernard Shaw, Early Texts: Play Manuscripts in Facsimile* series. Introduction by Daniel J. Leary. New York: Garland; for issue in 1981. Reviewed in next volume.

II. Books and Pamphlets

Burns, Morris U. *The Dramatic Criticism of Alexander Woollcott*. Metuchen, New Jersey: Scarecrow Press, 1980. A widely read drama critic from 1914 to 1943, Woollcott reviewed at least nineteen of GBS's plays—some of them several times. Notes and appendices list all of the reviews. In a three-page analysis, "George Bernard Shaw," Burns notes Woollcott's admiration for Shaw's wit and ability to "invigorate his audiences intellectually." He criticized Shaw for prolixity, poor play construction, mixing of moods, and lack of universality. Shaw's best play was *Candida*. He felt GBS in the early twenties was one of the three best contemporary playwrights—with Barrie and O'Neill.

Dukore, Bernard F. *Money & Politics in Ibsen, Shaw and Brecht*. Columbia and London: University of Missouri Press, 1980. Reviewed in this volume.

Fisher, Lois H. *A Literary Gazetteer of England*. New York: McGraw Hill, 1980. The index lists two dozen places associated with Shaw, including his country home at Ayot St. Lawrence, Hertfordshire, where he did *not* write *Saint Joan*, though the entry says so. The entry for Buckfastleigh, Devon, tells of GBS's visit to the Benedictine monastery there and his tour of the abbey with a scholarly Belgian monk. "The two men debated the merits of the Authorized and Douai Versions of the Bible, with the monk arguing that the Authorized was by far the better. So deeply impressed was Shaw that when he departed, he stuffed the building fund box with treasury notes."

Fussell, Paul. *Abroad. British Traveling Between the Wars*. Oxford, 1980. Several references to Shaw but gives him surprisingly little attention, given GBS's globe-trotting (liter-

ally) between the wars, and the impact of it on his plays (*Too True, Simpleton, Buoyant Billions*, for example).

Gielgud, John, with Miller, John and Powell, John. *Gielgud, an Actor and His Time*. New York: Clarkson N. Potter, Inc., 1980. Issued in U.K. as *An Actor and His Time*, 1979. There are a number of spot references to GBS and a three-page account of his knowledge and opinion of Shaw, including a missed chance to play Caesar in the film version, his parts in *Saint Joan, Doctor's Dilemma, Androcles, Dark Lady*, and (as Shotover) *Heartbreak*, his preference to read or see the plays produced rather than to act in them, his missed opportunities to meet GBS more than the single time he did so, and his admiration for Shaw's personal character as well has his sympathy with Shaw's difficulty in the Mrs. Patrick Campbell affair.

Gribben, Alan. *Mark Twain's Library. A Reconstruction*. Two volumes. Boston: G. K. Hall, 1980. Shaw is indexed in Volume II. Items are *John Bull's Other Island*, Constable & Co., 1907 (inferred from Isabel Lyon's enthusiasm over the work), and "Plays" written in Clara Clemens' mostly undated commonplace book. (Probably *Plays, Pleasant and Unpleasant*.)

Ingle, Stephen. *Socialist Thought in Imaginative Literature*. Totowa, New Jersey: Rowman Littlefield, 1979. Numerous substantial references to Shaw, including the following pieces: *Methuselah, Caesar, Candida, Everybody's Political What's What, Heartbreak, John Bull, Major Barbara, Superman, Mrs Warren, On the Rocks, Apple Cart, Dilemma*, and *Widowers' Houses*. An energetic assembly of the Shaw/socialism connection, Ingle's discussion cautions that while GBS was generally an advocate, he was not a fundamentalist. He did not want rule by the masses, and did not believe that the wisdom for a good socialism would arise from the populations bred in capitalism.

Johnston, Brian. *To the Third Empire. Ibsen's Early Drama*. Minneapolis-St. Paul: University of Minnesota Press, 1980. Analysis in depth of the plays which preceded the better-known social dramas. Makes some sweeping judgments involving Shaw along the way. *Love's Comedy* needs only directorial "brio" to be "as dramatically delightful as *Getting Married*." Also, Shaw was to repeat Ibsen's concept of hell as fashionable society (in *The Pretenders*) in *Man and Superman*, "but Ibsen's expression of this idea is ever more forceful."

Oehlschlaeger, Fritz and Hendrick, George, eds. *Toward the Making of Thoreau's Modern Reputation. Selected Correspondence of S. A. Jones, A. W. Hosmer, H. S. Salt, H. G. O. Blake, and D. Ricketson*. Chicago: University of Illinois Press, 1979. From a June 9, 1892, Henry Salt letter to S. A. Jones: "Bernard Shaw, whose name you may possibly have heard in connection with the Fabian Society, has also been here. He published a book on Ibsen ("The Quintessence of Ibsenism") a few months ago, which I believe was reprinted in America. He & [Edward] Carpenter are as unlike as possible in temperament, & yet they seem to be arriving at the same conclusions by different routes. . . ."

Rogers, Will. *Will Rogers' Daily Telegrams*. Volume III. The Hoover Years: 1931–1933. Edited by James M. Smallwood. Stillwater, Oklahoma: Oklahoma State University Press, 1979. This third volume of a four-volume collection of the "Telegrams" published as Rogers' newspaper column from 1926 to 1935, seems typical of his treatment of GBS. Here Shaw is mentioned six times, most often in connection with Lady Astor and the trip to Russia. Twice Rogers puts Shaw's name in the column title: "Will Rogers Sees Influence of a Woman on Bernard Shaw" (October 23, 1931); "Mr. Rogers Has a Plan to Win Kind Words from G. B. Shaw" (January 10, 1933). In retrospect, at least, the contents of the "Telegrams" seem trivial and bland.

Silver, Arnold. *Bernard Shaw, The Darker Side*. From Stanford University Press prepublication notice; promised for 1981.

III. Periodicals

Calill, Carmen. "Virago Reprints: Redressing the Balance." *TLS* (September 12, 1980), 1001. Calill speaks on behalf of the Virago publishing venture to reprint a series of novels. "I longed to put a bomb under Leavis's agonizingly narrow selection of 'great' novelists." Among these reprints is GBS's *Unsocial Socialist*, nominated for the series and provided with an introduction by Michael Holroyd. See in this connection the uncomplimentary review by John Lucas, *TLS* (May 23, 1980), noted in the September 1980 *Shaw Review* Checklist.

Collini, Stefan. "The Fabian Fringe Thinker." *TLS* (July 25, 1980), 837–38. Review of Terence B. Qualter's *Graham Wallace and the Great Society*.

Tobias, Richard C. "Shaw" in "Victorian Bibliography for 1979." *Victorian Studies*, 23, No. 4 (Summer 1980), 603–4. A selected list of twelve entries, two not in past *Shaw Review* Checklists.